TRANSNATIONALISM, ACTIVISM, ART

Transnationalism, Activism, Art

EDITED BY
KIT DOBSON AND ÁINE McGLYNN

UNIVERSITY OF TORONTO PRESS
Toronto Buffalo London

ISBN 978-1-4426-4319-2

∞

Printed on acid-free, 100% post-consumer recycled paper with
vegetable-based inks.

Library and Archives Canada Cataloguing in Publication

Transnationalism, activism, art / edited by Kit Dobson and Áine McGlynn.

Includes bibliographical references.
ISBN 978-1-4426-4319-2

1. Transnationalism. 2. Social movements. 3. Arts, Modern – 21st
century. 4. Arts and globalization. 5. World politics – 21st century.
I. Dobson, Kit, 1979– II. McGlynn, Áine

HM1271.T73 2013 305 C2012-904202-1

The University of Toronto Press acknowledges the financial assistance to
its publishing program of the Canada Council for the Arts and the Ontario
Arts Council.

This book has been published with the help of a grant from the Canadian
Federation for the Humanities and Social Sciences, through the Awards to
Scholarly Publications Program, using funds provided by the Social Sciences
and Humanities Research Council of Canada.

University of Toronto Press acknowledges the financial support for its
publishing activities of the Government of Canada through the Book
Publishing Industry Development Program (BPIDP).

Contents

Acknowledgments

We would like to begin by thanking the University of Toronto Press, and in particular Siobhan McMenemy, for working with us on this book. The anonymous readers of the manuscript helped a great deal to improve its final form. Additionally, the University of Toronto's Centre for Diaspora and Transnational Studies deserves profound thanks for sponsoring the conference that led to this book; as do the university's departments of English, Canadian Studies, Sociology and Equity Studies in Education, and Equity Studies; and as do the Women and Gender Studies Institute, the Graduate Students' Union, the Graduate English Association, the Faculty of Social Work, the Principal of University College, the Dean's Student Initiative Fund, and the Canadian Union of Public Employees, Local 3902.

Kit would like to thank the Social Sciences and Humanities Research Council of Canada for both doctoral and postdoctoral fellowships, as well as the Killam Trusts for a postdoctoral fellowship held during the production of this book. He would also like to thank his colleagues and friends at Mount Royal University – and across the time zones. People who have contributed in significant ways – whether they know it or not – to the development of this book include Archana Rampure, Allison Burgess, Gala Arh, Arti Mehta, Smaro Kamboureli, Linda Hutcheon, Daniel Heath Justice, Heather Murray, Len Findlay, Carrie Dawson, and Dean Irvine. Finally, thanks to his family: his partner Aubrey, daughters Alexandra and Clementine, parents Debbie and Keith, sister Beth and her partner Simon, and in-laws Patti, Paul, Bruce, Jesse, Dan, Ambrose, and Wynn. Support from community and friends is ultimately what makes a project like this one possible. Finally, Kit would like to acknowledge his cats Jack and Shelby, who were omitted from previous book acknowledgments.

Áine would like to thank the Ontario Graduate Scholarship fund for its support while this book was being written. In addition, she is grateful to the Viola Whitney Pratt Scholarship Fund. The University of Toronto provided Áine with a wealth of mentors as this book was being assembled, chief among them Neil Ten Kortenaar and Ato Quayson, whose encouragements landed on grateful ears. Esther DeBruijn and Cynthia Quarrie also deserve heartfelt thanks for sharing endless cups of tea over deep conversations about the writing and thinking life. Patient, loving support from partner Beth and sisters Grainne, Claire, Roisin, and Molly deserves the lion's share of credit, for it is only as a labour of love that one embarks upon these projects at all. Áine dedicates this work to the memory of her mother, whose grace and deep compassion was the first work of art she ever loved.

Finally, we would like to thank our contributors, whose excellent work throughout this volume stands for itself. Thank you.

TRANSNATIONALISM, ACTIVISM, ART

Introduction: Transnationalism, Activism, Art

KIT DOBSON AND ÁINE McGLYNN

> It's useless *to wait* – for a breakthrough, for the revolution, the nuclear apoca-
> lypse or a social movement. To go on waiting is madness. The catastrophe is not
> coming, it is here. We are already situated *within* the collapse of a civilization. It
> is within this reality that we must choose sides.
>
> The Invisible Committee, *The Coming Insurrection*[1]

So assert the authors of *The Coming Insurrection*, a pamphlet published
initially in France in 2007 and translated into English in 2009. It is
linked, in France, to a lawsuit against a small commune whose members
have been charged with terrorism. Sloganeering aside, the pamphlet
condemns the ills of the early twenty-first century through a rhetoric that
can be linked to Italian autonomism and anarcho-primitivism, among
other movements. On a parallel tangent, Slavoj Žižek has recently sug-
gested that 'the global capitalist system is approaching an apocalyptic
zero-point,' signalled by ecological crisis, economic upheavals, biogene-
tic engineering, and huge social divisions on a global scale.[2] What does it
mean to live within the collapse of civilization? As the globalizing world
veers from one moment of crisis to the next – think of the Asian tsunami,
the earthquakes in Haiti and Japan, political revolts in Tunisia, Egypt,
Libya, and elsewhere, not to mention ongoing military action in Iraq
and Afghanistan – what can our responses be?

Transnationalism, Activism, Art emerges from these and similar ques-
tions. For us, as editors, these terms came together organically. The con-
fluence began with a series of discussions held through the Transnational
Reading Group at the University of Toronto, under the direction of Ato
Quayson at the University's Centre for Diaspora and Transnational Stud-

ies. Those discussions were the organizing terms around which we shaped an international conference held at the University of Toronto. Subsequent discussions with our colleagues suggested to us that there was a widespread interest in pursuing what it means to place these three terms alongside one another. Our concern with how artistic practice and analysis coexist with activist or political work in the realm of globalization – or what we identify as the transnational – is shared by the contributors to this book as well as by many of our peers. This concern has been important enough to us to warrant the creation of this book in order to continue the dialogue. Of particular import to us is the desire to advocate for artistic agency at a time when globalizing forces are increasingly calling for economic rationalizations for creative practices, as we will discuss below.

This volume is therefore an exploration of the transnational and its relationships with activism and art. The three terms coalesce in many ways, and disaggregate in others. The global politics of dissidence, since at least the fall of the Berlin Wall in 1989 and the end of most socialist state systems by the mid-1990s, have grappled with an economics of neoliberalism that has claimed triumph over the global sphere. As a result, a politics of left activism has increasingly articulated itself in relationship to what is variously termed globalization, transnationalism, or Empire (for followers of Michael Hardt and Antonio Negri). This activism connects at times directly and at other times more abstractly with cultural production. Activism has not only its own aesthetics and performances but also its own series of cultural practices – what we might call an art of resistance. This art is practised by specific communities within the transnational sphere, and it articulates differences that cross and transgress against all sorts of borders.

In brief, this is how we understand our three terms to relate to one another. When placed alongside one another, each narrows the others so that no single one can be isolated from the other two without compromising this book's argument that we are living in an era characterized by transnational capital, political unrest, and the economization of cultural production and of all art forms. As editors of a volume that brings together three such heady concepts, we therefore offer here a gloss on each term that locates transnationalism, activism, and art in their temporal and spatial specificities. That these terms cross and recross one another will become increasingly apparent as the book progresses; while we separate the terms here in order to give the reader a genealogical sense of each, the contributors to this volume take this foundation in a myriad of directions.

Transnationalism

Evidence of how globally connected we are and at the same time of how constrained we are by state oversight and deceit, our transnational era is perhaps best described as a paradox. Steven Vertovec insightfully describes the paradox of contemporary transnationalism as follows: it is a 'condition' wherein global relationships are ubiquitous (in economic, political, personal, and cultural domains) and take place in a 'planet spanning ... virtual arena' in spite of the fortification of borders and regulatory national narratives.[3] Indeed, the 'condition' of the transnational is evident in the term's early uses. Randolphe Bourne was among the early adopters of the term 'transnational' when he wrote an article titled 'Trans-national America' for the July 1916 issue of *Atlantic Monthly*.[4] This nearly hundred-year-old essay, in its discussion of the power of the migrant to reroute the national imaginary into a cosmopolitan future, makes a strong claim for the term transnational to refer to people on the move. The transnational person, in Bourne's articulation, is one who is characterized by having several physical and imaginative homes.

In spite of how long the term has been circulating – or perhaps *because of* the time span – transnationalism remains a rather open term; at the same time, it has become radically overdetermined. While the term has become open-ended through popular usage, it has also gained currency in the realms of economics and law, where the prefix 'trans-' might reflect more accurately than 'inter-' the modes of capital exchange taking place among contemporary nation-states. In recent years, the term has been claimed not just by those referring to the global exchange of money but also by those referring to the worldwide movements of people. Transnationalism has, equally, pushed for a rethinking of the neoliberal reorganization of the nation-state. It challenges the dialectic of centres and margins by allowing for lateral relationships that move and flow through borders and that create communities allied across their differences. As a result, transnationalism is not defined in strict opposition to centres of power. Rather, it draws from the processes by which individuals are making inter- and intra-national connections across the networks of global exchange. It becomes, as a result, a useful means through which we might recognize the implications of cultural works within capital while still discussing their transformative and imaginative power. Our working definition of the term, in its most general form, understands the transnational as an articulation of the diverse processes by which bodies, capital, ideas, and goods achieve the dynamic mobility that has charac-

terized the late capitalist era. This is not to suggest that our definition of transnationalism 'buys into' – pun intended – a narrative of globalization whereby the very fact of the movement of goods, capital, and cultural products across borders heralds a flattening of the world. Rather, it suggests that the very dynamism of these movements and the narratives and assumptions that accompany them ought not to go unexamined.

In their introduction to *Minor Transnationalism*, Françoise Lionnet and Shu-mei Shih argue that the transnational 'is not bound by the binary of the local and the global and can occur in national, local, or global spaces across different and multiple spatialities and temporalities.'[5] The deterritorialized nature of their definition reflects an important spatial dimension to the term. As a theory and reading practice, transnationalism refrains from seeing a centre–periphery divide as central to all discussions of global flows of power, capital, and cultures. Rather, transnationalism, which we see as a condition, refers to how we experience the world in terms of the exchange of capital. This exchange occurs not just between centres and margins, but across every plane and dimension – both virtual and actual. Transnationalism in this volume therefore addresses the movements that occur as a result of the creation of open spaces that cannot be accurately described as simply being a centre or a margin. It aims to examine the middle of these spaces and their surrounding edges, making it difficult, or even at times counterproductive, to focus simply on the divides between centres and peripheries; indeed, the two are often interrelated.

Today's world may be one in which the formal colonialisms that typified European relationships to much of the world in the nineteenth century – with set ideas of centres and margins – have ended, but imperialism and new forms of colonialism are very much alive today. In analyses from the writings of Edward Said to those of North American indigenous thinkers – such as Lee Maracle, interviewed in this book by Chantal Fiola – imperialism is an ideological structure that maintains itself today. It maintains itself, Maracle suggests, in our lack of attention to the 'effect elsewhere' of our privileged consumption at home. The transnational is therefore temporally open-ended. One finds in the transnational an assertion, as Jeff Derksen's essay here makes clear, that the 'old' terms – 'capitalism,' 'imperialism' – are finding purchase once more, suggesting in fact that their attendant practices – political, economic, and cultural – never really disappeared. The fact of their permanence challenges the designation of any politics or geopolitical situation as temporally 'post-' anything whatsoever.

Since the transnational, in this formulation, acknowledges that processes of colonization are ongoing, it also critiques 'globalization' and the fantastic narrative of wealth for all that accompanies its widespread use. Globalization is a term that former U.S. Federal Reserve Chairman Alan Greenspan applies to the movement of bodies for purposes of labour. He suggests that we have recently seen in China 'globalization's vast migration' as people move from rural to urban settings in order to become a part of the labour pool exploited for the manufacture of goods for worldwide distribution.[6] Greenspan's use of the term suggests that globalization continues to function as an easy buzzword for the post-Fordist, neoliberal elite. This is an elite that either elides or fails to acknowledge the extent to which the global economy – which is in the midst of a U.S.-led economic slump as we write this – depends on the abuse of labour in Asia and elsewhere. The camp that has celebrated Thomas Friedman's *The World Is Flat* thesis – as well as the Francis Fukuyama who declared 'the end of history' in the wake of the Cold War – has been convinced that globalization has extinguished – or will extinguish – the unfair advantages held by post-industrial markets over emerging ones, allowing for the creation of universal wealth. This mindset, of course, neglects the material conditions, exploitations, and imbalances that have led to this 'globalized' world. This neglect also suggests that globalization is still in some quarters a naturalized inevitability – an assertion undermined by Greenspan's 2008 admission to the U.S. Congress that deregulated free market capitalism is a flawed economic model. The transnational, as we take it, interrupts the naturalization of the ideology of globalization and is thus defined by an ethical imperative to address the material implications of increased economic growth and speed for labouring populations, for transmigrants, for the impoverished, for the marginalized, and for the women and children who are overwhelmingly negatively impacted by globalization – in short, for those who have the least access to the surpluses of a globalizing world.

There is, moreover, an important terminological distinction between globalization and transnationalism. This distinction is that the nation is included within the latter term, the implication being that in the former, the nation-state is no longer relevant – an argument that rings false, however often it has been made. The nation-state in fact does continue to impact globalizing modes of artistic and cultural practice, as well as, of course, the ways in which people live their lives. Deonne Minto's chapter in this book reads the evolution of 'national dances' in lockstep with the twenty-first-century nation-state as indicative of the relevance of the na-

tion in spite of gestures that efface its relevance in the production of culture. The transnational is therefore distinctly not post-national. In spite of a globalizing economy wherein markets are entangled in one another, the nation-state remains, according to many, the 'chief mechanism for the dispersing and regulating of power, status and material resources.'[7] Theorists like Saskia Sassen have analysed early signs of transnational forms of citizenship located in major global cities – an analysis that runs parallel to Imre Szeman's reassessment of the space of the urban in this book. At the same time, documentaries such as *The Corporation* and *Manufactured Landscapes* make the point, if indirectly, that the nation-state and the right to citizenship have tremendous potential to protect labourers and environments from the amorality of corporate expansion.

However, the rights of citizenship are eroding as privacy vanishes under the guise of strengthening national security. Access to the virtual world becomes easier, though easily surveilled, even while movements across physical borders are accompanied by harassment, suspicion, and invasive and costly deterrence tactics. In short, borders within the transnational continue to be very real – at least for many. Barriers continue to impede the movement of people and ideas, while the capital and goods that sustain profits are hindered by fewer such restrictions. To return to China's 'vast migration,' evoked by Alan Greenspan, literature for prospective investors in Chinese markets reminds them that 'although immigration has expanded significantly over the past two decades in some large European countries and the United States, trade remains as the more important channel for accessing the large global labor force.'[8] In other words, while people have managed to move across borders in spite of restrictions, trade – goods and money – remains the prime mover of global capitalism and our present order. Bodies, on the other hand, are there to be put to use by capital when they lie within state boundaries like China's. Transnationalism differentiates itself from globalization by maintaining an interest in the differences in pace, scale, and access that exist among people, capital, products, and ideas. Transnationalism looks at the barriers that spring up to prevent certain groups, ideas, and products from moving as swiftly as they could. That which is sandbagged is that which evinces a threat to the luxurious freedom of movement that capital enjoys.

Activism

Activism is notoriously hard to define. In the following section we consider that term in light of the long twentieth century, which enables us

to see that today's forms of activist protest have arisen as a direct consequence of the economization of the body in the late nineteenth and twentieth centuries. In his afterword to this book, Rinaldo Walcott clusters today's activisms around identities and bodies in an even longer tradition – one that looks to the Haitian Revolution, which culminated in 1804, as well as to the conclusion of the British Atlantic slave trade in 1807. Counter-institutional actions have a long history, and it remains important to recognize the legacies of today's activisms in the opposition to the Vietnam War, in the critical and cultural theory of the 1960s (as well as its non-conformist art), in the developments in the socialist states, in the reactions to the Spanish Civil War and the rise of Nazism in the 1930s, and so on. This present book, however, gives particular evidence of the cultures of resistance as they have manifested themselves since 1989. Such presentism has a specific rationale. The fall of the Berlin Wall in 1989 and the ensuing collapse of the Soviet bloc have required, we believe, a fundamental rethinking of how political movements articulate themselves. Hardt and Negri argue that Empire is a complete world system, one that has no outside. Post-structural thinking, similarly, has worked to dismantle notions of inside and outside – the very notion of deconstruction. But these ideas have also appeared in neoliberal and neoconservative thought. Over the 1989–91 period, Francis Fukuyama developed the argument that the end of state socialism and the Cold War meant that liberal democracies and free market economics had been victorious against all opposition. This victory meant that there was no longer any struggle between opposing systems and that, by extension, history – as an Hegelian dialectical process – was at an end. All that remained, the argument went, was the even implementation of the neoliberal system over the entire globe and the even disbursements of capitalism's rewards.[9] Dangerously simplistic, this argument underwrote every popular pronouncement of the supposed 'inevitability' of globalization throughout the 1990s and the beginnings of the new millennium – an inevitability that was invoked to justify plant closures, massive layoffs, and the dismantling of the welfare state.

That there is no longer any outside, at least not as we used to conceive it, has meant that counter-politics have been pushed to formulate themselves in new ways. The difficulties of these reformulations have been visible throughout what have variously been called the anti-globalization, counter-globalization, and antiwar movements. The rallies and protests that have characterized these movements are notable, at least in part, for their variety – variety that demonstrates the tremendous amounts of organizing that take place beyond the explicit manifestations of political

will in the streets. The Seattle protest against the World Trade Organization in late November and early December 1999 boasted the participation of trade unions, Greenpeace, religious groups, members of the British Columbia government, and many more.[10] As this movement both altered and responded to global conditions, it channelled itself, arguably, into the opposition to the U.S.-led war on terror, which led in turn to the appearance of new organizations. The power of these groups to mobilize was especially visible on 15 February 2003, the largest day of mass global protest yet recorded, with estimates of ten million participants in locations around the world. Muslim groups marched alongside Christian groups, who marched alongside queer activist groups. Some Palestinian and Israeli organizations found common ground, and conservative 'doves' were accommodated. Unions, political organizations, and NGOs attended in mass numbers. That the U.S. attacks proceeded does not erase the symbolic importance of the temporary alliances that these groups were able to form in opposition to militarism. What these movements have been most often criticized for, following from this diversity, is a lack of coherent politics. For Hardt and Negri, this does not pose a problem. Their proposal is for a multitude in opposition to power and Empire. The multitude's potential, always greater than that of any realized politics, provides the ground for a fertile, mobile, and open-ended politics of futurity, one that is yet to be realized (and that will never be realized, always remaining in process).

Yet it has been difficult to shake the critique that these activist movements lack a coherent politics; this critique has been again on display in recent discussions about the Occupy Wall Street movement, for instance. This seeming lack of coherence is, we argue, the particular result of 1989 and thereafter, of what it has meant to live in the so-called aftermath of history. History, of course, has not ended, as Slavoj Žižek was quick to note after the events of 11 September 2001: he argued in 2002 that 'America's "holiday" from history' between the end of the Soviet Union and 9/11 'was a fake.'[11] If there has been a return to the dialectic, however, the dialectic that has been mobilized by governments across the West has – either consciously or with complete disavowal – too often been one that follows Samuel Huntington's notorious 'clash of civilizations' thesis and that is articulated around ethnicity, race, and religion rather than around questions of ideology or political system.[12] The systems of countries outside the West are largely assumed to be less advanced according to the old teleology. The antiwar left has advocated self-determination for everyone from Afghanistan to Iraq to Palestine to

Tibet; what that self-determination might look like is less often a topic of discussion. The return to history, if we can even talk of such a thing (and Fukuyama's recanting of his earlier stance might push us further towards critical reassessments of this argument), has not meant the advent of oppositional politics on which activist groups agree on a mass scale. In spite of a recent reinvestment in the familiar terms of mid-twentieth-century politics – one that Derksen argues is happening – to be a socialist or a Marxist today tends to sound, for better or for worse, quaint to many of those who take to the streets.

Transnationalism, Activism, Art aims to better understand why this is the case. While much activist energy takes its cue at some level from Marx, activisms are less often announced as Marxist or even post-Marxist (in the sense given by Ernesto Laclau and Chantal Mouffe).[13] Today's activisms are far from unanimous in supporting Marxism (and other analogous positions). Today's activisms seem, rather, to share some of the genealogy that we identify with the transnational, going beyond the category of class as a basis for analysis and moving in a myriad of directions at once.

Art

Art is, of course, an equally contested term, and one that we struggle to define even within the confines of this project. Seeing how questions of the political have shaped this project, we find ourselves asking what, if anything, art might do today. The answer is not easily arrived at. In the first place, we decided for this section not to define art in terms of aesthetic categories, or in terms of the relationship between art and conventional notions of beauty. In short, we are not interested in the question often posed of avant-garde or unusual art: 'Yes, but is it art?' Rather, we refer to art in terms of two superficially divergent but often interrelated practices, both of which represent, while also critiquing, high and popular cultures.

First in this context is protest art, the provocative and clever, portable and disposable banners, signs, effigies, costumes, performances, and sculptures of street protest. Its very disposability is antithetical to the preciousness associated with many artistic products. This kind of art is not (often) displayed in museums and galleries; it finds relatively few homes on library shelves; and it is seldom performed on Broadway. It is, among other things, aspects of the Situationism connected to the May 1968 uprisings in Paris, the turtle costume from the Seattle protests against the WTO in 1999, and the teddy bear catapult at the 2001 protest against the

Free Trade Area of the Americas in Quebec City. Its primary aim appears not to be one that seeks formal evaluation or admiration. It does not tend to be allusive or to require a wide knowledge of art forms in order to be understood. Its frame of reference, then, is the immediate context in which it is viewed. It is 'message' art at its most stripped down.

The second level, though very much a related one, of artistic practice with which we are concerned in this book is the art object that seeks out comment, that is more enduring by virtue of the fact that it is often in conversation with other works of art. This is the realm of cultural production that can be displayed in galleries, theatres, or libraries, or otherwise be granted widespread distribution. We are particularly interested in instances of overlap between differing modes of artistic practice, when we observe the blurring of 'high culture' and the culture of protest. As we will see, this interaction is at the very heart of the transnational. Mat Jacob's photograph of the gender-queering protester in a tutu fleeing a riot squad, which Melissa Autumn White reproduces in her chapter, reveals this interrelation. On the one hand, the cross-dresser as performance artist engaged in counter-globalization protest enacts the kind of momentary artistic performance that speaks to one aspect of the transnational activist aesthetic. On the other hand, Jacob's image of the performance speaks to an artistic practice that is more enduring, that seeks out comment, and that, in its permanence, speaks to what has come before. Its predecessors or intertextual references might include Goya's *Execution of the Rebels of the 3rd of May, 1808*, Motherwell's *Elegy to the Spanish Republic*, or even the image of a Vietcong being shot by an officer of the South Vietnamese Army. That this is more enduring art suggests that it reflects the conditions under which it was created and that it can stand as proof of a particular cultural moment. This more permanent art, then, crosses spatial and temporal borders that the more fleeting performance of protest might not. In her chapter in this book, Kirsty Robertson differentiates these two practices as the 'action of and the recording of protest.' These differing kinds of practice reveal a specifically transnational interaction between an immediately located and yet, for Robertson, deterritorialized art of protest and an art object that on the one hand enacts its reproducibility as mobility, while on the other becomes 'reterritorialized' within Western art history.

The question of what art can do, however, remains unanswered – probably necessarily so. Until at least the end of the Cold War, during the height of deconstructive disruptions of social categories, aesthetic pleasure – a powerful tool of both advertising and cultural propaganda

– was treated with deep suspicion. To believe in 'art' in the old sense was to assume the existence of universal standards for measuring beauty. How could that be possible in such a divisive era? Wasn't Adorno correct in suggesting that it was barbaric to write poetry after Auschwitz? What could art do? The words of an ACT UP poster campaign from the late 1980s suggest something of that mood: 'With 42,000 dead, art is not enough. Take collective action to end the AIDS crisis.'[14] Action, be it legislative, military, or populist, can compel change, according this argument, but art cannot. More recently, however, and perhaps particularly since 9/11, questions about art have taken on new dimensions. In his 2005 book *The Art of Protest,* T.V. Reed claims that the art from ACT UP's campaigns was able to 'both challenge the sense that real art was about form and abstract, universal experience, and … break down the complacent distinctions between art as representation and art as action.'[15] If art can be both representation and action, then we must pay attention to both the message and the aesthetic shape that that message takes in our post-McLuhanite world.

Aesthetics exist, argues Arthur Danto, 'in order that our feelings be enlisted towards what the art is about.'[16] That is to say that our sensual perception of the formal aspects of the art object turns our attention to what Danto calls the 'aboutness' of the art object. A conscious evaluation of that aboutness then needs to follow. Kelly Minerva's reading of Mumbai's literature about the city's slums displays this process, whereby the shape those novels take awakens us to the complexities of their authors' relationships to the communities about which they write and to readers' implicit positions as outsiders consuming a commodified vision of the slums through art, a process that seems to reach its apogee in the film *Slumdog Millionaire.* Such writers are, it seems, employing the effects and affects of such communities in order to move their cultural commodities. If the art is about the question of where artists derive their materials from – as it is at least in part in this case – as well as being about the complexity of marketing that work, then its aesthetic qualities play a role in alerting readers/viewers to this fact. Even Marcel Duchamp's readymades, such as his snow shovel and his urinal, are an exercise in vacating beauty from the sphere of art: they subject the viewer to an experience that we can identify as an aesthetic one, even if it is an experience of alienation or surprise.

The aesthetic, as far as it can be a dynamic and overwhelming force, can be used for all sorts of different ends. It has been the term that we have debated the most in our writing, and it is the easiest to distrust –

as well as the most tempting to try to dispel. Yet it returns, remaining a concept central to questions of art, both in the context of transnational activisms and elsewhere. Aesthetics are powerful, but what makes them dangerous is their operation on a population that is not aware of or that does not know how to read their manipulative potential. The greyness of everyday life is washed over by the colourful mediascape of Fox News and by the fetishization of the war machine. However, with repeated exposure and instruction, observers can begin to pick apart the functioning formal elements of any given object. Understanding how, in social terms, art 'works' allows for a critical evaluation of the message that the aesthetics of the object are working to enlist its viewers towards.

We therefore need to pay close attention to art and to the function of aesthetics in the transnational world. These are highly social, codified structures that affect viewers in a variety of ways, many of them far from innocent. Faith in art as revolution, particularly in institutionalized art, seems increasingly problematic in this context. Sven Lütticken, however – and usefully – argues in *Art Forum* that 'the refusal to engage in a tactical use of even compromised institutions and media ... can easily slip into acceptance and even celebration of the status quo.'[17] In short, artists have to work with what they have; the same applies to critical writing and thought. The radical potential of the art object to disrupt the norm is demonstrated in the neoliberal right's frequent protests against individual artists and their controversial works (which are often carried out, at least in Canada, in order to *really* attack the agencies that fund the arts in this country). To abandon art would be to abandon the possibility that the exchange of art – be it commercial, personal, intimate, global, micro, or macro – will enable the growth of communal restlessness and productive energy.

Life and art, Gerald Raunig argues in *Art and Revolution*, are distinct, as are the material realities of life and its fantastic reproductions. Revolution may take place in the realm of 'real life,' but it can be productively imagined and rendered first. Raunig suggests that art and life overlap continually.[18] So too do the machines of revolution and art. The dynamic and transnational interaction of a revolutionary spirit with art creates an ongoing and self-perpetuating cycle of micropolitical singular events that reflect art and activism as always already happening.

A Collision of Terms

Why do we insist on the interrelation of our three terms? One of the main reasons, which we signalled in the opening to this introduction,

is that we are interested in the effects of artistic production that might challenge the economic determinism of our times. Such a focus is indeed challenged by how art forms function today. Consider, for instance, the circulation of books. John B. Thompson argues that today, 'for most trade publishers, the "value" of a particular book or book project is understood in one of two ways: its sales or sales potential, that is, its capacity to generate economic capital; and its quality, which can be understood ... [as] its capacity to generate symbolic capital.'[19] Thompson's analysis, which takes its cue from Bourdieu, could be taken one step further: ultimately, a book's generation of symbolic capital feeds the longer-term accrual of economic capital, in that a publisher's being associated with quality projects will ensure longer-term interest from the marketplace than the fleeting, though potentially massive, sales of a contemporary best-seller. For writers publishing in this milieu, their publisher's interests may be quite radically at odds with their own; understanding what additional meanings might be retrieved from this circulation therefore becomes important.

This recourse to capital – a sort of 'vulgar' Marxism in reverse, given the market's seeming economic determinism – is very much part of the logic of neoliberalism. George Yúdice's analysis, for instance, has been important for recognizing the extent to which culture itself is increasingly deployed within globalization as a means to create economic growth. While tracing a variety of cultural processes, he argues that 'art has completely folded into an expanded conception of culture that can solve problems, including job creation. Its purpose is to lend a hand in the reduction of expenditures and at the same time help maintain the level of state intervention for the stability of capitalism.' In other words, according to Yúdice, 'culture ... is increasingly treated like any other resource' in the contemporary world.[20] In this context, and 'compatible with neoliberal reconversions of civil society, culture as resource is seen as a way of providing social welfare and quality of life in the context of diminishing public resources and the withdrawal of the state from the guarantees of the good life.'[21] We might think, in this context, of popular claims that culture is important for the creation of vibrant and economically functional cities, claims made most prominently by Richard Florida. This vexatious manoeuvre is one that many artists have readily participated in, often with good reasons and intentions, yet it appears to short-circuit some of the possibilities for art, particularly art that seeks to challenge capital and its workings.

How do we see this problematic on the ground? For us, we think right now of Toronto, the city in which this project was begun. In Toronto,

inquiries by provincial and federal ombudspersons have begun to reveal that repeated violations of civil liberties were committed in 2010 during the G20 and G8 summits held in the city's downtown core. The protests conducted during that week in June included a polar bear carved out of ice by British sculptor Mark Coreth. The ice, which people touched as they approached it, gradually melted away under the heat of the city's collective hands, revealing a metal skeleton underneath and signalling humankind's widespread complicity in global climate change. Protesters clad in boas, clown costumes, and wigs, banging pots and singing songs, took to the streets. These creative expressions of transnational resistance were aimed at the governments of the largest global economies, whose closed-door decision-making processes are at odds with the democratic principles espoused by those same governments' national narratives. The creative expressions on the streets sought forms of justice beyond the economic agreements that were the focus of this and other, similar summits, and it is important to read these cultural forms beyond the economic bottom line.

In addition to displaying disruptive aesthetics in the streets amidst 'movements of movements,' which Melissa Autumn White analyses in her chapter, activist movements have begun quite effectively to leverage technology for its resistant potential. Julian Assange's rise to media prominence in the winter of 2010–11 is evidence of the revving up of these sophisticated and globalized tactics. His website, WikiLeaks, has had a good deal of success publishing unflattering state documents. The implications of this website for our concept of global spaces of resistances is insightfully revealed in Nick Morwood's chapter in this book. Now that Assange, having published thousands of classified state papers on his site, has become a household name, he is considered both the arch-villain and the patron saint of the Internet Age. At the heart of these contrasting images of Assange – to momentarily, though problematically, set aside the other charges pending against him – is an apt metaphor for how transnationalism both produces and symptomatizes the call to re-evaluate what is meant by borders, nations, and citizenship. Evidence of how globally connected we are and at the same time of how constrained we are by state oversight and deceit, our transnational era is characterized by paradoxical celebrations of what we can 'do' once we are globally connected, as well as by lamentations over the loss of local community, national identity, and privacy. It is in the cultural products of this era, including those examined by the contributors to this book – such as Sarah Brouillette, who examines the poetry of Daljit Nagra and its relationship

to communities of various scales – that the anxiety produced by this paradox emerges.

Coupling the terms transnationalism, activism, and art allows us to foreground the connections among capital, politics, and culture in ways that allow our contributors to exceed the straightforward logic of capital. In postcolonial studies, Graham Huggan – interviewed in this book by Sam Knowles – argues that postcoloniality 'is a value-regulating mechanism.' That is, the postcolonial is invested in evaluating social values. For Huggan, this reminder is necessary because the field of postcolonial studies has sought to emphasize its elements of 'anti-colonial intellectualism' rather than its ties to capital. This suggestion is not intended as a declaration that the postcolonial fails to acknowledge the overwhelming power of capital in processes of colonization and decolonization. Rather, it makes clear that the postcolonial has at times failed to locate its own prolific output within commodity culture over the last half century. 'In the overwhelmingly commercial context of late twentieth-century commodity culture,' Huggan argues, 'postcolonialism and its rhetoric of resistance have themselves become consumer products.'[22] By explicitly tying our three terms together, however, we can both acknowledge the role of capital and examine what aspects of resistance or political force might remain – rather than risk the evacuation of those gestures through their absorption in the marketplace. The social struggles for cultural production and the always immanent potential for their recuperation within capital – or indeed, their always already recuperated status – need to be thought at the same time. Cultural work takes place and agitates towards social change, but it is also, absolutely, part of the structures it contests. Prasad Bidaye's chapter, which cites an 'ethic' to the radical distribution tactics of underground dance music, simultaneously understands capital and the disruptive restructuring or even undermining of the market. Rather than seeing this movement as contradictory, the authors in this book explore this rift, as we have here, as a source of productive tension.

NOTES

1 The Invisible Committee, *The Coming Insurrection* (Los Angeles: Semiotext(e), 2009), 96.
2 Slavoj Žižek, *Living in the End Times* (London: Verso, 2010), x.
3 Steven Vertovec, *Transnationalism* (Abingdon: Routledge, 2009), 3.

4 Randolphe Bourne, 'Trans-national America,' *Atlantic Monthly* 118 (July 1916): 86–97.
5 Françoise Lionnet and Shu-mei Shih, 'Introduction,' *Minor Transnationalism* (Durham: Duke University Press, 2005), 6.
6 Alan Greenspan, *The Age of Turbulence: Adventures in a New World* (New York: Penguin, 2007), 476.
7 Lionnet and Shih, 'Introduction,' 17.
8 T.J. Bond, 'Chinese Labor, Global Boom,' *The Asian Market Economist* (Hong Kong: Merrill Lynch, 2007), 9.
9 Francis Fukuyama, *The End of History and the Last Man* (New York: Harper-Collins, 1992).
10 The most accessible overview of the Seattle protest is the film *This Is What Democracy Looks Like* (Seattle: Big Noise Films, 2000).
11 Slavoj Žižek, *Welcome to the Desert of the Real! Five Essays on September 11 and Related Dates* (London: Verso, 2002), 56.
12 Samuel Huntington, *The Clash of Civilizations and the Remaking of World Order* (New York: Simon and Shuster, 1996).
13 Ernesto Laclau and Chantal Mouffe, *Hegemony and Socialist Strategy*, 2nd ed. (London: Verso, 2001).
14 Quoted in T.V. Reed, *The Art of Protest: Culture and Activism from the Civil Rights Movement to the Streets of Seattle* (Minneapolis: University of Minnesota Press, 2005), 191.
15 Reed, *The Art of Protest*, 191.
16 Arthur Danto, *The Abuse of Beauty: Aesthetics and the Concept of Art* (Chicago: Open Court, 2003), 59.
17 Sven Lütticken, 'Event Horizon,' *Artforum.com* (September 2007), 9 February 2011.
18 Gerald Raunig, *Art and Revolution: Transversal Activism in the Long Twentieth Century*, trans. Aileen Derieg (Los Angeles: Semiotext(e), 2007).
19 John B. Thompson, *Merchants of Culture: The Publishing Business in the Twenty-First Century* (Cambridge: Polity, 2010), 10.
20 George Yúdice, *The Expediency of Culture: Uses of Culture in a Global Era* (Durham: Duke University Press, 2003), 12, 13.
21 Ibid., 279.
22 Graham Huggan, *The Postcolonial Exotic: Marketing the Margins* (London: Routledge, 2001), 6.

1 Manhattanism and Future Cities: Some Provocations on Art and New Urban Forms

IMRE SZEMAN

Washington, laid out in 1800, is already in the age of the automobile.

Northrop Frye, *The Modern Century*[1]

Losing the city, we have lost everything. Recovering the city, we will have gained everything. If there is a solution possible today, it lies in reorganizing the place of communal life ... Working on the city, we will work on politics as well. In a way, this is a regression, since the word politics comes from *polis*, 'city.' We crashed into the wall, and we are now returning to the city.

Paul Virilio, *Politics of the Very Worst*[2]

1. Nothing More Than Feelings

The bombastic horns kick up and billow out, to be joined a few quick measures later by the imperious, exultant voice of Frank Sinatra: 'Start spreading the news! I'm leaving today! I want to be a part of it, New York! New York!' Thus begins one of the best-known hymns to the urban, a song that still captures the imagined possibilities and utopian longings that have crystallized around the city since at least the time of Baron Haussmann's transformation of medieval Paris into the managed boulevards of modernity in the mid-nineteenth century. New York, New York! If you can make it there, you can make it anywhere! To encounter the city is to experience just this rush of energy: the flush of adrenaline one gets tramping around Midtown; crossing the Thames towards Covent Gardens in London; staring across at Pudong from the concave embankment of the Bund in Shanghai; or even sweeping around the curve of the QEW driving east from Hamilton and glimpsing the Toronto skyline

across a small arm of Lake Ontario. The city is a space of energy, possibility, and hope. Or so it seems.

It takes only one small step back to see that mixed into this flood of energy – perhaps even a constitutive element of it – is an all too familiar ideology. The city is imagined not as a social space, not as part of the commons, but as designed for and built up around the individual, who is figured as the primary unit of city life and as its driving force. New York, New York! It's up to each individual to make it there, an idea that has changed little from Sinatra's evocation of urban desire and future possibility to Jay Z and Alicia Key's popular 2009 anthem to an 'Empire State of Mind.' The idea that 'making it there' means to 'make it anywhere' captures the animating drive of life activity under capitalism in a compressed figure – that of an exceptionalism (since not everyone can make it) to which everybody can equally aspire (*you* can make it, if you try hard enough).

The myth of the city, especially as it operates today in our experience and imagination of iconic global cities like New York, disguises ever more deeply the reality of its ideological and economic operations. This is due in large part to the sense and experience of the urban, its sheer phenomenological presence and its demands on consciousness. The city as an always already ideological device? Describing it as such seems like a category mistake, the wrong way of understanding what shapes a city and animates it. For one cannot help but be drawn to the energy of other bodies, to the furious scale and scope of human material production, to the delirium of the city, which the architect Rem Koolhaas locates paradigmatically in the experience of Manhattan:

> The City of the Captive Globe ... is the capital of Ego, where science, art, poetry and forms of madness compete under ideal conditions to invent, destroy and restore the world of phenomenal reality ... Manhattan is the product of an unformulated theory, *Manhattanism*, whose program [is] to exist in a world totally fabricated by man, to live *inside* fantasy ... a mythical island where the invention and testing of a metropolitan life-style, and its attendant architecture, could be pursued as a collective experiment ... a Galapagos Island of new technologies, a new chapter in the survival of the fittest, this time a battle among species of machines.[3]

In these scenes of battle and survival, the ideology of the city returns from a different angle. To name in this way the energy of the city is, of course, to name the relentless dynamism of capitalism – simultaneously

the producer and product of this space of lights, concrete, and commodities. Capital has long been the essence of the urban, even if this is disguised by quotidian acts of living (learning, shopping, being at home) and by the monuments, squares, and heritage buildings that linger as genteel reminders of earlier modes of production and spatial organization.[4] Medieval Paris had to go and the modern city had to come into being so that money could flow with less impediment through its cramped streets – money, and, if need be, the might of the state to enforce this flow, the secret of the Parisian boulevards (so beloved by tourists and connoisseurs of urbanity) being their capacity to allow troops and armaments to move with ease to squelch any new Commune that might arise. Every celebration of the urban, and every positive evocation of successive avant-gardes and of the dynamism of culture associated with them, has to reckon with the fact that the city is at its core an expression of the energies of capital, which produces new possibilities, but enormous limits as well. Which is to say, in the context that we find ourselves in today, start spreading the news: to say 'globalization' is to say that Manhattanism, which Koolhaas describes as 'a program to exist in a world totally fabricated by man, to live *inside* fantasy,' has become the universal condition of the urban today.

2. Good City, Bad City

What does the contemporary state of the global city mean for contemporary art and its politics? Even a simple genealogy of the urban and visual would point to the fact that they have a long-established relationship, with shifts in urban form being mirrored (though not in a determinate way) by changes in the hegemonic visual modes of different eras. Film is to the modernist city as television is to the postmodernist suburb, which would suggest that digital and network forms of visuality produce and are produced by cities that we already live in – what Manuel Castells, for instance, has described as 'informational cities.'[5]

As Manhattanism has grown more extensive and intensive, the imagined power and capacity of art (and of the visual more generally) has expanded and receded alongside changes in how the urban has been understood. In Georg Simmel's 'The Metropolis and Mental Life' (1903), the experience of urbanism creates myriad new possibilities even as it devours others – a situation of creative destruction in which the visual arts thrive. The urban extends the power of individuals, enriching human possibility: in the city, Simmel writes, 'a person does not end with the

limits of his physical body or with the area to which his physical activity is immediately confined but embraces, rather, the totality of meaningful effects which emanates from him temporally and spatially.'[6] But a half century later, the increasingly evident importance of the visual as a key category of the urban comes laced with warnings. In *The Society of the Spectacle* (1967), Guy Debord (a figure who is being rediscovered as both an urban theorist and a theorist of globalization *avant la lettre*) writes that 'the world at once present and absent which the spectacle makes visible is the world of the commodity dominating all that is lived. The world of the commodity is thus shown for what it is, because its movement is identical to the estrangement of men among themselves and in relation to their global product.'[7]

Art now must operate within a generalized regime of a fully commodified visual–social phantasmagoria; its power diminished, Debord and the Situationists turned from the artistic avant-gardism of modernism (and the modernist city) to experiments with urban form (through the practice of *dérives*) and commodity culture itself (through the practice of *détournement*). Since the logic of capital that animates the urban has rendered the politics of art impossible, it would seem that it is the urban form and capital that have to be unleashed from their imaginative limits if the critical thinking associated with art and the visual can emerge again.

So where does art – especially political art – find itself now? Is it fated to repeat the gestures of the Situationists ad infinitum? Or will future cities be populated by forms of art other than those of a wearied avant-garde or by forms of activism that take up the urban in gestures that collapse aesthetics into politics (more activism than art)? In her chapter in this book, Kirsty Robertson suggests that there is a renewed interest in political art, in an art that is less conceptual and far more locational, existing as it does at the very sites of protest, creating visual culture alongside urban agitation. However, this return to the political takes place on an historical terrain that renders the concatenation of politics and art very difficult – that reduces it to tenuous, occasional, brief conjunctions that are (Gerald Raunig has argued) doomed to incompletion and failure.[8] Changes in city form demand not just new forms of art, but new ideas about politics enacted in and through aesthetics.

3. Kolkataism!

As has been made clear by the repeated visual evocation of the Jetsonsesque skyline of contemporary Shanghai – already used without modifi-

cation as a setting for science fiction films (as in Michael Winterbottom's *Code 46*) and without comment in ads that want to signal the global quickly and effortlessly – these questions about the art and politics of future cities are already upon us: future cities are *already* here in the form of the *global megacity*. By their shape, these cities-to-come render Manhattan or Paris little more than quaint remainders – orderly processions of coiffed landmarks whose nineteenth-century gravitas and sharp, art deco pretensions make perfect safe scenes in which to act out tourist fantasies of the urban. The addition of the 'global' to the scale of the city means that Manhattanism has now exceeded Manhattan – or rather, that while Manhattanism continues to represent our feelings for the city (New York! New York!), the banal underside of capital, once hidden within the dynamism of this iconic city of modern art, has erupted into gigantic surface geographies on which excess and deprivation are combined in ways that are unmappable even to the citizens who live there. In his review of the fascinating multivolume *Project on the City* being carried out by Koolhaas and other members of the Harvard Design School, Fredric Jameson reminds us that

> the fact is that traditional, or perhaps we might better say modernist, urbanism is at a dead end. Discussions about American traffic patterns or zoning – even political debates about homelessness and gentrification, or real-estate tax policy – pale into insignificance when we consider the immense expansion of what used [?] to be called cities in the Third World: 'in 2025,' we are told in another Koolhaas collective volume [*Mutations*, 2001], 'the number of city-dwellers could reach 5 billion individuals ... of the 33 megalopolises predicted in 2015, 27 will be located in the least developed countries, including 19 in Asia ... Tokyo will be the only rich city to figure in the list of the 10 largest cities.' Nor is this a problem to be solved, but rather a new reality to explore.[9]

Manhattanism? No, today it should be Paulista-ism, Shanghai-ism, Guangzhou-ism, each space representative in its own way of the vexed realities of urban life in the twenty-first century. The addition of the 'global' or 'transnational' to the discussion of visual culture and urban identities forces us to think anew about the long-established connections between the visual and the urban. What happens to the urban when the scale on which (for instance) the economy works becomes planetary, and instantaneously so? When culture is no longer just urban or national, but is also, in some important new way, global? When the

visual arts, long imagined as offering a challenge to the existing state of things, become the very model of those forms of the 'immaterial' or 'affective' labour – working endless hours just 'for the love of it,' and at a substantial labour discount to boot[10] – that make the world go round today? How are we to shift our attentions from Sinatra's modernist city to a future city shaped by forces that inscribe the visual, the arts, and the urban together in ways only hinted at, for instance, in the scale of contemporary photography (the images of Andreas Gursky or Edward Burtynsky, among others), which tries to capture by size what eludes it in content?

4. Slum Art

These are questions that, unfortunately, are *not* being asked – at least not with the intensity that they should be. One reason for this is a tendency to view globalization as reducible to the intensification and extensification of current modes of social relations – as captured, for instance, in the now banal assertion about the spread of Western culture into non-Western spaces – as opposed to envisioning the need for entirely new modes of thinking about the novel social relations that are coming into existence both in the West and elsewhere. Can panopticism or theories of surveillance generated from analyses of a specific national circumstance simply be blown up to encompass the globe? Is the spectacle specifically Western, while in other contexts a different kind of mediating relationship explains the precise character of contemporary social relations? And what technologies of visuality and subjectivity can be viewed as proper to an 'informational society' – 'a social structure where the sources of economic productivity, cultural hegemony and political military power depend, fundamentally, on the capacity to retrieve, store, process and generate information and knowledge'?[11]

These questions also have to be asked of the practices and politics of art and activism in relation to new urban forms. If the shape of the city to come is Jakarta or Lagos, what kind of art can we expect to inhabit these new spaces? What is the art of the megacity or slum city? Put this way, the question is perhaps too general. After all, every city contains a multitude of art forms and practices: from older forms of craft production (whether expressions of cultural tradition or the birth of new kinds of production for the burgeoning tourist art economy), to the state art of monuments; from commercial art of various kinds (including the neon canyons and advertising billboards of consumerism, surely now to be

counted as a kind of installation art), to the canonical forms on display in fine art museums; and from the art of the international avant-gardes, to the popular and resistant arts of the streets and of the slums. It is with an eye on the new, emergent forms of art that the question of the art of slum cities or global megacities is posed. What kind of art can or will make sense of the disorganized, unmappable experiences and the physical and psychological challenges of living in these spaces (especially within and against surveillance apparatuses that imagine producing informational if not phenomenological certitude of the 'content' of contemporary spaces)? And for whom are these cognitive maps generated? For locals only, or for those international markets and academic–curatorial spaces that have the power to confer the title of 'art' to an artefact? Even if we accept the idea that the world is becoming increasingly homogeneous in the era of globalization, the answers to these questions will be as various as the cities to which they may be posed. The politics and criticality typically associated with contemporary Western art find only faint echoes elsewhere, typically in the privileged enclaves of the elite – and not on the streets or in the consciousness of the vast majority of urban dwellers.

It is easy to leap too quickly to conclusions about why this is the case. For instance, one can fall back immediately on the widely accepted (if dubious) idea that art becomes political only in conjunction with trade liberalization and liberal political freedoms (i.e., that art is secondary to more fundamental social and political changes). Or one can speculate that the denizens of megacities are so overwhelmed by the details of daily existence and by the complex sensoria of their cities that they have no time for art. Regarding the latter, one can only respond by asking: Who needs new forms of emergent art more than those who inhabit slums or the drab concrete sameness of contemporary urban spaces, such as Beijing or Sao Paulo? Who needs the uselessness of the aesthetic – that Kantian counterpoint to the brute utilitarian insistence of every other mode of cognition and social interaction – more than those whose lives have been reduced to pure utility? And in response to the former: we have to face the limits of our own sense of political freedoms. While we can say anything (in the way that one supposedly cannot do in China or Cuba, places whose very existence provides the necessary ideological support for our all-too-easy belief in our own small freedoms), nothing gets said – or, at least, nothing of consequence, since structurally art and intellectual practices operate in those spaces whose comfort and openness hide their social and political marginality.[12]

5. Future Cities–Art–Politics

To each kind of city its own kind of art: this is why we shouldn't expect
Western art practices to exert the same kind of critical energies else-
where as they might in Paris, New York, or Toronto – if they even do so
in the changed circumstances of those cities. Contemporary art emerges
out of an intimate relationship with the modern (and modernist) city:
with the density of the Paris's urban landscape, even after its twisting me-
dieval streets were crushed to make way for its axiomatic boulevards; with
the grid of New York, hooking squalor and spectacle together in geomet-
ric precision even while leaving gaps and margins in which art and artists
have flourished; and even with Toronto, one of the few Canadian cities
to have stumbled into the size and shape of the modern city, in which
density and relative prosperity come together to generate self-sustaining
electrical flashes of insight and ambition.

Megacities have different genealogies. They were born in the second
half of the twentieth century rather than the first, in a postcolonial mo-
ment that renounced the colonial imagination and exoticism that had
fuelled Western modernism. Contemporary megacities are organized
not around the factory system of Fordism and the politics that developed
in conjunction with it, but to take advantage of the disorganized flow of
global post-Fordist production, in which technology has radically trans-
formed labour, society, and culture, and for which an adequate politics
has yet to be discovered (*autonomia*'s dreams of a global purchase not-
withstanding). In her contribution to this book, Kelly Minerva begins to
address the art of the megacity as she looks at the crime fiction emerging
from the slums of Mumbai. In a narrative move that sees capital and sub-
version come together in the heroic quest for an enterprising interna-
tional criminal, the operational mode of the future city emerges. And if
modernist art could imagine that it was struggling for the soul of the city
against the deprivations of images of consumer or mass culture (as T.J.
Clark taught us), the art of future cities is emerging in an era in which
this struggle, while living on belatedly as one of the central themes of the
art world today (except when replaced by its opposite: the ideologically
suspect recourse to a language of beauty and self-development), is over
and done with, once and for all.[13]

The cities that emerge in the future will therefore have their own
modes and forms of artistic practice, even though, dominated as our
sense of the world scene is by Western art practices, these have yet to as-
sume their full form. There will have to be new avant-gardes, ones that

are simultaneously local, responding to the specificities of the art practice and political imaginaries in which they find themselves, and global, aware that contemporary cities are products of cultures and economics that extend far beyond local space. What shape these will take remains to be seen; what we need to do as critics and as artists is give up on the art of Manhattan without giving up on the *energies* of Manhattanism: invention, testing of limits, collective experimentation – all taking place in circumstances utterly different than the modernist city and the ambitions and self-understanding of the art practices that accompanied it. Paul Virilio is both right and deeply wrong at the same time. The solution today *is* to reorganize communal life – not through a recovery or a return to some lost city-form, but by facing up squarely to the drama and trauma of the spatial forms we inhabit collectively today.

NOTES

1 Northrop Frye, *The Modern Century* (Toronto: Oxford University Press, 1967), 36.
2 Paul Virilio, *Politics of the Very Worst* (New York: Semiotext(e), 1999), 52.
3 Rem Koolhaas, cited in Marshall Berman, *All That Is Solid Melts into Air: The Experience of Modernity* (New York: Penguin, 1982), 287.
4 For an overview of the links between the development of capital and the urban form, see Andy Merrifield, *Metromarxism: A Marxist Tale of the City* (New York: Routledge, 2002).
5 See Manuel Castells, *The Informational City* (New York: Blackwell, 1989).
6 George Simmel, 'Metropolis and Mental Life,' *The Blackwell City Reader*, ed. Gary Bridge and Sophie Watson (New York: Blackwell, 2002), 17.
7 Guy Debord, *Society of the Spectacle* (Detroit: Black and Red, 1983), para. 37.
8 See Gerald Raunig, *Art and Revolution: Transversal Activism in the Long Twentieth Century* (Los Angeles: Semiotext(e), 2007).
9 Fredric Jameson, 'Future City,' *New Left Review* 21 (2003): 66.
10 Andrew Ross, 'The Mental Labor Problem,' *Social Text* 63 (2000): 1–31.
11 Manuel Castells, 'European Cities, the Informational Society, and the Global Economy,' in *The City Reader*, 2nd ed. ed. Richard LeGates and Fredric Stout (New York: Routledge, 2000), 560.
12 See Susan Buck-Morss's intriguing reflections on the loss of avant-garde energies due to the internationalization of art in 'A Global Counter-Culture?,' chapter 3 of *Thinking Past Terror* (New York: Verso, 2003), 69. She writes: 'artistic "freedom" exists in proportion to the artists' irrelevance.

Whereas in Dada, meaninglessness was located in the artwork in a way that reflected critically on social meaning itself, now meaninglessness is bestowed upon the artist, whose critical and creative powers are kept isolated from social effect.'

13 See, for instance, Fredric Jameson's comment that 'the image is the commodity today, and that is why it is vain to expect a negation of the logic of commodity production from it; that is why, finally, all beauty today is meretricious.' In *The Cultural Turn* (New York: Verso, 1998), 135. Similarly, Rosalind Krauss has recently argued that 'the international fashion of installation and intermedia work' is essentially 'complicit with a globalization of the image in the service of capital.' In *A Voyage on the North Sea: Art in the Age of the Post-Medium Condition* (London: Thames and Hudson, 2000), 56.

2 Mumbai, Slumbai: Transnationalism and Postcolonialism in Urban Slums

KELLY MINERVA

> With 14 million people, Bombay is the future of urban civilization on the planet. God help us.
>
> Suketu Mehta, *Maximum City: Bombay Lost and Found*[1]

Mumbai is recognized as the glamorous capital of Bollywood and as one of the most modern cities in India. Yet at the same time, the nickname 'Slumbai' ridicules its corruption and social housing problems. While the city's housing crisis is not unique, its powerful cultural economy exports images of its slum life in internationally best-selling books. This literature unsettles the centre/periphery power divide that defines many postcolonial readings of Mumbai and India by presenting a postcolonial city that is active in the global marketplace. The majority of academic literature about Mumbai focuses on the international impact of Salman Rushdie's magic realism, or on Bollywood and Hindi cinema, or on how the city's sociological struggles serve as a metaphor for the postcolonial struggles of the nation. Mumbai is most often explored in terms of either its globalization or its postcolonialism, thus limiting the discussion within a rigid global/local binary – one in which local activities (such as domestic life, commerce, and political resistance) are juxtaposed with global forces (such as international trade or economic and cultural imperialism). Literature set in Mumbai's slums also demonstrates the transnational currents that affect local social dynamics between slum residents and government bureaucracy. I argue that the transnationalism of, and in, these texts clarifies the city's relationship to a spectrum of meanings of postcolonialism by revealing the equality of local-to-global and global-to-local movements of ideas, goods, and people – an equality that can be mapped in literature.

In twenty-first-century literature, portrayals of slums and gangsters create an opportune place to explore the dynamics of transnationalism because criminal protagonists expose the transnational routes of Mumbai's culture and economy. The two most prominent twenty-first-century novels that depict slum spaces and gangsters in Mumbai – Vikram Chandra's *Sacred Games* and Gregory David Roberts's *Shantaram* – simultaneously create and publicize the transnational networks that emerge as gangsters are shown living in city slums and working both within the city and across national borders. In the novels and in everyday life, slum dwellers and gangsters struggle equally against national and metropolitan citizenship regulations that segregate illegal from legal activities. Their illegal residences and activities render the individuals illegal – a culturally Other group that is invisible to government aid programs, but that is made visible again in literature. While representations of the local activities of Mumbai's slum dwellers often suggest that this is a local community isolated from global networks, the representations of the international criminal activities of gangsters demonstrate how transnationalism re-empowers invisible urban residents. However, the market consumption of the texts threatens to reduce both of these communities to exotic market commodities.

Shantaram and *Sacred Games* raise the issue of the complex relationship between housing and citizenship as an aside to the engaging gangster plots that are highlighted when these books are being marketed as pulp fiction. These books may unite humanitarian appeals for adequate housing through government housing policies, but they do so without necessarily espousing one political agenda. Consequently, the political and humanitarian appeals made in the texts are obscured by marketing strategies. Literature cannot always be read so impartially; consider, for example, Salman Rushdie's condemnation of Indira Gandhi in *Midnight's Children*, in which he depicts her as a green witch who seeks to destroy innocent children and families for her personal gain. But Chandra and Roberts temper their humanitarian and political appeals by focusing on the city and individuals rather than on ideology or politics. This limited perspective enables the marketing of these texts as 'pulp,' threatening the potential interpretations of the narratives by creating an insular atmosphere in which the texts can be read purely for their sensational plots and exotic locations, rather than as examples of postcolonial resistance.[2] Pulp fiction is distinguished from 'elite literature' by the perception of a text's relationship to the market – the former denotes texts believed to have only market value, while the latter identifies texts that

are imagined as shunning market appeal for complex political narratives and themes. However, all of these texts are both local cultural products and global commodities that demand a form of criticism that can move fluidly between local and global scales without privileging a hierarchical power relationship of the sort that can emerge through the confrontational politics of both postcolonial and anti-globalization rhetoric.

First published in 2003 by Scribe Press, and now distributed by Abacus, *Shantaram* has been reprinted at least eight times since 2004. A film adaptation starring major Hollywood and Bollywood actors – Johnny Depp and Amitabh Bachchan – is currently being produced by Time Warner.[3] *Shantaram* depicts the adventures and personal relationships of an Australian escaped convict who flees to Mumbai, where he creates a life for himself by moving into a slum and committing crimes with other gangsters. The international success of this book exemplifies Graham Huggan's explanation of 'postcoloniality,' which he differentiates from 'postcolonialism' or, more specifically, 'postcolonial resistance.' The distinction between 'postcoloniality' and 'postcolonial resistance' emphasizes how transnationalism enables a differentiation between these two different forms of postcolonialism without privileging either: 'Postcoloniality is a value-regulating mechanism within the global late-capitalist system of commodity exchange. Value is constructed through global market operations involving the exchange of cultural commodities and, particularly, culturally "othered" goods. Postcoloniality's regime of value is implicitly assimilative and market-driven: it regulates the value-equivalence of putatively marginal products in the global marketplace.'[4] *Shantaram* does sensationalize Mumbai's underbelly to appeal to global and local audiences, which exemplifies its postcoloniality as a market product, but this commodification of the text does not erase the postcolonial resistance *within* the text.

The international success of *Shantaram* was a result of its representation of market-valued 'otherness.' It was marketed as a sensational autobiographical account of Roberts's escape to Mumbai from an Australian prison, not as a work of fiction – thus, it has deceived readers just as James Frey did, only without an Oprah Winfrey to turn Roberts's marketing scheme into a public scandal. Huggan's definition of postcoloniality as market-driven also helps explain Western publishers' bidding frenzy over the publication of Chandra's second novel, *Sacred Games*. Huggan elaborates: 'whatever its status – consumer or consumed – India is currently very much in fashion; and several of its best-known writers, most of them living in the diaspora, have become minor metropolitan celeb-

rities, late twentieth-century household names, exponents of the latest literary craze.'[5] Publishers perceived an opportunity to turn Chandra's second novel into the next big seller in a Western literary market with a high demand for Indian novels. Indeed, the history of Indian novels nominated for Man Booker prizes reinforces the publishers' recognition of the potential in *Sacred Games* for high acclaim and high market sales. Similarly, the ability of Danny Boyle's 2008 film *Slumdog Millionaire* to capitalize on this market desire – securing the box office, American Academy Awards, and British Academy of Film and Television Awards – reveals the pervasiveness of postcoloniality throughout the international market for postcolonial texts.[6] Huggan exposes the danger of this market demand for texts set in postcolonial countries when he claims that postcolonialism is inextricably '*bound up with* postcoloniality [and in] the overwhelmingly commercial context of late twentieth-century commodity culture, postcolonialism and its rhetoric of resistance have themselves become consumer products.'[7] Readers encounter these texts as transnational objects and products rather than just postcolonial narratives; the challenge for them is to distinguish between the commodified postcoloniality of a market object and the postcolonial resistance that occurs within that object.

As the political implications of Roberts's themes are undercut by his and his publisher's commodification of them, *Shantaram* reveals the significance of the potential limitations to postcolonial resistance brought about by postcoloniality's global market desire. Within the novel, Roberts refuses to engage with either colonial pasts or postcolonial futures: the postcolonial histories of India and Australia remain incidental; the countries are merely exotic settings for Roberts's protagonist, Lin. For example, the plot advances through Lin's imprisonment in, and escape from, Indian and Australian prisons. Using the prisons only as plot devices, Roberts ignores the fact that these institutions also serve as ideological structures representative of the influence that British colonial governments had over how the Indian and Australian judicial systems were implemented and organized. Lin's lack of historical awareness functions as a way of undercutting any potential postcolonial critique of this problematic colonial legacy within the text by evading the implications of a national governing structure with residual ties to colonial authority. Instead, Lin's narration focuses on his imprisonments as part of the many experiences that enhance his personal strength and survival instincts. This isolation of the individual from the historical and political ensures that the novel is read as pulp fiction, rather than as an example

of postcolonial literature that reconstitutes national identity. Similarly, the depiction of slums can be read as a portrayal of idyllic, harmonious communities in which personal relationships help residents accept their physical surroundings, rather than as a political critique of Mumbai's housing crisis. This limitation of postcolonialism to postcoloniality or market desire weakens the potential for postcolonial critiques by suggesting that audiences of popular fiction are not interested in resistance narratives, thereby limiting the audience for postcolonial literature of resistance to academic readers who seek texts with specific agendas.

Though it suppresses postcolonial resistance in favour of commodified postcoloniality, the novel's depiction of Lin's actions draws attention to the local, national, and international social peripheries that are the foundation of postcolonialism. In other words, reading the transnationalism within the novel recuperates the possibility for postcolonial resistance within the text. Mapping his movements, we can see that Lin is an unwitting representative of transnationalism: his criminal activities reveal transnational flows of goods, people, currency, and ideas, even if his motivations are purely selfish. Lin embeds himself within urban society by aligning himself with the periphery – with criminals and gangsters – and from this position gains access to non-tourist destinations, exposing Mumbai's jails, brothels, drug houses, and slums. He arrives in Mumbai alienated and alone, but capitalizes on the city's local drug trade and international tourism – he sells drugs to tourists – in order to incorporate himself into Mumbai's gangster community. As a member of this peripheral social group of gangsters, he increases his mobility and can enter the more private, local spaces that the city has to offer because he is no longer strictly identified as a foreign outsider. It would appear, then, that Lin's narrative aims to draw attention to the spaces and transactions that comprise those isolated aspects of Mumbai life that are accessible only to local residents – those spaces that are, for now, seemingly inaccessible to globalization and that Roberts attempts to exploit for market sales. The more local Lin becomes (i.e., the more he is entrenched in Mumbai's gangster community), the more international the implications of his activities become. This is precisely the transnationalism missing from a text like *Slumdog Millionaire*, which was criticized for exploiting the slum locations and actors.[8]

In the most extreme example of *Shantaram*'s unwitting transnationalism, Lin's Mumbai mentor and crime boss, Khaderbhai, employs Lin in a gun-smuggling operation to Afghanistan, coercing him to join the fight against the Soviet Union during the Soviet–Afghan War. Yet, acting

within this political turmoil, Lin remains an apolitical soldier, an actor in a story controlled by Khaderbhai. Lin agrees to pose as an American and help Khaderbhai in his Afghani mission, but he does so only because Khaderbhai tells him to, not because he believes in the Afghani fight to end colonization. Lin's denial of political agency highlights the transition from 'international' to 'transnational,' where 'inter-' emphasizes 'between' or 'among' nations and 'trans-' denotes 'across' or 'extending beyond' nations. Because he refuses to act as an ambassador of a particular national politic, Lin can move across national borders without becoming representative of any particular nation. Moreover, because he is an outlaw travelling on fake passports, his citizenship is fluid; this fluidity, however, does not trap him on the periphery, nor does it relegate him to the position of 'other' (as, for example, is often the case with illegal aliens and undocumented workers). Consequently, Lin avoids becoming merely an exotic object in the marketplace and is empowered by this fluidity.

Much less fluid are the characters in *Slumdog Millionaire*, who are confined to an insular environment that restricts their identities and movements to the city of Mumbai and, occasionally, elsewhere in India. The film's central conceit – a 'slum dog' succeeds on India's 'Who Wants to Be a Millionaire?' – does not address the show as a transnational object. The show originated on British television and has been reproduced in a number of countries. While the concept and basic format of the show are transnational objects able to cross national borders, each particular manifestation is a local object, of interest only to its local audience. Thus, the penultimate sequence of Boyle's film depicts Jamal's final appearance on the show through a montage of television audiences eager to watch Jamal's fate unfold. The only clues that the program is of interest outside Mumbai are the segments of national news that cover Jamal's success and arrest (and even then, it's not clear that these news features have a wide audience beyond Jamal's home city). Jamal's only international audience, then, is the film's audience. Likewise, the gangsters that Jamal encounters are all local: they are shown to control the city's beggars and prostitutes, but no mention is made of any international or intranational criminal behaviour. Much as in *Shantaram*, any scenes or themes with the potential for political, postcolonial resistance in the film are subverted by the fact that they function merely as plot devices. For example, the opening scene depicts police officers torturing Jamal to elicit a false confession that he cheated on the game show. Although Jamal refuses to break under torture, he does begin to tell his story in

answer to the question 'What could a slumdog possibly know?'[9] The only critique of the police methods and corruption occurs when Jamal loses consciousness after he is electrocuted. At that point, the police inspector admonishes the sergeant who administered the electricity: 'How many times do I have to tell you? Now we'll have Amnesty International here talking about human rights.' But Amnesty International never appears, and while many critics and reviewers have decried the film's exploitative depiction of India's slums, no one has addressed the brutality of the police within the film. Thus, the postcolonial resistance of the film is limited not only by its postcoloniality and commodification of the Indian setting, but also by its insularity and its lack of transnationalism.

In *Shantaram*, transnational fluidity empowers Lin. His international mobility enables him to commit crimes throughout the world; by the end of the novel, he has sold drugs, guns, and passports in Australia, Afghanistan, India, Mauritius, Pakistan, Singapore, and Zaïre. His activities reveal the 'challenges to state power' that define the illicit global economy and highlight an illegal side of economic globalization, in that the demand for Lin's criminal products depends on national laws that prohibit or restrict them. Although Roberts may have intended to isolate Lin from the historical and political by trumpeting his individualism, Lin's criminal activities simultaneously 'reveal the retreat, persistence, and reassertion of the state' as it is connected to the contemporary subaltern.[10] In fact, Lin's activities illustrate the transnational community of criminals united by their circumvention of a global economy that depends on the ability of (a limited number of) individuals and capital to cross national borders. These illicit actions cannot be read simply as one man's apolitical attempt to make money, nor simply as resistance to state power, for their illegality is a function of the state's reification of borders. This is exemplified by a debate over legal tender during Lin's first trip to Mauritius, when his contacts try to buy passports with Mauritian rupees: 'What's *that* shit?' Lin asks them. 'That's not money ... Money is green. Money says, *In God We Trust*. Money has the picture of a dead American on it because money *comes* from America.'[11] While his attitude epitomizes the common criticism of globalization as 'Americanization,' he is not glorifying American culture, but rather the mobility of American currency.[12] The problem for Lin is not the value of the local currency, but the fact that it is kept out of the global market by national governments, since Mauritian rupees, like Indian rupees, can only be used within the issuing country. In this context, globalization remains focused on the economic exchange of certain authorized cultural commodities and on

the inescapability of participating in this kind of mitigated global exchange. Lin solves his problem by travelling to Singapore to exchange the rupees for licensed currency through a black market money changer; the black market enables an international exchange of the local currency, imbuing that un-American currency with global value in spite of the mechanism in place to de-value it. Thus, reading the transnational implications of Lin's actions imbues them with political meaning – his participation in the market becomes a form of postcolonial resistance regardless of the commodified postcoloniality of the text.

The trajectory of local product into the global market is also presented in Vikram Chandra's 2006 crime novel *Sacred Games*, but it is depicted in ways that directly challenge the marketing of the novel as pulp. Throughout his text, Chandra portrays the very market in which his text is a product and emphasizes the fluidity between the local and the global scales. Chandra's character Ganesh Gaitonde manipulates the illicit global economy and reveals the ways in which Mumbai's gang war intersects with its slums. The novel's chapters alternate between the competing but complementary stories of Ganesh Gaitonde, a Hindu gang leader, and Sartaj Singh, a Sikh police inspector. The plot centres on Sartaj's city-wide police investigation into the mysterious suicide of Ganesh, and Ganesh's retelling of his rise to power and subsequent quest to prevent his mentor, Swami Shridhar Shukla (an internationally renowned Hindu spiritual leader and nationalist), from detonating a nuclear bomb in Mumbai. In the end, Sartaj and Ganesh unite their searches and struggle to save Mumbai from nuclear holocaust. While neither Sartaj nor Ganesh can see past the possible destruction of their homes to the potential international consequences of a nuclear explosion, readers are forced to recognize this connection between Mumbai and the rest of the world through the depictions of the Swami's international following and the fact that he has been using Ganesh to smuggle the components of the bomb into Mumbai from outside India. Thus, Chandra makes explicit the transnationalism of his local characters and settings, unlike Roberts, who tries to isolate his characters through his depiction of the local and their individualism.

National borders continue to be crossed as Ganesh's criminal activities force him to leave Mumbai and operate his gang from aboard a yacht docked in Thai waters (not unlike the real-life Mumbai mobsters who move their bases of operations to Dubai).[13] Here in international waters, Ganesh recognizes the forces of globalization acting upon his crew – forces that simultaneously bolster the appeal of the local and thus em-

phasize the equality of local-to-global and global-to-local movements of ideas, goods, and people:

> When they were back home, in Bombay, all the boys begged for foreign service. They wanted the foreign jeans, and the foreign girls, and the salaries in foreign currency. They had competed with each other to come to Thailand, to my yacht and my overseas operations, and demonstrated their eagerness and hard work and commitment every hour. But after a month or two or five in these alien waters, they always grew sour. They became sullen. Their bodies missed Bombay. I know, because after a year away from Mumbai I still got attacks of yearning, I craved the spittle-strewn streets of that great whore of a city.[14]

The lure of generic 'foreign' commodities displaces America or any nation as the centre of power behind globalization, and allows every local home to become a centre in search of exotic peripheries. For Ganesh and his boys, the unspecified foreign reinforces the equality of movement identifiable through transnationalism, allowing Chandra to upset the Western-oriented view of globalization.[15]

Also implicit in this passage is a critique of postcoloniality as a desire for exoticized goods. Chandra depicts the market desire for foreign goods as incapable of replacing a desire for a local home that is 'spittle-strewn' and a 'whore' – in contrast to the idyllic exoticism that Roberts creates when he writes about Mumbai as a place where anyone can find a place for himself and make lifelong friends. Thus, Chandra provides an escape from the market commodification that limits postcolonialism to market-value-driven postcoloniality and restricts globalization to economic imperialism, as can be found by reading globalization's market desires through transnationalism (exhibited above in my reading of *Shantaram*). Transnational market currents reveal non-hierarchical exchanges of legal and illegal goods, services, people, and ideas based on demand, not power. Through criminal heroes like Ganesh and Lin, the exchanges that take place as part of legal globalization are seen to be codependent with the illegal black market that enables currency and individuals to move across national borders more freely than the laws of nation-states allow. This codependence is further problematized by the challenges that slum dwellers make (both inside and outside of texts) to the categorization of people as 'illegal' by various political agencies.

The novels juxtapose this transnational economy of desire and crime alongside the rise of the Shiv Sena, an ethnocentric Hindu political party

in Mumbai. The Shiv Sena began accumulating power in the 1960s following the division of India into states based on linguistic borders as part of the nation's decolonization. Bombay was initially divided between two states – Gujarat and Maharashtra. As the city grew into an economic capital of India, the Sena emerged, under the leadership of Bal Thackeray, claiming that Bombay rightfully belonged to Maharashtrians. By the 1980s, the Shiv Sena had organized itself as a political party based on a platform of ethnocentrism and religious intolerance, which can be seen as a reaction against globalization and the ideals of multiculturalism that the Sena believes have taken power away from the Hindu Maharashtrians. Thus, the Sena exemplifies the fact that transnationalism is not limited to a local-to-global trajectory and that global-to-local currents are equally important to the social landscape, in that the Sena is a seemingly isolated local group that depends on global migration to produce its political platform. This is where the texts demand, and transnationalism enables, a postcolonial reading that considers the politics presented or alluded to in the novels without privileging a particular political critique.

The Shiv Sena looks to banish non-Marathi-speaking, non-Hindu residents from the city and has been identified as marking the 'decosmopolitanization' or 'provincialization' of the city.[16] The support for the Shiv Sena in Mumbai exemplifies Arjun Appadurai's definition of globalization as a series of disjunctive flows that 'produces problems that manifest themselves in intensely local forms but have contexts that are anything but local.'[17] Arguments for cultural purity depend on juxtaposition with cultural 'others.' The party strives to insulate the city from foreign (i.e., non-Indian, but also non-Marathi) influence and control; in this regard, Roberts shows how the Shiv Sena gains support from those who perceive the platform as a response to local economics. Lin defends the ethnocentric movement by emphasizing the economic inequality at the heart of the housing crisis:

> I learned to speak Marathi in a little village called Sunder ... They're pure, *shudha* Marathi speakers, and Maharashtra has been their home for at least two thousand years ... When I came back to Bombay with my guide, Prabaker, I went to live in the slum, where he and twenty-five thousand other people live. There were a lot of people like Prabaker there in that slum ... They lived in the kind of poverty where every meal cost them a crown of thorns in worry, and slaving work. I think it must break their hearts to see people from other parts of India living in fine homes while they wash in the gutters of their own capital city.[18]

Thus, Lin explains the community's anger and resentment as stemming from a lack of recognition for the city's pre–British-colonial history. This sentiment reproduces the Sena's mission, which is to reclaim power not only from the British Raj but also from the Brahminical leaders who rose to power under British colonialism.[19] The Shiv Sena imagines economic disparity as a crime against local Marathi victims; it often seeks retribution from individual culprits (i.e., local Muslim shopowners and residents) and gains most of its support from slum communities.

Outside of the novels, journalist Kalpana Sharma encounters evidence of this perception of victimization and ethnocentric reaction in the growing generational gap among residents of Dharavi (one of the largest slums in all of Asia). Sharma explains that 'in a sense, what is happening in Dharavi is not very different from the changes taking place in many small towns in India. The big city is forcing a breakdown of social and caste barriers yet politics is forcing communities into becoming more insular and conservative.'[20] Similar to Sharma's connection between the views of residents in one Mumbai slum and the rest of India, in Roberts's fictional depiction Lin must admit that 'the problems here are not just Maharastrian problems. The poor, like the rich, are from every part of India. But the poor are far too many, and the rich are far too few.'[21] Lin here couples an emotional appeal for the urban poor with the logical acknowledgment of the country's seemingly insurmountable poverty epidemic. The expansive trajectory of Lin's logic is exemplified by his use of identifying adjectives and nouns: his first sentence refers to the regional Maharastrians, his second to India, and the last lacks any identifying category and might refer to economic inequalities anywhere.

The slums, then, serve as a nexus for the local and global forces that interact through transnational currents; they also reveal the falsity of perceiving these forces as isolated from or subordinate to one another. The dire consequences of this local backlash, which has its origins in the idealization of an isolated indigenous community, can be seen in the 1992–3 riots, which were sparked by the destruction of the Babri Masjid in Ayodhya. These riots plagued Mumbai but were not limited to it. Boyle depicts the riots, rather too simply, as religious unrest between Hindus and Muslims that orphans the film's protagonists; Roberts refrains from depicting particularities of the riots (which might have detracted from Lin's personal saga). Chandra, however, shows the destruction of one particular slum during the riots as a metaphor for the lines that have been drawn between communities; he also introduces the explicit politics that Boyle and Roberts avoid. The riots are depicted from Ganesh's

point of view as he returns to the city to protect his gang's territory. Ga-
nesh explains: 'During a lull in my own war I had left my home, and
came back to find my home the battleground for a larger conflict. They,
somebody, had drawn borders through my vatan. My neighbours were
now refugees.'[22] Ganesh recognizes that although he had been fighting
a gang war in the streets of the city, it had not disrupted the neighbour-
hood community. However, the communal riots alienated residents by
allowing non-local anger to manifest itself locally: neighbours had drawn
lines based on religion and had driven out certain members of their
once-united community.

Chandra stresses the invisibility and fictionality of these communal
lines by depicting Ganesh as viewing the riot-torn streets from above.
Despite his elevated position, Ganesh gains neither insight into nor con-
trol over the situation. Flying into Mumbai after the riots have begun,
Ganesh feels that he is no longer a 'king but an impotent clown,' unable
to protect the slum neighbourhood that he helped create. He and his
entourage look helplessly out the window as their plane descends:

> From the muddy coast-line emerged a scattering of islands, and then I
> could see clearly roads, buildings, the shape of colonies and the spreading
> brown patches of bastis. From behind [me and my wife] I could hear the
> boys arguing, 'That's Andheri there.' 'Maderpat, where Andheri? That's
> Madh island, can't you see?' Then they were all quiet. A thick black snake of
> smoke grew from a coastline settlement and twisted in towards the centre,
> towards another dark, curving fume – the city was burning.[23]

From the airplane, Ganesh and his gang are powerless and ignorant –
they can no more protect their neighbours from the flames than they
can properly identify the city's districts without artificial map lines. In-
stead of creating a Foucauldian panopticon or tower-perch from which
to view the circumstances, Ganesh's elevated views reinforce the blind-
ness that accompanies this height, thereby eliminating any suggestion
that there is a power hierarchy to be ascended. Their impotence and
the city's anonymity in this situation together reinforce the fiction of a
power hierarchy drawn between local and global people or places. In-
stead, this scene reinforces the importance of visibility in transnational
currents: from high above, all sections of the city are equally invisible to
the viewer. From this perspective, slums are not uniquely singled out as
they are in government housing policy, which often focuses on demol-
ishing slums.

Both novels continue to raise concerns over the visibility of slums and slum dwellers as these often isolated local communities are put on display for readers. I have already noted how Lin's economic livelihood depends on his ability to exploit the tourist demand for drugs; but as a cultural product, *Shantaram* has simultaneously been exploited by the tourism industry. Once Lin moves to the World Trade Centre slum, the slums lose their status as an invisible city secret, and readers follow Lin's wanderings through slum lanes and city streets. This situation is presented – and has been read by readers uninterested in postcolonial power struggles – as an idyllic picture of the hardship and struggle that unites residents into a cohesive, harmonious community. As a consequence, the now-visible slums are now being offered up as an exotic spectacle: since 2006, companies have been offering guided tours through them and have attributed the success of their tours to the popularity of Roberts's text.[24] The growing visibility of slums brought about by this new brand of tourism speaks to the international struggle to raise awareness of slum residents and their living conditions; however, tourism has restricted the struggle so that it is now seen as a value-driven postcoloniality rather than as a form of postcolonial resistance – visitors are not interested in the rights of slum inhabitants, only in viewing the spectacle. The colonizing centres of power now take the form of foreign tourists and local tour companies, who commodify the slums and, by extension, their residents. But this development has also changed the text's cultural commodification, as it can now be read for virtual tourism. This is the same spectacle that Boyle capitalizes on when he gives his audiences a tour of the slums. As Ajay Gehlawat explains: 'Following Alice Miles' labelling of *Slumdog* as "poverty porn," one could say the slum in *Slumdog* is aestheticized and invites the Western viewer to enjoy said aestheticization.'[25] To salvage both *Shantaram* and *Sacred Games* from this commodity exoticization, we as readers need to see the slum residents' struggle for visibility furthered by these texts as more than a postcolonial writing back to centres of power – as also a localized manifestation of a series of transnational forces.

Unlike Roberts, Chandra refuses to idealize the 'whore of a city' for which Ganesh and his men long; indeed, the very word 'whore' emphasizes Mumbai as a place of illegal and indecent transactions, as something at once selling itself and being exploited by the sale (even while Boyle's characters are able to escape the economy of prostitution and begging). By mapping this city through the movements of sympathetic albeit criminal protagonists, and by locating part of their narratives within slums, Chandra and Roberts shed new light on the unstable, illegal

status and invisibility of individuals. Much like the criminals who operate on both local and global levels, the individuals engaged in the struggles for housing rights in Mumbai are participating in a global fight for human rights; this is their attempt to gain visibility as citizens (not illegal inhabitants) of the city, the nation-state, and the world – even when their ambitions and concerns do not appear to extend beyond the condition of local dwellings. When read transnationally, the characters in *Shantaram* and *Sacred Games* who are engaged in housing struggles become a synecdoche for Mumbai's housing crisis, while the international outrage over slum housing produced by *Slumdog* focuses on the individual situations of the child actors and often fails to acknowledge the complexities of the situation.[26]

Overlooking, for the moment, the politics of how Roberts manipulates his own identity to fit into the city by claiming that the work is autobiographical, his description of the slum's growth epitomizes how the city government renders slums invisible by manipulating the requirements for citizenship. Lin tells of a fence that the Bombay Municipal Corporation (BMC) has constructed around the legal slum in Colaba to cordon off the housing provided for construction workers and their families from that of the squatter settlement growing around it – a settlement that the BMC continually demolishes but cannot prevent from growing. This fence physically manifests the relationship between the visible and invisible citizens of the city's slums – those recognized by the government as legal dwellers with rights, as opposed to the illegal 'squatters,' who will be removed. But it also highlights the lack of social barriers within the slum's community: 'To workers and squatters alike, the company fence was like all fences: arbitrary and irrelevant.'[27] The fence here is present, but permeable. It is broken, from a planning and functional standpoint, because people continue to forge friendships, marriages, and business relationships across the fence line – it fails to divide the community. Moreover, the comment that all fences are alike to these Mumbaikers suggests that a social barrier devised by any institution, not just the BMC, would lack power over this community. Roberts's diction refuses to blame any particular government or non-government organization for failing to control the growth of slums and the communities within them, whereas studies like Mike Davis's *Planet of Slums* blame local and civic organizations as well as the International Monetary Fund and the World Bank for the current world housing crisis.[28]

Through this complex relationship to the fence, Roberts highlights the space as one that need not be reduced to the language of power and

control. For the BMC, in Roberts's depiction, the chain-link fence provides a momentary, but necessary, illusion that renders the illegal squatters invisible long enough for their shacks to be erased by the demolition crews, though these people are still visible to the *legal* dwellers inside the fence. In his portrayal of the BMC's continual attempts to raze the illegal dwellings, which are rebuilt almost as quickly as they are bulldozed, he reveals that this demolition also forces the legal squatters to recognize their own tenuous hold on the land: in this case, they watch silently from above, safe within the unfinished World Trade Centre towers, aware that once the towers are complete, their own shacks will no longer be considered legal.[29] Thus, the mutual dependence of the slums and the city renders both groups powerless in their relationship to each other, since neither group can survive without the other. We can read this situation between city government and slum dwellers in the same manner as the relationship between international criminals and nation-states – they are codependent and reinforce each other. Reading this situation transnationally provides the critical distance that is necessary to understand the situation not in terms of a power struggle for control over space, but rather in terms of the visibility of the inhabitants.

The constantly shifting line between the visible and the invisible – the legal and the illegal – unites slum residents in an internationally recognized struggle for universal housing rights. The questions raised by activists and by Chandra and Roberts remain: When do urban poverty and impoverished living conditions become urban blight targeted for demolition by government agencies? And how do slum communities become no more than faceless statistics representing crime and poverty? The history of the housing rights struggle within slums provides part of the answer. The fight for slum dwellers' rights has been marked by contestations over citizenship claims – that is, by struggles to separate out the legal dwellers from the illegal. Historically, unauthorized (i.e., illegal) residents have been forcibly erased from cities by demolition crews. Roberts does not elaborate on the casualties caused by the BMC's attempts to demolish the illegal slum; however, images of the tragedies caused by the demolition of Mumbai's slums can be found in works as diverse as Salman Rushdie's *Midnight's Children*, Rohinton Mistry's *A Fine Balance*, and documentaries like Anand Patwardhan's *Bombay, our City*. In these texts, emphasis is placed on the irreversible displacement of families and on the destruction of all their worldly possessions – a destruction that destroys lives, not just houses. The consequences of demolition are not adequately represented by Roberts's brief assertion that 'the people had

just enough time to gather the bare essentials – babies, money, papers.'[30] Although this statement reinforces the futility of demolition, it does so by suggesting that victims are left with their essentials and, after this inconvenience, can rebuild their dwellings.

The city government began seeking alternative methods for improving living conditions in the 1970s, beginning with the Maharashtra Slum Areas Improvement, Clearance, and Redevelopment Act in 1971, which allowed the government to improve slums instead of simply demolishing them. But it was not until the decision in a 1985 Supreme Court case that slum residents began to be protected from eviction. Following the injustices of the Emergency, which ended in 1977, a petition to the Supreme Court argued that slum dwellers 'were citizens of the country with the same rights as everyone else and ... by not providing them alternative accommodation [after demolishing slums], the State was denying them the right to life because they could not work if they had nowhere to live.'[31] Thus, the housing crisis in Mumbai centres on the struggle to recreate the right to housing already guaranteed in the UN Declaration of Universal Human Rights.[32] According to Gita Dewan Verma, these rights have been manipulated and reinterpreted away from an understanding of the right to an adequate standard of living and have been limited to the 'right to stay' by the Mumbai city government.[33] Under what Verma identifies as the 'shadow charter of rights,' the conversation over housing rights has been taken out of the UN's global context, restricted to the city's own housing crisis, and limited to the physical conditions of dwellings and land rights.

So, while there has been an evolution in the language used in the plans for urban slums (from 'demolition' to 'rehabilitation' and 'redevelopment'), the pernicious notion of 'relocation' often remains part of the solution, because the government perceives slum dwellers as non-residents who do not have valid claims over the city land on which they live. Thus, they can easily be removed from those lands. Notably, this attitude defies the international operational definition of slums as outlined by the UN; while that definition focuses primarily on the physical conditions of dwellings, it also includes 'insecure residential status' as an essential characteristic of slums.[34] Consequently, the BMC need only *try* to provide specific amenities to improve the quality of life instead of trying to solve the root causes of the problem. Vandana Desai summarizes the government disconnect from slums:

> The BMC is considered to be the most affluent and one of the most efficient local bodies in India. Its scale of investment is both the highest in

the region and the highest in the country for a municipal body. Its range of services is wider than that of any other city corporation ... The BMC has, however, not been involved directly in public housing or slum upgrading on a major scale except for staff housing or the provision of facilities to slums on its own lands ... The maintenance of improved slums was seen as a problem of inadequate subventions from the government rather than of civic obligation to slum-dwellers.[35]

Thus, city residents may be exiled from the city based solely on the physical state of their dwellings. This has allowed the BMC to separate itself from the more difficult-to-define social characteristics that define and create slums. In other words, the BMC justifies the lack of assistance it provides slum dwellers by laying blame for the housing crisis on the Indian government's lack of financial support to the lower classes.

The threat of demolition, even when masked as 'relocation,' is justified by the concept of 'global cities' – a concept that identifies inadequate housing as a blight on the cityscape. These mega or 'future cities,' as Imre Szeman terms them in his chapter in this book, demand a rethinking in terms of the visuality we typically ascribe to the city. Perhaps rather than attempting to remake the megacity in the style of modernist cities such as, say, Paris, London, or New York, the 'future city' demands a new aesthetic, one that must include the slum landscape. Poor housing conditions relegate slum residents to the role of urban 'other' – antagonistic to the modernization and beautification believed to be required for global cities. As a consequence, these residents are often threatened with erasure from the city. The history of the Olympic Games exemplifies the worldwide attempts to beautify cities by erasing slums and other signs of urban poverty; Beijing and Vancouver are only the most recent cities to come under fire for their callous relocation of slums.[36]

When the scope of the debate is limited to local circumstances and the (il)legality of slum residents, the struggle for housing rights in Mumbai is limited thereby to a fundamentally flawed debate (a flaw that groups such as 'No One Is Illegal' are attempting to rectify). To gain the status of 'legal resident,' and thereby legitimize their claims to the local government for housing rights, slum dwellers must produce paper records, such as identity cards or utility bills. In 1976, while attempting to gather census data from all of the slums, the city gave out photo passes to participants. While this provided secure tenancy to some residents, many were left out. The BMC has been struggling since the 1970s to distinguish between 'authorized' and 'unauthorized' slums and residents. Another struggle: identity cards are gained by participating in infrequent and of-

ten incomplete censuses (though now these cards are also bought and sold on the black market), and slum residents often rely on illegal means to gain utilities such as electricity, often paying the local slumlord to provide them with illegal services. Additionally, inhabitants must establish that their residency began before a particular date; as it stands now, inhabitants only qualify as residents eligible for relocation and rehabilitation programs if they can prove that they have lived in a slum since 1995. Appadurai warns that

> their inability to document their claims to housing may snowball into a general invisibility in urban life, making it impossible for them to claim any rights to such things as rationed foods, municipal health and education facilities, police protection, and voting rights. In a city where ration cards, electricity bills, and rent receipts guarantee other rights to the benefits of citizenship, the inability to secure claims to proper housing and other political handicaps reinforce each other.[37]

This double-bind not only renders new slum residents invisible to the government but also handicaps the government's attempts at solving the city's housing crisis. Harini Narayanan summarizes the government's failure to meet residents' housing needs as a bureaucratic problem: 'though India has a multitude of land use laws and policies that purport to ensure a base level shelter for all its citizens, the two (i.e. the legislative framework and complementary policy instruments) have very rarely been blended effectively to produce a far-sighted and implementable set of tools that can actually result in concrete and dramatic changes on the ground.'[38] He goes on to conclude that 'until fundamental problems relating to the implementation of existing housing policies are addressed and corrected, the existence or otherwise of legislation like the [Urban Land Ceiling and Regulation Act] on the law books will make no difference to the lives of Mumbai's poor and homeless.'[39]

This exclusion of certain city residents from city planning and bureaucracy is compounded by a more comprehensive erasure of slums from the city through the identification of slums as urban villages. This categorization reinforces slums as isolated local spaces and implies a reversal of the BMC's assertion that slums are a national problem rather than a municipal one. The conception of slums as urban villages continually emerges in texts, from Rajesh Gill's sociological study *Slums as Urban Villages* (1994) to Suketu Mehta's description of community bonds, wherein 'we forget that out of inhospitable surroundings, [slum dwellers] form

a community, and they are attached to its spatial geography, the social networks they have built for themselves, the village they have created in the midst of' Jogeshwari.[40] Even Roberts likens his entrance to the slum to his arrival in Sunder, a village in northern India.[41] This perception of slums as reconstructed villages abounds, but isolating the slums as villages within the city constitutes a refusal to acknowledge the larger forces at work – forces that contribute to the growth and persistence of slums.

To begin with, this perception ignores the current plight faced in Indian villages at the national level: the majority of slum residents migrate to cities from villages, where the living conditions not only may be worse but also are often utterly without hope. Immigrants flock to Mumbai in droves, looking for economic opportunity, and often find it: sociologists A.R Desai and S.D. Pillai have found that while slums 'are among the most overcrowded localities in Bombay,' they 'are also among the oldest business localities.'[42] Thus, the city has come to depend on the labour provided by slum residents. Kalpana Sharma explains:

> In previous decades, the 'pull' factor of cities was seen as a problem which had to be deflected by developing the countryside and thereby negating the lure of cities. By the 1980s it was clear that the poor who came into cities were not just gainfully employed but provided essential services which cities needed. An informal census of Dharavi, for instance, revealed that only 10 per cent of the people were unemployed. In the absence of a welfare system, none of them were living off the State. Thus, they provided for themselves and for the city through their labour.[43]

Sharma's assertion is particularly insightful because it acknowledges that slum residents are a self-sufficient and industrious group – countering all stereotypes of the urban poor, and making them, whether illegal or legal, a visible, active, and indispensible part of the urban fabric. Boyle offers his audience a glimpse of slum industry early in the film when Jamal and his brother play with a ball among individuals washing clothes, but this is undercut by the lack of clarity about whether they are washing their own clothes or offering a laundry service like that of the washers in Dhobi Ghat, Mumbai. Perhaps as a consequence of the film's refusal to offer a clear image of the slum economies, media attention on the welfare of the film's child actors has suggested a lack of industry and entrepreneurship in slum residents and called on Boyle to secure the futures of his actors.[44] Alternatively, *Sacred Games* and *Shantaram* work to recuperate the image of slum residents. In their fictional texts, both Chandra and

Roberts acknowledge the city's dependence on slum labour: Roberts explains that the slum on the World Trade Centre construction site was established to accommodate 'the tradesmen, artisans, and labourers who built the towers' because 'the companies that planned and constructed large buildings, in those years, were forced to provide such land for housing'; while Chandra acknowledges the more widespread reach of slum labour and products, with Sartaj referring to Navnagar and places like it as 'the engine that pumped the city into life.'[45]

The emergence of grassroots campaigns within individual slums also speaks to this spirit of self-sufficiency as residents try to increase the visibility of their demands for adequate housing. For example, Rahe-haq ('The Right Path') is a women's group that emerged in the Jogeshwari slum when a group of Muslim women organized, taking it upon themselves to bring the voices of slum residents into the halls of government; now, Suketu Mehta explains, residents appeal to these women first.[46] However, this grassroots community organization still lacks a strong claim on power in the city; the women constantly battle against 'Those in Charge,' who, according to Verma, manipulate the slumming of the city to gain power for themselves and thus restrict the changes and improvements made in slums.[47] The women also fight against their fellow residents, since often even their husbands do not support their efforts.[48] Notably, the lack of power does not prevent these women from fighting; their efforts are not to become elected officials, but rather to bring the complaints of Jogeshwari's residents to the municipality. In their persistent bringing of demands to the appropriate bureaucratic agencies without trying to take control of the government agencies, the women of Rahe-haq prove the effectiveness of focusing on group visibility rather than engaging in a power struggle for votes and political leadership.

While the limited scope of Rahe-haq seems to reinforce David Harvey's conceptualization of grassroots movements as representing '"localized" forms of class struggle "displaced" from the workplace or productive sphere' and thus disconnected from the global, their motivations connect them to the international struggle for adequate housing.[49] Organizations such the Shack/Slum Dwellers International and its Asian partners, the Society for the Promotion of Area Resource Centres and the Integrated Village Development Project, unite local and international activists who are crusading to humanize the image of slum dwellers and to empower slum residents throughout the world. Even when international activists are involved, these groups reinforce the idea that the struggle for housing rights is dominated by activism mired in local situ-

ations. Helpfully, Sidney Tarrow provides a definition of transnational activists that effectively unites all housing activists; for him, transnational activists are 'people and groups who are rooted in specific national contexts, but who engage in contentious political activities that involve them in transnational networks of contacts and conflicts.'[50] Transnationalism makes visible the movement of people and goods across borders, but also the transmission of ideas; and as a result, the theories and motivations behind activism become just as significant as the cultural texts that cross international borders on more publicized circuits such as book markets.

The complex relations among activists and academics within this nexus have been and continue to be explored by international academics such as Arjun Appadurai, Gayatri Chakravorty Spivak, and Edward Said. But we must also highlight the connection between grassroots and international activisms and art in order to reinforce its significance for transnational readings of literature. István Adorján examines the possibility of political activism in notably non-activist novels; in 'New Cosmopolitanism: Altered Spaces in a Postcolonial Perspective,' he explores the ways in which postcolonial literature asserts identity problematics, and how it challenges the pigeon-holing theories of nationalism, diaspora, and cosmopolitanism, by focusing on the metropolis in Chandra's *Love and Longing in Bombay* and Rushdie's *The Ground Beneath Her Feet:*

> By subverting some of these preconceived notions, texts such as Chandra's and Rushdie's do not necessarily transcend the horizon of the tacit discursive consensus on which they are based. Nor do they offer a politically viable alternative (which is not at all reprehensible in itself), though they certainly draw upon heavily politicized issues. Apart from that, however, they also strive to maintain an ironic distance, to create an interstitial space of writing.[51] .

Similarly, Chandra's *Sacred Games* and Roberts's *Shantaram* draw our attention to numerous politicized issues and create a space for readers to examine and question the power relationships that make up the struggles over citizenship and housing rights, and to challenge our understandings of cultural commodities, globalization, and postcolonialism. Just as postcolonialism sheds light on particular identity struggles that arise out of colonization, transnationalism enables us to read these texts and consider the various power relationships within them without becoming complicit in a transfer of power by allowing texts to be dominated by their (artificial) market value.

Transnationalism deprioritizes the power struggles that define the local–global relationships in both globalization and postcolonialism. Reading global–local relationships transnationally implies that while it is significant that we are aware of subjects (in this case, slum residents) being commodified and fighting against commodification, it is also vital that we, as readers, recognize and analyse that situation without participating in or reinforcing the hierarchy. This process liberates the subjects from a postcolonial writing back, as well as from centre/periphery, victimized/victimizing, oppressor/oppressed binaries, because we can map all of these relationships in order to see that the binaries are not mutually exclusive but rather are codependent. This is not to say that the oppressed slum residents are complicit in allowing the relationship – that they give power to their oppressors – but rather that it is not a question of gaining power at all. If postcolonial readings of anti-colonial struggles have taught us anything, it is the need to explore without restricting either group to an identity category (and here I take 'identity category' to mean racial, ethnic, and/or position of power). Boyle's film continues to reify such identity categories, depicting an insular world for Western tourists to gape at on film; reading transnationally, we can critique the falsity of Boyle's perception of India as an insular place devoid of transnational connections. Chandra and Roberts, however, present rich and complex images of India and Mumbai that continue to challenge identity categories. Thus, they only exoticize the slums insofar as we as readers allow them to; they only idealize them as much as we let them. The slum residents do not actively participate in these representations, they are merely depicted in them, and so are neither fighting against nor lobbying for the textual portrayals. When the power struggle is eliminated from the debate, the call to adequate housing as a universal human right gains strength and visibility in these works of art – regardless of the efforts of activists and despite the attempts of authors such as Roberts to keep politics out of novels. Since reading transnationally allows for this visibility by demanding an active and engaged relationship between reader and text, it comes to constitute a form of activism.

NOTES

1 Suketu Mehta, *Maximum City: Bombay Lost and Found* (New Delhi: Penguin, 2004), 3.
2 Also known as 'dime novels,' pulp fiction is a tradition of 'cheaply printed,

paperbound tale[s] of adventure of detection, originally selling for about ten cents.' William Harmon and Hugh Holman, *A Handbook to Literature*, 11th ed. (Old Tappan: Pearson Prentice Hall, 2009), 165.

3 Stacey Ivers, 'Warner Bros. Pictures and Graham King Sign First-Look Producing Deal,' 4 April 2005, http://www.timewarner.com/corp/newsroom/pr/0,20812,1045636,00.html, accessed 21 September 2008; Internet Movie Database, 'Shantaram,' http://www.imdb.com/title/tt0429087, accessed 4 June 2008.

4 Graham Huggan, *The Postcolonial Exotic: Marketing the Margins* (London and New York: Routledge, 2001), 6.

5 Ibid., 59.

6 A trend in cinema that Ajay Gehlawat examines in 'Slumdog Comprador: Coming to Terms with the Slumdog Phenomenon,' *CineAction* 78 (Winter 2009): 2–9.

7 Huggan, *The Postcolonial Exotic*, 6.

8 See Gehlawat, 'Slumdog Comprador,' 2–3.

9 *Slumdog Millionaire*, dir. Danny Boyle (UK, Celador Films, 2008).

10 Richard Friman and Peter Andreas, quoted in Susan Koshy, 'The Postmodern Subaltern,' *Minor Transnationalism*, ed. Françoise Lionnet and Shu-mei Shih (Durham: Duke University Press, 2005), 117.

11 Gregory David Roberts, *Shantaram* (London: Abacus, 2004), 615.

12 Notably, the American dollars that appear in *Slumdog Millionaire* serve only as a token of guilt and not as economic currency. Jamal is given a hundred-dollar bill by American tourists trying to assuage their guilt at being the reason why Jamal is assaulted – he had been trying to protect their car from thieves. But Jamal has no way to convert the money, and after carrying the bill with him for years, he passes the token on to one of the beggars that Maman has blinded to assuage his own guilt for not being able to save the boy when he and his brother escaped from the gangster.

13 See Thomas Blöm Hansen, *Wages of Violence* (Princeton: Princeton University Press, 2001); Mehta, *Maximum City*.

14 Vikram Chandra, *Sacred Games* (London: Faber and Faber, 2006), 537.

15 This polyvocality is reinforced by the novel's alternating first-person narration by Sartaj and Ganesh and by the absence of an omniscient authorial narrative voice.

16 Arjun Appadurai, 'Spectral Housing and Urban Cleansing: Notes on Millennial Mumbai,' in *Cosmopolitanism*, ed. Carol A. Breckenridge, Sheldon Pollock, Homi K. Bhabha, and Dipesh Chakrabarty (Durham: Duke University Press, 2002), 54; Rashmi Varma, 'Provincializing the Global City: From Bombay to Mumbai,' *Social Text* 22, no. 4 (2004): 65–89.

17 Arjun Appadurai, 'Grassroots Globalization and the Research Imagina-
 tion,' in *Globalization*, ed. Arjun Appadurai (Durham: Duke University Press,
 2001), 6.
18 Roberts, *Shantaram*, 619–20.
19 Hansen, *Wages of Violence*, 20–9.
20 Kalpana Sharma, *Rediscovering Dharavi* (New Delhi and New York: Penguin,
 2000), 72.
21 Roberts, *Shantaram*, 620.
22 Chandra, *Sacred Games*, 366.
23 Ibid., 364.
24 Justin Huggler, 'Alternative Tourist Trail: Slumming It in Mumbai,' *The Inde-
 pendent*, 25 July 2006.
25 Gehlawat, 'Slumdog Comprador,' 4.
26 See, for example, Gina Serpe, '*Slumdog* Kids No Longer Slumming It,'
 E! Online, 25 February 2009, http://eonline.com/uberblog/b101571_
 slumdog_kids_no_longer_slumming_it.html, accessed 13 June 2009; 'Slum
 Dog Star's Home Is Demolished,' *BBC News*, 14 May 2009, http://news.bbc
 .co.uk/2/hi/south_ asia/8049735.stm, accessed 13 June 2010.
27 Roberts, *Shantaram*, 249.
28 Mike Davis, *Planet of Slums* (London and New York: Verso, 2006).
29 Roberts, *Shantaram*, 261–2.
30 Ibid., 261.
31 Sharma, *Rediscovering Dharavi*, 16.
32 Article 25, Section 1, states: 'Everyone has the right to a standard of living
 adequate for the health and well-being of himself and of his family, includ-
 ing food, clothing, housing and medical care and necessary social services,
 and the right to security in the event of unemployment, sickness, disability,
 widowhood, old age or other lack of livelihood in circumstances beyond his
 control.' Office of the High Commissioner for Human Rights, 'The Univer-
 sal Declaration of Human Rights,' *Official UN Universal Declaration of Human
 Rights*, 10 December 1948, http://www.unhchr.ch/udhr/lang/eng.htm,
 accessed 6 September 2008.
33 Gita Dewan Verma, *Slumming India: A Chronicle of Slums and Their Saviours*
 (New Delhi and New York: Penguin, 2002), 66–80.
34 The UN Human Settlements Programme, UN-HABITAT, defines a slum
 as 'an area that combines, to various extents, the following characteristics:
 inadequate access to safe water; inadequate access to sanitation and other
 infrastructure; poor structural quality of housing; overcrowding; insecure
 residential status.' In *The Challenge of Slums: Global Report on Human Settle-
 ments* (London and Sterling, VA: Earthscan, 2003), 12.

35 Vandana Desai, *Community Participation and Slum Housing: A Study of Bombay* (New Delhi: Sage, 1995), 115–16.

36 Alexa Olesen, 'Rights Group: Olympics Displace 2 Million People over Last 20 Years, 1.25 Million in Beijing,' *International Herald Tribune: Europe*, 5 June 2007; and 'Whistler's Homeless Relocated Ahead of Olympics,' *CBC News*, 8 January 2010, http://www.cbc.ca/canada/british-columbia/story/2010/01/08/bc-whistler-homeless-olympics-relocate.html, accessed 15 June 2010.

37 Arjun Appadurai, 'Deep Democracy: Urban Governmentality and the Horizon of Politics,' *Public Culture* 14, no. 1 (2002): 27.

38 Harini Narayanan, 'In Search of Shelter: The Politics of the Implementation of the Urban Land (Ceiling and Regulation) Act of 1976 in Greater Mumbai,' in *Bombay and Mumbai: The City in Transition*, ed. Sujata Patel and Jim Masselos (New Delhi: Oxford University Press, 2003), 184.

39 Ibid., 205.

40 Mehta, *Maximum City*, 59.

41 Roberts, *Shantaram*, 116.

42 A.R. Desai and S.D. Pillai, *A Profile of an Indian Slum* (Bombay: University of Bombay Press, 1972), 41.

43 Sharma, *Rediscovering Dharavi*, 18–19.

44 Nilanjana Bhowmick, 'What Will Happen to *Slumdog's* Child Stars?' *Time*, 10 March 2009; Mazeher Mahmood, 'Slumdog Millionaire Star Rubina Ali Who Played Latika Is Offered for Sale by Dad Rafiq Qureshi to the News of the World's Fake Sheikh,' *News of the World*, 19 April 2009, http://www.newsoftheworld.co.uk/news/271325/Slumdog-Millionaire-star-Rubina-Ali-who-played-Latika-is-offered-for-sale-by-dad-Rafiq-Qureshi-to-the-News-of-the-Worlds-Fake-Sheikh.html, accessed 13 June 2010; 'Slumdog Millionaire Star Rubina Ali Up for Sale?' *Palestinian Telegraph*, 24 April 2009.

45 Roberts, *Shantaram*, 247; Chandra, *Sacred Games*, 210.

46 Mehta, *Maximum City*, 54–9.

47 Verma, *Slumming India*, xv–xx.

48 Mehta, *Maximum City*, 57.

49 Michael Peter Smith, *Transnational Urbanism: Locating Globalization* (Malden: Blackwell, 2001), 145.

50 Sidney Tarrow, *The New Transnational Activism* (New York: Cambridge University Press, 2005), 29.

51 István Adjorán, 'New Cosmopolitanism: Altered Spaces in a Postcolonial Perspective,' *Hungarian Journal of English and American Studies* 7, no. 2 (2001): 200.

3 Ends of Culture

JEFF DERKSEN

The Temporality of Cultural Critique

Raymond Williams forcefully characterized culture as a long revolution of process and change, yet culture is often experienced more abruptly, as events cut across our everyday lives and as moments merge into a collective interruption of the making and remaking of social relations. This crosscut of moment and event against the grain of the long duration characterizes the temporality of 11 September 2001. Yet the temporality that emerged from that day – through the media representation and political fallout of the attacks on the World Trade Center and the Pentagon – has been deeply contested and has shaped the critical frames and the language used to grasp the present. If 9/11 marks either a rupture or break in the historical moment that signals a new reality, or, conversely, if it is an event that requires a longer analysis to properly locate, this tension challenges the temporality of cultural critique and the language of globalization.

This critical disruption became evident when terms such as *imperialism, hegemony, primitive accumulation,* and *creative destruction* began to appear anew at all levels of cultural and political discourse. Beginning with the worldwide anti–Iraq War march and then the peace protests in February and March 2003 – massive gatherings that conjured either a public sphere located in globalized cities, a cohesive global public opinion, or the merging of the inchoate multitude – and then accelerating after the invasion of Iraq turned from a triumphal event into a relentless occupation, these terms that had previously been relegated to bygone stages of political and cultural analysis began to circulate as explanations of the moment. Arif Dirlik, in his analysis of global modernity, situated

the ground from which these terms pushed up: 'in some contemporary works, the colonial and imperial pasts appear merely as stages of an inexorable globalization that has presently replaced an earlier modernization discourse as the paradigm for understanding the development of the modern world.'[1] Here the logic and language of development provides a paradigm of stages and a temporal unfolding of the modern world that leads to the present moment. Yet with Iraq, the historical repetition of invasion, occupation by a (coerced) coalition force, the promise of democracy, and the privatization of common resources (since repeated stealthily in Haiti) has led to the timely re-emergence of these concepts as active processes of the present rather than as past stages. As Dirlik asserts, *imperialism* and *colonialism* do not 'disappear into a new teleology of globalization'; rather, they are forces that have created the unevenness – in the distribution of wealth, in social stability, and in political and cultural power – of the present.[2]

These relaunched terms draw strikingly on a powerful if somewhat submerged critique that brings forward the language of resistance to colonialism and imperialism – that is, a language of critique and of possibility that Fredric Jameson has periodized as the 1960s. For instance, Retort, the collective of writers centred in the Bay Area, argue the necessity to reclaim *capitalism* and *primitive accumulation* as terms of analysis in their engaging analysis *Afflicted Powers:* 'We take it the time is over when the mere mention of such categories consigned one – in the hip academy, especially – irrevocably to the past. The past has become the present again: this is the mark of the moment we are trying to understand.'[3] Retort are sharp in their parenthetical assertion that 'it is "the end of Grand Narratives" and the "trap of totalization" and "the radical irreducibility of the political" which now seem like period pieces.'[4] But Retort also cautions that *imperialism* should stay where Lenin put it in early 1916, as the highest stage of capitalism rather than as an imperialism that could occur again (as modernity is continually allowed to do!) in forms not identical to Lenin's vision. The Retort collective 'find[s] it understandable, if in the end a mistake,' that imperialism is used in a smug or even relieved manner – one that denies the dialectic of the moment – in order to arrive at that past once again.[5] But the crucial question that arises is not simply whether the past has been arrived at again. Instead we are confronted with the question of whether imperialism and other strategies of accumulation are unfinished projects and strategies that migrate or surge in an uneven moment, in a temporality that is not split between the present and the past.

Reflecting on the constellation of culture after the euphoria of a globality in which cultural criticism had grown weary of concepts such as *capitalism* (as a determinant but not as a phenomenon), archiving them as too obvious or too overdetermined for investigation – while seeing everyday life opened by the possibilities of resurgent cosmopolitanism, emergent forms of citizenship, and the connectivity of globalization – it is possible to say today that the rejection of such hardened terms is a hangover from a developmental theory of globalization. Despite a spatial view of globalization as a complex net of connections, nodes, and flows, its temporality has been fairly straightforward – we progressed to the present global moment. This view of globalization was not cracked by 9/11 as an *event*, but rather in the ways in which that day scuttled the terms of such *progress* and *presentism*. As the route of culture in globalization theory – a narrative of the jumping over of the national scale toward a mash-up of place-specific cultures – has shifted the site of critique downward to borders, cities, bodies, things, and events while moving away from larger categories and constellations, this view of globalization as synonymous with progress has begun to crumble. But against the supposed fragmentation of the present, the return of terms that gesture upward also sets up an historical reverberation with the period in which *imperialism*, for example, carried a forceful note of critique from the past – a critique, however, that is also useful to understand the present. In this way, *imperialism* has been a flexible term, one that has been adapted to a critique of everyday life, to economic and military expansion, to the forms of cultural tensions.

Get Your Imperialism On

Plodding and monologic, *imperialism* is often figured as the unidirectional application of state power now nudged under by fluid globalization and its promise of mobile citizenship, ineffective nations, and hybrid cultural formations fermented in the dynamic mix of the global–local. So imagine the rusty creaking as *imperialism* and *hegemony* made their way into even the mainstream media. The American shock political commentator Rush Limbaugh felt hegemony to be an accurate marker for the ambitions of the right and recommended Antonio Gramsci as useful reading. Curiously, some liberals, on the other hand, saw new forms of imperialism as an inevitable and ethical way of managing the world. This rebranding of imperialism as what Michael Ignatieff termed 'the burden' gathered strength in the run-up to what we were told was an

unwanted yet just war: it was argued that imperialism was a reasonable political strategy to promote the happy hegemony of liberal democracy. Ignatieff, who later left his position at Harvard University to return to Canada, where he entered federal politics, identified the present form of imperialism in a manner that is careful in its philosophical positioning but also startling in its dehistoricization and condescending in its explanatory tone:

> Imperialism used to be the white man's burden. This gave it a bad reputation. But imperialism doesn't stop being necessary just because it becomes politically incorrect. Nations sometimes fail, and when they do, only outside help – imperial power – can get them back on their feet. Nation-building is the kind of imperialism you get in a human-rights era, a time when great powers believe simultaneously in the right of small nations to govern themselves and in their own right to rule the world.[6]

Ignatieff goes on to outline imperialism as a necessity in which there are no winners, no losers, just good global neighbours helping one another out when one falls on bad times through no fault of its own.

This post-political view of imperialism – an imperialism with no real conflict or economic interest but instead imbued with a reluctant humanism – is what Fred Moten identifies as part of 'The New International of Decent Feelings,' an affective alliance that 'will ultimately align itself against evidence and analysis, as if proper thought will have taken place only in the obsessive oscillation between false alternatives.'[7] Here, of course, the false alternatives are liberal democracy forced through imperial rule or the risk of failure. Ignatieff, who has already narrowed the possibilities of the political, does not have to obsess between 'temporary imperial rule' and states slipping further into disrepair, for his proper thinking does not imagine other forms of political engagement. For Neil Smith, who analyses liberalism over the long haul, Ignatieff and other liberal hawks provide a clear view: he states that 'rarely since 1898 has the vice of liberal American Imperialism been so honestly on display.'[8] Yet for Smith, this moral order of 'liberal realism' is tied to the historical roots of liberalism rather than to a shocking rupture from it. The past is not flipped forward; rather, the project of capitalism continues astride, upping its 'shock doctrine' as Naomi Klein observes, but using a language that buffers and even normalizes the shock.[9] The 'shock therapy' that Jeffrey Sachs recommended for the transformation of the Russian economy in 1991 has given way to a language of 'liberalization'

of trade and 'harmonization' of national economies through trade pacts.

Curiously, this resurfacing of *imperialism* occurs precisely at a moment when the cultural discourse of globalization has settled into an image that smooths the surface of the world, eroding uneven development with transnational flows of people, finance, images, and ideas. And imperialism is posed merely as an idea that migrates easily on these post-political flows. Despite acknowledging the unevenness of capitalism (though never touching on its real effects, instead seeing uneven development as a complication of centre and periphery), such a view presents a world where borders and the nation-state become more immaterial and where the barbed edges of interstate rivalries are seen as cultural rather than economic. While global flows and 'relations of disjuncture,' as Arjun Appadurai designates them, navigate the global tension of cultural homogenization and cultural heterogenization, the complex structures of power of this disjunctive global economy nonetheless move through national spaces. The dynamic production of a geography of globalization cuts through all spatial scales, altering and being altered as it follows paths of both beckoning and resistance. Imperialism, understood as a crude power with military, economic, and cultural tentacles, enters into this fluid world conception as an irritant that is insufficiently disjunctive and still troublingly geographical. It *takes* place.

Retrospectively, the post-geographical view of empire that Hardt and Negri have popularized (tapping into a language of deterritorialization that was once invigorating) has taken a number of hits, and not only from the radical geographers. Eric Lott, writing on the disappearance of the liberal intellectual, observes, 'how musty now seems the globalization theorizing of just a few years ago, when Antonio Negri and Michael Hardt could argue in *Empire* that the global relations are today dominated by a set of imperial, but not imperialist, interests.'[10] In contrast to the centreless imperial focus, and in a harsher critique of *Empire*'s 'dreamlike desire of fluid social boundaries [that] effectively blurs the crude imperialism of American realpolitik,' Timothy Brennan points to a longer-term 'infrastructural necessity of imperialism.'[11] And, previous to *Empire*, Gayatri Spivak described the 'continuing narrative of shifting imperial formations' and the intense 'financialization of the globe' in which capitalism's 'seeming advance is caught back into its transformation into imperialism by way precisely of the money circuit: finance capital.'[12] For Spivak, this seeming advance is a transformation that confounds a stage theory of imperialism and that invigorates new forms such as 'aid–trade

imperialism.'[13] This is what Ignatieff happily defines as 'empire lite': 'a global hegemony whose grace notes are free markets, human rights and democracy.'[14]

Cultural studies, as a methodology for reading the world and its cultural effects, also can be questioned for how it shades its view from a global hegemony in which imperialism takes hold in both the stability and expansion of capital. As Rey Chow argues, 'cultural studies contains within its articulations this fundamental *theoretical* understanding of the need to challenge the center of hegemonic systems of thinking and writing.'[15] Challenged in this way, 'standard cultural imperialism' was decentred and replaced with the constricting and commoditizing project of tolerant multiculturalism and a politics of recognition that left little space for forms of the political while expanding the spaces of the post-political.

For cultural studies, cultural imperialism was figured as a staid Galina Khrushchev alongside globalization's Chanel-clad Jackie O. But, interlaced with military and imperialist adventures globally and the neoliberal transformation of state structures and the push to privatize public resources and spaces, global flows have hardened against the tropes of cosmopolitanism, complex connectivity, cultural dialogue, and emancipation that have been used to describe the cultural effects of globalization. And since the economic meltdown caused by the credit crisis, we see rising again new anxieties about *national* economic protectionism. The cry of 'Buy American' has shifted from a global imperative to a national economic recovery plan!

Do flows ever rust? Do flows have points of origin? Imperialism, once the problem of the periphery, did not end as a tidy stage. Yet a renewed investigation of imperialism, or a new engagement with the term, can ask how it may have cohered into unrecognizable forms, how it may dig in at new scales, and how a new or a different language that bypasses the state to pledge allegiance to the mercurial and ephemeral market has become its new oath. The inward turn of colonization that has given rise to the slogan 'the colonization of everyday life' may today help us identify a stealth imperialism of everyday life. A more brutal imperialism aimed at the dispossession of territories and resources (what the Midnight Notes Collective pointed to in 1990 and what David Harvey has called 'accumulation by dispossession') might also be tied with the denial and dispossession of a non-market imagination of the social. An imperialism of everyday life that forecloses deliberation beyond the false alternatives of liberal democracy or failure might well be cohering underfoot.

Back to Culture (Let's Get Political!)

Since the 'cultural turn,' culture has become an overworked term, signifying everything, taking place everywhere. In the theoretical struggle to loosen the bolts of economic determinism, relations between the economic and the cultural were variously separated and folded together: but culture, as a category, emerged as the reified dominant, the expanded category of life and the everyday across scales. Seeking to embed culture in the processes of everyday life and to retrieve it from a superstructural adjunct, Raymond Williams famously defined 'the theory of culture as the study of relationships between elements in a whole way of life' – a definition that would echo through cultural studies.[16] But this expansion has only added to the difficulty of defining this 'noun of general process.'[17] And beyond definition – as Don Mitchell has continued to argue – culture is wielded as explanation to the extent that 'the emptying out of the abstraction of culture – the very fact that it means nothing – allows for an imperialization of culture: a world in which culture is everything (because it is nothing).'[18] For Mitchell, the emptying of the term has led to an 'abandonment of explanation' and a culturalism in which '"culture" is used to explain culture (or cultural forms).'[19] When culture is figured in this way, Mitchell posits, it becomes a 'phantom,' a 'superorganic mysterious thing,' and a default determinant of the social – a 'prison-house of social life.'[20] Mitchell argues that the political consequences are costly: 'it is precisely because the term "culture" has no clear reference that it becomes a useful tool for arraying power, for organizing distinctions in the world.'[21] In place of this, Mitchell asks that '"Culturalism" in geography ... be replaced by a fuller, richer dialectical argument about "culture" as a social product and a social practice, one that is fully implicated in systems of domination, oppression, and exploitation.'[22]

Mitchell's compelling argument is a reaction against *cultural studies* as much as it is against the *category of culture:* the theoretical challenge is to effectively open the cultural to the social without falling into the binds of culturalism ('the doctrine,' Terry Eagleton argues, 'that everything in human affairs is a matter of culture'[23]), without reducing the cultural to a sphere detached from real materialist and systemic concerns, nor to have culture explain differences that are also rooted in and derived from many other spheres. That is, to look at culture as determined and not only as determining.

Without explicitly forming a definition, Rey Chow gives a working model of culture that better answers Mitchell's challenge while also gen-

erating a cultural politics: '"culture" is an unfinished process, a constel-
lation – never in pristine form – of social relations that are continually
unworked and reworked.'[24] Chow's view does not fetishize culture as a
process of open-ended representations; rather, it locates the 'unfinished
quality' of culture in the social; in 'the lingering effect of massive in-
equalities inherent in the international divisions of labour; in the access
to social representation and political power; and in the possession, ex-
change, and consolidation of cultural capital.'[25]

Yet when culture is not viewed as a process as Chow provides, and
when it is not contested as a category as Mitchell does, it can be a tool for
dividing up the world and generating area knowledges with little histori-
cal depth. This area knowledge constructs regions as static spaces rather
than as socio-historical processes and contested territories. Culture can
then be used to explain a range of imperial and foreign policy projects
– particularly, as we see today, that the 'region' of the Middle East has
not 'known' democracy due to a cultural lack rather than due to the very
type of imperial interventions that are now called up as the solution. It is
difficult to hear Ignatieff do anything other than invoke an old form of
imperialist knowledge when he muses that 'the case for empire is that it
has become, in a place like Iraq, the last hope for democracy and stabil-
ity alike.'[26] This culturalism also allows a binaristic rhetoric to emerge:
civilization versus the barbarians, skyscrapers versus caves, enlighten-
ment versus primitive darkness, democracy *or* totalitarianism, and the
greater mythic simplification of 'good' and 'evil.' As many commenta-
tors have asserted, a lack of geographical and political knowledge allows
or generates such justifications and mystifications. But this process works
in tandem with a static view of culture, and the result is a cultural–spatial
politics tied into foreign policy architecture. An application of 'culture'
as traits and distinctions results in a static map of the world. What is
lost here is the kind of geopolitical jockeying and hegemonic shoulder
bumping that propels nation-states to take positions in relation to the
world economy, and increasingly, access to the resources. Ironically, cul-
ture itself is now such a resource.

The Other Ends of Culture

Theories that detail the use and consumption of culture by particular
communities and institutions have convincingly argued for agency at a
number of scales through notions of global civil society, insurgent citi-
zenships, and emergent publics. But the determinations on the produc-

tion end of culture, the ends towards which culture is deployed, have to be looked at as both restrictions and possibilities of what artists, writers, and cultural groups do. The uses of culture cannot be so easily pried from the places, conditions, and discourses of its production – particularly if we view globalization as a mechanism of capital and not as a network of connections between things and ideas or people and places. It is through this nexus that I approach questions of another seemingly old term of analysis, a term that illuminates the very type of cultural tensions that a global view of connectedness and flows drifts away from – this term, a merging of two difficult words, is *cultural imperialism*. What order of culture and what uses of culture does a resurgent imperialism aim for? And to counter these ends of culture, I want to turn to oppositional forms of creative practice today in literature and visual art. In the term *creative practice*, Raymond Williams was sifting for a term to bring culture into a productive realm as both cultural production and mental labour. I use it here as part of what political economist Michael Lebowitz terms the 'red thread' woven through Marx – the push for living with the potential for creativity in life, a creativity that is stymied by capital – and as a counter to the 'creative destruction' that often drives globalization.[27] The estrangements and alienations of work and of life that are structural under capital are now spread over the globe to a greater extent. As Peter Hitchcock argues, 'this is the crisis in activity that globalization seeks to globalize.'[28] Here the crisis and potential of everyday life is globalized. Yet Hitchcock points to an historical, cultural, and economical nexus that frames globalization as a cultural and philosophical problem:

> The problem with globalization is not only the nefarious economic system it represents, but that it lacks a coherent or logical basis for its apprehension. Within the time/space compression of the moment ... and with all the loud trumpeting that because of technological and economic integration the world is a smaller place, there is relatively little discussion about how globalization can be understood without expounding on some cognitive, imaginative, or sensate means to do so.[29]

The problem of understanding globalization becomes cultural in a different way when artists and writers try to explain or intervene with the apprehension and definition of globalization through the imaginative. The question for artists and activists, then, is how to join the everyday of globalization – the goods, the information, the cultural drifts – to the systemic. This problem itself is not new, nor is it unique; perhaps, though,

what is different from previous interventions into everyday life, into public space, and into the larger relations that shape our lives, is that the very structure of globalization is rendered more opaque.

For instance, it is possible to read Vancouver artist Brian Jungen's 'Nike masks' – sculptural works collectively titled *Prototypes for New Understanding* – as complex reworkings of iconographic First Nations culture through global products. On the surface, this is a dramatic clash of a 'localized' culture and a globalized product. The prototypes rework Nike Air Jordans into masks that are uncannily similar to classical Northwest Coast ceremonial masks. Jungen's sculptures rework this highly recognizable global product (and a symbol of both the consumerist cultural logics of globalization and global modes of production) as 'postmodern' Northwest Coast Indian art, which is shown in a gallery (present, urban) rather than in a museum. Displayed on armatures and in glass vitrines, the prototypes reveal the deconstructive labour of Jungen (the cut seams, the cleaved glue joints) in tandem with the labour of the distant and anonymous workers who originally assembled the Air Jordans in Nike's South Korean plant. *Prototypes for New Understanding* addresses, through the different forms of labour shown in the sculptures, what David Harvey calls the 'hidden spatiality' of the geography of capitalism. The Air Jordans have been transformed into cultural commodities (ones that, ironically, have themselves travelled globally) that show both the labour and the hidden global spatial relations of the shoes; as a result, these Nikes have become ciphers of the current moment of globalization. In a sense, this is not simply a canny refiguring of First Nations culture outside the bad tropes of anthropology, but a making visible of the relations of globalization as well.

From Old to New Imperialism?

Cultural imperialism has returned as tragedy and farce within cultural theories of globalization. Imperialism now has to be designated as new or neoliberal or neoconservative in order to differentiate it from 'the final stage' of capitalism. Mohammed Bamyeh clocks out the 'logic of the old imperialism' with the 11 September 1973 coup against Salvador Allende in Chile; others begin a stage of new imperialism through American hegemony from the 1970s, leading to the declaration of infinite war after 9/11.[30] This runs against the grain of the temporalities of globalization and its compressed moment of triumphal capitalism's continuous present. Globalization, charged with a neoliberal urgency, is imagined

as the immediate now and the replicant future. But the spatiality of globalization submerges theories of imperialism: globalization imagines no outsides to itself, yet theories of imperialism assumed that imperialism, as a stage of capital accumulation, needed an outside, a non-capitalist environment as an outlet and for expansion.[31]

Theories of 'traditional' imperialism progress from a strong state that pushes its reach beyond its borders and that establishes an imperial centre and a colonial periphery. Theories that have privileged global processes of fluidity, deterritorialization, and complex connectivity tend to propose a porous state adrift without a function: its borders and boundaries breached on multiple levels ranging from the economic (via global finance and trade) and the cultural (through the global circulation of images and ideas) to the citizen (made global through transnational migration or technology). But in globalization as it presently exists, capital in order to maintain itself needs a 'global system of multiple states and local sovereignties, structured in a complex relation of domination and subordination.'[32] And a new imperialism lives within this system of coercion, corruption, and dominance. Cultural theories of globalization that jump the nation-state and that privilege global–local connections tend to see cultural imperialism deflected, in the final instance, by the local, rather than administered by a system of states and localities.

Ellen Meiksins Wood argues in *Empire of Capital* that no overall theory of imperialism exists that is 'designed for a world in which all internal relations are internal to capitalism and governed by capitalist imperatives.'[33] For understanding the forms – and functions – of cultural imperialism, this means that the ideological function of universal cultural imperialism must, in a sense, guard its borders against the cultural imagining of another world order or social order while simultaneously trying to contain or deflect critiques that are internal to the system. Cultural imperialism can be then understood as both expansive and limiting: economically expansive, yet socio-culturally limiting. Expansively, cultural imperialism pushes the project of global capital as the only possible form of life, yet as a limitation, it also worships neoliberalism as its proper guiding philosophy. 'Neoliberalism' as Brian Massumi picks it up, 'defines freedom as the right of individuals to act according to their personal interest, as rationally indexed to the needs and opportunities of the market economy that sustains them.'[34]

Individual consumption, personal (rather than collective) property rights, and privatization of public resources become hallmarks of a neoliberalism that leaks into everyday life. With this ramping up of individu-

alism and property, and the state of continual or permanent war that is spread across the globe, *fear* has become – as Massumi argues through Foucault – 'the correlative of neoliberal freedom.'[35] Picking up on this correlation of fear, affect, and the state, a neon work by Vancouver artist Ron Terada, 'Five Coloured Neon Words,' deploys pop conceptualism to bring the U.S. Department of Homeland Security's (DHS) colour-coded words of warning into another context. Terada's ironic flipping of politics into art through the material of a nostalgic form of commercial signage (and a material with a solid conceptualist heritage, particularly with Bruce Nauman) is a counter to the DHS's rather non-ironic (yet unintentionally humorous) approach, which once proposed duct tape as deterrence for chemical weapons and saw flour spills shutting down airports, for example. Terada's shift in context foregrounds the lack of self-reflexivity that typifies the DHS. 'Five Coloured Neon Words' does not seek an 'in-between' space for art: its political value is that it brings the social into the aesthetic without the cultural fear that the political context will override all cultural relations or crack down on the multiple meanings available. In fact, the reverse is set in motion: art is used to open up the suppressed ambiguities of the political and to let out the absurdist nature of the colour-coded warning semaphores. In this case, the element of farce that seems to be part of the DHS comes into clarity – despite the tragedy of its origins.

Terada's work also defuses (pun intended!) the wearying repetition and tug of affect that the colour-coded fear spectrum seems to have been set up to sustain. Brian Massumi describes the system in this way: 'The alert system was introduced to calibrate the public's anxiety. In the aftermath of 9/11, the public's fearfulness had tended to swing out of control in response to dramatic, but maddeningly vague, governmental warnings of an impending follow-up attack. The alert system was designed to modulate that fear.'[36] The result, Massumi proposes, was that 'across the geographical and social differentials dividing them, the population fell into affective attunement.'[37] In Massumi's reading, the system creates an affect that harmonizes the public to the same register of fear and insecurity, and this register then becomes the new normal (as Massumi points out, there is no DHS hue for 'Safe').[38] Terada's deployment of the spectrum cracks the unity of affect that is tied together in what Massumi calls 'the affective fact': 'So what is an affective fact? The mechanism is quite simple: "Threat triggers fear. The fear is disruptive. The fear *is* a disruption."'[39] Terada's reworking of this mechanism takes a step back into the conceptualizing or shaping of the fact about to be launched: 'Codes for

alert create fear. The codes are disruptive. Disrupt the code (and derail the affective fact).' The colour codes of alert ignite the affect of fear, and then fear itself becomes the affective fact – rather than a hot spectrum of fear, we get the cool conceptual glow of neon as Terada retakes affect into an artistic context to deploy it as laughter, or even the type of disgust one can feel when a scenario for duping you becomes clear. Terada does not empty the signs, he redeploys them.

Further In, Reaching Out

The cultural wing of neoliberalism was also deployed during the Cold War, aimed at everything from World's Fairs (think of the Kitchen Debate between Nixon and Khrushchev as a particularly sweaty instance of this) and Olympics (think of the transformation of Vancouver's inner city and the economic distortion of that city in the lead-up to our Olympics) through forms of popular culture to even the marketization of conceptual artistic production. By limiting the discussion and imagining of other shapes of the world and of other forms of social order, universal cultural imperialism tries to enact Althusser's call for interpellation at a global level: national cultures are to turn to the call of 'hey you' made by neoliberalism and to further embed themselves into its systems and logic. This cultural wing is writ large and *turned inward* towards culture itself. Everyday life then begins to reshape itself along the lines of this new common sense. The triumphant language and hectoring talking heads of neoliberalism shut down what the poet Bruce Andrews has referred to as the social horizon that cultural production strains at, or what Ernst Bloch calls 'real utopian critique,' which speaks out for the 'particular *tendency to come.*'[40]

Yet cultural imperialism still has an expansiveness based on interstate rivalries, even though culture is being dispersed through transnational ownership of the 'entertainment industry' and administered by a network of states and local sovereignties. Sophie Coppola's successful film *Lost in Translation* (2003) does not merely reflect an askew and sympathetic American view of the cultural strangeness of the Japanese – a kind of comedic ethnography; it also shows a fascination with Japanese adaptations and rejiggings of forms of American culture that result in things both familiar and odd (yet never defamiliarized). From their crazy talk show hosts who do not present the facade of Letterman and Leno, to their commercials that buff the luster of fading American stars, the Japanese mimic without invigorating. But the obsequious forms of capital-

ism that the film portrays are also held in a parodic frame, represented as lacking the sincerity or robustness of their American versions. The film's question is not so much 'Why are the Japanese so strange?,' but rather, 'Why can't they correctly reproduce American forms of doing business?'

Yet this film of cultural disconnection, of the lack of real interface between two cultures, comes at the moment when Japan has a rapidly increasing 'content industry' and when the economic aspect of its culture is growing. As an article on the website of Japan's U.S. Embassy points out, 'Japanese cultural exports, i.e. revenue from royalties and sales of Japanese music, video games, anime, art, films and fashion, soared to $12.5 billion in 2002, up 300 percent from 1992.'[41] And in the seamless inversion of the cultural into the economic that neoliberalism seeks, this cultural expansion is tied to a stronger position within the system of states. In an article that measures Japan's 'gross national cool' as a form of soft power, Douglas McGray positions Japan globally: 'Japan is reinventing superpower again. Instead of collapsing beneath its political and economic misfortunes, Japan's global cultural influence has only grown. In fact, from pop music to consumer electronics, architecture to fashion, and food to art, Japan has far greater cultural influence now than it did in the 1980s when it was an economic superpower.'[42]

Yet Coppola's film portrays a weak Japanese culture that is trying to copy American cool rather than a culture revved up with the possibilities of globalization's productive hybridity, a culture that reworks the cool of American culture by lifting it out of its own determinates. In this way, *Lost in Translation* is one of a number American films that represent Japan as out of sync, and locked into a losing competition with, the United States. From Tom Selleck's *Mr. Baseball* to the Michael Keaton vehicle *Gung Ho*, *Lost in Translation* reflects a transnational war of culture.

This interstate form of cultural imperialism constitutes a rivalry over cultural capital, yet it can also reflect a struggle for control of cultural institutions and of those national cultures (even though these must be understood as multiple!) that are a part of capital accumulation. In Canada, particularly during its more cultural nationalist moments, cultural imperialism was understood as structured into the Canadian–American relationship. The late London, Ontario, artist Greg Curnoe was driven to produce a work that inverted the stripes of the American flag and that replaced the stars with the suggestion 'Close the 49th Parallel' (a process that is ironically under way post-9/11, although not for the reasons Curnoe originally had in mind). Post-NAFTA, Curnoe's work has taken

on a complex temporality, reflecting its moment and at the same time commenting on the present.

Cultural expansion – via treaties and, in the case of Iraq, by military force – goes hand in hand with restrictions and clampdowns on culture internally. The sacking of the National Museum in Baghdad on 10 April 2003 was possible because the 'coalition of the willing' forces guarded the Ministry of Oil and the oil rigs but left key cultural sites unguarded, despite warnings from advisers and archaeologists that museums and libraries would need protecting and despite the museum looting during the 1991 Gulf War. This event is a cultural example of what David Harvey calls 'accumulation by dispossession – an accumulation strategy within the new imperialism' – as well as a part of the 'inside–outside dialectic' of capitalism.[43] The decidedly old-school imperialist expansion into Iraq has dispossessed the country of its cultural institutions and also of the archives of its cultural history: the National Museum was looted (although some works have been sleuthed from the black market and returned), the national library was burned out, and the education system is in ruins. Into this void, American cultural products and models of education continue to be poised to step. Iraq is caught between the 'authoritarian statism' of Saddam Hussein and the neoliberal state weakening of the occupation.[44] Culture, as a sphere wherein the shape of the state and the role of the public can be debated, has been severely disassembled.

This disassembling of the institutions and archives of culture, and the intense bombing and segregation that Baghdad has endured, are invoked by Jamelie Hassan's public work at the Morris and Helen Belkin Art Gallery on the UBC campus, 'Because ... There Was and There Wasn't a City of Baghdad.' The image on the billboard, a cropped cityscape with a cupola in the foreground, was first photographed in 1978 when Hassan was in Baghdad studying Arabic. But the billboard itself was generated after the 1991 bombing of Baghdad and Operation Desert Storm. In terms of the temporality of cultural critique that I have been outlining, Hassan's work not only spans (rather than links) the period of air assaults on the city, but also can be read as a chronotope (Mikhail Bakhtin's term for the fusing of time *into* place) of Baghdad. The text of the billboard – 'Because ... there was and there wasn't a city of Baghdad' – invokes the opening narrative of *The Arabian Nights* and asserts Baghdad as a centre of Arabic culture; yet it is also a statement that carries a complex temporality that captures the ruin and renewal (or perseverance) of the city. The cruelty of the accuracy of this statement is that the past tense of the phrase not only locates the city in the narrative time of the fable (what

Bakhtin called 'adventure time') in which the city always exists, albeit in the past, but also points to the present destruction of the city.

Shifting this temporality into a relationship with capitalism – and particularly the shock doctrine of neoliberalism – the phrase also describes the process of 'creative destruction.' *Creative destruction* was adopted from biological science by the economist Joseph Schumpeter in the early 1940s to describe 'an essential fact about capitalism.' For Schumpeter, the continual making and remaking of the economy was not simply an effect of capitalism – it was central to capitalism itself: 'capitalism, then, is by nature a form or method of economic change and not only never is but never can be stationary.'[45] But this change is not simply an evolution or stage or progression of the economy; rather, it is a process 'that incessantly revolutionizes the economic structure *from within*, incessantly destroying the old one, incessantly creating a new one.'[46] Isn't this the destructive process that is at work with culture in Iraq? An argument can be put forward that somehow culture *endures*, but it is vital to see culture as also central to the dispossession of national resources and not merely as a form of 'collateral damage.' 'Because ... There Was and There Wasn't a City of Baghdad' is a constant reminder of the adventure time of capitalism, a 'type of time' that, as Bakhtin notes, 'merges only at points of rupture ... in normal, real-life, "law-abiding" temporal sequences.'[47] This is the time of 'creative destruction,' 'the shock doctrine,' and 'the state of exception.'

Creative Practice versus Creative Destruction

If cultural imperialism is a central aspect of the new imperialism, and if it works through various forms of dispossession and creative destruction, new cultural strategies counter this process in ways that can angle both toward explanation and toward an understanding of how social relations are determined. These strategies would collide with how neoliberalism has narrowed the imagination of the social by narrowing the definition and possibility of culture, that is, as Mitchell argues, looking at how culture itself is mediated. Bruce Andrews, in writing about the possibilities of poetry and poetics, similarly proposes a grasping of the limits of cultural practices and social limits as a determining and a guiding factor: 'the grasp of these social limits can help to define the projected future of the [poetic] work.'[48] In this frame, I'd like to identify two types of critical cultural practices that grasp at social limits: the one counters the claims and ideology of neoliberalism; the other is more spatialized and engages

with particular globalized contexts or localized struggles at the scale of the nation and below. These two types of creative practice are not disarticulated; indeed, they can overlap in a joining of a particular scale with ideological issues.

As an example of creative practice that addresses neoliberalism and universal capitalism yet is grounded in a region, Larissa Lai's speculative fiction novel *Salt Fish Girl* describes a futuristic and fully destabilized Pacific Northwest. The region has broken down into two sections called 'Serendipity' and 'The Unregulated Zone.' In this corporate landscape, Nextcorp has bought out the Diverse Genome Project and used the DNA of 'so-called Third World' workers mixed in with fish DNA to clone a variety of workers. One group manufactures shoes in the sweatshops of Pallas shoes. The Sonias, as these worker clones are called, begin to organize themselves and start sending out anti-capitalist messages imprinted on the very soles of the shoes they make. The text's narrator states:

> I noticed the footprints when the unpaved shoulder gave way to newly poured sidewalk, all kinds of footprints, from all kinds of shoes and boots. Because I was not on foot myself, I didn't notice that some left a textual imprint behind ... The wet soles of the shoes functioned like rubber stamps, the wet mud like ink ... One set of footprints was just a price list:
> *materials: 10 units*
> *labour: 3 units*
> *retail price: 169 units*
> *profit: 156 units*
> *Do you care?*[49]

This novel can be read as a narrative that *explains* our present globalization through an allegorical move towards a future anti-globalization dystopia with its focus on the power of corporations and the absence of nation-states. But it also carries an anti-capitalist perspective that is braced though explanation. In the scene above, the labour theory of value is made material: illustrating by the price list that outlines the equation of surplus capital, Lai firmly places this type of exploitation within the machinations of capitalism – as part of 'the crisis in activity that globalization seeks to globalize'[50] – rather than as an effect of isolated corporate greed and sweatshop outsourcing that leads to an apology, a vow to shift production sources, and monitoring by an NGO.

This strain of anti-capitalism in *Salt Fish Girl* also has a utopian impulse, for, as Fredric Jameson concludes in *Archaeologies of the Future*,

'it is still difficult to see how future Utopias could ever be imagined in any dissolution from socialism in its larger sense of anti-capitalism.'[51] *Salt Fish Girl*'s moment of rupture, its revolution, marks the shift from the dystopic to the utopic by imagining an ideological and organized resistance that springs from productive forces – the Sonias – to counter the zombie passivity of the consumer citizen. Here *Salt Fish Girl* fits Jameson's proposition that 'any formal solution [to producing new versions of utopia's tensions] will, then, need to take into account both the historic-originalities of late capitalism … and the emergence, as well, of new subjectivities.'[52] And in the emergence of new formations of old subjectivities (for the Sonias are *workers* as well as new, technologically produced subjects), *Salt Fish Girl* unties a bind in one formation of identity politics. The Sonias, clones from the same corporate Petri dish, find unity through their exploitation by Pallas and establish their collective identities and resistance on that. The unregulated or guerrilla society that they set up is based on their common identity – a common identity literally *produced* outside of them – as exact clones. This inside–outside politics troubles the dichotomy of the universal and the particular while fusing the politics of identity with class-based point-of-production organizing; as Jameson poetically captures it, 'the collectivity is thus inside of us, fully as much as it is outside us, in the multiple social worlds we also inhabit all at once.'[53]

A gallery installation from The Speculative Archive (a collaborative project from Los Angeles between Julia Meltzer and David Thorne) addresses past collectivities attached to specific places, times, and utterances rather than future utopian collectivities. The full title is 'Free the, demand Your, We want, All Power to the, We Must, Stop the, End All, Don't, Fuck the, The People Will, You Can't, Those Who, women Are, If You, Resistance Is: some positions and slogans recollected from an archive of political posters.' This installation universalizes forms of social protest – and the conditions that give rise to the protest – through a two-part reading process that engages the viewer's social imagination and memory. Small monochrome text paintings provide a neutral description of, but not an image of, protest posters, which range from the SILENCE=DEATH Project to the anti-Vietnam Art Worker's Coalition, the Black Panthers, and so on. The text paintings simply and clearly describe the slogans but do not quote them. The strange act of reading these descriptions leads one to a recognition of the poster and the possible slogan as well as to one's own position ideologically (or historically) in relation to the poster and the particular struggle. It is a curious expe-

rience of social amnesia in reverse, and reading brings back the loaded context: you recall the familiarity of the poster or the slogan and recall your relationship (if any) to the struggle it boosted. The following is a sound element based on the 'seemingly endless calls to action' drawn from the posters:

> Would you buy a used war from this man? Si, se puede. The Vietnamese never froze my wages. When history cannot be written with a pen, it must be written with a gun. Support the copper strikers. Join the campaign for human rights for all immigrants, Free Los Tres. Attica. Make love not war. Join el moviemiento … again. Was your shirt made by Guatemalan women making $3 an hour? The time is now to smash Jim Crow. Let's Rap rap. Stop child labour. Don't buy grapes or Gallo wine. Ahora es cunado. For all these rights, we've just begun to fight.

The list of around 250 slogans ends with 'Never again,' and then starts up again. The temporality of this installation is not a bleak looping of oppression, but an insistence on the structural necessity of protest and resistance.

Creative practices such as these can operate out of a social necessity. As consent has taken over the North American mainstream media – as comic Stephen Colbert's address to the White House Correspondents' Dinner in 2006 sharply satirized – there has been a rise of semantically dense, information-laden cultural production. Visual art, poetry, and documentaries, in particular, have stepped in to provide a range of information that has been obscured in the public domain. This has emerged in recent years in the popularizing of critical documentary films and the impulse towards relaying the context and intensity of localized and regional struggles and conditions – an impulse that was displayed in *documenta 11* (2002), curated by Okwui Enwezor. Another part of this is demonstrated in the type of 're-mining' of the archive of social struggle that the Speculative Archive engages in and in a rise of works that record or socially map information.

Addressing the bad side of the connectivity of globalization – and doing so in relation to the invisibility of many of these connections – Mark Lombardi's drawings of corporate or governmental 'narrative structures' appear more as linked and looped lines forming a global flight path of corruption. Lombardi gathers massive amounts of information from the media on 'the interaction of political, social and economic forces in contemporary affairs,' as he puts it in an artist statement.[54] The connections

he traces out form the titles of the drawings: 'banca nazionale de lavaro, reagan, bush, thatcher, and the arming of iraq, c. 1979–90,' 'pat robertson, beurt servaas and the UPI takeover battle c. 1985–91,' and 'george w. bush, harken energy, and jackson stevens c. 1979–90.' The results are dense, map-like loops of connections that are part a world systems narrative (with the title of each work demarcating that world) and part conspiracy theory grids. Here, mapping as a form of knowledge is used to produce dense and opaque narratives to relations that generally remain invisible. In a similar form and impulse, the Bureau d'études from France have initiated a 'World Monitoring Atlas' that provides maps of global issues and resistance groups.

Outside of galleries, political theatre also provides a media platform for information that does not circulate in the public. Tricycle Productions in London, for instance, mounted a play titled simply 'Guantanamo' that uses letters home from 'the detainees,' as well as testimonies of political prisoners recorded after their release from Guantánamo Bay. In an art context, a multichannel video installation, '9 Scripts From a Nation at War,' produced by Andrea Geyer, Sharon Hayes, Ashley Hunt, Katya Sanders, and David Thorne for *documenta 12* (2007), also derives its scripts from the military tribunals at Guantánamo Bay, as well as from interviews with American soldiers, blog entries from soldiers active in Iraq, and other public blogs. These scripts were read by actors in various locations, and each of the scripts (comprising around nine hours of video in total) is an edited mix from the various source materials. Each script circulates around the relationship between speaking and speech, reporting and reportage, writing and position taking, while destabilizing or displacing the narration and positioning generated by the speech or text: the videos aim to break the expectations – or frames – of the material. The initial displacement is achieved through the medium of video, but also through various formal devices such as the mannerisms of actors reading written text, the writing of recorded speech on a blackboard, the non-correlation of the identity of the actor reading with the self-description of the author, multiple readings of the same text by different actors, and staged readings of press conferences. Operating through these defamiliarizing devices, '9 Scripts From a Nation at War' breaks the seams between media reception and accepted fact as well as between media presentation and affective fact: the dropping out of affect by the form of the readings and the various displacements blocks the generation of what Massumi calls 'the affective fact.' And in that gap between affect and fact, critique steps in.

As '9 Scripts From a Nation at War' shows, the nation as a scale of critique has emerged strongly post-9/11; but the nation is still a troubled scale when it comes to the type of 'revolution' that is imagined in *Salt Fish Girl*. In *Art and Revolution*, Gerald Raunig argues that 'even though ... variations of national revolts still take place, from the separatist regional insurrections and the African civil wars of recent decades, to South American examples in Argentina and Venezuela, to the insurrectionary aspects of the protests against right-wing governments in Europe, the phenomenon of the national revolt today seems to have become too large and too small at the same time.'[55]

This shift in scale away from the nation is dramatic, for it was not so long ago that the nation as a scale was tied both to the narration of the identity of a people and to the reproduction of the nation-state (Bhabha) as well as to the concept that created a deep historical commonality (Anderson). But if we place Raunig's spatial problem of the nation being both 'too large and too small' in the temporality of cultural critique, what emerges is that the nation is too 'old' as a site for transformation, having missed its chance before we proceeded to a post-national view of globalization. This theoretical scale jump and temporal problem has been reflected in the particular case of Venezuela, an oil-rich nation that throughout its history has been deeply divided by poverty as well as by the structural inequalities of colonialism. Since the election (and re-elections) of Hugo Chavez as president, there has been a rejection of the globalized neoliberal project at the national scale. Cutting across the grain of neoliberalism, the 'Bolivarian Revolution' ('el processo' as it is called locally) has renationalized the oil industry and moved towards securing resources as national common goods and towards the redistribution of national wealth. Politically there has been an emphasis on 'participatory democracy' that is constitutionally enacted rather than a reliance on individual participation in liberal democracy. Yet cultural engagement with this anti-neoliberal project (at the national scale) is so symbolically weighted that in 2006, a controversy flared up at the show 'Now-Time Venezuela: Media Along the Path of the Bolivarian Process' at the UC Berkeley Museum. The curator, Chris Gilbert, resigned his position when the gallery asked for changes to the curatorial statement – the welcoming wall text of the exhibition. That statement asserted that the show was 'in solidarity' with the Bolivarian process that had 'evolved from a modest critique of neoliberalism to a broad and internationalist plan for socialism for the twenty-first century.'[56] The gallery asked for a shift away from the rhetoric of 'in solidarity' towards the non-aligned

and neutral notion that the exhibition was merely 'concerning' the Bolivarian process. That and the ensuing tussle led to Gilbert's departure.

Sabine Bitter and Helmut Weber's photographic series 'Caracas, Hecho en Venezuela' steps into this overdetermined space of cultural projects regarding Venezuela's anti-neoliberal project. In a series of black-and-white images titled 'Super Citizens,' scenes from various pro-government, union, and independent media rallies set within the spectacular modernist urban landscape of Caracas are mediated through software to abstract the architecture while foregrounding the citizens.[57] These photo-sketches were responses to a moment of political optimism and a degree of social unity on a national scale arising from the promise of the redistribution of wealth, access to land, and the constitutional possibility of an active and participatory democracy (which included a public process for rewriting the constitution, to the point where the constitution became a popular book, an actual pocketbook carried by people and read on buses and so on). As Raunig notes, 'the Constitution introduced "participatory democracy" ... the 'protagonist role' of the people, including a complex version of human rights and the rights of women and Indigena, and generally followed an anti-neoliberal course.'[58] In contrast to this series, in the media landscape of Venezuela and in the North American mass media, the images that circulated of the politics of the streets in Venezuela were of opposition marches. Images of the poor and highly mobilized majority were rarely seen – with the exception of the documentary *The Revolution Will Not Be Televised*, which filmed the eruption outside the Presidential Palace that, in some part, overturned the 2002 coup attempt against Chavez. Bitter and Weber's images are, in part, images of a curious formation – an anti-neoliberal 'pro-government' (or at least pro-participatory democracy) demonstration that understands the stakes to be the shape of democracy nationally, as well as the *articulation* of an anti-neoliberal project regionally and globally.

The cityscape, as sketched out in Bitter and Weber's series, emphasizes the straight lines of international modernism, while the human actors, the 'super citizens,' are foregrounded. The figure and ground here is citizen and architecture, as well as transnational (architecture) and national (citizen). The modernist city program, though rendered more linear through the perspectives of an architectural drawing, does not clash with the social program of the demonstrators. The modernist architecture, despite its bad history as dictators rationalized the city and contained the urban poor, is not figured as a deadening force on

the possibility of everyday life. Reminiscent of the socially optimistic (if not utopian-leaning) projects of architectural groups from the late 1960s such as Superstudio and Archigram, these drawings record people in the street while proposing the city as a platform for psycho-spatial and even social transformation. This spatial aspect is laced into the particular national project of participatory democracy in Venezuela. The problem of the nation being 'too large and too small' as the scale for transformation is addressed spatially by joining the global with the national and urban scales: the globalized city is the platform for national rights as well as global claims. These images represent a joining of spatial scales from the urban political subjectivities of the people marching, to the national 'process' against neoliberalization and privatization, to the regional and global imagination that is explicitly against imperialism and *empire*.

These examples of creative practice against the logic of capital and against the return and justification of imperialism foreground cultural production as a necessary element in any social project. But these works also show the dialogue between different forms of critique. When artistic critique is expansive and turns outward towards the social, it merges what we could call an activist critique that is based on social justice and the demands of participatory democracy, on the one hand, with the imagination of social change and a more equitable life on the other.[59] The cultural aspect of new social movements, whatever shape they will merge into, can be understood as encompassing the aesthetics and performativity of the protest marches as well as the more direct action of disruption and property damage. But this cultural aspect can also bring an infusion of information and analysis, a turn of humour and irony to sharpen a focus on a social horizon that is not determined solely by the market. What is compelling about the activist critique at this particular moment is that the combination of political actors, and the emergence of a formation that will give coherence to demands and declarations of social activists, is always, seemingly, on the horizon. The shape of the coalitions, contingencies, or convergences (as this process was called during the resistance to the 2010 Olympics in Vancouver) of political subjects and social actors is still to be discovered; and within this, culture as a practice and as a social process bound in new and dynamic ways to all aspects of the economy has a critical and active role to play. Coming out of the 1960s, culture has been understood as *political,* and today it can be fundamentally grasped as an aspect of *the political:* beyond a shift in semantics, this grounds culture in all forms of political and social work.

NOTES

1 Arif Dirlik, *Global Modernity: Modernity in the Age of Global Capital* (Boulder: Paradigm, 2007), 102.

2 Ibid., 103–4.

3 Retort, *Afflicted Powers: Capital and Spectacle in a New Age of War* (London and New York: Verso, 2006), 9.

4 Ibid., 9.

5 Ibid., 18.

6 Michael Ignatieff, 'The Burden,' *New York Times Magazine* (5 January 2003).

7 Fred Moten, 'The New International of Decent Feelings,' *Social Text* 20, no. 3 (2002): 190.

8 Neil Smith, *The Endgame of Globalization* (New York: Routledge, 2005), 44–5.

9 Naomi Klein, *The Shock Doctrine: The Rise of Disaster Capitalism* (Toronto: Alfred A. Knopf), 2007.

10 Eric Lott, *The Disappearing Liberal Intellectual* (New York: Basic, 2007), 184.

11 Timothy Brennan, 'The Empire's New Clothes,' *Critical Inquiry* 29, no. 2 (2003): 367.

12 Gayatri Spivak, *A Critique of Postcolonial Reason: Toward a History of the Vanishing Present* (Cambridge, MA: Harvard University Press, 1999), 101.

13 Spivak, *A Critique of Postcolonial Reason*, 102.

14 Michael Ignatieff, 'America's Empire Is an Empire Lite,' *New York Times* (10 January 2003).

15 Rey Chow, *Ethics after Idealism: Theory – Culture – Ethnicity –Reading* (Bloomington: Indiana University Press, 1998), 4.

16 Raymond Williams, *The Long Revolution* (New York: Harper Torchbooks, 1961), 46.

17 Raymond Williams, *Marxism and Literature* (Oxford: Oxford University Press, 1977), 17.

18 Don Mitchell, 'The End of Culture? Culturalism and Cultural Geography in the Anglo-American "University of Excellence,"' *Geographische Revue* 2, no. 2 (2000): 8.

19 Ibid., 9.

20 Ibid., 10.

21 Don Mitchell, 'There's No Such Thing as Culture: Towards a Reconceptualisation of the Idea of Culture in Geography,' *Transactions of the Institute of British Geographers* 19 (1995): 106.

22 Mitchell, 'The End of Culture?,' 13.

23 Ibid., 11.

24 Chow, *Ethics After Idealism*, xiv.

25 Ibid.
26 Ignatieff, 'America's Empire Is an Empire Lite.'
27 See Michael Lebowitz, *Beyond Capital: Marx's Political Economy of the Working Class* (Houndsmill: Palgrave MacMillan, 2003).
28 Peter Hitchcock, *Imaginary States: Studies in Cultural Transnationalism* (Urbana: University of Illinois Press, 2003), 194.
29 Ibid., 185–6.
30 See Mohammed A. Bamyeh, *The Ends of Globalization* (Minneapolis: University of Minnesota Press, 2000).
31 See Ellen Meiksins Wood, *Empire of Capital* (London: Verso, 2004), 126.
32 Ibid., 141.
33 Ibid., 127.
34 Brian Massumi, 'The Future Birth of the Affective Fact,' http://browse.reticular.info/text/collected/massumi.pdf, accessed 10 August 2008.
35 Ibid.
36 Brian Massumi, 'Fear (The Spectrum Said),' *Positions* 13, no. 1 (2008): 32.
37 Ibid., 32.
38 Ibid., 31.
39 Massumi, 'Affective Fact.'
40 Ernst Bloch, 'The Meaning of Utopia,' *Marxism and Art: Essays Classic and Contemporary*, ed. Maynard Solomon (New York: Alfred A. Knopf, 1973), 581.
41 Junya Ishii, "Cool' Japan: Spreading Japanese Pop Culture in the United States,' http://www.us.emb-japan.go.jp/english/html/embassy/otherstaff_ishii1115.htm, accessed 8 August 2008.
42 Douglas McGray, 'Japan's Gross National Cool,' *Foreign Policy* (May–June 2002): 44.
43 David Harvey, *The New Imperialism* (Oxford: Oxford University Press, 2003), 140–1.
44 See Nicos Poulantzas, *State, Power, Socialism*, new ed. (London: Verso, 2001), 203 ff.
45 Joseph Schumpeter, *Capitalism, Socialism, and Democracy* (1942; New York: Harper, 1975), 82.
46 Ibid., 82.
47 M.M. Bakhtin, *The Dialogic Imagination: Four Essays*, trans. Caryl Emerson and Michael Holquist (Austin: University of Texas Press, 1981), 152.
48 Bruce Andrews, *Paradise and Method: Poetics and Praxis* (Evanston: Northwestern University Press, 1996), 41.
49 Larissa Lai, *Salt Fish Girl* (Toronto: Thomas Allen, 2002), 238.
50 Hitchcock, *Imaginary States*, 194.

51 Fredric Jameson, *Archaeologies of the Future: The Desire Called Utopia and Other Science Fictions* (London: Verso, 2005), 196–97.

52 Jameson, *Archaeologies of the Future*, 214.

53 Ibid., 214.

54 Mark Lombardi, 'The Recent Drawings: An Overview,' http://www
.cabinetmagazine.org/issues/2/lombardi.php, accessed 15 October 2008.

55 Gerald Raunig, *Art and Revolution: Transversal Activism in the Long Twentieth Century*, trans. Aileen Derieg (Los Angeles: Semiotext(e): 2007), 56.

56 Dario Azzellini and Oliver Ressler, *Now-Time Venezuela: Media along the Path of the Bolivarian Process* (Berkeley: BAM/PFA, 2006), n.p.

57 My familiarity with this work is not simply academic: Sabine Bitter, Helmut Weber, and I work collaboratively as Urban Subjects.

58 Raunig, *Art and Revolution*, 65.

59 In *The New Spirit of Capitalism*, trans. Gregory Elliott (London: Verso, 2005), Luc Boltanski and Eve Chiapello outline two forms of critique that are in a dialectical relationship with capitalism: artistic critique and social critique. Artistic critique follows the alienation of everyday life, authenticity, and the limitations of the possibilities of life within capitalism, while social critique is grounded in ideas of justice and equity. I'm suggesting that a third category of critique exists or is formed in the overlap of these two – activist critique.

4 Transnational Culture: An Interview with Graham Huggan

SAM KNOWLES

SAM KNOWLES: In your work on the commodification of 'other' cultures in a globalized, capital-ized marketplace, *The Postcolonial Exotic*, you start by emphasizing the aesthetic dimensions of postcoloniality, through what you describe as the 'global commodification of cultural difference.'[1] To what extent do you see this interpretation of a cultural, aesthetic framework as imbricated in the concrete, material facts of 'postcolonial' existence?

GRAHAM KUGGAN: I've never been happy with the – for me – somewhat arbitrary distinction between ('weak') culturalist and ('strong') materialist perspectives that one finds in certain, usually Marxist-inflected, kinds of postcolonial criticism, and that reaches its apogee in, say, Benita Parry's or Neil Lazarus's work.[2] Having said that, I certainly agree with Parry that there needs to be more empirical work in the field and that there's always a danger of substituting text-based work for more direct forms of anti-colonial opposition. The word I gave for such opposition in *The Postcolonial Exotic* was 'postcolonialism,' which I initially pitted against the market mechanisms of 'postcoloniality,' though I thought I made it clear – even if the book hasn't always been read that way – that the one is bound up in the other in such a way as to complicate previous attempts to distinguish between 'oppositional' and 'complicit' postcolonialisms: yet another binary that continues to bedevil the field. While one would always expect a contested field like postcolonial studies to generate internal disputes of this kind, they sometimes play into the hands of those people who are apt to dismiss the field altogether, or, more common these days, to see the postcolonial paradigm as having been superseded by other, often 'globalist'

paradigms without recognizing that the 'postcolonial' and the 'global' also go together, and that the one can't simply be seen as an alternative to, still less as a replacement for, the other.

SK: Given that the two terms are, as you say, undoubtedly separable, where would you say the 'transnational' is – or should be – positioned?

GH: The 'postcolonial' and the 'global' are separable, yes, but they are mutually entangled, as can be seen in different ways in Simon During's, Arjun Appadurai's, and Tim Brennan's work.[3] The 'transnational' is positioned somewhere between the 'postcolonial' and the 'global' but is irreducible to either. The key point, I think, is that transnationalism is a function of the very category ('nation') it contests, a point particularly well made by Robert Dixon in his recent work on Australian literature.[4] One might say that transnationalism presupposes the nation in much the same way as postcolonialism presupposes colonialism, although their shaping prefixes are different; perhaps the more useful thing to say is that 'trans-' and 'post-' terms aren't mutually exclusive and profit most from being seen together in the context of a globalized world. What I like about the term 'transnational' is that it allows for different economies of scale, unlike the rhetorical juggernaut that is the 'global,' which also tends to mistake economic connections for cultural ones, and to make sweeping statements that it can't possibly back up.

SK: You mention Robert Dixon's writing; your own work, of course, has of late focused on postcolonial and transnational interpretations of Australian literature. I'm thinking of your latest book,[5] and your recent presentation to the 30th Anniversary Conference of the Association for the Study of Australian Literature (2008). What is it that makes Australian literature in particular a fruitful field for your study of the transnational?

GH: Australian literature has long been seen as a vehicle for the national consciousness. One result has been the critical tendency to slide between national self-examination and nationalist self-congratulation, though there are plenty of examples of Australian writers not wanting to be co-opted to the national cause. A transnational approach to Australian literature arguably counteracts this tendency while acknowledging that Australian writing, at the level of both production and consumption, has always been a transnational phenomenon. At the same time, this acknowledgment doesn't alter the distinctiveness

of the national literature or dismiss the historical importance of Australian nationalism.

SK: Especially in the context of recent debates about nationalism fuelled by Kevin Rudd's apology to the indigenous peoples?

GH: Well yes, since the apology has been seen – ironically, perhaps – as part of the project of producing a more inclusive nation, despite abundant evidence of racial discrimination (and not only against Aboriginal people, of course) being embedded within the national cause. What's interesting to me here is the tenacity with which many Australians hang on to the idea of the nation even as globalization visibly weakens the power of the Australian nation-state. While these sentiments can be found in other former settler colonies – Canada, for instance – they seem, to me at least, to be at their most powerful in Australia, although this may also be because Australia has been the focus of my recent work!

SK: Can you say a bit more about this political discourse of 'globalization in a former settler context'? What are the effects on the mechanics and aesthetics of artistic production?

GH: It's difficult to generalize about this, but if we focus on the Australian literary context, it's possible to make the argument that a few writers are doing better, while fewer still are now confirmed in a 'global celebrity' role. Thus, while there's still a tedious, media-driven debate about whether Australian literature is 'dead' or not, this debate sidesteps the more important issue of how Australian literature is more diffused than ever across different social and cultural sectors, both within Australia itself and 'offshore.'

SK: And work that moves between 'onshore' and 'offshore'? I'm thinking of the 'travelling' element in modern, 'postcolonial' literature, and the extent to which such literature capitalizes on what you've called 'exoticist perceptions of cultural difference.'

GH: Yes: one of the advantages of a transnational approach to nominally national literatures like Australia's is that it complicates reified distinctions between 'domestic' and 'foreign' perceptions of those literatures – distinctions that help keep the whole machinery of exoticist representation in place. Having said that, it's interesting to consider the extent to which self-exoticization plays a part in all so-called postcolonial literatures – for example, by anticipating and manipulating

the processes by which 'foreign' perceptions of the nation can be sold back to the nation itself.

SK: How do you see this 'self-exoticization' as complicating the binary debates to which you referred earlier, around the idea of 'postcolonialism'?

GH: The 'postcolonial exotic' can be seen either as a tautology or as a contradiction in terms, depending on perspective. Self-exoticization is effectively an awareness of both perspectives or, perhaps better, an awareness of 'cultural difference' as a global commodity that allows for the possibility of both perspectives at once. 'Transnational' is maybe a more accurate term than 'global' to describe the ways in which this commodity circulates, especially insofar as it includes the marketability of 'national culture' both within the nation and offshore. Since my examples so far seem mostly to have been Australian, here's another one. A classic case of commercial self-exoticization would be the self-stereotyping antics of the late Steve Irwin, whose 'Australianness' is no less nationalistic for being routed back to Australia through the United States. Irwin, of course, is not strictly speaking a 'postcolonial' figure, but I think there's a place for 'postcolonial' analysis of his work.

SK: You make clear through your work your belief that analysis of 'postcolonial' cultures should be restricted neither to what is perceived to be 'postcolonial,' nor to what is seen as purely 'literary,' or 'high' cultural – whether it is a consideration of Steve Irwin's U.S.-inflected Australianness, or an extended musing on the Senegalese Tintin figurine pictured on the cover of *The Postcolonial Exotic*.

GH: There are a couple of things I can say to this. The first is that I'm unhappy with the catch-all designation of 'postcolonial culture,' whether seen in 'high' or in 'popular' terms, though I suppose we could also say that it draws attention to precisely those forms of cultural commodification into which postcolonial criticism is drawn even as it makes them its business to contest. In that sense – going back to transnationalism – I think that the 'transnational' needs to be seen alongside its rough cultural equivalent, the 'transcultural,' although, as I said before, 'trans-' terms such as 'transnationalism' and 'transculturalism' are perhaps best seen in conjunction with 'post-' terms like 'postcolonialism' rather than as alternatives to them, and all such terms implicitly come equipped with a question mark that challenges

the usual meaning of the prefix they deploy ('after' for 'post'; 'across,'
or 'beyond,' for 'trans'). 'Postcolonialism,' for me at least, still has
an oppositional edge that 'transnationalism' lacks, and the use of the
one without the other seems to me to misrecognize the fundamen-
tally conflicted, as well as complexly interconnected, nature of our
contemporary globalized world. There's a sense, of course, in which
postcolonialism effectively negates its own prefix, a very obvious point
to make but one that still seems to bother anti-postcolonialists, who
tend to assume that a small, deluded band of postcolonialists – unlike
the rest of us – persist in the illusion of inhabiting a fully decolonized
world. Nothing could be further from the truth, but then that's a fun-
damental problem with all 'post-' terms, which are linked inextricably
to the 'root' words they contest. The second point I'd like to make
here is thankfully less abstract. As Chris Bongie among others has
rightly pointed out, postcolonial critics and theorists have generally
been more adept at analysing 'high' than 'popular' culture, although
the Irwin and Tintin industries are just as interesting to look at as,
say, the more high-minded, self-consciously literary work of Walcott
or Rushdie (though this last perhaps isn't a very good example inso-
far as the popular reception of Rushdie and his work has generated
an industry of its own).[6] I think the increasing attention now being
paid to popular modes of consumption – still disingenuously used to
distinguish the tasks of 'cultural' and 'literary' studies – has helped
knock more elitist versions of postcolonial textualism off their pedes-
tal, although I'd still support the centrality of literature to whatever we
might envisage as being the postcolonial cause.

SK: To return to the title of this volume – and, in some senses, my opening
question – what role do you see these various 'transcultural' examples
playing in 'the postcolonial cause,' however it might be envisaged?

GH: This isn't easily answered, since the examples I've mentioned so far
do different kinds of (trans)cultural work. However, to stick to the two
cases of Irwin and the African Tintin – quite a pairing! – I think the
former's work needs to be seen in light of the colonialist issues sur-
rounding both historical and contemporary conservation movements,
while the latter draws attention to the ideological contradictions sur-
rounding (French) African 'art colon.' It's possible in other words
to see both Irwin and Tintin within a neocolonial as well as an anti-
colonial context, and as you know from my previous work, I see that
tension between the 'neo' and the 'anti' – also apparent in, say, Mary

Louise Pratt's Ortizian definition of 'transculturation'[7] – as defining the 'postcolonial predicament' in today's globalized world.

SK: It's interesting that you mention the need to see Irwin in the light of historical conservation movements. To what extent were his undoubtedly positive conservationist efforts overshadowed by his reputation as a larger-than-life, money-making figure? To put it in more literary terms, how are activism and commercialism squared – or not – in your experience of the writing and broadcasting of 'postcolonial' literature?

GH: Nice question! I think it's possible, maybe even necessary, to argue that commercialism and activism go hand in hand in the global conservation industry, and Irwin and his work were/are a good example of this. Whatever the case, he was singularly successful in turning his global celebrity status to both national and transnational activist ends. Celebrity activism of this kind is inextricably linked, of course, to the global media industries, and it's difficult not to argue that the success of Irwin's public image, as well as his conservationist message, was largely an effect of American cable TV. Some postcolonial writers have had similar success, though hardly at the same level, and I think it needs to be understood that celebrity activism doesn't work in the same ways across different media, and that the meaning of both terms ('celebrity' and 'activism') isn't quite the same in different parts of the world. A celebrity writer, in other words, is never quite the same thing as a celebrity broadcaster, and the nature of their celebrity, which is a product of the mediated relationship with their audience, is profoundly influenced by the primary medium in which they work. Another question, of course, is the relationship between postcolonialism and activism ...

SK: ... and the way in which figures like Aung San Suu Kyi in Burma – or, to take a more participatory example (in every sense), Ken Saro-Wiwa in Nigeria – have shaped 'postcolonial' cultural output?

GH: The relationship between postcolonialism and activism is more complex than meets the eye. I would agree with Robert Young that postcolonialism is by definition a form of activism; the question then becomes, activism of what kind?[8] There are obviously more forms of activism than manning the barricades (Frantz Fanon) or doing fieldwork with disempowered South Asian peasants (Gayatri Chakravorty Spivak).[9] The word 'activism,' while it ostensibly covers the kinds of

intervention practised by academic postcolonial critics, inevitably sig-
nals a disjunction between theory and practice that is endemic to the
field.

SK: We touched on this earlier, with respect to 'postcolonialism' and
'postcoloniality,' but how do you see your own work as addressing this
disjunction?

GH: Actually, I'm not sure it *is* a disjunction, or more of an entangled
relationship whereby the oppositional or interventionist component
within postcolonialism is repeatedly compromised by its involvement
in global consumer networks. I am certainly not saying, however,
that all postcolonial writers and thinkers are inevitably 'complicit,' as
Bruce King among others seem to think (and I have to say his crudely
reductive summary of *The Postcolonial Exotic* made me very cross).[10]
The whole point about the postcolonialism/postcoloniality nexus
is that it takes us beyond binary formulations about 'resistance' and
'complicity.'

SK: It strikes me that these binary formulations lend too much emphasis
to an historicizing mode, one that insists on something you touched
on earlier: the '"post-" as "after-"' debate.

GH: Yes, that's probably true, though I would want to differentiate be-
tween the kind of contextualizing historical work without which
postcolonial studies couldn't function and the teleological emphasis
to which it's still occasionally prone. I think Anne McClintock's criti-
cisms, now over a decade old of course, are still valid to some extent,
though most present-day postcolonialists would take issue with them.[11]
Despite the – to me, correct – insistence on multiple or disaggregated
modernities, there's still a developmentalist logic in certain kinds of
postcolonial debate.

SK: Do you feel the idea of plural modernities is something specific to
postcolonialism?

GH: No, I think it probably owes more to contemporary globalization
processes than to colonial/imperial factors, though the two are ob-
viously interlinked. Postcolonialism can be seen, of course, in terms
of the continuing series of historical engagements by which global
modernity/modernities have been renegotiated in local terms. These
engagements reconfirm that the idea of modernity needs – at the very
least – to be disaggregated; it also needs to be disabused of some of the
assumptions that link it automatically to 'the West.'

SK: Could you say that these same assumptions tend to present the contemporary 'non-West' as a subject that invites postcolonialism/activism/interventionism?

GH: I'd want to separate these issues. Postcolonialism can be seen, in part, as an attempt to emphasize the importance of 'non-Western' ways of thinking and seeing, though not in such a way as to create a false binary between the 'non-West' and the 'West.' Postcolonialism is also a critique of the West, despite its largely Western provenance; included in this critique are those forms of human rights or humanitarian imperialism in which 'intervention' operates largely in Western interests – for example, see Joe Slaughter's or Rey Chow's work.[12]

SK: Is it possible to separate these two, though? Can you have the emphasis without the critique?

GH: Maybe I didn't make myself clear: what I was trying to suggest is that it's important for postcolonial studies not to reify the distinction between the 'West' and the 'non-West'; indeed, it could well be that – to borrow a phrase of Anthony Appiah's – the 'West' versus the 'non-West' is one of 'the shibboleths of the modernizers' that postcolonial critics will have to learn to do without.[13] The economically driven North–South distinction is probably more meaningful in the context of today's unevenly developed world, though not without its own complications, for example the conspicuously privileged position of many of those who claim to be speaking for the South.

SK: 'North' versus 'South' becomes just as meaningless a binary, though, if we think in purely geopolitical terms; India and China spring to mind as drawing these two terms together (as explored in Aravind Adiga's recent work, *The White Tiger*).[14]

GH: Well yes, but 'North' and 'South' aren't really geopolitical terms anyway, and those who like to use them would be the first to acknowledge this. I still think they're useful in terms of drawing attention to structural inequalities within the capitalist world system. Obviously, complications are going to set in as soon as national examples are cited – see, for example, the vast disparity of wealth in India, which is largely what Adiga's novel is about.

SK: Doesn't this suggest a way for postcolonialism to move forward, though? If we as critics can stop thinking in terms of global binaries – in whatever guise – might it not open the way for more fruitful localized discussion?

GH: I agree with you that binary thinking isn't exactly helpful in looking at either the imperial past or the colonial (globalized) present, but I would also accept the point made by Lazarus and others that the post-structuralist vocabulary that still dominates postcolonial criticism sometimes has the unintended effect of neutralizing the very struggles that made it possible in the first place, thereby obscuring the obvious fact that we continue to live in a violently conflicted world. A sophisticated analysis of anti-colonial conflict is needed in today's world as much as it has ever been – and this is at least one way of understanding the activist role of the postcolonial intellectual – but where there are sides there will be binaries, and that shouldn't be forgotten, either.

SK: Yes, in the context of anti-colonial conflict, binaries are undoubtedly helpful. What happens, though, when further binaries emerge within a multifaceted postcolonial structure? To take one example, how do you, as a postcolonial critic, see the current Palestinian/Israeli conflict in Gaza, a postcolonial humanitarian crisis to which many Western powers are reluctant to respond?

GH: The current Israel/Palestine conflict is an excellent example of what I'm talking about, requiring as you say many different levels of analysis. It's a national struggle that obviously takes place within, and is to some extent driven by, a larger transnational context; and a territorial one that's caught up in a larger, deterritorialized war. Derek Gregory's work – for example, *The Colonial Present* – is particularly useful in showing how postcolonial analysis can be used to tease out both the local and the global complexities of the conflict without necessarily 'relativizing away' the considerable injustices involved for those whose lives and livelihoods are at stake.[15] Your phrase 'postcolonial humanitarian crisis' draws attention to another aspect of the struggle, a struggle that also has to do with the colonial/postcolonial contradictions inscribed within such politically loaded terms as 'humanitarianism' itself.

SK: So postcolonial analysis can contribute towards the negotiation between national and transnational perspectives that an understanding of such conflict requires?

GH: Yes, it can; in fact, it must, since – as I've been arguing throughout this interview – postcolonial criticism effectively bridges between national and transnational perspectives, not least in the context of the contemporary globalized world.

NOTES

1 Graham Huggan, *The Postcolonial Exotic: Marketing the Margins* (London and New York: Routledge, 2001).

2 Benita Parry, *Postcolonial Studies: A Materialist Critique* (London: Routledge, 2004); Neil Lazarus, 'Introducing Postcolonial Studies,' in *The Cambridge Companion to Postcolonial Literary Studies*, ed. Neil Lazarus (Cambridge: Cambridge University Press, 2004), 1–18.

3 Simon During, 'Postmodernism or Postcolonialism?,' *Landfall* 39 (1985): 366–80; Arjun Appadurai, 'The Production of Locality,' in *Counterworks: Managing the Diversity of Knowledge*, ed. Richard Fardon (London and New York: Routledge, 1995), 208–28; Timothy Brennan, *At Home in the World* (Cambridge, MA: Harvard University Press, 1997).

4 Robert Dixon, *Prosthetic Gods: Travel, Representation, and Colonial Governance* (St Lucia: University of Queensland Press, 2001).

5 Graham Huggan, *Australian Literature: Postcolonialism, Racism, Transnationalism* (New York: Oxford University Press, 2007).

6 Chris Bongie, 'Exiles on Main Stream: Valuing the Popularity of Postcolonial Literature,' *Postmodern Culture* 14, no. 1 (2003): n.p.

7 See Mary Louise Pratt, *Imperial Eyes: Travel Writing and Transculturation* (London and New York: Routledge, 1992), esp. Introduction, 6.

8 See Robert Young, *White Mythologies: Writing History and the West*, 2nd ed. (Abingdon and New York: Routledge, 2004), esp. 27–31.

9 See, for example, Frantz Fanon, *The Wretched of the Earth*, trans. Constance Farrington (New York: Grove, 1963); and Stephen Morton, *Gayatri Chakravorty Spivak* (London and New York: Routledge, 2002).

10 Bruce King's comments on *The Postcolonial Exotic* can be found in his review of Luke Strongman's 2002 work 'The Booker Prize and the Legacy of Empire,' published in *Research in African Literatures* 34 (2003): 213–15.

11 Anne McClintock, *Imperial Leather: Race, Gender, and Sexuality in the Colonial Contest* (London: Routledge, 1995).

12 Joseph Slaughter, *Human Rights, Inc.: The World Novel, Narrative Form, and International Law* (New York: Fordham University Press, 2007); Rey Chow, *Writing Diaspora: Tactics of Intervention in Contemporary Cultural Studies* (Bloomington: Indiana University Press, 1993).

13 Anthony Appiah, 'Is the Post- in Postmodernism the Post- in Postcolonial?,' *Critical Inquiry* 17 (1991): 354.

14 Aravind Adiga, *The White Tiger* (London: Atlantic, 2008).

15 Derek Gregory, *The Colonial Present* (Malden, Oxford, and Victoria: Blackwell, 2004). See also Gregory's other work on colonial history and contemporary geography, for example, 'Colonial Nostalgia and Cultures of Travel:

Spaces of Constructed Visibility in Egypt,' in *Consuming Tradition, Manufacturing Heritage: Global Norms and Urban Forms in the Age of Tourism*, ed. Nezar Alsayyad (London and New York: Routledge, 2001), 111–51; and 'Vanishing Points: Law, Violence, and Exception in the Global War Prison,' in *Terror and the Postcolonial: A Concise Companion*, ed. Elleke Boehmer and Stephen Morton (Malden, Oxford, and Chichester: Wiley-Blackwell, 2010), 55–98.

5 The Translegality of Digital Nonspace: Digital Counter-Power and Its Representation

NICK MORWOOD

Introduction

The transnational is a useful analytic term for assessing the continued rapid advancement of computer technology, and specifically the Internet, because it maintains that conceptions of the nation remain important for understanding even the most global of entities or events. Ulrich Beck echoes Louisa Schein's aim of 'imagining nation-state and transnational as interlocked, enmeshed, mutually constituting,'[1] a methodology that emphasizes the continued role of the national in even conceiving of that which is beyond or in addition to its borders. Put another way, if the nation-state has a limit-concept, the transnational is not it. Rather, each concept informs and crosses into the others in a relationship that is well served by the emphasis on the *trans* in transnational.

This chapter is concerned with assessing the spaces of public digital networks through the lens of the transnational. In particular, I will consider the extent to which this space offers opportunity for action against the established order, especially from a legal perspective. I will argue that, despite significant problems with overly utopic conceptions of the technological world, we may find spaces of counter-dominant power on the Internet, but only in very specific instances. I will examine a particular example, the Internet entity 'WikiLeaks,' which offers a relatively safe even though public destination for suppressed documents of public interest. I contend that the wider significance of entities such as 'WikiLeaks' is not limited by their impermanent nature. Rather, such bodies are situated in transnational and translegal space, where the force of law and – it follows – the power of state sovereignty are both temporarily disrupted by a zone of juridical vacuum or *anomie*. In a move towards

the importance of finding innovative ways to represent these complex ideas, I link this argument to the novels of William Gibson in attending to the depiction of this kind of non-space. In drawing out the figurative similarities between the virtual havens and the physical refuges that his counter-cultural, disenfranchised characters inhabit, Gibson provides recognizable spatial equivalents of the abstracted digital spaces in which his anti-heroes oppose the established order. In this way, I argue that Gibson's representative experimentation makes the power of projects such as WikiLeaks seem much more translatable to the non-digital world, and thus that artistic illustration of the theory and practice of transnational technology is crucial in opening up the possibilities of both digital and physical space for counter-dominant power.

Activism Reloaded: The Importance of Qualification

While calls for anti-establishment action can be highly seductive to those of us concerned with the transnational, particularly in the digital world, where change is so ubiquitous as to promise real opportunity for such acts, activism itself has become a distinctly loaded term in its association with counter-dominant struggle around the world. Nevertheless, it must be emphasized that, referring to the *OED* at least, *activism* has no intrinsic rebellious content, despite the history of that term's involvement with the American civil rights movement and the suffragettes, among many others. In other words, 'activism' does not automatically signify a challenge to established power and institutions. Rather, activism refers to the advocacy of action, and while we have images of anti-globalization protesters in our minds, Naomi Klein might argue that the Chicago School of Economics has itself been very successful at producing activists for free market economics.[2] So, in the same way that we might do well to qualify activism via its area of interest – such as political activism or social activism – we should also note that the activist's affiliation is not contained within the term. That is to say, claiming that Naomi Klein is an activist is distinctly more vague than saying she is an anti-globalization activist.

What activists of all affiliations *do* require is the capability to act – or, more simply, power. Since advocating action is itself very much an act, the activist has a doubly intimate relationship with power, in that she both requires it and encourages others to make use of it. Of course, power is equally unaffiliated, employed by nation-state and revolutionary alike. This in turn produces problems when it comes to uncovering alternatives to interpretations of the world governed by the established

order. I use 'the established order' here in the sense that Spinoza uses it, of 'rules governing the nature of every individual thing.'[3] This term is a useful shorthand for the written and unwritten laws that often determine the nature and order of politics, economics, culture, and so on; in addition, further than Spinoza's focus on individual being, it provides a reference point for gesturing towards the dominant and vested interests in national and transnational space. Returning, then, to the non-affiliation of activism and power, the most salient issue here is that it can be misleading to propose activist or empowering readings of the transnational, without advancing language more aligned with countering the action and power of the established order.

This is precisely the problem addressed by Michael Hardt and Antonio Negri with their formulation of 'counterpower.' In their essay 'Globalization and Democracy,' Hardt and Negri assert that the unrealized nature of democracy has resulted in a *caesura* between the idea of the democratic project and its instantiation.[4] Government by the people has not approached sovereignty, or supreme rule, by the people; the latter remains very firmly in the hands of the politically and economically powerful. Therefore, for Hardt and Negri, the anti-establishment activist must qualify her democracy, and in 'Globalization and Democracy' this takes the form of revolutionary democracy or (from Marx and Spinoza) democracy of the multitude.[5] Of more interest for this chapter is the concurrent reformulation of 'power' here into 'counterpower,' for counterpower signifies capability and action that is more explicitly tied to a counter-dominant discourse.

Counterpower in Hardt and Negri's work consists of three specific and mutually supportive elements: resistance, insurrection, and constituent power.[6] Resistance, used here as opposition to ruling power, prepares the ground for the more targeted nature of insurrection, which is 'a collective gesture of revolt' whose ultimate aim is to realize the power to invent or constitute a new social and political fabric.[7] This final element engages explicitly with theories about the difference between constituent (sometimes and hereafter 'constituting') and constituted power. Briefly, *constituted* power is power already created and in place, such as a parliament, whereas *constituting* power is the power to create such situations in the first place, such as the power wielded by the sovereign. Constituting power is thus highly potent and – for Hardt and Negri at least – is therefore a crucial element of power that may be used to counter the dominant force of the established order. Counterpower, therefore, is a useful way of signifying the potential for counter-domi-

nant activism that is latent in the competition for power in transnational digital spaces.

That art has an important role in this relationship between power and digital space is an idea that is open to some question, particularly given the unmediated quality of the Internet experience. Where once there was *Encyclopedia Britannica*, there is now Wikipedia; where once there was *The Cambridge Companion to Shakespeare*, there is now SparkNotes; and where once there was the *Oxford Atlas of the World* bowing bookshelves across the globe, there is now the simultaneously sparse and intrusive Google Maps (with Street View). The point here is not that we are somehow staring down the barrel of a digitally lobotomized future just because Google now outranks the *OED*, but more that the process of finding out about the world, which once involved numerous reference, critical, and survey books, now requires little more than a computer and an Internet connection. In turn, I can understand why a novel about digital counterculture might seem frivolous in the face of directly lived experience.

The reason why texts like William Gibson's classic cyberpunk novel *Neuromancer* are so relevant to this kind of subject matter – and one of the many reasons why his books continue to be so popular (especially at universities) – is that they give the lie to this easy sense of what is sometimes called 'net neutrality': a techno-utopia where all information, and therefore all information seekers, are treated equally. Gibson has been concerned since the 1980s with how what he calls the 'nonspace' of the digital world is as much subject to the vicissitudes of power, commerce, and violence of human affairs as the offline world; his works have thus continued to maintain the necessity for both counter-cultural representations of nonspace and depictions of what resistance and insurrection against the established order might look like in the world beyond the visible. Gibson has created what I like to call a phenomenology of digital space,[8] one that bridges the perceived gap between online and offline worlds. Thus, his novels are key conceptual meditations on the enduring human capacity for action in both. The worlds of the Internet and digital networking notoriously change faster than almost anyone can keep up with. Since I wrote this chapter in 2008, for example, the hitherto anonymous façade of WikiLeaks has changed, at least on the surface, with the emergence of Julian Assange as the figurehead of the project, and its media profile has increased exponentially with the release of the Iraq war files. I argue that novels like *Neuromancer* and the Bridge trilogy account for that change by focusing instead on human experience of nonspace, making them a crucial counterpoint to consideration of the

transnational action of inevitably shorter-lived entities like the WikiLeaks project. In other words, while I cannot be sure that WikiLeaks will even exist by the time you read this chapter, Gibson's concept of 'the Matrix' is already enshrined in all our imaginations.

WikiLeaks and Counterpower

Events in the loosely connected jumble of publicly accessible digital networks that we call the Internet continue to fascinate many of us who are concerned with ideas of the global, the cosmopolitan, and the transnational. Any sphere that combines two of the fastest-growing phenomena in much of the world – those of communication infrastructure and computing – is bound to churn out new political material faster than we can keep up with. Indeed, of late the Internet has begun to resemble a juridico-political battleground. E-mail 'Phishing' fraud, where recipients are encouraged to hand over bank details to the fraudster, most often in another country, after the promise of unfeasibly large monetary gain, has been highly successful. Our nation-state system, with its multiple data protection laws, conceptions of civil liability and criminal culpability, and standards and conceptions of proof, has made 'copyright violation' across international peer-to-peer networks very difficult to prosecute, outside the confines of the United States. Furthermore, the very notion of copyright, as well as the system that administers it, has come under intense scrutiny, with some high-profile musicians (as well as myriad less successful ones) concluding that they are better off without institutions like the Recording Industry Association of America (RIAA).[9] Indeed, Prasad Bidaye's chapter in this book addresses just this type of anti-industry production, in considering the importance of the Detroit-based collective Underground Resistance.

What both links and enables these kinds of events, celebrated by some as blows against the established order, is the massively distributed nature of the Internet. Although there is, to a certain extent, centralized administration (particularly of the communication protocols that facilitate navigating the networks), there is limited central control at the moment, due to the extreme difficulty of policing the path of information in large networks or even of monitoring the kind of information being sent.

All Internet communication happens in 'packets' of information, which are routed through a bewildering array of communications hardware. Until those packets are resolved and decrypted at the end of their journey, they appear to the outside world as pretty much the same, whether they contain a call to arms against an oppressive government

or a request for a Google search engine (this equality of information is changing with the advent of less resource-hungry deep-packet scanning technology, but this can be countered to an extent with stronger encryption). In short, there seem to be compelling reasons why the wars on piracy and Internet fraud have been such striking failures and why distributed projects like Wikipedia have been so successful. The Internet has always linked many more people together than even the largest law enforcement agency or book publisher may do, which means that institutions of state and capital often appear to be playing catch-up to the interconnected talents of the world's online communities. For some activists, this is a seductive interpretation of digital space, as evinced by the central role played by websites in organizing anti-globalization movements. New projects like WikiLeaks seem to hold still more promise for using this kind of transnational space for political action against the established order. Events like Phishing and WikiLeaks seem almost to inhabit the zones signified by the *trans* in transnational; at the same time, it is the continued prevalence of the nation-state form that offers the possibility of that movement, that transfer between spaces.

WikiLeaks, which went live in December 2006, claims to facilitate the anonymous publication of hitherto suppressed documents of interest. Its connection to other 'Wikis' such as Wikipedia is merely that it uses similar 'Wiki' software. Found at http://www.wikileaks.org, and at several other back-up domain names, mirrors, and IP addresses, the project claims to have robust systems in place for protecting the anonymity of those who choose to send information to them, whether by e-mail or by post. Precautions at various levels are recommended, depending on how much a subject finds herself a 'person of interest' to powers wishing to suppress that information; such precautions include sending documents from an unsurveilled public Internet terminal, using an anonymous e-mail address, and sending with high levels of encryption. While less well-organized (and less well-funded and hyped) Web projects aiming to distribute sensitive information have existed almost as long as the Internet – Cryptome being one of the older and more controversial examples[10] – the level of legitimacy that WikiLeaks has garnered in a short space of time has surprised many and is worth examining.

WikiLeaks gained a certain amount of legitimacy for two key reasons. The first was that major news organizations started to publish articles based on information first overturned by WikiLeaks. The second was that hitherto deniable documents on the site were proven to be at least partly genuine when the alleged suppressors of the information took

legal steps to have the material removed from the public domain. These two factors are linked by a common thread that itself demonstrates the different kind of discursive power harnessed by a project like WikiLeaks. Although much of the information published on the site, due to its unverifiable sources, would not be permissible in a peer-reviewed journal or edited broadsheet or in most courts of law, once posted online that information seemed to acquire sufficient subversive power that broadsheets wished to work with it and vested interests wanted to suppress it. That is to say, with sensitive information there is quite often a gap between what a journalist knows and what can be said legally, as British news organizations found to their farcical cost over the ex–secret agent Peter Wright's book *Spycatcher*.[11] WikiLeaks creates a bridge across that gap, a bridge both enabled and protected by its home in what I will focus on later as zones of '*anomie*' or 'juridical vacuum.'

The transnational counterpower of the Wikileaks project – and of massive networking in general – was thrown into sharp relief on 31 August 2007. Xan Rice of the British-based broadsheet *The Guardian* published a shattering article on corruption in Kenya under ex-President Daniel Arap Moi titled 'The Looting of Kenya.' In it, Rice claimed that Moi, his family, and his associates had siphoned the equivalent of more than £1 billion of public money out of the country for personal use over his twenty-four-year reign.[12] Laundered money and assets were allegedly stashed in more than thirty countries, including Australia, Belgium, Brunei, Canada, Finland, Germany, Grand Cayman, Israel, Italy, Japan, Liechtenstein, Liberia, Luxembourg, Malawi, Namibia, the Netherlands, Puerto Rico, Russia, Somalia, South Africa, Sudan, Switzerland, the UAE, Uganda, the United Kingdom (including the Isle of Jersey), the United States, and Zaire. The report by international risk consultancy Kroll & Associates, 'seen by the Guardian,' was originally obtained and published by WikiLeaks on 29 August 2007.[13]

According to *The Guardian*, the 110-page Kroll document had been commissioned by President Mwai Kibaki in 2003, after he succeeded Moi. (Kibaki had run on an anti-corruption platform.) The new Kenyan government had received the Kroll report in April 2004 but had elected not to release it. Spokesman Alfred Mutua claimed to the newspaper that this was because 'it was based on a lot of hearsay' and was not credible.[14] Having read the document, I would argue that it resembles a painstaking forensic investigation more than it does hearsay and that the Kibaki government's involvement in what the African press has dubbed the 'Anglo-Leasing' corruption scandal shortly after Kibaki came to power

had rather more to do with the report's suppression.[15] Sadly, events since August 2007 tell their own story of the Kibaki government's credibility.

Since whoever in Kenya released the report in the first place remains anonymous, we have no way of discovering what motivated the leak. Leaking is itself a political action rather than a disinterested function, so we must be wary of ascribing too much counterpower to such individual cases. As we will see later, total transparency in the digital world can result in the imprisonment of citizens rather than the freedom of ideas, but it can also serve the purpose of clarifying the various interests involved in actions such as the release of sensitive documents. Nevertheless, there appears to be a fairly clear historical narrative here, one that ends with the conclusion that, without a space providing legal anonymity for both the document and the source, the Kroll report would not be in the public domain today.

Addressing Space beyond the Visible

Dr Craig Venter's 2007 lecture 'A DNA-Driven World' is particularly striking for its attention to the importance of understanding different spaces located in or beyond visible space. Venter argues that 'to begin the process of change we need to start with our children by teaching them in place of memorization, to explore, challenge, and problem solve in an attempt to understand the world around them, and most especially the world they cannot "see" or feel directly.'[16] In his lecture, Venter links scientific problem solving and invention, such as his own expertise in DNA, with abstracted understanding of non-visible space: spaces revealed through electron microscopes, mathematics, and so on. I argue that active participation in digital space and, more widely, in spaces of juridical vacuum, by individuals and communities interested in counterpower, requires an equally nuanced understanding of that space. Just as mathematics, for Venter, provides a language for the world of the electron microscope, so representative languages in literature provide ways of conceiving of and acting in non-visible space. I argue that, despite his reputation as a technological prophet, William Gibson's novels show very much that spaces for counterpower are not limited to technology, and that reconceiving of spaces both new and old, using ideas counter to those of the established order, is effective at constituting these areas in new, counter-dominant ways.

Consider Gibson's description of a virtual representation of a massively parallel digital network ('the matrix') in his debut novel *Neuromancer*,

published in 1984, almost a full decade before public Internet became a reality: 'Cyberspace ... A graphic representation of data abstracted from the banks of every computer in the human system. Unthinkable complexity. Lines of light ranged in the nonspace of the mind, clusters and constellations of data. Like city lights, receding.'[17]

Rather than focus on computers, I would like to draw attention to the image of the 'nonspace,' space that both is and is not real, for the strength of Gibson's work lies often in the way in which he links virtual spaces with real ones. By providing recognizable spatial equivalents of the more abstracted spaces in which his anti-heroes oppose the established order, Gibson makes the counterpower of projects like WikiLeaks seem much more translatable to the non-digital world, particularly in the face of the potential impermanency of something like WikiLeaks, which, while significant, is inevitably only part of one of the fastest-changing discursive spaces in existence. Gibson's phenomenological approach to space beyond the visible is, I argue, the kind of intervention that Craig Venter is calling for because it is both illuminating, in the sense that it emphasizes the possibility of making sense of unfamiliar or unrecognizable space in communicable terms, and also sustainable, in the sense that it does not completely rely on the particular nature of the space being represented. This is important because, as I will come to later in this chapter, Gibson in his novels takes care to emphasize the extensiveness and persistence by which digital nonspace can be colonized by the established order – a warning that is highly relevant to our discussions of WikiLeaks. For me, rather than showing the limitless potential of digital nonspace for counterpower, WikiLeaks is somewhat more like Gibson's cyberpunk hero 'Case' in *Neuromancer:* an entity more outside the law than in, and hardly representative of its more illustrious digital brethren – the exception to action in the realm of the Internet, perhaps, rather than the rule.

Digital Space: As Compromised as the Physical World

The rather idealistic interpretation of WikiLeaks that I have already outlined, of the Internet being ideally suited to righting wrongs perpetrated against disenfranchised communities and peoples, is the kind of narrative often invoked when the possibilities of digital technology for action, both national and transnational, are being considered. Of course, despite my Gibsonian pessimism, analysis that highlights the potential of massive networks for activism against the established order is certainly

not without merit. Nevertheless, there is a frequent association in this discourse between networking technology and political freedom, one that is not only generalized but often all too inaccurate. Diane Morgan's 2007 introduction to *Cosmopolitics and the Emergence of a Future* is worth quoting at length for its conflation – echoed by many others – of inter-connectedness and political and personal freedom:

> Indeed, technology plays a central role in Kant's cosmopolitical utopia: it is a constitutive part of the production of the human, with and against the grain of nature.
>
> For instance, in *Answer to the Question: What Is Enlightenment* (1784), the technology of the printing press, the postal service and long-distance travel (or, to use a contemporary example, the interactivity of the Internet) all help to construct the public sphere of the 'world of scholars' wherein the 'private self,' otherwise a 'mere cog in a machine' obediently carrying out orders in the workplace, is converted into a different sort of animal. By assessing and contributing to the cosmopolitan world of global informa-tion and ideas, the 'public' self can express itself and act more freely, by exploring the extension of the (personal and inter-subjective) self through telecommunications.[18]

Some crucial factors have been left out of this reading of technologi-cal interactivity, most importantly that interactivity is at least two-way. Like activism and power, interactivity is a neutral concept, not one that naturally aligns itself with freedom. The self is not the only actor extend-ing her reach in such a network, for the telecommunications apparatus reaches out to touch the subject in just as powerful a way. As we shall see, this relationship between user and network is far from a facilitation of a public sphere that naturally encourages free action. Indeed, there is a mantra among the tech 'enthusiast' community that warns not to do anything on your Internet connection that you would not be happy run-ning out into the street and shouting about, because without extensive precautions, that is effectively what you do every time you access any-thing. As the AOL leak of search details of hundreds of thousands of its subscribers showed all too clearly, there is a great deal that your chosen search engine – never mind your service provider – can infer about your life.[19] On a less paranoid note, the variety of events and struggles on the Internet, which I gesture towards in this chapter – in some ways dem-onstrate nothing more than the Internet's emergence from the equally complex and multiple offline world. As a recent *Globe and Mail* article

demonstrated, speech and action on digital space owned or controlled by large corporations is just as likely to be muzzled or repressed as it is offline.[20]

Saskia Sassen identifies this discord between real and imagined use of digital networks in what she calls the polarization between utopic and dystopic approaches to the Internet.[21] For her, both these approaches lack the nuance required for assessing what is an overwhelmingly complex set of phenomena. However, even Sassen, in an echo of Morgan's orientation, advances the possibilities of transnational interconnectedness for political freedom,[22] and while I agree with this prospect when put into action in specific instances, it is the celebration of 'possibility' that I find most troubling.

Case studies of digital interconnectedness often verge on pastiche, even mockery, of such possibilities. Not many people missed the participation of Google, whose corporate mission statement is 'to organize the world's information and make it universally accessible and useful,'[23] in Chinese censorship of the Internet, but Google's competitor Yahoo got there first. Yahoo's Hong Kong office played its part in the prison conviction of prominent Chinese journalist Shi Tao in 2005, after he sent details on the planned censorship of demonstrations, on the anniversary of the Tiananmen Square massacre of 1989, using his private Yahoo e-mail account. The Chinese government monitored the e-mail and demanded that Yahoo release the sender's personal information to it, which Yahoo did. Shi Tao was sentenced to ten years in jail.[24]

Elsewhere, in the United States, the RIAA (Recording Industry Association of America) is mounting a shamelessly aggressive fighting retreat, prosecuting a conviction of one single mother in October 2007 to the sum of $222,000. Jammie Thomas was fined $9,250 per song for apparently 'making available' twenty-four tracks that others had the opportunity to download.[25] Despite the vast technical intricacy of the arguments on both sides of the case, it emerged after Thomas's conviction that one of the members of the jury had never used the Internet.[26]

Attacks on 'fair use' provisions in copyright law are under way in Canada, with a proposed overhaul to the 1997 Copyright Act that would radically curtail the use to which a legally purchased piece of copyrighted material may be used.[27] Internationally, the July 2008 meeting of the G8 nations had several key items on its agenda, including 'World Economy,' 'Environment and Climate Change,' 'Development and Africa,' 'Nuclear Non-Proliferation' (i.e., further sanctions on Iran), and the development of an 'Anti-Counterfeiting Trade Agreement' (ACTA).[28] The last

of these proposes, among other things, that all participating countries be authorized to conduct *ex parte* searches of private property in pursuit of some 'offences' that, as I write this, appear to be protected under 'fair use.' I refer specifically to the proposed criminalization of the 'circumvention' of digital rights management software, or DRM – an act that you can perform as you read this by transferring almost any song purchased from iTunes onto an audio CD.[29]

There Is No Law without Enforcement

The wider relevance of these case studies lies in the frequency with which the law becomes involved in the world of massive networking. The extent to which these cases are circumscribed by questions of legality is significant, particularly since analyses such as Sassen's pay much less attention to the impact of transnational technology on the juridical than they do to its effect on politics and democracy. An easy response here might be to assert that it is appropriate for the law to become involved when crime is suspected, online as much as offline. However, there is significant disagreement regarding the legality of state actions in all the examples I have listed above, from Google's censorship onward. For example, given that no one had even been arrested for file sharing in the United Kingdom until June 2008,[30] and that no conviction has of yet been forthcoming, it is difficult to imagine Jammie Thomas being handed a six-figure fine in many countries outside the United States. Indeed, Canada's proposed copyright amendment and the G8's ACTA proposal are both representative of an increasing number of cases that resemble desperate efforts by states and businesses to criminalize hitherto legal actions for the purposes of augmenting profit.

The significance of the law for our understanding of massive networking is substantial, but just as important is the idea of the juridical order. The distinction here is fine but potent. For Giorgio Agamben, the juridical order 'carries the sense of law in the abstract, or the entire sphere of law,' while the law 'refers to the specific body of rules that a community or state considers binding.'[31] In this context, the transnationality of the Internet has important juridical ramifications. The *aporia* in, say, Yahoo's legal obligation to protect Shi Tao's private data, is not only the applicability of state (individual and multiple) regulation, but the very possibility of the enforcement of those laws. Yahoo is a private company registered in the United States and thus is bound to a certain extent by U.S. law on the protection of the privacy of its users (to the extent that

Yahoo faced scrutiny by a congressional panel over the case), as well as to Chinese law relating to dissident activity by citizens and companies on its territory. The applicability of the laws in this instance, however – at least as far as Shi Tao's fate was concerned – proved to be largely irrelevant. The Chinese juridical order was merely in a better position to enforce these aspects of its laws than the United States was. Here we see the gravity of Derrida's maxim that there is no law without enforcement,[32] and here as well we observe that understanding what Beck calls 'the translegal'[33] in technology must consider the wider sphere of action that produces legal or extralegal effects. For both Agamben and Derrida, this is the domain of juridical enforcement and, more simply, force.[34]

If the space of the Internet offers anything beyond the 'possibility' of counterpower or activism, I argue that it lies in the zones of what Agamben calls, in a different context, *anomie* or juridical vacuum.[35] *Anomie* comes from '*a*' and '*nomos*,' Greek for 'without' and 'law.' This is more nuanced than an absence of law, for Agamben's work explicitly follows Derrida's 'Force of Law' in underscoring the importance of the juridical order as a whole to conceiving of law, for *anomie* is emptiness of enforcement and force of law just as much as it is of the letter of the law. In other words, it is a mix of lack of law and lack of legal force (the police, the army, the courtroom, and so on) that produces *anomie*. Neither is *anomie* a situation where the juridical is irrelevant, for the combination of 'without' and 'law' maintains a relationship to the juridical somewhat like the relationship of transnational to the nation. That is to say, *anomie* maintains the notion of the juridical by making its absence explicit: it is very much a juridical phenomenon. Agamben argues that state power desires to annex *anomie*, to gain sovereignty over it, because it enables state violence without juridical regulation.[36] I argue that counterpower, too, needs to make use of *anomic* space for its resistant, insurrectionary, and constituting purposes.

Whether or not the case studies mentioned in this chapter resemble rebellious or suppressive political acts, what links them is that they represent at least a small battle won in the translegal war over sovereignty of digital space. Sassen, in explaining the role that private financial networks have played in emptying out some of the power of state sovereignty (as in the power of massed financial speculators over central banks), is typically astute in implying a less than absolute connection between ideas of sovereignty and the state – that sovereignty is to a degree open to other forces: 'The rapid proliferation of digital networks and the growing digitization of a broad array of economic activities have

raised a number of questions about the state's capacity to regulate this domain and about the latter's potential for undermining sovereignty.'[37] Just as important, Sassen's words reveal the interreliance between sovereignty and juridical regulation – a useful definition of sovereignty being, of course, supreme *rule* (my emphasis) – couching simultaneously the notions of dominating power and juridical authority. Agamben goes to some lengths to demonstrate the connection between sovereign power and control over zones of *anomie* or juridical emptiness.[38] When that control reaches its limit, or is disrupted, by a failure of enforcement, in *anomie* there may, momentarily, be a space for counterpower.

As we have seen, for Hardt and Negri, 'the concept of counterpower consists primarily of three elements: resistance, insurrection, and constituent power,'[39] factors that link together to oppose domineering power from above (the established order) with a rebellious power from below (the less enfranchised, politically, economically, legally, socially, and so on). I argue that, despite the problems and complexities we have already discussed, we may find spaces of counterpower on the Internet, but only in very specific instances where the force of law and, thus, the power of state sovereignty are both temporarily disrupted by a zone of *anomie*. Indeed, I move later to show that, in the light of Ulrich Beck's claim that 'life under conditions of transnational anomie could become a source of social capital and transnational publicity,'[40] the reconception of *anomic* space in the novels of writers like William Gibson holds possibility for counterpower beyond these rarified cases of technological rebellion.

Wikileaks as Counterpower without Law

During its short life, the entity 'WikiLeaks'[41] seems to have amply met Hardt and Negri's three conditions of counterpower. Opposition to established authority and governmental restraint could almost be its *modus operandi;* and constituting power, or the power to create major changes in the political landscape, has certainly been its consequence. Most important, it owes its capacity for action to adroit use of the *anomie* that characterizes the law's interaction with the more transnational aspects of the Internet.

The essential function of technologically *anomic* space in enabling the action of entities like WikiLeaks became clear during the same case that both cemented the project's reputation as a legitimately political symbol of insurrection and resistance, and also encapsulated the translegal nature of the battle for sovereignty of the Internet. On 6 February 2008,

Swiss-based Julius Baer Bank and Trust filed a complaint against Wiki-
Leaks in a U.S. District Court in California, claiming that it had com-
mitted 'the unlawful and wrongful publication of confidential, as well as
forged, bank documents belonging to Plaintiffs on the website Wikileaks.
org.'[42] There are hundreds of these documents, most of them pertaining
to alleged tax evasion and money laundering.

What should be noted here is the distinctly bewildered language used
to describe the defendants in the Julius Baer suit. The plaintiffs filed
against '**WIKILEAKS**, an entity of unknown form, **WIKILEAKS.ORG**, an
entity of unknown form; **DYNADOT, LLC**, a California limited liability
corporation.'[43] While the description of unknown entities here seems
better suited to a UFO than to a website, this very factor demonstrates
the legal conundrum presented by this kind of digital space. On 15 Feb-
ruary, Judge Jeffrey White of the U.S. District Court, in the absence of
any representative of Wikileaks who might remove the documents con-
cerned, ordered an injunction against the U.S.-based domain registrar
Dynadot LLC, instructing that the domain name wikileaks.org be dis-
abled and not be moved to another registrar and that its DNS entries be
deleted.[44]

However, there was significant confusion in the press as to what Judge
White's order actually resulted in, a level of confusion that is instructive
regarding how the technologically savvy may circumvent legal measures
that are designed to regulate a sovereign nation-state rather than to
control a transnational and translegal entity. The BBC declared 'whistle-
blower site taken offline' and that it had been 'cut off from the Inter-
net.'[45] Elizabeth Montalbano for *Computerworld* stated that Judge White
had 'shut down a controversial Web site in the US' but that 'the Wiki-
leaks.org site remains online in Belgium and Germany.'[46] Other reports,
however, got more or less closer to the truth: the WikiLeaks website was
never shut down at all and remained online throughout the month until
Judge White's dramatic U-turn on 29 February, when the wikileaks.org
domain was reinstated after wide protest. Judge White was compelled
to reverse his decision against WikiLeaks and Dynadot following *amici
curiae* (friend of court briefs) by the Electronic Frontier Foundation
and the American Civil Liberties Union (ACLU), alleging among other
things that his initial decision had infringed First Amendment rights.

According to Federal Standard 1037C, an online computer system is 'a
computer system that is a part of, or is embedded in, a larger entity, such
as a communications system, and that interacts in real or near-real time
with the entity and its users.'[47] More specifically, then, a website is consid-

ered online when it may be interacted with by users of the Internet. This was always the case for WikiLeaks during February 2008 – a demonstration of its resistance to state power and regulation. To understand how, we must take a brief and crude look at how a website comes to be 'online' and how slippery this process proves in a court of law, as well as for law enforcement.

A website consists of one or more pages of information that can be accessed by a Web browser, such as Internet Explorer. This access tends to take place through what is called the 'HTTP.' protocol. For this accessibility to be possible, the site must be connected to and locatable on the Internet. To be connected, a website must be stored on one or more computers that have relatively unrestricted access to the Internet. To be locatable, these computers must be able to provide the website with a numeric IP address (or more than one), a standardized method of providing locations for Internet space. This process of assigning an address, or 'space,' is called 'hosting.' With this accomplished, you may type the IP address into your Internet browser; generic distributed software, routers, and other servers then take care of displaying that website on your computer screen. An alphabetical domain name, such as www. wikileaks.org, is not required for a website to be online and navigable-to. For example, Google has many servers with their own IP addresses that you can enter into a browser to get the Google search engine. As I write this, one of their California addresses is 66.102.7.104. Thus, typing http://66.102.7.104 will take you to Google. This will be out of date by the time you read this, but you can find the IP of almost any website you want by using a service such as http://websiteipaddress.com: simply type your chosen site's domain name, such as www.google.com, into the former's search bar and it will 'ping' that site for you, returning its IP address(es) and location.[48]

So, a website is Internet-compatible information hosted on a computer, connected to the Internet, which is assigned an IP address. As the *New York Times* found out, WikiLeaks is hosted by the Swedish company PRQ, owned by two founders of the infamous torrent site *The Pirate Bay*. The *Times* dubbed PRQ 'the world's least lawyer-friendly hosting company.'[49] The physical location of WikiLeaks, then, was fairly secure and accessible throughout Judge White's proceedings. Despite the recent Swedish crackdown on *The Pirate Bay*, WikiLeaks continued to operate with relative impunity into 2010.

What was not secure in February 2008 was the domain name 'wikileaks.org.' Domain names are a method of making Internet navigation

easier for humans, who find alphabetic addresses easier to remember than numeric or alphanumeric ones. Simplifying, one or more domain names may be assigned to an IP address by the Domain Name System (DNS), and more than one IP address may be associated with a domain name. There is enough centralized control, via the Internet Corporation for Assigned Names and Numbers (ICANN), that it is unusual for two IP addresses with different websites associated with them to be given the same domain name, or for two domain names signifying different sites to be given the same IP address. To return to the Google example, Google's IP addresses are mostly random and act a bit like telephone numbers, assigned by a largely disinterested, automated system. However, Google has multiple domain names, such as google.com, google.ca, google.fr, and so on. These domain names are registered and managed by thirteen private companies and organizations authorized by ICANN, which has more or less financial interest in the process.

When WikiLeaks requested the 'wikileaks.org' domain name (it has many other domains registered by different DNS registrars), it was assigned to the U.S.-based company Dynadot LLC, one of the thirteen authorized DNS registrars. Thus, Dynadot was named as a co-defendant in the Julius Baer suit. While WikiLeaks was *anomic* as an 'entity of unknown form,' Dynadot was much more recognizable to the U.S. legal system as 'a California limited liability corporation' because it had offices physically located within the nation-state of the United States. When it became apparent that there was no way for the court to compel any action from WikiLeaks, due to the complete lack of an American presence of that 'entity' (or indeed, much of a presence anywhere physical), Judge White ordered Dynadot to remove all connection between the domain 'wikileaks.org' and the WikiLeaks IP addresses by deleting the domain's DNS entries and disabling the domain itself. Dynadot complied, and the domain became useless.[50] Typing 'wikileaks.org' into a browser would not yield any results, but typing a WikiLeaks IP would direct you to the site as normal, as would any of its other domains, such as the Belgian domain 'wikileaks.be.'

Although Judge White had temporary success at making it harder for some users to get to the WikiLeaks website, what the Julius Baer versus Wikileaks case revealed more than anything else was the resistance of well-designed websites to attempts at legal regulation by the nation-state and, more generally, to definition in a juridical sense at all. The transnational nature of WikiLeaks makes it profoundly translegal, in the sense that it is so multiply juridified in different ways in different nation-states

that it is effectively beyond jurisdiction. Simultaneously, jurisdiction that might be possible over one specific facet of such a site applies to only part of the mutually constitutive web of facets, which transfer information and function between one another, and most of which are located in another state or outside the state form altogether. It hardly seems necessary here to emphasize how significant the concept of the nation is, in its simultaneous involvement and inapplicability, to the well-designed Web space or entity. Nevertheless, it is necessary to do so in order to underscore how relevant a transnational and translegal theorization of massive networked space is.

In order to actually turn WikiLeaks offline, one would have to win an injunction in every country where a WikiLeaks domain was registered; otherwise, when one cut the hosting company off, the administrators, or any number of back-up affiliates, could just upload the website to a different server and reassociate it with the domains. One would then have to win an injunction in Sweden to cut PRQ off and prevent the WikiLeaks administrators from having any relationship with any other hosting company, through arrest and conviction. To perform a *reductio ad absurdum*, one would even have to locate and cut off from the Internet every person who has access to hardcopy of the website material, otherwise it could just be put up again. Even Judge White, when he removed the injunction over Dynadot at the conclusion of the hearing of the WikiLeaks case, recognized that projects like WikiLeaks constitute significant resistance to state power, that there is a 'definite disconnect perhaps between the evolution of our constitutional jurisprudence and modern technology ... And what I mean by that is we live in an age where people can do some good things and people can do some terrible things without accountability, necessarily, in a court of law.'[51]

In turn I argue that, much as the established order relies, as Agamben describes, on the principle of *necessitas legem non habet* – that is, 'necessity does not recognize any law,' or 'necessity creates its own law'[52] – so must counterpower. Agamben describes how the state uses sovereign power to achieve what it deems necessary through manipulation of the whole sphere of the juridical system. When it is convenient for it to bypass the law's immutability, the state does just that, until it becomes necessary to reinstate legal proceedings with the constitution of new law. Furthermore, the interpretation 'necessity creates its own law' is ineffably connected with Derrida's conception of force-of-law. With sufficient power or force, the state may realize a need through decreeing that 'it must be so,' thus making it so. What is interesting to me about the WikiLeaks

project is that it has used its technological counterpower to create its own effective law; it has also employed translegal *anomie*, in the transnationality of the Internet, in order to not have to recognize any one juridical system. It may seem prosaic to claim that the power to counter the established order needs to be difficult to regulate by state power, but the WikiLeaks case demonstrates how difficult it often is for political activists, on or offline, to achieve this.

It is crucial at this point to emphasize the ramifications of such projects for anti-establishment activism and counterpower, rather than attending too far to WikiLeaks's own action against the established order. There are significant problems in valorizing the WikiLeaks project, mostly to do with that entity's notable lack of transparency in sourcing, organization, vetting, editing, and funding. A more important thread may be drawn from our study than mere celebration of a limited Internet event. Specifically, an analysis of the powerful transnational and translegal space utilized by such a project reveals the symbolic and actual importance of attending to what lies beyond the visible, and of developing a language for representing such space, so that we may conceive more consistently of political action in the light of the transnational.

Towards a More Tangible Virtual Space

Fredric Jameson praises William Gibson's 1984 debut novel *Neuromancer* for its mesmerizing figuration of contemporary technology that offers a 'privileged representational shorthand for grasping a network of power and control even more difficult for our minds and imagination to grasp: the whole new decentered global network of the third stage of capital itself.'[53] Indeed, Gibson is famous as the inventor of the word 'cyberspace' and for the first sustained attempt, with 'the matrix' in that first novel, at imagining an Internet-esque virtual world. Gibson has since gained something of a reputation as a cultural and technological prophet. Yet what is fascinating about Gibson's career is in fact how *ambivalent* his representations of technology are. The history of Gibson's work tells the story of how the promise of technology as a universal tool for countering hegemonic power came to seem, quite precisely, a fiction, and how counterpower must always be moving across new interpretative space to stay resistant. In that sense, technological space is only useful by proxy.

Gibson's first and best-known book, *Neuromancer*, was published the same year as the English translation of Jean-François Lyotard's *The Postmodern Condition* and the first chapter of Fredric Jameson's *Postmodern-*

ism, or, The Cultural Logic of Late Capitalism, and even now it seems equally innovative. The subsequent two books in the trilogy riffed more extensively on representations of the matrix – a three-dimensional virtual network spanning the globe – as a countercultural sandbox: a sandbox where those subcultures disenfranchised by society in the trilogy might regain agency. Nevertheless, while the second novel, *Count Zero,*[54] celebrates both an anti-state and anti-corporate orientation forged in the fresh zones of technological action – an orientation similar to utopian visions of the Internet – by the trilogy's conclusion in 1988 with *Mona Lisa Overdrive,*[55] that new world has become a lot less inviting. Readers are confronted, for example, by the distinctly creepy prospect of a dead major character from *Neuromancer* living on, impotently, as a digital construct in the matrix, perhaps emblematic of the fading potential of that alternative construct.

By the time of the 'Bridge' trilogy, spanning 1993 to 1999,[56] Gibson's representations of the communicative ramifications of modern hardware had become more consistently ambivalent. If they wished to recapture counter-cultural potential, his anti-heroes would have to search for 'nodal points' of potential change, hidden in a landscape, both virtual and physical, now inhabited by corporations and digital celebrities that were just as at home there as our rebels. The virtual world was by now less of a sandbox and more of a dangerous zone of surveillance and data mining.

Today, Gibson has abandoned the figurative possibilities of technology almost altogether. The main character of 2003's *Pattern Recognition,*[57] Cayce Pollard, presents her high-tech media malaise quite literally, by wanting to vomit every time she is exposed to heavily advertised trademarks and logos. *Spook Country,*[58] perhaps in a nod to the prevalence of automated surveillance systems in the so-called 'war on terror,' presents a mess of overlapping networks almost entirely populated by competing intelligence agencies rather than communities of anti-heroes.

With the benefit of hindsight, we can see that Jameson was more correct than he might have first appeared in reading Gibson's representation of technology as a warning of its role in perpetuating capitalist power structures; he was also right elsewhere in *The Cultural Logic* when he wrote of *Neuromancer* that 'one is tempted to characterize it as "high-tech paranoia."'[59] Jameson made this claim in 1984, but the tagline for 2003's *Pattern Recognition* is, 'It's only called paranoia if you can't prove it.' So, sweepingly, one way of describing Gibson's twenty-year oeuvre – a way that helps explain why he's so good at producing representations of

power – is to say that it represents twenty years of novels of a particular kind of paranoia. The connection between counterpower and paranoia lies in Gibson's close affiliation with the novelist Thomas Pynchon. In *Gravity's Rainbow*, Pynchon describes 'paranoia' as the reflex of 'seeking other orders behind the visible,'[60] and by that explicit reference to his literary idol in *Pattern Recognition*'s tag, William Gibson gives voice to what I assert is a consistent project in his novels, which is, to encourage an understanding of the character of zones and spaces 'beyond the visible' that offer positions for counterpower.

The hidden virtual zone created by hackers and digital outcasts of 'The Walled City' in the trilogy *Virtual Light, Idoru,* and *All Tomorrow's Parties* is paralleled by an extrajudicial shanty town that has been built by a disenfranchised community on a disused bridge appropriated from the city. That town is what gave the series of novels its moniker 'The Bridge Trilogy.' The Walled City and The Bridge are both lands where *necessitas legem non habet*, where communities take on part of the power created or utilized by the established order.

In much the same way as Wikileaks annexes the transnational and legal zones of the Internet for its own existence, *Hak Nam* or 'The Walled City' in *Idoru* and *All Tomorrow's Parties* is a re-creation of a real historical space that originally existed in Hong Kong following, in part, Imperial conflict over that territory. It was left behind by the Chinese after they ceded Hong Kong to the British but was not formally part of Hong Kong (and thus British jurisdiction) either. It thus grew into a haven for the disenfranchised and the illegitimate, at its height containing some 35,000 residents on a 200 by 100 metre plot of land. What sounds like a shanty town looked more like an incredibly condensed version of an entire city. *Hak Nam* had been a problem for both states for a number of years, falling as it did outside the British *and* Chinese territories, for this effectively created a free zone for organized criminal gangs ('Triads') to operate from.[61]

The virtual version of *Hak Nam* in Gibson's work is a space hidden in the digital world, and takes its inspiration from the *anomic* space of the original:

And then the thing before her: building or biomass or cliff face looming there, in countless unplanned strata, nothing about it even or regular. Accreted patchwork of shallow random balconies, thousands of small windows throwing back blank silver rectangles of fog. Stretching either way to the periphery of vision, and on the high, uneven crest of that ragged façade, a

black fur of twisted pipe, antennas sagging under vine growth of cable. And past this scribbled border a sky where colors crawled like gasoline on water.

'Hak Nam,' he said, beside her.

'What is it?'

'"City of darkness." Between the walls of the world.'[62]

Gibson uses The Walled City as a potent analog for imagining the nature of radical spatial invention that is possible within motivated communities. The virtual world is filtered in Gibson's prose through a sieve of industrial metaphors and references to artificial yet beautiful substances; this emphasizes that, with the right language, the space beyond the visible may still be conjured and acted in.

'The Bridge' translates this space of counterpower into representations of our more familiar physical universe. The shanty town (again, the phrase is completely insufficient) of The Bridge, too, is built upon what was already there, a failed grand public work fallen into disuse. One character in *Virtual Light* speaks with pride of how the city's homeless and destitute one night gathered at the chain fence blocking off entry to the bridge, and, reaching a flashpoint of collective energy, swarmed over the sharp barriers, passing up carpet, clothing, and wood to enable passage over the barbed wire. The police arrived, he says, but could not risk a charge into the massed ranks of densely packed people in full view of the circling TV helicopters.[63] So instead, the city pretends that 'The Bridge' does not exist and allows it to continue because of the difficulty of evicting those who live there. The residents built tiny shacks all over the roadway, and when they ran out of space started to build up, using the bridge gantries as support and lashing points. It sounds, of course, like impossible fantasy, until we remember that the Walled City in Hong Kong was once an Imperial fort and that in the twentieth century, the disenfranchised found another use for it. Gibson's fictional play with carving out new space in the ruins of areas made by the established order encourages a lack of acceptance of that order's idea of the proper use of space, with one description of The Bridge disavowing the purpose of the entire modern project of great works:

As ever, it stirred his heart to see it there, morning light aslant through all the intricacy of its secondary construction.

The integrity of its span was rigorous as the modern program itself, yet around this had grown another reality, intent upon its own agenda. This had occurred piecemeal, to no set plan, employing every imaginable technique

and material. The result was something amorphous, startlingly organic. At night, illuminated by Christmas bulbs, by recycled neon, by torchlight, it possessed a queer medieval energy. By day, seen from a distance, it reminded him of the ruin of England's Brighton Pier, as though viewed through some cracked kaleidoscope of vernacular style.[64]

Here, the original modern project has disappeared beneath its new inhabitants' 'secondary construction,' a potent analog for the way in which constituting power, both repressive and activist, often builds on what has gone before. Indeed, for Gibson, the city's concern with building grand projects, rather than housing the less fortunate, has ironically provided this other reality with the 'integrity' it needed to work in the first place. There is also the notion here that what was steel and concrete has acquired a 'startlingly organic' nature through the action of its new inhabitants – a powerful metaphor for the ramifications of reconceiving the form and function of a space. Through not respecting the chain-link border that *Virtual Light*'s fictional state had placed around this disused, uncertain zone, the invading community has created, precisely, a zone of *anomie* or juridical non-space that is highly reminiscent of Gibson's Walled City and, of course, of the play with technological boundaries displayed by the WikiLeaks project.

Conclusion: Those Old Boundaries

As we cross established spatial and juridical lines, as we identify an area where the law cannot be enforced, we may reconceive even spaces of the established order as organic and more humanized. In many ways, as Gibson shows, crossing a boundary is itself a reconception of space in one's own terms. Hardt and Negri note that a key facet of many of today's activists of counterpower is that of their radical capability to move beyond their own flesh: 'they are cyborg bodies that move freely without regard to the old boundaries that separated the human from the machinic.'[65] Indeed, I would go further and claim that acting against established or received conceptions of the world, in order to resist and insurrect, calls out for many sorts of crossing of 'old boundaries' of space, be they national, juridical, or local. Despite premature claims of its demise, the nation-state and its control of much sovereignty and power is still very much a factor in the world, but its nature and reach is constantly changing. Producing and examining equally changing instances, and representations, of the transnational and translegal encourages the retention

of the ability to conceive of and, hence, act in the context of, that changing world of power and counterpower.

NOTES

1 Ulrich Beck, *Cosmopolitan Vision*, trans. Ciaran Cronin (Cambridge: Polity, 2006), 63. Subsequent references are to this edition.
2 Naomi Klein, *The Shock Doctrine: The Rise of Disaster Capitalism* (Toronto: Alfred A. Knopf, 2007).
3 Benedictus de Spinoza, *Theological-Political Treatise*, trans. Samuel Shirley, intro. and notes Seymour Feldman (Indianapolis: Hackett, 1998), 179.
4 Michael Hardt and Antonio Negri, 'Globalization and Democracy,' in *Implicating Empire: Globalization and Resistance in the 21st Century*, ed. Stanley Aronowitz and Heather Gautney (New York: Basic, 2003), 111–15. Subsequent references are to this edition.
5 Ibid., 115.
6 Ibid., 115–16.
7 Ibid., 118.
8 I am indebted to Scott Bukatman here, who emphasizes that 'the interest of Gibsonian cyberspace derives from its status as a *phenomenal*, rather than a mathematical elaboration of electronic space ... Gibson continually stresses the endless *space* as well as the data contained within it.' Scott Bukatman, *Terminal Identity: The Virtual Subject in Postmodern Science Fiction* (Durham: Duke University Press, 1993), 151–2.
9 Both Radiohead and Nine Inch Nails, to name more prominent examples, have distributed albums for free, directly over the Internet, in 2007–8: *In Rainbows* and *The Slip*, respectively.
10 The Cryptome URL is http://www.cryptome.org.
11 'Unfit for British Print,' *New York Times*, 7 August 1987.
12 Xan Rice, 'The Looting of Kenya,' *The Guardian*, 31 August 2007.
13 http://www.wikileaks.org/leak/KTM_report.pdf, accessed 7 July 2008.
14 Ibid.
15 Joyce Mulama, 'Vehicle Saga Shows Kenyan Govt Lacks Budgetary Teeth,' *Mail and Guardian*, 7 February 2006.
16 Dr Craig Venter, 'A DNA-Driven World,' 4 December 2007, http://www.bbc.co.uk/pressoffice/pressreleases/stories/2007/12_december/05/dimbleby.shtml, accessed 7 July 2008.
17 William Gibson, *Neuromancer* (London: Voyager Classics, 2001), 67.
18 Diane Morgan, 'Introduction,' in *Cosmopolitics and the Emergence of a Future*, ed. Diane Morgan and Gary Banham (Hampshire: Palgrave, 2007), 7.

19 Ellen Nakashima, 'AOL Takes Down Site with Users' Search Data,' *Washington Post*, 8 August 2006.

20 Anick Jesdanun, 'Internet Soapbox Still a Little Shaky,' *Globe and Mail*, 7 July 2008.

21 Saskia Sassen, 'Digital Networks and Power,' *Theory, Culture, and Society*, ed. Mike Featherstone and Scott Lash (London: Sage, 1999), 50.

22 Saskia Sassen, 'Digital Networks and the State: Some Governance Questions,' in *The Global Resistance Reader*, ed. Louise Amoore (New York: Routledge, 2005), 373. Subsequent references are to this edition. Please note that this chapter is an edited version of the above piece.

23 Google company overview at http://www.google.ca/intl/en/corporate/index.html, accessed 6 July 2008.

24 'Muffled Voices,' *The Guardian*, 16 November 2005.

25 Lewis Krauskopf and Gavin Haycock, 'Music Industry Wins Song Download Case,' *Reuters*, http://www.reuters.com/article/technology-media-telco-SP/idUSN0541841120071005, accessed 6 July 2008.

26 Greg Sandoval, 'Defendant Knocks Web Illiterate Juror in RIAA Case,' *Cnet News*, http://news.cnet.com/8301-10784_3-9795095-7.html, accessed 6 July 2008.

27 Matt Hartley, 'Ottawa Gets Tough with Illegal Downloaders,' *Globe and Mail*, 12 June 2008.

28 'Main Themes,' *G8 Hokkaido Toyako Summit*, http://www.g8summit.go.jp/eng/info/theme.html, accessed 6 July 2008.

29 Paul Marks, 'Global Treaty Promises Hard Times for File Sharers,' *New Scientist*, 3 July 2008.

30 Rosie Swash, 'UK File-Sharers Arrested,' *The Guardian*, 3 June 2008.

31 Giorgio Agamben, *State of Exception*, trans. Kevin Attell (Chicago: University of Chicago Press, 2005), 27.

32 Jacques Derrida, 'Force of Law: the "Mystical Foundation of Authority,"' *Acts of Religion* (London: Routledge, 2002).

33 Beck, *Cosmopolitan Vision*, 101.

34 Agamben, *State of Exception*, 32–40.

35 Ibid., 60.

36 Ibid., 59.

37 Sassen, 'Digital Networks and the State,' 371.

38 Agamben, *State of Exception*, 59.

39 Hardt and Negri, 'Globalization and Democracy,' 115.

40 Beck, *Cosmopolitan Vision*, 104.

41 The Wikileaks static IP is http://88.80.13.160.

42 'Complaint: Baer v Wikileaks,' http://www.eff.org/files/filenode/baer_v_wikileaks/wikileaks1.pdf, 2, accessed 6 July 2008. The invaluable *Electronic*

Frontier Foundation (http://www.eff.org) has mirrored all case files submitted in the District Court in PDF format.

43 'Complaint: Baer v Wikileaks,' 1.

44 'Order Granting Permanent Injunction as to Defendant Dynadot,' http://www.eff.org/files/filenode//wikileaks48.pdf, accessed 7 July 2008.

45 'Whistle-Blower Site Taken Offline,' *BBC News*, 18 February 2008, http://news.bbc.co.uk/2/hi/technology/7250916.stm, accessed 6 July 2008.

46 Elizabeth Montalbano, 'Federal Court Shutters Whistle-Blower Website,' *Computerworld*, 25 February 2008. Available online at *Scholars Portal* (http://www.scholarsportal.info), search for 'wikileaks.'

47 'Federal Standard 1037C,' http://www.its.bldrdoc.gov/fs-1037/fs-1037c.htm, accessed 6 July 2008.

48 The more technically adventurous readers can accomplish this using their own systems. On the Windows platform, go to 'start,' then 'run.' Enter 'cmd' and hit the Enter key to get the Command Prompt. Enter 'ping' followed by the website of interest, for example, 'ping google.com.'

49 David Gallagher, 'Wikileaks Site Has a Friend in Sweden,' *New York Times*, 20 February 2008.

50 This is a crude summary of the vast swath of case information available at the Electronic Frontier Foundation, http://www.eff.org/cases/bank-julius-baer-co-v-wikileaks, accessed 6 July 2008.

51 Alanna Malone, 'Wikileaks Unplugged, Free to Flow,' *News Media and the Law* 32, no. 2 (2008): 32.

52 Agamben, *State of Exception*, 24.

53 Fredric Jameson, *Postmodernism, or, The Cultural Logic of Late Capitalism* (London: Verso, 1991), 37.

54 William Gibson, *Count Zero* (London: Voyager, 1995).

55 William Gibson, *Mona Lisa Overdrive* (London: Voyager, 1995).

56 William Gibson, *Virtual Light* (London: Penguin, 1994); *Idoru* (London: Penguin, 1997); *All Tomorrow's Parties* (London: Penguin, 2000).

57 William Gibson, *Pattern Recognition* (London: Penguin, 2004).

58 William Gibson, *Spook Country* (London: Putnam, 2007).

59 Jameson, *Postmodernism*, 37.

60 Thomas Pynchon, *Gravity's Rainbow* (London: Penguin, 1987), 187.

61 'Kowloon Walled City,' *Newsline: Columbia University Department of Architecture, Planning, and Preservation* 3, no. 2, http://www.arch.columbia.edu/gsap/21536, accessed 7 July 2008.

62 Gibson, *Idoru*, 181–2.

63 Gibson, *Virtual Light*, 86–9.

64 Ibid., 58.

65 Hardt and Negri, 'Globalization and Democracy,' 120.

6 Queers without Borders? On the Impossibilities of 'Queer Citizenship' and the Promise of Transnational Aesthetic Mutiny

MELISSA AUTUMN WHITE

Pleasure has no passport, no identity.

<div align="right">Michel Foucault[1]</div>

Queer Mutiny, Not Consumer Unity!

<div align="right">Placard Slogan</div>

Ours is becoming the age of minorities. We have seen several times that minorities are not necessarily defined by the smallness of their numbers but rather by becoming or a line of fluctuation, in other words, by the gap that separates them from this or that axiom constituting a redundant majority.

<div align="right">Gilles Deleuze and Félix Guattari[2]</div>

Tactical Frivolity

On 26 September 2000 (S26), the pink bloc[3] was born in Prague as another 'carnival against capitalism' mobilized against the IMF and World Bank meetings. Along with the blue bloc (a grouping that used the tactics associated with the black bloc) and the yellow bloc,[4] the pink bloc developed tactics for thwarting the securitized zone of the meetings. With unprecedented flair and *jouissance*, the 'terrorists in tutus'[5] met the riot cops in seriously frivolous costumes of pink and silver. Part drag, part queer performance, the pink bloc is often cast as queer/feminist kissing cousin to the black bloc: where the black bloc uses 'projectile reasoning,'[6] including the deliberate destruction of corporate property, the pelting of cops, and the burning of blockades, the pink bloc tends towards non-violent performance art to develop an aesthetic tactics of

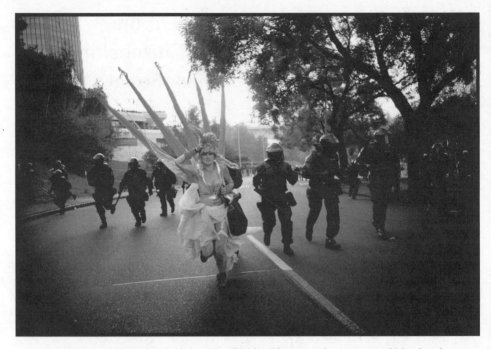

6.1 *Tactics of Flair: On the Side of Joy* (2000). Photograph courtesy of Mat Jacob, Tendance Floue.

resistance that mocks, teases, and laughs in the face of violent authority in order to subvert and celebrate counter-public formations.[7] Part of the idea is that the cops – the armed fists of the state and of global capital – don't know what to do when faced with a gender-fucking crowd dressed in sparkles, boas, and tutus (of course, in keeping with the world war machine, the batons and tear gas come out regardless). *If I can't dance, I don't want any part of this revolution.*

During that mobilization in Prague, about a year after the Seattle protest against the WTO (referred to as N30 for the date in November 1999 on which it took place), photographer Mat Jacob captured a brilliant image of the carnivalesque – or we could say, burlesque – tactics of the pink bloc. The photo (Fig. 6.1) captures a gender-queering pink-tutued super-hero/ine just two steps ahead of a wall of cops in black riot gear closing in on her. Her face bears the slightest trace of a smile, and we,

made spectators by the artefact of the image, cheer her on – *flee, flee, you've almost made it!*

The *ad hoc* linkages of anti-capitalist[8] queer activists might be considered a truly transnational phenomenon, not only because these are 'movements of movements'[9] against transnational corporations that exploit workers and pollute the environment, and the international financiers who fund their processions of death under the seemingly benign rubric of 'structural adjustment policies,' but also because these are temporary, cross-border groupings of many who wish to live and dream another world (without borders) into being. Indeed, transnational movements of movements are increasingly challenging the very notion of borders, recognizing – perhaps more intensely post-9/11 – that border security and citizenship regimes are directly connected to an intensification of geopolitically organized divisions of possibility and hope, abjection and despair. Theorizing and enacting the transnational within activist practice may thus open space to disrupt the nation-state as the primary locus for political and social (un)belonging. One of the primary aims of this chapter is to dislodge the centrality of discourses of 'citizenship' as *the* means of producing, organizing, and distributing membership in the body politic. I argue that we must work against the constraints that the horizon of citizenship sets up for our political imaginations. Why does otherwise progressive, even radical, scholarship continually return to citizenship as a term and concept to describe socio-cultural as well as legal belongings?

To set up the critical deconstruction of citizenship and the nation-state that I undertake here, I begin with the provocative linkages that contemporary queer anti-capitalist movements – deeply inspired by the flair tactics of the pink bloc – are making with migrant rights' struggles in no-borders or open-the-borders camps, solidarity work, and organizing.[10] This chapter is not meant to offer a genealogical or empirical accounting of these movements, (counter-)acts, and practices as transnational linkages, but rather to take this convergence as a launching point from which to think about the *impossibilities* of a 'queer' citizenship and the future-oriented *political promise* of aesthetic mutiny. I am concerned primarily with terms, tactics, and imaginaries in what follows because I am convinced that thinking through the ways we frame our political struggles (and goals) is key to realizing their subversive and transformative potentials. Such a thinking through is positioned against an often-invoked division of labour – between knowledge production (in here, in

the text) and activism (out there, in the streets) – otherwise described as a split between theory and practice.

Queers without Borders?

Since the heyday of counter-globalization organizing, there has been a proliferation of transnationally oriented anti-capitalist networks in multiple localized contexts. Among these networks, radical and/or anti-capitalist queer organizing has increasingly converged with no-borders activism. As one U.S.-based Queers without Borders (QwB) network puts it, queers without borders defy 'spatial, physical, religious, gender, political, and all other imposed boundaries.'[11] Another network under the same banner explains that they come together to 'discuss future actions against border regimes and in support of those experiencing oppression from state, church, or a lack of freedom of movement' while aiming 'to strengthen existing links between queers throughout Serbia and the Middle East, and work toward creating a network of queers that can make coordinated actions.'[12] Yet other QwBs, organizing against the Hammondsworth and Colnbrook Immigration Removal Centres' (UK) Detention and Deportation Centres, put it this way: 'As queers our understanding of borders is clear: we reject the borders imposed between sexualities, between genders, between our abilities to live as we wish and the strictures imposed by the state that attempt to prevent us defining of [sic] our own ways of living.' [13] They go on to clarify that 'in a society which always attempts to strengthen the position of institutionalized power by making someone "other" (whether this be by race/sexuality/gender or any other means) we refuse to accept this present condition of nations and borders, of a containment of people behind false boundaries that only serve to profit those who hold power.'[14]

These varied articulations make clear that queer mutinists are making crucial connections between the production and organization of *difference* that various borders enact – borders that tirelessly make 'others' through striations of sex/gender, sexuality, 'race,' class, nation, ethnicity, and citizenship status. That is, there is a profound and fundamental connection between the functioning of normative sex/gender regimes and that of the state's expression of sovereignty through the management of its borders. Heteronormativity (and *homonormativity*[15]) and citizenship go hand in hand, or co-assemble as part of a contemporary state apparatus of difference making.[16]

Against these difference-making machines, anti-capitalist queers across Europe, Australia, and North America have been networking across borders at yearly 'queercore' gatherings under the banner of 'Queeruption' for over a decade, theorizing and taking action against these critical connections between state and capital's exploitations of (racialized and gendered) labour, citizenship, and sexuality. Queeruption, held by and large in metropolitan centres,[17] is a yearly transnational gathering of queer mutinists, political activists, theorists, and artists. Generally accommodated within buildings, often squatted, reclaimed as *de facto* 'public space,' queeruption provides a common gathering point for sharing pleasures, tactics, and politics, for rebuilding connections and collaborative creative strategies – not only to resist the violences justified through discourses of state sovereignty and global capitalism, but also to produce, actively, queer multitudes organized around the desire to live and love beyond the inherent violence of borders.

Now, opening as I did with a somewhat fantastic portrait of the pink bloc as a transnational phenomenon of in-your-face, tongue-in-cheek resistance and creativity may have raised some eyebrows (I hope). What has thus far gone unacknowledged in my depiction of the pink bloc (and by extension other contemporary queercore/queer anti-capitalist mutinists inspired by gender-queering tactics of frivolity and flair) is the very privileges – of predominant whiteness, able-bodiedness, citizenship, and economic status – that allow QwBs to cross borders to join aesthetic and political collaborators in global metropolitan contexts. For the most part, this is a transnational convergence of the (relatively) globally privileged, for whom borders are experienced as 'mere formalities.'[18] In a sense, pink bloc and queercore gatherings might be considered a strange form of anti-capitalist 'protest tourism,' a kind of action-travel ironically made possible through the very neoliberal reorganizations of borders and citizenship privileges and the global division of mobilities that carnivals against capitalism endeavour, in part, to transform. Having acknowledged this, I would nevertheless argue that the evidence of a growing queer anti-capitalist attentiveness (in QwBs, for example) to the organization of global inequities through nationalized modes of exclusion – border security, immigration, citizenship policies and practices – is suggestive of the extent to which revitalized queer networks are attempting to puncture open spaces in the hyperconnections between 'political economies, the geopolitics of war and terror, and national manifestations of sexual, racial, and gendered hierarchies.'[19]

Theorizing and Enacting the Transnational

Migration and migratory politics are inherent to theorizing the trans-national. Though 'transnational' is becoming a ubiquitous term in the academy, its moorings are often less than obvious. Indeed, as Inderpal Grewal and Caren Kaplan have pointed out, its overuse teeters on the 'point of meaning nothing in particular.'[20] While transnationalism is evocative of 'corporate capital in motion,'[21] it is also suggestive of cross-border linkages and movements of people, ideas, and praxis. Indeed, my engagement with the 'transnational' in this chapter hinges on a con-sideration of the challenges that this working concept poses to borders and nation-states in relation to migration politics. What praxical work can the 'transnational' perform? When kept sharp, the term 'transna-tional' maintains a critical edge, with a capacity to illuminate the inequi-ties and asymmetries inherent in the 'globalization' process.[22]

According to the United Nations, more people are crossing national-ized borders today than ever before in world history.[23] This numerical increase[24] in migration is often attributed, in large part, to the glo-balization process – that is, as a consequence of the instabilities and opportunities produced through global capitalist expansion, or what Hardt and Negri in *Empire* refer to as the establishment of (capital's) Empire. Transnational migration challenges concepts of borders and nation-states but also brings them into greater clarity as powerful modes of organizing capital. In the early 1990s, Nina Glick Schiller, Linda Basch, and Cristina Blanc Szanton's collaborative work defined transnationalism 'as the *processes* by which immigrants build social fields that link together their country of origin and their country of settle-ment.'[25] Firmly linking the transnational to processes of migration and the development of emergent, linked social fields, Glick Schiller and her colleagues designate such migrants as *transmigrants*, or those who 'develop and maintain multiple relations – familial, economic, social, organizational, religious, and political that span borders.'[26] The 'trans-national' disrupts more static notions of immigration, where the migra-tion process is often framed as beginning in the 'homeland,' which is subsequently (and permanently) left behind for the new country. What is highlighted in the notion of transmigration is a kind of multiplica-tion of 'homes,' a connection of spaces of attachment and belonging *across* nationalized borders – connections and attachments that cannot be contained within a single territorial zone and that thus forge trans-national linkages.

Considered through a migratory lens, one of the crucial critical capacities that the transnational performs is that it challenges the nation-state as the privileged site of political and social belonging. As Elizabeth Povinelli and George Chauncey have put it, 'in a world defined by transnational movements, the rights that people moving and staying put can legitimately and practically demand of nation-based governments and publics are being rethought.'[27] Equally though, the term transnational – and this is crucial – simultaneously *maintains* the importance of nationalized spaces as a key node of power. In other words, even in its unhinging of the predominance of a *singular* mode of nationalized identity, the transnational nevertheless reasserts the nation-state as the locus that is disrupted and reconfigured through migratory processes. As Yeoh and colleagues suggest: 'Transnationalism draws attention to what it negates – that is, the continued significance of the national. It reminds us that we are far from having reached a postnationalist state of affairs.'[28]

This doubleness of the transnational as a critical concept is important to consider, given the apparent paradoxes of globalization – the opening of borders to goods and to temporary and highly monitored labour and services, coupled with the tightening of borders to the movements of most, save the capitalist and business classes. While the expansion of global capitalism seems to have 'opened the borders' to the market, to the 'trade' of goods and services, the nation-state remains an important node in the establishment of the conditions that make the emergence of Empire possible. Far from a generalized crisis of sovereignty in late capitalism, what we are in fact seeing is the reassertion of national sovereignty through the production of global lockdown (i.e., of particular bodies and subjects). The rise of the prison-industrial complex in the United States and the global North more generally, coupled with the fortification of borders around larger blocks of territory – Fortress North America, Fortress Europe, Fortress Australia – along with increasingly punitive immigration and citizenship regimes in the world's wealthiest countries, are leading to what Nandita Sharma has called the creation of a global apartheid vis-à-vis *citizenship* regimes.[29]

Interminalities: Becoming Queer, Becoming Migrant

I've been so far relying on concepts that I will now take a rather long pause to define. I have been deploying the somewhat general term 'migrant' to intentionally disrupt the differential categorizations of people who cross borders and *become* immigrants, refugees, undocumented mi-

grants, migrant workers, visa students, asylum seekers, and so on. To re-sist these distinctions is not to ignore or evade the material consequences these categories enact in relation to access to socio-economic resources and political life as organized and managed through the nation-state. Instead, my insistence on 'migrant' takes seriously Eithne Luibhéid's ar-gument that 'such distinctions do not reflect empirically verifiable dif-ferences among migrants, who often shift from one category to another. Rather the distinctions are imposed by the state and general public on migrants in order to delimit the rights that they will have or be denied, and the forms of surveillance, discipline, and normalization to which they will be subjected.'[30] Thus, the use of the term *migrant* in this essay is intended to direct analytic attention toward the 'technologies of nor-malization, discipline, and sanctioned dispossession' on which the state's literal production of different 'types' of migrants relies.[31]

In provocative resonance with the categorical disruptions invoked by 'migrant,' the use of the term 'queer' in this chapter also scatters technologies of normalization, particularly through unravelling logics of identity. In this chapter I use 'queer' as, somewhat paradoxically, both an umbrella for LGBT identities (always provisional, and always underwrit-ten or made possible by neoliberal capitalism),[32] and *as a radically resis-tive concept* that minoritizes (in the Deleuzian sense) the very concept of 'identity' – that, in other words, breaks with or refuses the ontologization of identity. As Eng, Halberstam, and Muñoz suggest, queer epistemology works as a 'continuous deconstruction of the tenets of positivism at the heart of identity politics.'[33] 'Queer' thus functions to denaturalize and call into question normative categories of 'being,' including but not lim-ited to categories of identity that coagulate around sexual acts, relations, and orientations. In this way, 'queer' works as a conceptual wedge, a mode of critique, a fragmenting splinter in dominant modes of thought. In the eloquent words of David Halperin, queer 'demarcates not a *posi-tivity* but a *positionality* vis-à-vis the normative ... [describing] a horizon of possibility whose precise extent and heterogeneous scope cannot in principle be delimited in advance.'[34] To 'queer' the dominant mode of imagining the political ushers in the possibility of subverting the hege-mony of citizenship as the ultimate mode of belonging in politically and affectively invested community.

Furthermore, 'queer' is poised to demand a beyond-accommodation or assimilation within the political frames already inscribed by hetero-normative – and increasingly homonormative – social institutions, in-cluding that of citizenship, which has its roots in racialized categories of

exclusion wrought through colonial histories. As Sioban Somerville has put it, heteronormativity works in tandem with processes of racialization, and 'if queer theory's project is characterized, in part, as an attempt to challenge identity categories that are presented as stable, transhistorical, or authentic, then critiques of naturalized racial categories are also crucial to its antinormative project.'[35] This is to say, queer theory making *as an existential necessity* must pay attention to the crucial ways in which sex/gender and sexuality are configured through, and constitutive of, racialized discourses of power.

Jasbir Puar's recent work demonstrates the rise of new 'homonationalisms' made possible precisely through the underwriting of nationalized belongings by racialized, ethnicized, gendered, and sexualized identities.[36] Homonationalisms, she argues, are emerging through the contemporary incorporation of formerly excluded LGBT subjects into processes of life. Though queers have been long associated with death (vis-à-vis an association with AIDS, as well as a disruption of the 'straight'forward links between sexuality and reproduction), a biopolitical 'turn to life'[37] is now possible for assimilable LGBT subjects, by way of, for example, gay marriage / same-sex partner (partial) recognition and same-sex parenting. This 'incitement to life,' however, is experienced differentially, if at all, through the mediating effects of racialization and ethnicization.[38] Homonationalisms, like 'Queer Nation,' seem to enact what Gayatri Gopinath refers to as an 'uninterrogated assumption of queer citizenship.'[39] In other words, the folding of assimilable (or homonormative) LGBT subjects into processes of life in the context of late capitalism relies on the state's organization and distribution of *citizenship status*.

Citizenship: Organizing Injustice Transnationally

The term 'citizen' originally referred to a particular sort of resident of a Greek city, that is, 'a member of an elite class who was said to be capable of self-governance and therefore of the legal and military governance of the city.'[40] In a contemporary sense, citizenship formally refers to 'a standing within the law,' and one of the primary ways that the modern nation-state manifests and reproduces its sovereignty is through defining who is excluded from, and who has 'the right *not to be excluded*' from, the circle of citizenry.[41] To put the status of citizenship firmly in the terms of *exclusion* makes the apparatus of citizenship absolutely clear – it is a form of determining membership through a logic of exclusion. Inclusion in

the body politic is fraught; it is underwritten by protections that confer, precisely and temporarily, the right not to be excluded.

At the present time, most countries determine automatic citizens vis-à-vis birth circumstance – that is, the accident of being born within a particular territory (*jus soli*) or to particular parents (*jus sanguinis*).[42] As Ayelet Shachar points out: 'Both the *jus soli* and the *jus sanguinis* principles rely on (and sustain) a prior conception of closure and exclusivity; if everyone had access to the benefits of full membership in any polity of his or her choice, then there would be no need to formally distinguish insiders from outsiders, since both would be able to enjoy the benefits of citizenship.'[43]

The 'birthright identity' organized by *jus soli* and *jus sanguinis* forms of citizenship is intrinsically linked to the sustenance of systemic global inequities. As Shachar astutely points out, while heredity is rejected 'as a determining factor in almost any other admissions criteria,' birthright citizenship is rarely challenged in the scholarly literature,[44] even in the most politically progressive streams of radical critique.

If we consider citizenship status as *a form of property*, then the links between immigration and citizenship regimes and neoliberal global capitalism may become clearer. As Shachar explains:

> When we speak about property as a legal concept we are talking about relations between people and things. Modern theories of property extend the concept beyond concrete and tangible objects (my car, your house) to refer to a host of more abstract entitlements (shares in a company, intellectual property in the form of patents and copyrights, professional licenses and university degrees, genetic information, even folklore practices) ... Once we categorize certain relationships as falling under the rubric of property, important questions of allocation are raised: Who gets what, and why?[45]

Citizenship as a form of property thus consolidates a global distribution of transnational injustice – transnational because these are inequities organized across and through the (im)permeability (for some) of boundaries between sovereign nation-states.

Along with Shachar, a number of theorists have argued that the state system is inherent to global injustices.[46] Curiously, though, there has been less attention to how the state system is organized and resecured through citizenship regimes. Shachar's work is startling inasmuch as she does explicitly consider the ways in which citizenship works as a form of

property, inherited through the accident of birth in a particular geopolitical area. On the other hand, while Michael Hardt and Antonio Negri, for instance, develop a nuanced critique of the state system, drawing connections among imperialism, colonialism, and the formation of sovereignty in their controversial *Empire*, they nevertheless go on to argue that 'the mobile multitude must achieve a *global citizenship*.'[47] Of course, the problem is exactly that the multitude is *not* mobile, given the assemblage of border security regimes, citizenship policies, and global capitalism.

What can the promise of 'global citizenship' be, given that citizenship works as a difference-making device and as a form of property, creating complicated hierarchies *within* the nation-state as well as *between* nation-states? Indeed, citizenship policies and practices do not simply determine who will be allowed to reside within a particular geopolitical zone; they also create differential memberships that, as Nandita Sharma puts it, 'accomplish, both materially and ideologically, the gendered racializations of class.'[48] In this way, citizenship can be linked to the production of a global apartheid system that not only determines who can move and where – who will be made (im)mobile – but also reproduces 'others' *within* the space of the nation-state. To return to Nandita Sharma's argument, introduced above,

> while a commonsensical understanding of apartheid is one where racialized classification schemes are the major makers of legal differences, historically many regimes of apartheid have depended on the difference of *citizenship* to make common sense of the gross inequalities organized through them … Yet, apartheid continues to be largely associated with race-based legal definitions. And because such differentiations are, almost without exception, no longer an explicit part of most national legal systems, there is a strong tendency to deny that any form of apartheid exists at all.[49]

If citizenship functions to produce a system of apartheid (one not only based on a binary between citizen and non-citizen but also organized through racialized, gendered, sexualized, and classed gradations of differential citizenships), how and why do progressive politics (and theory) continually attempt to recuperate 'citizenship'? Why does citizenship continue to structure the horizon for political action and connection?

For despite astute critiques that illuminate the inherent exclusions that citizenship as a category of nationalized *identity* enacts and entails,

tropes of citizenship remain a dominant category for so-called transnational reorientations of the political. While citizenship has been stretched somewhat through, for example, a process 'in which culture becomes a relevant category of affinity,'[50] so that 'cultural citizenship,' 'diasporic citizenship,' 'transnational citizenship,' and 'sexual citizenship' have emerged as significant contributions to critical citizenship studies, such expansions are far from transformative of the state system. Certainly, it remains far from clear why *affinities* and *shared activities* – cultural, social, affective, and/or political – need necessarily be framed *within* or valorized *through* dominant discourses of citizenship.

To make this argument is not to deny the severe material consequences that non-citizenship enacts, nor is it to suggest that those differentially included with respect to citizenship regimes are romantic, revolutionary, somehow inherently progressive agents. I am attentive, for example, to cogent arguments such as Martin Manalansan's point that 'citizenship for queers of color and diasporic queers is neither a birthright nor is it about the romance of dissidence and resistance ... [rather, it] is about struggling to create scripts that will enable them to survive.'[51] However, what I hope to begin to accomplish here is the production of a slight crack in our nation-bound imaginations, such that we might begin not only to imagine other forms of attachment – shared in common practice and activity, rather than in nationalized or other territorialized notions of identity – but also to suggest how a critical *disidentification* with the hegemony of citizenship might allow for a move beyond survival strategies. Because as much as citizenship is a legal, juridical formulation, it is also a complex form of *identification*, one that is structured through institutional *and* psychic modes of power. In other words, what is achieved through border security, immigration, and citizenship regimes is the production not only of state sovereignty, but also of particular subjectivities that might be thought of, in Foucauldian terms, as state-mediated *bio-citizens.*[52]

Given that citizenship 'involves not only juridical enfranchisement but symbolic incorporation into a national community,'[53] part of what must be challenged is our symbolic attachment to citizenship – which works as a form of identification with the fantasy of nationalized 'community.'[54] The convergence of queer anti-capitalist politics with no-borders movements is a good example of the ways in which, in the words of Steven Seidman, 'queer politics ... is about rights and legitimation, but is also about the remaking of selves and social orders – struggles that are irreducible to the politics of citizenship.'[55]

If citizenship can be understood as an identification underwritten by fantasy, then I argue that we need to cultivate a queer disidentification with this most central organizing concept of nationalized life, a concept that imposes radical constraints on the possibilities for a materialization of what Hardt and Negri call the 'multitude.'[56] José Esteban Muñoz posits that 'disidentification is about cultural, material, and psychic survival. It is a response to state and global power apparatuses that employ systems of racial, sexual and national subjugation.'[57] Disidentification is thus, for Muñoz, a tactics of minoritarian subjects, and crucially, he argues that 'the disidentifying subject is not a flier who escapes the atmospheric force field of ideology. Neither is she a trickster figure who can effortlessly come out on top every time. Sometimes disidentification is insufficient.'[58] Indeed, a disidentification with citizenship will not be sufficient in and of itself – what will we replace it with? More to the point, what is it *already* being replaced with, from the vantage of a convergence of 'queer' and 'migrant'? In the context of this chapter, 'migrant' and 'queer' are both positioned as minoritizing *processes* (rather than minoritarian subjects); but nevertheless, I would like to expand on Muñoz's contribution by suggesting that disidentification might tend also to enact a creative minoritization of subjectivity and politics, thus unravelling a state apparatus of thought and ontology.[59]

Towards the Future

What is required for transformative politics – for a transnational mutiny against borders – is a reorganization and *proliferation* of transnational practices that allow for new modes of social and political attachment, belonging, connection. A nomadic politics, a becoming-minoritarian of everyone. Such a proliferation will both require and produce a disidentification with nationalized imaginaries. To accomplish this – to move beyond nationalized identifications and identities – we may need to let go of citizenship as a primary organizing concept and develop new modes of becoming political.

As we cheer on our queer superhero/ine, the one just abreast of the armed fists of the state, we might take a reflective pause to question what our attachments to this fantastic image might be. She represents the promise of slight escape, yet 'shifts in affective atmosphere are not equal to changing the world.'[60] So let us call to her something that Deleuze said: *Flee, but in fleeing, grab a weapon*[61] – an iconoclastic club, a wrench-in-the-gears, a transformative flare.

NOTES

1 As cited in David Macey, *The Lives of Michel Foucault* (London: Hutchinson, 1993), 364.
2 Gilles Deleuze and Félix Guattari, *A Thousand Plateaus: Capitalism and Schizophrenia*, trans. Brian Massumi (Minneapolis: University of Minnesota Press, 1987), 469.
3 I deliberately use the lower-case in referring to the various blocs to highlight the temporary and in-process tone of the formation of these autonomous networks and affinities.
4 For a good discussion of the organization of the blocs for S26 Prague, and the delineations between them, refer to http://www.wombles.org.uk/article20060317.php, accessed 3 January 2008.
5 Notes from Nowhere Collective, ed., *We Are Everywhere: The Irresistible Rise of Global Anticapitalism* (London: Verso, 2004).
6 See ibid.
7 This binarized split between the pink and black blocs is problematic for a number of reasons. Briefly, to distinguish between violent/non-violent tendencies associated with each bloc is to undermine the extent to which the participants in each bloc overlap. A change of clothing can visibly confuse the philosophical 'commitments' of each participant. Indeed, many reports from the Genoa carnival(s) against capitalism (2001), for example, suggest that black bloc participants joined the pink bloc by shedding clothing as a tactical move, and furthermore, that pink bloc enactors supported such chameleonic gradations. Second, a tendency to associate the feminist/queer pink bloc with non-violence may unwittingly repeat a gendered logic that suggests that feminized 'women' and 'queers' are somehow naturally opposed to violence. An effect of this may be to deny the 'negative affects' of depression, anger, and rage that pink bloc enactors might reasonably feel in the face of the violences of Empire.
8 Rather than referring to the 'anti-globalization' movements, I use 'counter-globalization' or 'anti-capitalist' because these terms more accurately convey the spirit in which creative resistance has emerged – toward a reconstitution of global politics and possibilities of justice for all.
9 Tom Mertes, ed., *A Movement of Movements: Is Another World Really Possible?* (London: Verso, 2004). This is a common phrasing in Italy, and one that I appreciate very much since it maintains the distinctiveness of the 'multitude' of Hardt and Negri – as an assemblage of persons with different political goals and visions and yet finding a common enemy in capitalist exploitation and environmental destruction.

10 These are by no means mutually exclusive movements, of course. Indeed, there is evidence of a growing emphasis on the injustices of national borders in queer anti-capitalist movements (e.g., 'Queers without Borders,' discussed below), and an emerging attention within migrant rights' struggles on the situation of 'queer' or LGBT migrants (e.g., in networks such as No One Is Illegal).

11 Queer Without Borders website, http://queerswithoutborders.com, accessed 15 December 2007.

12 No Border Network website, http://www.noborder.org/archive_item .php?id=319, accessed 15 December 2007. Jasbir Puar, *Terrorist Assemblages: Homonationalisms in Queer Times* (Durham: Duke University Press, 2007) advances a thoughtful critique of the ways that queer politics often reproduce an Orientalization of the Muslim 'other.' We need indeed be wary of the ways in which 'transnational' queer politics may unwittingly participate in racist and hegemonic presentations of the 'Middle East' (itself a problematic geopolitical indicator with strong area studies overtones).

13 Indymedia UK website, http://www.indymedia.org.uk/en/2005/02/305769 .html, accessed 15 December 2007.

14 Indymedia UK website.

15 Lisa Duggan coined this term. Jasbir Puar discusses the connections between homonormativity and the war(s) of terror in *Terrorist Assemblages*.

16 Nandita R. Sharma, *Home Economics: Nationalism and the Making of 'Migrant Workers' in Canada* (Toronto: University of Toronto Press, 2006).

17 The first Queeruption was held in London (98), then New York City (99), San Francisco (01), again in London (02), Berlin (03), Amsterdam (04), Sydney and Barcelona (05), controversially in Tel Aviv (06), outside of Vancouver – the first non-metropolitan location (07) – and in Rome (08).

18 Sharma, *Home Economics*, 4.

19 David Eng with Judith Halberstam and José Esteban Muñoz, 'What's Queer about Queer Studies Now?,' *Social Text* 84–5 (Fall–Winter 2005): 1.

20 Inderpal Grewal and Caren Kaplan, 'Global Identities: Theorizing Transnational Studies of Sexuality,' *GLQ* 7, no. 4 (2001): 666.

21 Kit Dobson and Aine McGlynn, Prospectus for *Transnationalism Activism Art* (2008).

22 Grewal and Kaplan, 'Global Identities,' 664.

23 As of 2003, the UN Population Fund estimates that 175 million people cross national borders every year.

24 I put the emphasis on *numeric quantity* since this statistic (see note 23) does not indicate necessarily an increased *rate* of migration. There may be more people than ever before documented as crossing national borders, but this

number in and of itself conceals the histories of movement that are foundational to human community. Obscured in such a numeric emphasis are not only rates of migration, but also the rates of border establishment – in other words, the colonial histories that relatively recently carved the world up into a geopolitical system of nation-states capable of tracking the movements of 'others.'

25 Nina Glick Schiller, Linda Basch, and Cristina Blanc-Szanton, 'Transnationalism: A New Analytic Framework for Understanding Migration,' in *Toward a Transnational Perspective on Migration* (New York: New York Academy of Sciences, 1992), 1 (emphasis added).

26 See ibid.

27 Elizabeth Povinelli and George Chauncey, 'Thinking Sexuality Transnationally: An Introduction,' *GLQ* 5, no. 4 (1999): 442.

28 Brenda S.A Yeoh, Karen P.Y. Lai, Michael W. Charney, and Tong Chee Kiong, 'Approaching Transnationalisms,' in *Approaching Transnationalisms: Studies on Transnational Societies, Multicultural Contacts, and Imaginings of Home*, ed. Brenda S.A. Yeoh, Micheal W. Charney, and Tong Chee Kiong (Boston, Dordrecht, and London: Kluwer Academic, 2003), 2.

29 Nandita Sharma, *Home Economics*, 139–67; see her 'Anti-Trafficking Rhetoric and the Making of a Global Apartheid,' *NWSA Journal* 17, no. 3 (Fall 2005): 88–111.

30 Eithné Luibhéid, 'Introduction,' in *Queer Migrations* (Minneapolis: University of Minnesota Press, 2005), xi.

31 Luibhéid, *Queer Migrations*; see also Sharma, *Home Economics*.

32 In the words of Lisa Duggan: 'What the progressive-left must understand is this: Neoliberalism, a late twentieth-century incarnation of Liberalism, organizes material and political life *in terms of* race, gender, and sexuality as well as economic class and nationality, or ethnicity and religion. But the categories through which Liberalism (and thus also neoliberalism) classifies human activity and relationships *actively obscures* the connections among these organizing terms.' In *The Twilight of Equality? Neoliberalism, Cultural Politics, and the Attack on Democracy* (Boston: Beacon, 2003), 3 (original emphases).

33 Eng et al., 'What's Queer?,' 3.

34 David M. Halperin, *Saint Foucault: Toward a Gay Hagiography* (New York and Oxford: Oxford University Press, 1995), 62.

35 Siobhan B. Somerville, 'Queer,' in *Keywords for American Cultural Studies*, ed. Bruce Burgett and Glenn Hendler (New York: New York University Press, 2007), 190.

36 Puar, '*Terrorist Assemblages*.'

37 Within the logic of Lacanian psychoanalysis, Lee Edelman has suggested

that the lure of this 'incitement to life' rests on a 'reproductive futurism.' Provocatively, Edelman argues that the queer – in juxtaposition to the homonormative citizen-subject – is *with*, or on the side of, the death drive, or that which would unravel the Symbolic. See Edelman, *No Future: Queer Theory and the Death Drive* (Durham: Duke University Press, 2004).

38 Puar, *Terrorist Assemblages*, xii–xiii.

39 Gayatri Gopinath, 'Funny Boys and Girls: Notes on a Queer South Asian Planet,' *Asian American Sexualities: Dimensions of the Gay and Lesbian Experience*, ed. Russell Leong (New York: Routledge, 1996), 20.

40 Lauren Berlant, 'Citizenship,' in *Keywords for American Cultural Studies*, ed. Bruce Burgett and Glenn Hendler (New York: New York University Press, 2007), 37.

41 Ayelet Shachar and Ran Hirschl, 'Citizenship as Inherited Property,' *Political Theory* 35 (2007): 254.

42 'The vast majority of today's global population – 97 out of every 100 people – have acquired their political membership by virtue of birthplace or "pedigree."' Ibid.

43 Ayelet Shachar, 'Children of a Lesser State: Sustaining Global Inequality through Citizenship Laws,' in *NOMOS: Child, Family, State*, ed. Stephen Macedo and Iris Marion Young (New York: New York University Press, 2003), 346.

44 Shachar, 'Children of a Lesser State,' 347.

45 Ibid., 380.

46 For example Sharma, *Home Economics*; Michael Hardt and Antonio Negri, *Empire* (Cambridge, MA: Harvard University Press, 2000).

47 Hardt and Negri, *Empire*, 361 (emphasis added).

48 Sharma, *Home Economics*, 142.

49 Ibid., 141–2.

50 Lisa Rofel, 'Qualities of Desire: Imagining Gay Identities in China,' *GLQ* 5, no. 4 (1999): 457.

51 Martin Manalansan, IV, *Global Divas: Filipino Gay Men in the Diaspora* (Durham: Duke University Press, 2003), 121.

52 Rosi Braidotti, *Transpositions* (London: Polity, 2006), 38–9. Braidotti is drawing here on Nicholas Rose, 'The Politics of Life Itself,' *Theory, Culture, and Society* 18, no. 6 (2001): 1–30.

53 Steven Seidman, 'From Identity to Queer Politics: Shifts in Normative Heterosexuality and the Meaning of Citizenship,' *Citizenship Studies* 5, no. 3 (2001): 321–3.

54 Benedict Anderson, *Imagined Communities: Reflections on the Origins and Spread of Nationalism* (London: Verso, 1991[1983]). Anderson famously re-

fers to the nation as a 'an imagined political community [that is] imagined as both inherently limited and sovereign.'

55 Seidman, 'From Identity to Queer Politics,' 328.

56 See Hardt and Negri, *Empire.*

57 José Esteban Muñoz, *Disidentifications: Queers of Color and the Performance of Politics* (Minneapolis: University of Minnesota Press, 1999), 161.

58 Munoz, *Disidentifications,* 161–2.

59 'Thought as such is already in conformity with a model that it borrows from the state apparatus.' In Deleuze and Guattari, *A Thousand Plateaus,* 374.

60 Lauren Berlant, 'Cruel Optimism,' *differences: A Journal of Feminist Cultural Studies* 17, no. 5 (2006): 35.

61 'A society, but also a collective assemblage, is defined first by its points of deterritorialization, its fluxes of deterritorialization. The great geographical adventures of history are lines of flight, that is, long expeditions on foot, on horseback or by boat … It is always on a line of flight that we create, not, indeed, because we imagine that we are dreaming but, on the contrary, because we trace out the real on it, we compose there a plane of consistence. *To flee, but in fleeing to seek a weapon.*' In Gilles Deleuze with Claire Parnet, *Dialogues II, Revised Edition,* trans. Hugh Tomlinson and Barbara Habberjam (New York: Columbia University Press, 2007[1987/1977]), 136 (emphasis added).

7 Outernational Transmission: The Politics of Activism in Electronic Dance Music

PRASAD BIDAYE

Introduction

When it comes to pop music, many of us have very fixed ideas on which styles and sounds are socially and politically significant: acoustic guitar-driven folk; raging, anarchist punk; and what veteran rapper KRS-One once called the 'edutainment' side of hip hop. A more globally tuned playlist might include the rebel traditions of reggae, Afrobeat, qawaali, and rai. While such gestures succeed in diversifying the picture of socially and politically conscious music, they do little to introduce new concepts, theories, and praxes of musical activism. In pursuit of those alternative possibilities, this chapter turns its ears to the underground of electronic dance music.

Electronic dance music is not a genre but a field continuously proliferating with innumerable subcultures, movements, and scenes. It is true that none of these have developed a reputation for radical protest or critique. Club anthems often penetrate the Top 40 charts, but they are arguably the last thing one expects to hear being chanted at a march or spun at a benefit party. This is often due to the misperception that techno and other such discofied sounds present an escape from, rather than a confrontation with, the real issues of our contemporary world. A closer listen, however, finds that the high-speed tempos and dissonant tones of this field provide some of the best metaphors for the ways in which human beings physically and psychologically experience the flows of capital, digital information, and diasporic dislocation in our transnational world. But the radical appeal of this music goes beyond the fact of its innovative aesthetics. For techno collectives like Underground Resistance (UR), there is a praxis that emerges in their subversive use of

communication technologies, studio production techniques, and community building on and off the dance floor. Unfortunately, it is a praxis that has been largely overlooked in the contemporary discourses of most journalists, academics, and activists, and perhaps even mystified by the collectives themselves.

This chapter explores the political dimensions of electronic dance music through three movements of inquiry. The first examines the countercultural aesthetics, economies, and performance spaces that characterize this field of music as a revolutionary alternative, and how such phenomena are rendered ambivalent when commodified through the cultural industry of late capitalism. The second turns to the projects of UR and their conflicts with multinationals like Sony and BMG as a case study in musical activism on the local, global, and translocal terrain. The third traces out the dual aspects of UR's activist philosophy: its 'outernational' challenge to postcolonial theories of diaspora and hybridity; and its post-black Atlantian ethics of dialogue across marginalized spaces. Through these three movements, I argue that UR is more than just an example of political consciousness within electronic dance music; the collective's work and ideas are exemplary for all forms of musical activism, regardless of genre or historical context.

Revolutions per Minute

There are two dominant modes of discourse through which many of us theorize the political dimensions of electronic dance music: the mainstream thesis and the underground anti-thesis.

Despite the popularity of rave culture, turntablist craft, and synthesizer/sampling technologies, the mainstream view of electronic dance music remains one of stereotype and cliché. Rock-centric critics often undermine its rich language of sonic expression as mechanistic, repetitive, and unmelodic. The ecstatic rituals of the dance floor are similarly disregarded as escapist, hedonistic, and drug-oriented, not to mention illegal. At the level of identity politics, the innovative producers and DJs behind the many micro-scenes of electronic dance music generally lack visibility in the media and are therefore assumed to be white, male, and probably straight. For these and other reasons, one finds a strong tendency among the intellectual and activist community to dismiss the phenomenon of electronic dance music as wholly apolitical.

A common response to this thesis is to insist that electronic dance music is *inherently* political, countercultural, and revolutionary. For

those who are disenchanted with mainstream pop, the supposed lack of musicality in techno, house, drum & bass, and dubstep represents an aesthetic revolt against the three-minute pop song formula. These genres are also privileged because they circulate through the flows of an alternative economy. Their unique use of the 'track' format tends to be disseminated through various non-commercial media and DJ-friendly technologies: 'white label' vinyl; 'mix-tape' CDs and MP3s; and pirate and community radio. As commodity, these tracks are often produced through artist-owned imprints and other forms of independent, local business, many of which have been highly successful at circulating their works on a global scale, all the while deftly outmanoeuvring the matrix of major record companies and music video channels. Ultimately, the climax of this narrative lies in the creation of underground subcultures and sonic communities: the transformation of warehouses and other urban spaces abandoned by post-industrial capitalism into after-hour parties. Dancing communally as one nation under a groove thus comes to represent more than a Dionysian ritual; it is a symbolic act of mass organization.

The problem with the underground anti-thesis is not its utopian vision: there are many artists, recordings, labels, and events that have achieved these ideals at various times and places over the past twenty years. The real issue is the rhetorical emphasis on a revolutionary essence, one that is eternally present in the music rather than a product of particular social and historical contexts. As the histories of folk, punk, and hip hop have shown, all revolutionary moments in pop music are subject to the dialectics of the culture industry, and electronic dance music is no less vulnerable to these processes.[1] The past twenty-five years have seen the charts make space for the crossover success of one-time underground artists like Inner City, Moby, Massive Attack, and Daft Punk. These crossovers are usually accomplished through 'radio friendly' remixes, often commissioned by a major label in order to edit 'track'-format compositions down to pop song listenability. One could turn to the careers of Goldie, Roni Size, Talvin Singh, and other innovative DJ-producers of the late 1990s as models for achieving both artistic freedom and commercial success via independent labels. However, their underground status is questionable, given the ways they have been celebrated through awards like the Mercury Prize and other forms of critical acclaim within the privileged spaces of 'alternative' rock culture; much of their success has also come from selling themselves as remixers for established pop stars like Madonna, Björk, and Sarah McLachlan. These centripetal patterns

also register at the level of social space, through the phenomenal transport of warehouse parties to pseudo-raves on the international super-club circuit (London's Ministry of Sound, New York's Twilo, Toronto's Guvernment, etc.) at the turn of the twenty-first century. The type of DJ who performs at such high-priced venues is usually pampered with levels of celebrity excess not unlike those of rock and hip hop stars. At the same time, I would unsympathetically argue that these DJs are symbolic casualties of transnational capitalism: travelling and performing everywhere (which really means the metropolitan centres of North America, Europe, Japan, and the BRICs) but almost never in the local settings of the sonic communities from which they emerged. In this way, the job of spinning tunes and providing entertainment for E'ed-out clubbers around the world constitutes another form of migrant labour – though a well-paid one if you're Carl Cox or Tiësto.

Commercial success and global popularity can be exciting for any artist or musical form, but it is always illusory. For one, there's never enough room for everybody in the house of official culture; the majority of the underground must be left out. Their exclusion does not necessarily equal silence, let alone a lack of success. In most cases, the mainstream assimilation of electronic dance music ironically provokes a revitalizing of underground styles and spaces. This centrifugal response to the mainstream is often generated rhetorically through the renaming of a scene. 'Techno' was initially the term for a particular blend of minimal, electronic funk that flowed out from a handful of African American musicians in and around Detroit, Michigan. In response to its global popularity, some fans of the music's original sound chose to distinguish it as 'Detroit techno,' while others toughened it up with the street cred of tags like 'ghetto-tech,' 'techno-bass,' or 'hi-tech soul.' Though intended to be regenerative, these and other such vernacular processes are inevitably subject to time and end up taking place gradually over a period of five to fifteen years. Thus, in the temporality of youth culture, a new rhetoric concurs with the emergence of a new generation of fans for whom the original rhetoric (and its accompanying history) remains on the margins of their cultural consciousness, if not totally outside it; and of course, there are also numerous cases where the new rhetoric dies off before it reaches most ears. This sense of subcultural amnesia arguably leaves many new listeners deaf to the past and equally blind to the future. Harder, edgier styles and scenes emerge from the underground only to restimulate the dialectic of the culture industry through a chain reaction of hipster curiosity, media buzz, chart crossovers, and corporate interest

in the Next Big Thing. This cyclical interplay of regenerative centrifugal-
ity and commercial centripetality is best illustrated in Britain, where the
transatlantic export of Detroit techno (as well as Chicago house and New
York garage) helped set off the late-1980s rave explosion better known as
'acid house.' Since that pivotal moment, there have been an overwhelm-
ing number of cases where the working-class, and dominantly black,
music underground of that country has reinvented and consequently
resold itself on an almost annual basis with the hype of various names
and associated movements: acid house (1988), hardcore (1991), ragga
(1992), jungle (1994), trip hop (1995), speed garage (1997), Asian un-
derground (1998), 2-step (2000), grime (2003), dubstep (2006), and
funky (2008).[2] While it is evident that none of these scenes are identical
to one another, they do share a similar revolutionary appeal to DiY cre-
ativity, democratic expression, and forward-thinking innovation from an
underground place. On the other hand, they tend to lack strategies for
anti-capitalist resistance. Thus, while these movements succeed in dis-
rupting the glossy soundscape of mainstream pop, the degrees to which
they break the backbone of its economy are far less evident.

Imagine the dialectical wheels of the culture industry's steel as a pair
of turntables spinning Marx on loops, 'first as tragedy' and 'second as
farce.' If this is what the party sounds like at the 'end of history,' then
it's hard not to be cynical about the state of electronic dance music –
and perhaps all forms of popular music in the age of late capitalism.
For intellectuals and workers within these sonic communities, the situa-
tion provokes a particular set of questions: Should we resign ourselves to
the machinations of the culture industry and avoid the romanticism of
all such underground rave-o-lutions? Should we be more honest about
our hedonistic priorities and celebrate electronic dance music as an es-
sentially apolitical field of artistic expression? Or if we are to remain
politically committed, should we accept that the radicalism of electronic
dance music will always remain limited to momentary forms of carni-
valesque reversal, while more authentic forms of political protest are ul-
timately best pursued through the stable modes of folk, punk, and hip
hop culture? It is easy to answer a passive 'yes' to all such questions and
still fail to develop a sound analysis of the discursive structures that un-
derpin this conversation. If folk, punk, and hip hop are privileged as au-
thentic, much of it has to do with the politics of their being *seen* (rather
than heard) as 'political' music.

From a purely observational point of view, I would argue that there
are two dominant discourses through which a pop artist or style is rec-

ognized as 'political.' One is through the use of social commentary –
something that is rarely associated with electronic dance music because
of its dominantly instrumental form. The other is through benevolent
works of charity and fundraising *à la* Bob Geldof and Bono. The history
of electronic dance music has its share of both in cases as wide-ranging as
the AIDS fundraising work of the late garage innovator, Mel Cheren; the
participation of DJ-producers Joaquin Claussell, Louie Vega, Ski Oaken-
full, and Venom in the Hope Collective's tsunami relief recording 'Give
and Let Live'; and the catalysing role played by Asian Dub Foundation's
single 'Free Satpal Ram' in their campaign to release a South Asian im-
migrant wrongly imprisoned in the United Kingdom. These are not iso-
lated incidents, and with further research into more localized scenes,
we would surely find other examples. However, what remains clear in
these cases is that the idea of being 'political' entails more than selling
the rhetoric of an eternally present, revolutionary essence. Instead, it's
centred on an activist commitment to ongoing struggle.

I want to emphasize the concept and work of activism here because it
is generally mystified in contemporary pop culture, particularly in dis-
courses on 'political' music. For the culture industry, 'political' music
sells, regardless of genre; the labour of activism does not. In other words,
it's cool to be a back-to-roots folk singer or a 'conscious' rapper and re-
lease a song about global peace, love, and unity, along with a video and
advertising campaign to back it up. It's the kind of work that makes an
artist feel good about her or himself, and consumers feel just as good,
if not better, for having done their part by purchasing both song and
video with a mere click on iTunes. Either way, the work of activism is
understood narrowly through a synthesis of commercial transaction and
sentimental affect. It is probably more subversive for a fan to download
these products through illegal sites and continue sharing them through
peer-to-peer networks. By disrupting the chain of commercial activism,
such measures do more to spread the message than the artist intended
in the first place, and obviously with far less sentimental aims.

The point of this discussion is not to slam the musical activism of more
commercially successful pop artists, nor is it to assert that less popular
forms of activism within the field of electronic dance music are more
underground and therefore more authentic; nor is it to advocate piracy.
My interest here is in critically exploring new possibilities for musical
activism, particularly those that aim to subvert if not almost completely
disregard the superstructures of the mainstream culture industry and
late capitalism in general. While it is clearly an act of folly to romanticize

the entire field of electronic dance music as being the source and solution to this grand political (as well as artistic) question of our times, a closer examination shows that there are musical activists, communities, and organizations whose projects not only have succeeded over the span of numerous underground movements, but also have contributed concepts and practices that are relevant to the theoretical concerns of our globalized yet extremely capitalist world. In the realm of techno, one such example is in the work of Underground Resistance.

'Fuck the Majors'

Underground Resistance began as a Detroit-based musical project and record label of the same name founded in 1989 by 'Mad' Mike Banks and Jeff 'The Wizard' Mills, who were joined by Rob 'Noise' Hood shortly after. The original UR line-up came to prominence during the early 1990s, a period widely regarded as the 'second wave' of Detroit techno. The significance of the term 'second wave' arguably has nothing to do with the aesthetics of the music; an uninitiated listener will find very few sonic differences between the techno of UR, Carl Craig, and Kelli Hand and that of 'first wave' legends Juan Atkins, Derrick May, and Kevin Saunderson. What constitutes the 'second wave' as a genuine movement is their drive to move on in light of the transnational successes and failures of the preceding generation.

It was Atkins, May, and Saunderson's now-classic twelve inches that put Detroit techno on the map of pop music and helped launch rave culture in Britain during the late 1980s. According to the dialectics of the culture industry, history would have it that this movement would come full circle and criss-cross back to North America, though redesigned as a British invasion import. This Eurocentric remix of techno's racial identity is evident in North America's warm reception for the equally innovative music of 808 State, Orbital, and the Aphex Twin in the early 1990s, but also in the massively hyped and rock-oriented 'electronica' sound of acts like the Prodigy, the Chemical Brothers, and Fatboy Slim at the end of the decade. 'First' and 'second' wavers have also had to struggle against the Elvis/Eminem factor, for the only North American techno artists to be taken seriously by music journalists were (and still are) white DJ-producers like Moby and Richie Hawtin, the latter a Canadian who grew up just across the Detroit River in Windsor, Ontario. That said, while black DJ-producers are conveniently ignored in North America, they do enjoy a formidable level of critical acclaim with journalists, fans,

and fellow artists on the transnational techno scene, and this diasporic condition is no less true for Banks, Mills, and Hood as well as for others who have been associated with the UR brand. What distinguishes their careers from those of their more solo-driven peers is an emphasis on collective effort, an effort whose many faces and phases have been consistent in being critically responsive to the cultural paradoxes of this music's history.

Among fans of Detroit techno, UR is well known for taking polemical stances, but their political appeal lies doubly at the non-literal level of aesthetics. Stylistically, the sound on early recordings like 'Riot' and 'Sonic Destroyer' is characterized by a signature combination of abrasive textures, kinetic tech-house rhythms, and a cathartic yet calculated sense of sirenic energy not unlike that of their closest contemporaries in the arenas of rap and rock, Public Enemy and Rage Against the Machine. In live performance, the original line-up often drew controversy for their theatrical use of Black Panther-esque gear and terrorist-style masks. If there's anything overtly political about such sounds and gestures, it's mostly at the level of a rebellious attitude, yet one that tends to be received ambivalently by critics (though perhaps less so by fans). The reception of this attitude has its discursive parallels in the journalistic view of late 1980s hip hop, oscillating as it does between the juvenile indulgences of fighting for your right to party (Beastie Boys circa 1987) and the no-nonsense militancy of partying for your right to fight (Public Enemy circa 1988). In his widely celebrated work *Energy Flash*, Simon Reynolds draws yet another parallel with punk, but with a conclusion that decisively reduces the ambivalence of UR's aesthetic to one of an empty and transparent rhetoric: 'What Underground Resistance seem to herald ... is a kind of Dionysian politics, a cult of orgiastic, unconstructive anger. If this was techno's punk-rock, the parallels were less with the rabble-rousing but ultimately goodhearted Clash, and closer to the appetite-for-destruction throbbing inside Sex Pistols' songs like "Anarchy in the UK."'[3]

Reynolds is one of the most influential writers on electronic dance music, matched only by Kodwo Eshun (whom I will discuss later on); in fact, both writers have a cult following of their own that arguably rivals that of some of the artists about whom they write. For this very reason, a critical intervention with regard to the politics behind their respective discourses is highly warranted. In the case of Reynolds, what is most evident throughout his critiques is a clichéd use of postmodernist scepticism regarding all forms of electronic dance music that attempt to go

beyond offering the listener and dancer something more than a virtual-chemical soundtrack to what he otherwise privileges as the 'hardcore' pleasures of the dance floor.[4] This critique is certainly styled in eloquence and grounded in a thorough knowledge of the UR discography, not to mention the transnational spectrum of electronic dance music. But at the same time, Reynolds quite clearly fails at engaging the complexity of UR's musical and non-musical work as masked behind its seemingly ambivalent face. If UR's politics appear to be 'vague' and born of 'non-specific belligerence,' much of this has to do with what is intentionally left unspoken in the music as well as in its processes of dissemination.[5]

Like most techno recordings, the early work of UR is dominantly instrumental and thus highly non-referential. The intentions behind these recordings are further obscured by the fact that the members of UR rarely give interviews to the press – and Reynolds admits to being one such journalist rejected by Banks.[6] On the one hand, this disinterest in the media enunciates a message of non-cooperative protest against the broader machinations of the culture industry: *we avoid your journalists because your empire avoids us and, more importantly, the historical, cultural, and economic contexts of our music.* On the other hand, this gesture of resistance can also be read as a preservation of secrecy and therefore underground knowledge. The claim to underground-ness may seem contradictory, given UR's global reputation, but for Banks, who has never volunteered to be photographed or videotaped without his Zapatista-like guises, it's a reputation that has been uniquely secured without the cult of a visible personality. Instead, much of it is in response to what lies disembodied in the collective's material culture: coded messages etched into the inner grooves of the vinyl; comic book–style illustrations of musicians-as-mutant-warriors on the label art; fictional mythologies in the sleeve notes; and titles ranging from the cryptic 'Install "Ho Chi Minh" Chip' to the more straight-up 'Fuck the Majors.' For a critic like Reynolds, the ideological content of these semiotic sites may appear no less vague or ambivalent than the music encapsulated within them. Nevertheless, I argue that the radical potential of these sites lies in the ways they provoke the listener to scan the whole product for information. If the first step towards becoming an activist is simply to be an active rather than a passive participant, then this is ideally what happens when a consumer encounters a piece of UR vinyl. Mills explains: 'It kind of sends out a signal that things aren't always the way they are supposed to be … That maybe you should pay more attention to what you're buying or what you're listening to.'[7]

UR thus takes a great deal of pride in letting their twelve inches do the talking, and their preference for disguise and clandestine identities demonstrates an unwillingness to make a spectacle of themselves in ways that are endemic among other celebrity activists, not to mention within the exploitative traditions of racial minstrelsy and orientalist exotica that most artists of colour have to confront at one point or another in their career. This emphasis on underground-ness is also one that doubly signifies itself as an invitation to the listener to descend and explore what Ralph Ellison might have called 'the lower frequencies' of the UR project, the history of which extends further than that of the original trio's classic period. Mills and Hood ended their musical (but not personal) partnership with UR in 1992. It was at this juncture that UR became less of a 'band' and more of a multilevel organization featuring other up-and-coming Detroit-based musicians and DJs (Rolando, Drexciya, Suburban Knight, and Chaos, to name a few) as well as visual artists (Abdul Haq) and writers (The Unknown Writer). However, most crucial to this apparatus was and continues to be UR's business operations. As Banks often repeats in his selective interviews with the press, the original concept behind Underground Resistance was as much about its rebellious musical style(s) as it was about its cultivation of a business model that sought maximum independence from all agents of the culture industry – the media as well as those third parties involved in the mastering, manufacturing, and distribution aspects of the music.

If the establishment of UR as a record label was the first step in this model, the second was the construction of Submerge in 1992. Initially co-owned and administered by Christa Weatherspoon Robinson, the Submerge building functions on multiple levels. It is an office space for the UR record label as well as its famed Black Planet recording studio. Submerge is also a distribution centre for numerous other underground labels on the Detroit techno scene (Electrofunk, Motech, Black Nation, and so on) and consequently doubles as something of a community centre and network space for local scenesters. Its record and merchandise store, called Somewhere in Detroit, similarly operates with the atmosphere of a resource centre housing a rich oral as well as aural history of the city's music scene. When the building relocated to a new address (proximate to Berry Gordy's original headquarters for Motown) in 2002, a small museum was added to display vintage instruments donated by first and second wave Detroit artists. For all of these reasons, techno fans from around the world have hailed Submerge as a must-see pilgrimage spot, one that makes it difficult for any visitor to leave with any of the

Eurocentric myths she or he may have held about this music before entering. Unsurprisingly, the building has since inspired similar collective operations in Detroit (such as the Detroit Techno Militia) as well as more globally dispersed ones like Ele_mental in Columbus, Ohio, Public Transit Recordings in Toronto, and Reinforced in the Dollis Hill district of London, England.

It is through these and other such unique business practices that Underground Resistance has managed to consistently produce innovative music for almost two decades (a rarity for electronic dance music, even more so for contemporary hip hop, rock, and pop). And while the Detroit techno scene has spawned numerous other waves and movements of renown, the UR/Submerge venture remains relevant because of its activist ethos and its uniquely critical approach to the culture industry as set in the patterns of reception for the scene's first- and second-wave movements. Again, it is through the music and touring schedules of DJ-producers like Atkins, Craig, Mills, and May that Detroit techno has become a global form. The other side of this transnational success story is that it set a rigid template for the profession, transforming DJs and producers into highly exilic figures, peddling foreign sounds to foreign places exclusively. The project of UR/Submerge marks one attempt to disrupt and reverse these processes of global dislocation by setting up shop at home to cultivate the scene's local talents and vernacular sounds. The focus on community is also a matter of personal choice for Banks; he keeps his tour schedule at a minimum in order to devote himself to studio and administrative work, but also to have time for other activist projects such as coaching a baseball team for inner-city Detroit youth.

In all cases, the idea of the local is in the foreground of UR's musical and non-musical activities – ironically so, given the importance of exile, diaspora, migrancy, and other such concepts popularized by postcolonial theorists Homi Bhabha, Paul Gilroy, Stuart Hall, and Edward Said. It is to the discourses of the latter that most of us would probably turn when theorizing the nexus of race, empire, art, and popular culture in a case study such as this, only to realize their contextual limits. For Bhabha and company, symbols and tropes of migration, diaspora, and exile offer some form of resistance against colonial or national borders. In the age of global capitalism, the narratives of Detroit techno tell a different story – one of alienation, estrangement, dislocation, exploitation, and appropriation. This story does not necessarily negate the usefulness of postcolonial theory. Rather, it is one that brings those discourses into confrontation with the crisis of their own rhetoric, a crisis that unveils

itself when concepts of transnational movement are defamiliarized by the power of late capitalism. Ultimately, the crisis of postcolonial theory reflects the larger one of globalization, which, unlike nineteenth-century colonialism and twentieth-century nationalism, is not the object of a comparatively dead archive, but rather a grand event living itself out through the chaos of the present and consequently demanding new theories and concepts.

Simply put, globalization is no evil monolith; like many of the phenomena discussed here, its ideologies are ambivalent. On one hand, globalization accelerates processes of cultural interaction and hybridity that have otherwise been operating since the beginning of time; it is only the means and pace that have changed. On the other hand, texts tend to circulate more freely than their contexts. This is certainly the case for musical recordings: techno travels and becomes a music without borders, while the histories and politics of Detroit remain comparatively stranded, even ghettoized in their local spaces. The borderless life of a DJ or an MP3 download may mock the concept of the nation and its strategies of internal containment, but that same person or track is otherwise reduced to a lifeless object when sold (and souled out) through the equally borderless circuits of global capitalism. Resistance is not impossible; it just needs to be theorized differently.

A vulgar reading of UR/Submerge would privilege it for turning to the stability of the local over the transnational, but this is clearly flawed and impractical. If globalization has taught us one thing, it is that no community or economy has ever been perfectly self-enclosed or self-sufficient. Most tend to participate in *translocal* networks, and some are significant in the ways they challenge the sovereignty of national borders. In a world where the repressive structures of capitalism are said to be borderless, the resistance to them must also take on a borderless shape. Such acts of resistance also carry a critical recognition of globalization's unspoken paradox: that the borderless world is itself highly bordered. Thus, the task of both transnational and translocal activism is to point out the borders of the borderless in order to push against them. To illustrate this strategy further, I turn to UR's infamous battle with Sony and BMG over the twelve-inch recording 'Jaguar.'

In the spring of 1999, DJ Rolando (aka The Aztec Mystic) released 'Jaguar' on the UR imprint. Its distinct synthesis of carnival-style polyrhythms, futuristic strings, and a superbly melodic bassline found its way into the crates of the world's most renowned techno, house, and even jazz-funk DJs, making it one of the most successful tracks to ever come

out of the UR camp and the Detroit music scene in general since the first-wave era. The anthemic popularity of 'Jaguar' also caught the ears of Sony Music's Dance Division in Germany, which went on to commission and circulate a cover version of the track by a hitherto unknown German trance duo, Type. Promotional copies of the Type cover entered the United States in December 1999, provoking an amazingly rapid series of responses from the UR/Submerge camp. Through e-mails and Web postings to various techno and electronic dance music listservs, the collective called for a mass boycott directed at Sony offices in Germany as well as the United States and Canada.[8] Written by Banks and UR representative Cornelius Harris, these correspondences present various points of offence. First, that the trance style of the Type cover is artistically inferior. Second, that the time between the release schedules of the two recordings hardly qualifies the new version as a 'cover': 'cover versions traditionally have been done by fans of the original track as an homage to the original. In this case, it is being done as a method of undercutting the sales of the original.'[9] Third and most important, that Sony had allegedly produced and released the track without obtaining licensing permission from the original composer or label – neither, in fact, had been contacted prior to its release.

When reproached, Sony representative Dirk Dreyer defended the sincerity of his corporation with a dubious statement of diplomacy and respect for the music of Underground Resistance. I have selected excerpts from two of his correspondences with the Detroit collective:

> As we don't want to be seen as guys who rip off or bootleg a well-known track, we have chosen the way of rerecording the track tone by tone. Indeed the new version has lost some of the typical Detroit flavour, [which] makes me still prefer the original. On the CD will be the original writer and publishing credits [so] that you get the publishing money that you deserve.[10]

> We don't share your point of view that a cover version of Jaguar makes you sell less records. The people interested in your original vinyl are way different to Sony buyers. People who have bought UR records will still buy UR records.[11]

I find the repeated use of the term 'original' here to be both conspicuous and ironic, particularly so given the post-structuralist critique of origins that remains *de rigueur* within contemporary thought. Dreyer's arguments move in the opposite direction by emphasizing the authenticity

of Rolando's 'Detroit flavour' (translation: the exotica of that flavour's so-called authenticity). And while Sony's access to high-level digital technologies is powerful enough to produce a seemingly perfect mimesis of the original, Dreyer nevertheless insists on deprecating his company's 'tone by tone' cover as a profane imitation rather than an illegal work of appropriation. He goes further to suggest that UR fans are well informed enough to discern the authentic from the fake and can therefore rest assured that Sony is neither stealing UR's music nor luring away their listeners – a rhetorical gesture that does not acknowledge so much as marginalize the underground. Finally, the tone of Dreyer's rhetoric is one that attempts to mock consumerist tastes with open admissions of his product's aesthetic inferiority. What is cleverly hidden, though, is the confidence of knowing that a profane imitation is nevertheless highly profitable precisely because of its contiguity to the aura of the original.

After receiving numerous angry letters and phone calls, Dreyer announced on 17 December 1999 that Sony would cease all plans to release the Type cover for the sake of preserving 'the relationship of the industry to the underground.'[12] Despite a tone of friendship and humility, Dreyer also expressed hope 'that a different company will use the idea and milk the cashcow.'[13] These comments rang true, for BMG announced an official release for the Type cover less than a month later. The track would make its way into the Top 10 of Germany's dance charts soon after. Representatives at BMG claimed their rights to the track through 'third party licensing' – the legal technicalities of which are best explained in Mark A. McCutcheon's work on this case.[14] But as many suspected, this was essentially an internal transfer, and it is no coincidence that BMG would eventually merge with Sony in 2004, making the latter one of four major labels that currently dominate 80 per cent of the global music market.[15]

In one of his first online missives regarding the 'Jaguar' controversy, Banks expressed his disinterest in resolving the case through legal means: 'I intend on showing them that these wars will not be fought in the unfair conditions of their courtrooms where their corporate lawyers have an advantage! [T]hese wars will be fought in the new arena – out here in deep space where the playing field is more level.'[16] Banks is intentionally vague on the location of this 'new arena.' It could be anything from the unrestricted channels of the Internet to the dispersed subcultures of electronic dance music to the free markets of the culture industry. In all cases, the 'new arena' is essentially a space of transnational proportions. As Nick Morwood's chapter in this book suggests, this transnational space does indeed share much with what Giorgio Agamben calls juridi-

cal *anomie*, zones of emptiness and confusion. It lies outside the borders of national and international law and simultaneously draws attention to the 'non-place' of subversion deep within the transnational structures of popular culture, the Internet, and global capitalism.

Interestingly, the first steps into this 'new arena' of activism were taken by people outside of the UR/Submerge camp. On 24 January 2000, another Detroit-based label, 430 West, announced it would re-release the original 'Jaguar' through its UK distributors and thus see its circulation in a wider range of markets. Titled 'The Real Jaguar,' the re-release also featured remixes by 430 West's mainstay, Octave One, as well as Derrick May and Jeff Mills – two of Detroit's most diasporic DJs. This display of scene solidarity was further symbolized through an international tour of DJ performances by Rolando and Octave One's Lawrence Burden titled 'Brothers in United Black Vinyl.' And later in the year, the much-revered progenitors of techno, Kraftwerk, sought both Banks and Rolando to remix their comeback hit, 'Expo 2000.' That collaboration amounted to a symbol for a political alliance between the old school and the new in this battle for underground electronic dance music.

Dialogical Dub

A more sceptical observer might see all of this as nothing more than a well-disguised 'anti-marketing marketing scheme,' a concept that Dan Sicko uses in his engagement with UR's early critics.[17] While I disagree with such critiques, I think it is important to raise questions rather than blindly celebrate the 'Jaguar' episode for the sake of its theoretical relevance.

If Sony tried to capitalize on the success and appeal of the original 'Jaguar,' what makes the UR-led campaign any different? Could this really be just another career move, particularly for artists (such as May) with no prior reputation for political activism? There is no doubt that the collective and its network of supporters sold a good number of records and boosted the profiles of their respective labels and rosters. The popularity of the reincarnated 'Jaguar' did not turn Rolando into a pop star at the level of Prodigy or even Richie Hawtin, but it did increase his notoriety beyond levels enjoyed by any other UR-affiliated artist (save Mills). The re-release of 'Jaguar' also succeeded in flooding the market to the point where BMG would recall all unsold copies of the Type cover, making it commercially unavailable to the public, be it in the form of vinyl, CD, or MP3. Most Detroit techno fans are aware of the controversy generated

by the Type cover, but few (including myself) have ever listened to it, let alone heard of the duo. In the end, the memory that most fans have of 'Jaguar' is with reference to the UR-sanctioned mixes. Type, on the other hand, have not had a single hit since and are as significant to electronic dance music history as Milli Vanilli is to contemporary pop.

But if any of this is truly to be seen as an 'anti-marketing marketing scheme,' we still have to account for the fact that UR never received any royalties from either Sony or BMG. Though a lawsuit battle might make that possible, Banks and Rolando have clearly chosen not to go back on the decision to keep this battle restricted to the 'new arena.' One reason might be that their idea of victory is more symbolic than monetary. For fans like Dutch techno DJ MG, the 'Jaguar' case represents a contemporary rewriting of the David and Goliath myth: the humbling of the mainstream music industry through the struggles of local, black-owned businesses.[18] Such interpretations obviously offer a source of empowerment and inspiration to DJs, dancers, label owners, and other denizens of the underground. However, they can also carry certain ambivalences that prove to be highly problematic when scrutinized under the lens of contemporary theory. Though technically a matter of intellectual property, the battle for 'Jaguar' can be read just as easily as a discursive victory for concepts of originality, authenticity, and purity – the very ones Dreyer ironically affirmed in his e-mails. The critiques of Eurocentrism and cultural appropriation may just as easily be read as a celebration of black capitalism. And as someone like Reynolds might be prone to argue, the excessive use of war imagery and confrontational rhetoric can be similarly translated as a glorification of machismo and purposeless violence. Ultimately, the point behind these and other such questions is a matter of ethics: to what extent is a collective like UR able to secure its right to artistic control without reproducing its own dominating forms of hegemony and power?

If we return to Banks's online missive, we find that his rhetorical declarations of war were doubly sounded as a call to community formation on a transnational but also translocal scale:

> we will have no choice but to defend ourselves and the whole of underground music ... I hope you and the brave warriors of your clan can assist us as we are musicians w/ no muscle[;] we can only implant ideas via music[,] which we will continue to do but a co-ordinated effort of the underground global community will be needed to attack such a giant nemesis as Sony.[19]

The battle against the corporate Other is not solely a matter of UR's own self-interest. It is envisioned here as an act of self-defence for the entirety of electronic dance music culture. Banks's rhetoric includes a request for solidarity, but it is equally – and more interestingly – voiced as a challenge to DJs, musicians, and dancers to repoliticize themselves as activists within their respective sonic communities. His idea of activism is vague and has no real positive ideological definition. Instead, the attention is to praxis: to the work of being *active* in generating critical awareness of the culture industry's corporate assimilation of the underground; and to developing collective and networked responses to such machinations. Harris echoes the urgency of this praxis in an e-mail titled 'UR Contacts the Underground':

> while this is an unethical and unprincipled act in and of itself, it is also a very dangerous act. In doing this, a major label, Sony, has determined that it has the right to stomp all over an independent label in its pursuit of profits. With this as a precedent, the question that should concern any and everybody in the music community is who will be next?[20]

For Banks and Harris, the answer is obvious: if UR was first, 'you are' next.

Of course, not every single DJ or dancer took up UR's challenge, but the call nevertheless remained significant as an act of outreach to other like-minded souls positioned near and far, albeit ultimately *outside* the UR umbrella. The mere presence of distance between the various players involved in this case is of tremendous significance to this discussion. Distance is the starting point for all dialogical acts of communication, and it is communication as such that I regard to be at the centre of UR's praxis for musical activism. The means of communication discussed above are mostly in regard to the material culture of vinyl and CD recordings as well as the content of various e-mails and listserv postings. At this point, I want to reread the case of 'Jaguar' and the UR project in general through the lens of musical form, specifically that of antiphony. Antiphony is a technique of call-and-response commonly used in songs performed by two groups of voices. However, as Paul Gilroy has shown in *The Black Atlantic*, this concept is theoretically useful as a metaphor for the dynamic between multiple agents involved in a chain of verbal as well as non-verbal dialogical activities. With 'Jaguar,' the chain begins with Banks and Harris putting out calls to boycott the majors. 430 West responds with the 'The Real Jaguar' and uses the remixes to call on other

participants: the all-star ensemble of remixers; the DJs in various sonic communities; and finally the dancers, who shout back a messy polyphony of responses from dance floors all over the world, giving affirmation to UR's initial call while doubly voicing various calls to action of their own accord.[21]

It is no coincidence that antiphony has a long history of performative use in jazz and other black Atlantic musical forms that have emerged since the era of diasporic African slavery. For Gilroy, this history has political resonances, even though the content of many antiphonic musical works is not overtly political. He writes that 'there is a democratic, communitarian moment enshrined in the practice of antiphony which symbolizes and anticipates (but does not guarantee) new, non-dominating social relationships.'[22] Many theorists limit their engagements with black Atlantic music to the lyrics, but Gilroy is one of the few to translate the non-verbal dimension of its aesthetics into a larger discourse of political philosophy. The work of UR makes similar translations, albeit in the opposite direction. It treats the task of political activism as a musical performance, one that is no less antiphonic, participatory, and improvised than a bebop jam session. No one player, not even Banks, dominates in this culture jam, and the laws of genre as well as ideology are equally displaced. Instead, what lies at the crux here is a shared praxis of dialogical communication.

For UR, dialogical communication is also a subject for political philosophy, one that has its discursive roots in a manifesto that was first etched onto the blank b-sides of the 'World Power Alliance' trilogy and that has since been slightly revised and posted under the 'Creed' section of the collective's website. Two excerpts are highlighted below:

> We urge you to join the resistance and help us combat the mediocre audio and visual programming that is being fed to the inhabitants of Earth, this programming is stagnating the minds of the people; building a wall between races and preventing world peace. It is this wall we are going to smash.

> We urge all brothers and sisters of the underground to create and transmit their tones and frequencies no matter how so called primitive their equipment may be. Transmit these tones and wreak havoc on the programmers![23]

The manifesto opens with a theory of technological difference: programming versus tonal transmission. The former is a top-down inductor of

passivity; the latter is interactive and dialogical. The Type cover would qualify as the work of the programmers, and the same would be true for trance, electronica, and other uninspired, non-vernacular, corporate-friendly reproductions of electronic dance music. In the spirit of Malcolm X, the manifesto calls for a by-any-means-necessary approach to technology; the tools don't matter so long as they can generate tones that are loud enough to reach across translocal distances and borders. Ultimately, at the heart of the 'World Power Alliance' is the antiphonic rhetoric of its last line, its invitational challenge to participate in this not-so-unreal fantasy of a 'sonic revolution.'[24] Widely quoted by journalists as well as fellow artists and fans, this manifesto may very well be more popular than any piece of music in the UR discography.

There is no authorial credit for the 'World Power Alliance' manifesto; all we know is that it was 'composed somewhere in Detroit, Michigan U.S.A. on May 22, 1992 at 4:28 PM by various elements of the world underground legions.'[25] This is also the same year that Francis Fukuyama declared the global triumph of capitalism as a signpost to the 'end of history.' Whoever actually wrote the 'World Power Alliance' manifesto knew well that history has a b-side and that the end of it was really a beginning for new forms of empire and social injustice. While the emotional tone of the manifesto is uninhibitedly angry, its message is essentially hopeful in presenting a vision of resistance as well as community building in a transnational world. Music, sound, and technology are the means by which this vision is realized, but the key is in their dialogical use. To conclude on this aspect of the collective's political philosophy, I will briefly look at a few examples of what Kodwo Eshun calls 'sonic fictions' within the UR discography and re-examine them from the perspective of Gilroy's enduring work on diasporic, African consciousness in *The Black Atlantic*.[26]

The first of such 'sonic fictions' is in a series of recordings by Drexciya, a codename for the late UR producer James Stinson. In between bass arpeggios and minimal electro-breaks that are otherwise *de rigueur* for most Detroit techno, the music of Drexciya distinguishes itself with a penchant for distorted cybervoices and splashes of analog noise. Liner notes to *The Quest* compilation supplement the mysteries of these eerily undecipherable tones with a creation story based on African American folklore. Drexciya, the Unknown Writer tells us, is the name of a black Atlantis civilization built by the survivors of the Middle Passage: 'pregnant America-bound African slaves were thrown overboard by the thousands during labour for being sick and disruptive cargo. Is it possible that they

could have given birth at sea to babies that never needed air?'[27] For Eshun, the Drexciyan mythology affirms the same 'webbed networks' of diasporic migration theorized by Gilroy in *The Black Atlantic*. At the same time, the myth enunciates a critique of Gilroy's grand yet selective archive of music, literature, philosophy, and other such discourses re/produced through their circulation on transatlantic routes; this is a critique of Gilroy's musical tastes as well as his unconscious humanism.

Gilroy hails the music of Soul II Soul, with its syncretic redesigns on African American hip hop, Jamaican reggae, and black British diasporic memory, as one of the most profound expressions of late-1980s black Atlantic cultural politics. Uncomfortably queasy with the regenerative optimism of classic tracks like 'Keep on Moving' and 'Back to Life,' Eshun argues in favour of Drexciya's cybersatyric modes of expression: 'Drexciyan tonal communication is worlds away from this nice 'n' easy lyrical message. Electronics volatises the soul at the push of a button: there's no singer, no redemption, no human touch. Far from rehumanising electronics, Drexciyan fiction exacerbates this dehumanization, populating the world with impalpable hallucinations that get on your nerves.'[28] It is interesting that where Reynolds rejects UR's music and rhetoric as thuggish, Eshun celebrates the same sonic signifiers in Drexciya, going so far as to exalt it as a form of *eso-terorrism*: 'the esoterrorist plants logic bombs and then vanishes, detonating conceptual explosions, multiplying perceptual holes through which the entire universe drains out.'[29] While I admire Eshun's creative interpretations as a supplement to Drexciya's mythopoetic works, his metaphors of terrorism demonstrate a critical sensibility that has more to do with matters of aesthetic taste than political consciousness, let alone activism. Drexciya, for Eshun, is post-humanist in its techniques of estrangement and alienation; it refutes the kind of interpersonal connection that so beautifully inspires Gilroy in his listening experiences with Soul II Soul. And while I too derive pleasures from symbolic forms of terror in music and art, I am wary of the kinds of controversies that emerge when those pleasures are fetishized within the political contexts of our post-9/11 world.

I have my own interpretive remix of the Drexciyan myth, one that aims to do justice to UR's praxis of dialogical communication. The squelches and noises on classic tracks like 'Depressurization' and 'Doctor Blowfin's Water Cruiser' are undecipherable only to the majority of terrestrial beings. On the other side of the veil, separating land from water and the Americas from the Atlantic, these same tones seem to constitute a vocal language and, therefore, a communicative act of transmission from one

chronotope to another. The music of Drexciya confounds the program-
mers, but it sends a direct signal to those tuning into the coded frequen-
cies. The question is not whether Drexciyans exist, but rather to whom
are these tones speaking? To underwater refugees of the Middle Pas-
sage? To descendants of slaves on land? Either way, for this listener, they
symbolize a desire for translocal dialogue between the members of two
communities similarly marginalized by modernity.

As Arif Dirlik points out, postcolonial theories of hybridity are almost
always concerned with interactions between black and white, First World
and Third, but never with the interstitial exchanges between two non-
Western or non-white subjects.[30] Gilroy is arguably the rare theorist to
engage this as a discursive possibility when he redefines the concept of
blackness as something that emerges in between the communication
routes that link up communities of African descent from various times
and spaces in Africa, the Caribbean, North and South America, and Eu-
rope. However, as with Bhabha, Gilroy's dazzling use of wordplay can
lead the less rigorous reader to overlook the significance of his historical
framework: the Middle Passage, slavery, racism, and colonialism. Black
culture, be it in art or politics, is significant for Gilroy when it represents
a critical response to those and other unjust conditions of oppression,
and the same is no less true for the focus on race in UR discourse.

Contrary to first impressions, UR's membership is not uniformly black:
Rolando is Latin American; DJ 3000's parents are Albanian; and Banks
is of African American, Blackfoot, and Choctaw descent. Where many
contemporary musicians (anyone from Shakira to M.I.A.) draw atten-
tion to their hybridity as a symbol of ever-increasing globalization, UR
complicates things further by exploring these and other such identities
through the language of science fiction, as in the case of the Drexciyan
aquanauts. Another important example is the Red Planet series, whose
visionary tracks are dominantly titled according to themes from First Na-
tions mythology and ceremonial practice: 'Ghostdancer,' 'Tobacco Ties,'
and 'Prayer Stick.' Yet the authorship on these tracks is credited solely
to The Martian, an anonymous figure whom many believe is Banks's al-
ter ego. Such techniques of self-estrangement are continuous with the
larger narrative of deception and mystique that characterizes the major-
ity of UR's story, but there are moments where the masks do come off, as
in the case of Banks's most recent work as collaborator with Indigenous
Resistance (IR). Despite the similarity of name, IR is not a UR-affiliated
project, nor is it one in which Banks plays a central role. It exists on the
periphery of the UR archive, yet its significance is crucial to this discus-

sion on what I call the 'outernationalist' philosophy and praxis of musical activism within UR and electronic dance music in general.

IR is an offshoot of The Fire This Time, a 'radical musicaldubwisdom collective' whose history of music, video, literary, and visual art productions spans more than two decades.[31] The political focus of their work is on anti-colonial/globalization struggles, but with specific attention to the translocal alliances among black, South Asian, Latin American, and various Aboriginal peoples from reservations in North America to the Solomon Islands in the South Pacific. IR recordings incorporate a strong use of spoken word, historical commentaries, and factual information, giving tracks the feel of an audio documentary. At the same time, the polyphonic interplay of sounds, voices, and discourses being transmitted within these sonic *non*-fictions is produced through the use of various techniques that have their origins in 1970s Jamaican dub reggae – a point of great emphasis in IR literature.[32] Dub is one of the earliest forms of electronic dance music, underacknowledged partly because it predates rave culture but also because it grew out of the margins of the postcolonial Third World rather than the inner cities of Western modernity. Popular for its psychedelic use of echo, reverb, and other pre-digital studio technologies, dub privileges the studio engineer and his/her soundboard at the centre of musical creation – in other words, it's all about the mix. For IR, dub science is ultimately what makes it possible not only to record and layer a wide range of translocal voices, but to also bring their subversive sounds and radical ideas into a virtual conversation. The case of 'Krikati' is one born out of multidirectional dialogue between Banks's dreamy electro-rhythms, the reverb assaults of Black Uhuru producer Steve Stanley, and the distorted tabla samples of Asian Dub Foundation founder Dr. Das; the assemblage of sounds here is then used as a soundtrack to a bilingual commentary on the Krikati Indians and their struggles for land demarcation rights in contemporary Brazil.

Dub is a big influence on Soul II Soul but also on Gilroy, who demonstrates his affinity with the art form through frequent deployments of the term 'outernational' in *The Black Atlantic*. The term has its origins in Jamaican sound system culture, and although Gilroy acknowledges this vernacular history, he never examines its deeper theoretical significance. For me, 'outernationalism' is the most accurate one-word description for the political philosophy and praxis of musical activists like UR and IR. If 'international' suggests a relationship between subjects at the national level, 'outernational' is one that takes place outside of state and metropolitan centres of power. It signifies a dialogical relationship from the

7.1 Back cover art by Dubdem for *IR14 Direct Action Dubmissions* CD (2008). Courtesy of Indigenous Resistance and Dubdem.

chronotope of one margin to another. Outernationalism is thus a synthesis of transnational and translocal modes of consciousness, the global awareness of the former and the dialogical intimacies of the latter. It is also a type of attitude: a sense of disregard for nationalism, internationalism, and other political processes that exercise a more systemic disregard for minorities (who are technically majorities) marginalized on the borders of a seemingly borderless world.

Conclusion

Praxes of musical activism born from outernational transmission are not unique to techno, dub, or electronic dance music in general. We

might find similar examples of antiphony and dialogical outreach in folk, punk, hip hop, and other such forms if we look and listen for them – in their lower frequencies. What makes the work of UR and IR unique is the ways in which their musical activism foregrounds this philosophy through turntables, synthesizers, mixing boards, computers, and the Internet. One might argue that the reappropriation, subversion, and translation of these technologies cannot undo, but can only affirm, the capitalist industries from which they originate. If we tune in to the lower frequencies of Western modernity, we find that the attitude behind these forms of musical bricolage is not specific to those 'new technologies.' In fact, they have their pre-digital antecedents in the widely recounted narrative of plantation slavery, when slaves used drums to communicate with other slaves, particularly during times of crisis. Drums represented an early form of communications technology, and their rhythm operated as a language born from the consciousness of oppression, one's own but others' as well. As the story goes, these drums were banned by the plantation owners but their rhythms survived well into contemporary forms of popular black music and, consequently, Western pop; they also mutated into alien forms such as techno and dub. For outfits like UR and IR, their connection to this legendary history is more ethical than ethnic and ancestral. It's about making music as a transmission, one with the tonal urgency of a banned drum, calling us to listen and challenging us to respond as individuals and communities. In the age of global capitalism, not all listeners are ready to take up the challenge of an outernational transmission. Many have lost what once was part of their cultural memory: an aural literacy of sonic literatures, fictional or otherwise. It is the task of musical activists of any age, society, and genre to remember and reinvent this literacy as a strategy of underground resistance.[33]

NOTES

Sound Recordings Discussed
Hope Collective, *Give and Let Live* EP. Pony Canyon, 2005.
Asian Dub Foundation, 'Free Satpal Ram.' FFRR, 1998.
Underground Resistance, 'Riot' and 'Sonic Destroyer.' *Revolution For Change.* Network, 1991.
Underground Resistance, 'Install 'Ho Chi Minh' Chip.' *Electronic Warfare.* Underground Resistance, 1996.
The Aztec Mystic, 'Jaguar.' *Knights of the Jaguar* EP. Underground Resistance, 1999.

Type, *Jaguar*. Ariola, 2000.
DJ Rolando, *The Real Jaguar*. 430 West, 2000.
Kraftwerk, *Expo Remix* EP. EMI Electrola, Kling Klang, 2000.
Drexciya. *The Quest*. Submerge, 1997.
The Martian, 'Ghost Dancer.' *Ghost Dancer* EP. Red Planet, 1995.
The Martian, 'Prayer Stick.' Red Planet, 1998.
The Martian, 'Tobacco Ties.' Red Planet, 2003.
Indigenous Resistance, 'Krikati.' *IR14 Direct Action Dubmissions*. Indigenous Resistance, 2008.

1 The inspiration to address the music business as a culture industry comes from John Hutnyk in his brilliant study of British Asian dance music, *Critique of Exotica* (London: Pluto, 2000). However, where Hutnyk's concept of the culture industry is clearly derived from his use of Frankfurt School theory, the framework for this chapter has its unspoken foundations in Bakhtin's notions of un/official cultures and the interplay of centripetal/centrifugal forces. While Adorno and Horkheimer are useful for analysing the means by which art is commodified and emptied of its ritual (or radical) value, Bakhtin arguably takes the discussion one step further in theorizing practical possibilities for subversion and reappropriation at the proletarian level.

2 Readers familiar with these scenes are likely to debate the dates here, and that is inevitable, given that some of these developed over periods longer than a year, while others developed their sounds long before finding a suitable tag. As a listener rooted in North America, I also defend this timeline based on the time it took for these scenes to arrive on this side of the Atlantic.

3 Simon Reynolds, *Energy Flash: A Journey through Rave Music and Dance Culture* (London: Picador, 1998), 206.

4 '*Hardcore* is that nexus where a number of attitudes and energies mesh: druggy hedonism, an instinctively avant-garde surrender to the "will" of technology, a "fuck art, let's dance" DJ-oriented functionalism, and a smidgen of underclass rage.' Ibid., xvii.

5 Ibid., 207.

6 '"Mad" Mike – a self-described "serious brother," famous for his refusal to be pimped or "tap dance" on cue – declined to be interviewed, arguing that the history of Detroit techno should be written by a Detroit native, and someone black.' Ibid., 205. It should be noted that Banks has granted a good number of interviews with other white journalists for magazines like *Debug, Jockey Slut*, and *The Wire*. His rejection of Reynolds was likely for reasons that went beyond racial differences.

7 Ibid., 207.
8 These correspondences are currently archived at the Renegade Rhythms website under *Boycott Sony & BMG: Corporate Multinationals, Sony and BMG, Have Stolen Rolando's Track*, http://www.renegaderhythms.com/home.html?main=http://www.renegaderhythms.com/articles/ur/home.html, accessed 14 October 2008.
9 Ibid.
10 'Sony Informs UR of Their Intentions,' at ibid.
11 'Sony Recalls Fake Jaguar,' at ibid.
12 Ibid.
13 Ibid.
14 Mark A. McCutcheon, 'Techno, *Frankenstein* and Copyright,' *Popular Music* 26, no. 2 (2007): 273.
15 Ibid., 260.
16 Renegade Rhythms website, 'UR has been Ripped Off.'
17 Dan Sicko, *Techno Rebels: The Renegades of Electronic Funk* (New York: Billboard, 1999), 147.
18 DJ MG, 'UF Reports: UR vs Sony/BMG – David Vs Goliaths,' *The Underground Files*, February 2000, http://www.undergroundfiles.com/ur.html, accessed 14 October 2008.
19 Renegade Rhythms website, 'UR Has Been Ripped Off.'
20 Renegade Rhythms website, 'UR Contacts the Underground.'
21 McCutcheon cites a few cases of UR fans secretly scratching up vinyl copies of the Type cover at their local record stores, then going online to publicly encourage others in doing the same. McCutcheon, 'Techno, *Frankenstein* and Copyright,' 274.
22 Paul Gilroy, *The Black Atlantic* (Cambridge, MA: Harvard University Press, 1993), 79.
23 Underground Resistance website, 'Creed,' http://www.undergroundresistance.com//main/content/view/12/26, accessed 14 October 2008.
24 Ibid.
25 This date is on the original version's manifesto, for which the transcript is available at http://www.discogs.com/label/World+Power+Alliance, accessed 14 October 2008.
26 Kodwo Eshun, 'Fear of a Wet Planet,' *The Wire* 167 (1998): 18–20.
27 The Unknown Writer, untitled liner notes to *The Quest*. Submerge, 1997.
28 Eshun, 'Fear of a Wet Planet,' 20.
29 Ibid.
30 'The hybridity that postcolonial criticism refers to is uniformly a hybridity

between the post*colonial* and the First World; never, to my knowledge, between one post*colonial* intellectual and another.' Arif Dirlik, *The Postcolonial Aura: Third World Criticism in the Age of Global Capitalism* (Boulder: Westview, 1998), 65.

31 Indigenous Resistance, 'Tapedave Music Press Release,' 2008.

32 Atua Dub, *Indigenous and Black Wisdubs* (Toronto and Sosolakam: The Fire This Time Pub, 2005).

33 I gratefully acknowledge the oral and aural resources of UR's Cornelius Harris and various anonymous members of IR in the research of this paper.

8 Transnational Indigenous Feminism: An Interview with Lee Maracle

CHANTAL FIOLA

CHANTAL FIOLA: The concept of 'transnationalism' remains open to interpretation and discussion. What is your understanding of this term, and do you see it as relevant to contemporary indigenous struggles?

LEE MARACLE: Almost all of my understanding of any word, English or otherwise, is connected to my indigenous point of view, our stories, and my particular interpretation of them. In our language [*halkomeylem*] there is no word that comes close to 'exclusion.' Furthermore, we believe there is one earth and that all humans are relatives. That being said, colonialism has skewed the relations between all humans such that in order to even perceive of ourselves as relations, those denied nationhood must have it and those from the privileged colonial nations must participate in the resurrection of nationhood for the colonized. Those impoverished by colonial exploitation must be relieved by those who have come to enjoy the privilege of being located in the colonial mother countries.

Indigenous people are in an odd circumstance: on the one hand, we are denied nationhood, we are surrounded by settlers. On the other hand, we garner some of the privileges generally granted only to the settlers. This tells me that we need to look beyond our nations, beyond our borders at the whole world, the conditions of our relatives everywhere, and include them in our sense of justice.

Furthermore, the women of the world (women of colour, including indigenous women here) live under constant threat of violence. As a woman, my sense of justice, my sense of transnationalism, includes a feminist foundation. As long as it is not safe to be a woman, I will uphold a transnational feminist point of view.

CF: Your response draws attention to the inextricability of culture, world view, and language. If 'transnationalism' and 'transnationalist' discourses are predominantly theorized in English, what consequences might this have on indigenous cultures, world views, and people?

LM: I believe that, as indigenous people, we have made great strides in adapting English to accommodate our sense of story, world views, and philosophies. I also believe that a great deal of work has already been done by indigenous scholars to articulate our world view in English. I realize some indigenous people believe that to understand the culture, to express it, one must speak their 'own' language. Those who are disconnected from their culture *and* lack the flexibility that a thorough grounding in English (as a polyglot language) can offer, may have difficulty. However, those who grew up in the culture *and* who have mastered English, with the express purpose of articulating their own world view, do not experience this difficulty. In short, those who have mastered their original sense of story and English are more than able to engage in dialogue.

CF: Earlier you said that, while denied nationhood, indigenous people also 'garner some of the privileges generally granted only to the settlers.' Can you please explain what you mean by this, as well as what this might mean in terms of transnational indigenous activism?

LM: We live in a global, imperial empire. Corporate exploitation, to some degree, deprives us all, but much of the wealth extracted globally finds its way to North America, where many of us have acquired enough exchange power to purchase cheap goods from the areas of superexploitation outside our continent. The level of unemployment for indigenous people has been steadily dropping since the 1960s. The level of education has been rising. This enables us to work and acquire the consumer items that the rest of the world is denied. This is the nature of privilege established by international, corporate imperialism. Furthermore, this privilege of only having to work 37.5 to 40 hours a week creates 'leisure time.' Time is a privilege.

CF: You point out that some indigenous people simultaneously enjoy such privileges, but nonetheless exist in a relationship of power imbalance with the dominant population – for example, the descendants of the settlers. What are the consequences of this complex positionality in relation to transnational crossings of ideas and people, especially transnational indigenous activism?

LM: Wow! It isn't often I receive a question that I am not sure I can answer. Here is my effort:

It is a single global system of oppression that we are dealing with. In this computer age, recessions are resolved – I should say mediated – on behalf of capitalism reasonably quickly, in such a way that those in the privileged sector barely notice they are in a recession. That is, programs are dumped, and money is withdrawn from one sector and deployed into another. Most of our clothing, for instance, is produced piecemeal elsewhere, and those who produce it are paid at starvation rates. If we experience a downturn in wages, generally they find ways to pull more money out of Asia, Africa, and Latin America. What we need to do is be cognizant that when we seek monetary gain here, we are also assuring greater exploitation elsewhere. As transnational activists, we need to be continuously cutting back wasteful consumption and searching for the 'effect' elsewhere of gaining greater privilege here. Indigenous people need to be less concerned about being 'programmed into privilege' and more concerned about an equitable share of the land and resources. We ought to be looking at nationhood rather than funding.

CF: Can you please further elaborate on what you mean when you say that you uphold a 'transnational feminist point of view'? How does this play into your call for indigenous peoples to focus on nationhood in their activism?

LM: To develop a transnational (across countries) point of view that is inclusive of all women, from all countries, and to look at the conditions of women in general and apply a feminist analysis to these conditions. Nationhood, under colonization, is a prerequisite to democracy. However, if we apply a feminist world view, then we need to look beyond simple self-determination and establish, as the foundations for activism, the reclamation of the original position of women in those societies that were matriarchal and alter the structure of our communities to make this original position real. That is, to ensure the power and place of women in the active struggle for self-determination, not simply for Aboriginal nations, but globally. We need to tie ourselves to the global struggle of women for liberation and emancipation.

CF: What do you mean by 'matriarchy'? Also, what is entailed in the 'original position' of women in such societies?

LM: Some societies were organized in such a way that women controlled

all wealth, including determining surplus and influencing trade with surplus. As well, women in general were in charge of the social well-ness of the community. People did not have the right to choose to be violent, stingy, and so on. This is matriarchy to me.

CF: Do you have any suggestions on how we can make such a position 'real' in contemporary times?

LM: First, I think we need to use the privilege of access to information to connect ourselves to women's struggles in those countries where women are unsupported in their efforts, and in those countries and regions where Canada clearly benefits from imperialist interference: Afghanistan, Africa, and South America. We need to reconfigure our lives to link ourselves to others. Even the simplest of things, such as clothing purchase – when possible, buy less, choose organic, choose to purchase from those areas where women are making efforts to form survivalist co-ops – can help. Over the past two years, I have been switching to organic (cotton) clothing produced in India by women who have formed co-ops.

Second, I think we need to get really petty (in a good way) and calculate the number of spare hours that we have each week. My calculation goes something like this: 45 hours of work time (including teaching, writing, editing, speaking, and so on) each week, 14 hours for family, 49 hours for sleeping, 14 hours for eating (I eat twice daily), 8 hours a week for R and R, 20 hours for travel back and forth to work, and 8 hours for maintenance (laundry, house cleaning). There are 168 hours per week. This leaves approximately 24 hours to devote to my international/feminist/indigenous commitments. Much of this time is spent on research, writing, changing my lifestyle, trimming back, and planning and connecting to feminist struggles elsewhere. Time is a privilege that imperialist economies secure for people in North America; we need to budget it in the same way we need to reconceive of our family and personal budgets. We need to reconceive of our personal time management and budget it in a way that connects us to the global struggle for women and oppressed peoples' freedom.

Some of the above time is 'spent' attending feminist (international) activities and some is spent travelling gratuitously to those areas that cannot pay, but most of it is spent trying to find out who is growing organic cotton in areas where women or children actually benefit. Whenever I can, I shop at organic food stores and purchase 'fair

trade' coffee that comes from organic farms in which women are participants.

In our families we need to reconceive of our family relations, first by talking about them, second by forming a family (liberation) plan. We must rear our children (grandchildren, nieces, nephews) as a unit in a way that breaks down patriarchal thinking and being. We need to *rematriate* our families. For me, it means letting go of sons who eventually will become the husband of a woman who must be in charge of her family. It also means keeping daughters close and raising them in a way that makes them capable of managing the social relations within the family – empowering our daughters.

If you came from a matriarchal society, why would you need feminism? Many of our societies were either matriarchal or co-lineal (gender complimentary). Anyone who argues that this is still the case is delusional. Reinstituting either of the above structures is a feminist act.

CF: In your opinion, does art play a role in indigenous [and] feminist transnational struggles?

LM: Art is always conjured, imagined from a position and aimed at freedom. Of course, it plays a role in both feminist and indigenous struggles. In fact, for the oppressed, art, freedom, and feminism intersect and become part of a global struggle for renewal. This always begins with an imagined sensibility of future and becomes artful and lends itself to artistic growth and development.

CF: How do questions of globalization impact your own artistic practice as a poet, storyteller, and author?

LM: Globalization is really just a strange concept, almost an apology for the reindustrialization of imperialism in those parts of the world that have hitherto been on the periphery. I think it impacts both my personal and my artistic life. Indigeneity becomes connected to the 350 million indigenous people who are being globalized, particularly women.

CF: In your opinion, are traditional indigenous spiritual beliefs important in contemporary transnational, indigenous feminist struggles? Do they connect to these questions about globalization and transnationalism?

LM: I am really not fond of the term 'traditional,' as it has become so

connected to the desperate need of those who have one foot in Euro society, and one foot in redemption of the past, to grant credibility to the 'paganism' we suffered so much for. I have a spiritual sensibility. It is personal, familial, and originates in my own sense of beliefs, praxis, and world view. I am contemporary, transnational, and engage in feminist struggle. Does my spirituality reconcile itself to that? Yes. Is it a requirement? No. Is it important? It is to me.

Also, isolating our spiritual beliefs from feminism, transnationalism, globalization, and what we 'know' is a Western practice based on a compartmentalized paradigm of 'quarantine, isolate, and study.'[1] Globalization is a by-product of a colonial-capitalist-imperialism that fits the paradigm. I have said this over and over again: Nothing is disconnected – NO THING. Whatever happens to the earth reverberates in the world, affects us, and joggles our thinking in a certain direction. Violence to earth, violation of women, and globalization are all connected; to struggle for one and pay no attention to the rest of the humanization process would be a waste of time. The belief that nothing is disconnected is bolstered by our thinking, our being and, of course, our sense of the spirit. Our spiritual belief systems are not separate from our bodies, nor are they disconnected from the world.

CF: Further pointing out the controversy surrounding the term 'tradition,' some indigenous people say that feminism and same-sex relationships, for example, are not 'traditional' and therefore should not occupy space within indigenous struggles. What is your response to this?

LM: We don't have to dig very far to find *berdache*, homosexuality, lesbianism, and so on, in our societies. The missionary texts that form *The Jesuit Relations* are full of the open and 'immoral' sort of sexuality found in Sodom and Gomorrah that the Jesuits so loathed. It is what had us designated heathen and pagan in the first place. Again, I am a little wary of the term 'traditional,' but 'traditionally' some of us also held slaves. I don't believe that anyone wants to volunteer for this position anymore. Furthermore, 'traditionally,' in some societies – Salish, and so on – men had more than one wife, and although humans generally don't deal well with monogamy anywhere in the world, few women would want to volunteer to be part of a polygamous arrangement today. We also had societies that were polyandrous, and I don't know any men who want to be part of some woman's harem. Plenty of

things went on 'traditionally' that no one wants to sign up for, hence traditionalism is not what it is about.

Freedom has always been the direction we travelled in. To imagine that there were never gay or homosexual or transsexual people in our communities prior to the colonial period is to say that sexuality is a choice. I don't know anyone who sat down as a ten-year-old and said, 'Hmmm ... gay, lesbian, homosexual, heterosexual, what shall I choose?' Same-sex relationships have always existed; whether they were persecuted, forbidden, or banned does not render them mute. There is a story here on the West Coast about a woman who had a husband and a wife. She had a husband so she could have children (no artificial insemination in those days). Once that role was fulfilled, he pretty much had to find his own sexual entertainment, so he took another wife.[2]

The denial of the space to love, any love between adult human beings, for any reason, is oppressive. Our cultures once were inclusive cultures, which meant that the space to love one another was accorded to all citizens. To restrict same-sex relations between adult humans amounts to social rape.[3]

CF: You have been discussing the importance of indigenous peoples working together, despite difference, on a transnational and global scale. Would you say you are advocating a *pan-indigenous* position? What would you say are the advantages and disadvantages of such a position?

LM: No, I would say that I am advocating an anti-imperialist, global, and national/feminist position. If you look at the Iroquoian Constitution, 'we can all sit under the tree of peace and co-exist, maintaining our own nations and identity so long as we follow the laws of co-existence, non-interference and non-oppression.' In which case, there are no disadvantages, only advantages.

CF: On 11 June 2008, the federal Canadian government officially apologized for the assimilative agenda of residential schools and to Aboriginal survivors of residential schools. Utilizing the transnational attention being garnered by the apology, what would you say to the federal government, as well as to Aboriginal survivors and relatives of survivors, in the wake of the apology?

LM: I have nothing at this time to say to the federal government. However, I think it is absurd to apologize for the residential school system after stealing half a continent and continuing to hang on to it as though

it were theirs. Canada is still a settler state, and Aboriginal people here are still being colonized. This can be seen in the apology, which essentially says: 'Oh, sorry if any of what we put you through hurt.' Exactly how does an apology decolonize this settler state? It trivializes ongoing colonization. So, for Aboriginal people, it is not actually much of a wake. We still have a mountain to climb, a colonial order to defeat, and a struggle to find freedom in this oppressive context.

CF: What role do you believe non-indigenous people play in transnational, indigenous feminist struggles?

LM: I don't know any non-indigenous women who are playing any specific role in transnational, indigenous struggles, but whatever role they choose to play is their business and the business of those they connect with.

CF: What advice would you give to indigenous people who are interested in becoming [more] involved in transnational, indigenous feminist struggles?

LM: I think we need to envision our lives, determine how we want to have lived them. That is, at the age of seventy-seven (the average woman's life expectancy in North America), when we look back on our journey, what would we like to have accomplished? Who would we like to have established relations with? What values would we have liked to uphold? Then sit down and plan out how we are going to chart our lives so that we die without regrets.

CF: What are you working on now? How does it relate to these issues?

LM: I am working on *Oratory on Oratory*, a book about indigenous story writing and the study of indigenous story. It is about colonization and decolonization of the so-called canon and the inclusion of literary works outside the canon, the breaking down of gatekeeping as a practice, and so it is aimed at freedom for all. I am working on a novel entitled *Celiasong*, a continuation of the family in my novel *Ravensong*, from the child Celia's perspective. It is about the 'dance of death,' murder, child sexual abuse, and all that dark stuff we are currently immersed in. Facing it will help us to come into our own light, as women, as children, as empowered international and transnational citizens. I am also working on a collection of short stories. I also belong to various groups, not a devoted member, but I do keep my oar in the civic water, as it were.

CF: Thank you so much for taking the time to share some of your ideas and important messages. Are there any final words you would like to conclude with?

LM: My stories are always geared at cultural/national recovery from an indigenous perspective. I conjure stories because they come to me.

NOTES

1 Terry Spanish, *Quarantine, Isolate, Study.* Unpublished manuscript.
2 Personal communication between Lee Maracle and J.B. Joe Didinat.
3 See Lee Maracle, *I Am Woman: A Native Perspective on Feminism and Sociology* (Vancouver: Raincoast, 1996), especially the chapter 'Isn't love a Given?'

9 This Is What Democracy Looks Like? or, The Art of Opposition

KIRSTY ROBERTSON

In 2003, at the age of twenty-four, photographer Ryan McGinley became the youngest artist to have a solo exhibition at the Whitney Museum of American Art in New York. That show quickly spun into others, including an exhibition organized by the prestigious PS1/MOMA and a 2007 International Centre of Photography 'Young Photographer of the Year' award, which propelled him into the upper reaches of artworld stardom.[1] Known for his highly sexualized photographs of Dionysian release – of youth running through the streets and partying on cocaine and alcohol – McGinley became something of a phenomenon, lauded for capturing a carefree youthful essence somehow missing from the artworld.[2] At the centre of the Whitney show was McGinley's 2000 photograph 'Dash Bombing,' a grainy image of a young man (actually McGinley's friend and fellow artist Dash Snow) standing precariously on a ledge high above New York City, caught in the motion of tagging an abandoned building.[3] 'It's an image of anarchic freedom,' wrote *New York Magazine* reporter Adrien Levy, 'one that seems anachronistic and almost magical in this city of hermetically sealed glass-cocoon condo towers. It's as if Snow were an animal – prevalent in the seventies, now thought to be extinct – that was spotted high over the city.'[4]

The Kids Are Alright was the title of McGinley's now famous breakthrough series, a label referring to the 'downtown neverland where people are thrilled and naked, leaping in front of graffiti on the street, sacked out in heaps of flannel shirts – everything very debauched and drug-addled and decadent, like Nan Goldin hit with a happy wand.'[5] According to the numerous reviews, what made McGinley's work so popular was not so much his technical skill (although formal and aesthetic judgments were often called upon to back up the exhilaration with which McGinley

was/is celebrated),[6] but more so the idea that there was a subculture of joy, hedonism, and vitality alive and well in the city and that McGinley himself was living this life.[7] Wrote critic Philip Gefter in a review in the *New York Times*, 'by day [McGinley] photographed [his friends] running, skateboarding, moving, always in motion. By night they were partying, having sex, taking drugs, living fast.'[8] Brian Droitcour, writing in *Artforum*, called McGinley's images 'a fantasy landscape where time and underwear don't exist.'[9]

Within the hyperbolic celebration of alternative lifestyle that characterized the reception of McGinley's work, however, there ran a subcurrent, a slippage that pointed to a hope that in the laughing faces of McGinley's friends could be found an assurance that it was not just the kids, but everything that was all right. The drug- and alcohol-fueled lifestyle found in the photographs brought with it not a moral message (McGinley was not the progeny of Nan Goldin, though the comparison was often made), but an erasure of concerns defining that moment in George Bush–led America – the tumbling economy, the war in Iraq – an erasure so strong that it implied denial. While McGinley's *The Kids Are Alright* series might have suggested 'that a gleeful, unfettered subculture was just around the corner – still – if only you knew where to look,'[10] it also suggested a certain desperation in that search, particularly when McGinley intimated that he himself did not belong to the fantasy life that he purportedly documented.

What is of interest here is not a value or aesthetic judgment of McGinley's youthful sexuality turned into art, but instead the timing of his meteoric rise into the artworld. The year 2000, the year of McGinley's *The Kids Are Alright* series, was one in which the kids were very much not all right, but were taking to the streets in cities around the world in unprecedented numbers to protest the inequitable results of the spread of global capitalism. In fact, the very period that was captured by McGinley as one of bacchanalian release was more often characterized by the mainstream media as one of political uprising, of massive protests marked by tear gas and arrests, and of youth out of control and creeping dangerously close to an anarchy far removed from the 'anarchic freedom' found by writer Ariel Levy in McGinley's work.[11] There is a compelling, though unintentional, mirroring here in the 'anarchic freedom' of the partyers and the protesters – the numerous anti-corporate, 'anti-globalization' (referred to more accurately here as alter-globalization) activists who took to the streets in North America between 1999 and 2003 (and elsewhere, of course, long before and long after). This is a similarity that goes beyond a formal comparison and that speaks to a more com-

plicated affiliation, particularly given the repeated dismissal of protesters as alienated teenagers looking for a place to party.[12]

Without suggesting a direct or cause–effect relationship here, I investigate and unravel the knotty correspondence between the embrace of McGinley's apoliticized, indeed anti-politicized, work by the artworld and its oblique relationship with the contemporaneous alter-globalization movement. Unlike the many remarkable and engaged creative projects that were taking place self-consciously outside of the artworld and in conjunction with the 'movement of movements,' McGinley made no claims to a resistant standpoint, nor to any connection with anti-capitalism. In fact, his work with corporations such as *Puma* and magazines such as *Vice* might instead suggest in his work a blurring of the lines between art and advertisement.[13] It is not my goal to position McGinley's work as in any way resistant. Rather, I use the series of bacchanalian photographs as exemplary of a certain focus of interests in the artworld in the period between 2000 and 2008, a period that saw protest move from a spectral presence on the margins to a central position at the heart of a number of American and international exhibitions, even as the artworld itself was increasingly imbricated in global economics. The relationship of McGinley's images to protest may be a circuitous one, but it speaks strongly to the fractious relations among political activism, capitalism, political art, and the artworld.

Though I will spend the greater part of this chapter tracing the dismissal of protest art by the mainstream, I end by suggesting that in the embodied experience of action/activism rests a fundamental and inexorable difference between the *action* of and the *recording* of protest. I play out this comparison by drawing on reviews of specific artworks, where both the work and the review focus on the momentary and ephemeral experience rather than on the (infinitely co-optable) politics or formal elements of the piece. The difference that I draw out is the divergence between the performance of escape within the action of protest, and the writing of escape into a chronologically organized, linear art-historical model that tends to use resistance to support the idea that art is at the vanguard of society. Another way of looking at this might be to contrast the unlocatable 'deterritorialized' politics of certain artworks and the transnationalism of the alter-globalization movement with the reterritorialization of a Western art-historical discourse.

In 1998, just before the alter-globalization movement emerged as a global force, activist John Jordan wrote that 'since the beginning of this century, avant-garde agitational artists have tried to demolish the divisions

between art and life and introduce creativity, imagination, play and pleasure into the revolutionary project. My argument is that the DiY [do it yourself] protest movement has taken these "utopian" demands and made them real, given them a "place."'[14] It was the carnivalesque outpourings of youth-led and rave-inspired politics such as the Anti-Road movement in Britain in the late 1990s and Reclaim the Streets around the same time that were 'finally breaking down the barriers between art and protest.'[15] Jordan, a well-known figure in activist circles (although sometimes criticized for his hyperbolic belief in the power of protest and for his somewhat misconstrued interpretation of the trajectory and goals of the European avant-garde), argued that it was only the 'radically creative' that could question the enormity of current-day capitalism. 'It is increasingly clear,' he noted, 'that there is no time to be dispassionate.'[16] Instead, he wrote, what was needed was 'a society where the personal and the political, the passionate and the pragmatic, art and everyday life, become one.'[17] The separation of art and life, suggested Jordan, was a root cause of many issues facing the contemporary world: ecological destruction, the disintegration of social bonds, and the elevation of economic over other concerns. Such issues, he suggested, were cultural, and as such 'require[d] a cultural response.'[18]

In spite of the centrality of 'art' to Jordan's argument, artists themselves came in for special criticism. He wrote that 'it's not difficult to notice the state of this world, yet so many artists immured in their enclosures of studio, gallery, theatre or museum seem blind to it. Those who attempt to push the boundaries of the revolutionary project are rapidly recuperated, neutralised, their political ideas forgotten, their work turned into commodities.'[19] Depoliticized through incorporation into authoritative museums, into art history and the art market, 'art has clearly failed historically as a means to bring imagination and creativity to movements of social change.'[20] Perhaps referring obliquely to the fallout and self-censorship left by the 'culture wars' in the United States in the 1990s, and to concerted attacks on artists working with standpoint or identity politics, queer subjectivity, anti-religious stances, or anything else that might have been deemed 'controversial,' Jordan dismisses the artworld as particularly bereft of any political agency.[21]

Looking through Jordan's lens, by 1999, radical creativity did indeed appear to be located firmly outside the artworld as the streets in Seattle, Prague, Mexico City, Seoul, Quebec City, Calgary, London, Genoa, Miami, Washington, and elsewhere became sites for the vocal, messy, carnivalesque outpourings of the alter-globalization movement. Here,

Jordan's call for a revolution enacted through a mass creative response to the myriad problems brought about through a century of environmental and economic pillage appeared to be falling into place. The reckless beauty of costumed and unarmed protesters facing the police may have been denigrated in the media; but, as predicted by Jordan, the alter-globalization movement seemed poised to take on a life of its own. Jordan's call for 'the insistence on creativity and yet the invisibility of art or artists in [the] midst [of protest]' materialized as activists took the carnivalesque to extremes, battling authorities with costumes, theatre, puppets, and posters.[22] 'Creativity is considered once again political,' wrote Naomi Klein in 2004, 'not just a political priority as in dressing up the protests – but at the center of the spirit of how political alternatives will emerge.'[23] In protest could be found 'a desire to capture that sense of spontaneity and creativity as a political act.'[24]

As it turned out, the split between creativity and art called for by Jordan was perhaps less of a polemic than a self-fulfilling prophecy, as mainstream artists largely (though not completely) ignored the growing movement. Nevertheless, in the late 1990s, any suggestion that artists were not deeply involved in politics would have been disingenuous, for it could be argued that the face of the 'new economy' was also the face of the international artworld. Artists were political. The difference was that this was not the radical anarchist or Marxist politics of the turn-of-the-twentieth-century avant-garde, but the free market politics of neoliberalism.[25]

Many artists who came to the forefront of critical and scholarly attention, particularly in North America and England, appeared to be acting in complete opposition to the goals of the alter-globalization movement. If anything seemed 'radical' in the artworld of the late 1990s it was the antics of the partying, art-star, ironically detached 'young British artists' (yBas), among them Damien Hirst and Tracey Emin, whose works were held to be exemplary of a changing attitude towards the commodification and marketability of art.[26] What passed for radical was celebration of art's *lack* of autonomy, its status as luxury commodity, and its ability to pitch certain artists to a level of stardom more typically reserved for popular actors and musicians. The commonly accepted myth of the artist starving in a garret, inherently rebellious and positioned at the vanguard and on the margins of society – that was the idea that had become calcified.

There were artists and theorists drawn in by the heady combination of mass protest and creativity, who celebrated the autonomy of the front lines of protest. Protesters became 'the multitude' against the unfettered

power of Empire, and the protest itself a creative 'temporary autonomous zone' outside the strictures of life under post-Fordist capitalism.[27] But the acceptance of such analysis was far from complete – there was a void in the space formerly occupied by the artists and left-wing academics[28] whose art works and voices had been so important in establishing the critical project of the 1960s through to the early 1990s.[29] There was, it seemed, no place for art in protest and no place for protest in art, as the latest round of art stars appeared comfortably ensconced in their incipient roles as cultural capitalists.

All the same, as the century turned, only a very few artists were achieving this kind of success. Ryan McGinley's reception was the exception rather than the rule. In fact, although it was overlooked by Jordan – and indeed by most other writers and activists associated with the alter-globalization movement – artists were quickly becoming not only the cultural ambassadors of a new economy, but also some of its most exploited workers. Brian Holmes described the artist's role as that of 'the Flexible Personality,' one who is able to navigate both the positive and the negative aspects of a neoliberal economy. As he noted, 'the word "flexible" alludes directly to the current economic system, with its casual labor contracts, its just-in-time production, its informational products and its absolute dependence on virtual currency circulating in the financial sphere. But it also refers to an entire set of very positive images, spontaneity, creativity, cooperativity, mobility, peer relations, appreciation of difference, openness to present experience.'[30]

The positive 'flexible' qualities of artists, their entrepreneurial and mobile lifestyles, and their creativity were drawn on to validate everything from Richard Florida's Creative Cities Index to government-led projects gentrifying downtrodden neighbourhoods. All of this arguably led to the acceptance of increasingly precarious labour standards for artists and creative workers. Furthermore, at a systemic level, any residual radical politics nurtured by the generation of artists who had been politically active in the 1960s and who had come into positions of power in the 1990s were forced into alignment with what art critic Kathryn Rosenfeld pointed to as the real power behind the American art world: 'the relative seamlessness between the financial drivers of the art world (patrons, collectors, museum trustees) and the core of American capital.'[31]

When it seemed as if the alter-globalization movement had faltered in the streets of Genoa with the July 2001 death of activist Carlo Giuliani, and when the huge outpouring of antiwar sentiment in massive global protests in February 2003 failed to halt the invasion of Iraq, diagnoses of

collapse were quick to follow.[32] That the alter-globalization and antiwar movements failed was largely taken as a given in North America, if not in Europe, and coverage of the movement diminished accordingly. And before the outpouring of hope that greeted Barack Obama's Yes We Can election campaign (and even after), a series of post-2001 events – 9/11, the collapse of Enron, prevarication over weapons of mass destruction, the American-led invasion of Iraq (and the consequent bogging down of troops), attacks in Madrid, London, and Bali, the mortgage and credit crises, the tumbling U.S. economy, the growing scandal over Guantánamo Bay, torture at Abu Ghraib, extraordinary rendition, climate change, and Hurricane Katrina – might have seemed to have fulfilled even the most dire prophecies. Yet to admit to such would be to admit that the protesters had a point. Better to simply pretend that the movement never happened. Certainly, until very recently, this was the position of the vast majority of mainstream artists (particularly in North America), for a brief look through the major art periodicals shows very little engagement with social or political realities.

Arguably, however, as artists were redefined as 'flexible workers,' they were even more closely aligned with the events they chose to ignore than might at first have seemed apparent. The alter-globalization movement, the expansion of the global artworld and rise of the contemporary art market, and the contemporaneous embrace of culture by global capitalism all emerged as part of a shift in the global economy towards encouraging the development of information and knowledge as capital and property. The post-manufacturing 'new economy' manifested itself through increased trade in cultural and other immaterial goods, most notably intellectual property. Even as Jordan stated that 'the solution needs to be cultural' and Klein embraced creativity as a vital element of global activism, creativity itself was being promoted as a strategy of economic expansion. To make this perfectly clear, even as culture was celebrated as the solution to the vagaries brought about by the expansion and spread of global capitalism, it was in the process of being incorporated by that same economic system.[33]

Caught spectacularly in a moment of transition, artists were perhaps not only absent, but also confronted with a situation that was in many ways unrepresentable. If we accept that the artworld is an assemblage, in the Deleuzian sense, then the contradictory elements that allow for creativity to be a methodology of both resistance and maintenance come into sharp relief.[34] That the biennale circuit was at this time itself symptomatic of a new globalization and economization of culture is unde-

niable.[35] Yet the biennale circuit was also the location of some of the most effective artistic political interventions. The flurry of new museum building that resulted in new, spectacular galleries and 'starchitect'-designed cultural institutions in hundreds of cities worldwide raised the ire of many, but was this better or worse than (or incomparable with?) the slashed budgets of the 1990s? Alongside architectural manifestations one found also Art Expos, Cultural Olympiads, creative cities, Capitals of Culture, and meetings by transnational bodies such as the World Trade Organization and UNESCO to discuss the economic potential of culture as it was tied up with regional development, economics, international politics, and tourism. The same international meetings targeted by protesters (using creativity as a weapon) were often accompanied by well-organized and spectacular art events and cultural festivals.[36] And cutting across this scenario one found also an art market skyrocketing to ever dizzying heights.[37] These were confusing times.[38]

To illustrate, take the production of artist Carey Young, whose work demonstrates the profound ambiguity of this situation. In her essay on the yBas, Kirsten Forkert focuses on Young, whose work she describes as containing a nostalgic 'melancholy' found in much of yBa production.[39] Where Young's work differs from that of many of her contemporaries, however, is in its engagement with politics, although that engagement is often centred on illustrating how political standpoints often feed advertising and new management philosophy. In her *I Am a Revolutionary* video, for instance, two suited characters – Young and a voice coach – stand opposite each other in a corporate office as Young repeats the phrase, 'I am a revolutionary.' Although the voice coach tries to get her to say it with conviction, she is unable to do so. Young wrote of the work that the video refers to the commodification of dissent, noting: 'It seems there is no "outside" left, no clear position for critical distance that is not soon incorporated back into the flow of capital around the globe. *I Am a Revolutionary* points to this in a cyclical sense: the artist and her helper appear suspended in a continuum of repetition, effort and belief that change may be possible.'[40]

Young suggests that the work was inspired not only by what she perceived as the vapid commodification of dissent, but also by the way that the rhetoric of 'revolution' had become popular in the business world at the turn of the millennium.[41] *I Am a Revolutionary* takes the word revolution and, through repetition, empties it of meaning.[42] The work, she concludes, is an exploration of the desire for political change, 'but my aim was also to give a sense of vulnerability and pathos through the per-

formance of the characters you see on screen, who are both deadly seri-
ous in their effort and intent, but also impossible to take seriously.'[43]

In her discussion of *I Am a Revolutionary*, Young hedges between the
complete co-option of revolution into systems of consumption and its
potential as symbolic of a fantasy of finding a place and space for the
performance of dissent. She concludes that

> at some point in the future, with the benefit of hindsight we may perhaps be
> able to call recent 'revolutions' such as the public overthrow of the corpo-
> rate-owned water system in Bolivia in 2000, or the 2004 'orange revolution'
> in the Ukraine elections 'radical innovations' for their impact on emergent
> forms of corporate or state power, although their model – street protest – is
> of course an ancient one. But through their relentless focus on the new for
> the sake of market dominance, corporations can be seen as offering today's
> avant-garde – with all the military and cultural interpretations of that term.
> As an artist I'm interested in the hugely problematic implications of that
> for society, and also for artists and cultural production. My work is not a
> question of accepting the status quo, or of creating a polemical or didactic
> work, or even offering some kind of a solution, but of creating pieces which
> immerse the audience in the problem – albeit presented in a roundabout
> way – for the sake of engendering a discussion.[44]

Set in the context of a much wider incorporation of cultural produc-
tion and creativity into global economies, Young's work has a degree of
complication that is perhaps not immediately apparent. Is her work a
symbol of the complete absorption of resistance into the system? Or of
an ironic detachment from it? Does the use of management discourse in
contemporary art signal a new trend for global art as part of a 'capital-
ist' avant-garde described by Young? Or, by contrast, is irony a tactic by
which politics can enter the space of the authoritative museum and gal-
lery unchallenged?

If there is an assumption that the political is either absent, ineffective,
or co-opted by the artworld, this is complicated in this chapter through
an attempt to understand the larger economic, social, and historical
imperatives determining what art should be and how it should act in
myriad settings. While I chose to open with Ryan McGinley, I did so be-
cause the relationship of his work to the occupation of the streets by
alter-globalization protesters is present yet oblique. Unlike her yBa col-
leagues, Young's work appears to be more committed to a certain radical
stance, though perhaps ambiguously so.

More recently though, particularly since 2003 and the bogging down of American troops in Iraq, there has been a distinct reversal in the detachment of artists from current concerns. In fact, one might argue that the very recent artworld can be accurately described as *saturated* with political and politicized art.[45] Mainstream artists may not have been involved in the alter-globalization protests; yet in the passage from the alter-globalization movement, to the 9/11 attacks in Washington and New York, to the subsequent invasion of Iraq and the antiwar movement, and finally to widespread and negative public opinion about the presence of American troops in Iraq, artists began to make their presence felt.

Flipping through the pages of art periodicals such as *Art in America*, *Artforum*, and *Art News* from 2008 quickly reveals a pattern of renewed interest in political, antiwar, or (perhaps to a lesser extent) anti-capitalist art. What I refer to here is not the kind of conceptually oriented art that reveals the inequalities brought about through the globalization of commerce, or the changing notions of identity therein – one might point to Fred Wilson or the Bureau of Inverse Technology in this context; rather, I am referring to art that is specifically located within a traditional framework of oppositional or political art. These are artworks that return to a sort of metaprotest rhetoric, that deal with unambiguous events, make specific closed-loop statements, and often use pedantic poster-style methods to convey information. Thus, this is not at all the obscure relationship that I posited at the beginning of this chapter when connecting McGinley's work to the alter-globalization movement, but a much more situated commitment to paying witness to a specific event (such as the invasion of Iraq).

To take just a few examples among many, one might point to the re-opening of New York's New Museum in 2008, complete with Thomas Hirschhorn's TATTOO series of 'unframed collages that mingle fragments of cheesecake imagery or tattooed limbs from specialty magazines with horrific images of the bleeding flesh and severed limbs of Iraq war victims.' Hirschhorn's collages hung near Martha Rosler's reworking of her anti-Vietnam images in the well-known 2004 series *Bringing the War Home: House Beautiful*, which juxtapose glamorous domestic interiors and photo images from the Iraq War.[46] Just a few pages further on in the same issue of *Art in America* covering the New Museum's opening can be found coverage of the Whitney Museum's purchase of artist Jane Hammond's *Fallen*, an ongoing installation that consists of a platform covered in digital prints of autumn leaves – each one representing one American soldier killed in Iraq.[47] One might point also to the work of renowned

artists such as Clinton Fein, Fernando Botero, Richard Serra, Gerald Laing, Jenny Holzer, and Paul McCarthy, all of whom have made work dealing specifically with the American presence in Iraq.

What I've mentioned here is obviously just a slice of the vast production of protest (primarily antiwar) art created since 2003, a production that in turn was folded into the vast circuit of biennales, many of which either included political components or were arranged directly around political themes. Take, for example, the 2008 Istanbul Biennale 'Not Only Possible But Also Necessary: Optimism in the Age of Global War,' a transnational exhibition that 'dealt with such themes as global trade, war, terrorism, the legacy of architectural modernism, and art's capacity for nurturing social change.'[48] No longer anomalous, political art could be seen increasingly as central, perhaps achieving an apex in the awarding of the 2007 Turner Prize to British artist Marc Wallinger in the same year that he displayed *State Britain* at the Tate Britain Gallery. *State Britain*, which took six months to piece together, was a replica of antiwar activist Brian Haw's 40-metre-long protest installation outside Parliament in London, England. Haw's paintings, posters, banners, and toys were all confiscated by the police when the Serious Organised Crime and Police Act was passed in 2005, disallowing protest within one kilometre of Parliament. A thick black line painted on the floor of the exhibition marked the fact that part of the Tate is within this one-kilometer zone, thus making the re-creation of the protest illegal – except for the important caveat that Haw's message was now filtered through the lens of the artworld.[49]

The increase in production did not, however, bring with it an increase in critical acceptance. Writing about an exhibition of American art collected by Charles Saatchi and shown at the Royal Academy, *Guardian* critic Adrian Searle asked, 'After 9/11, after Hurricane Katrina, after Iraq, Afghanistan, Guantánamo, what should one expect from American culture, apart from rage and crawl-into-a-hole-in-the-ground-and-die abjection?' Describing his lack of emotion when facing a painting by Barnaby Furnas showing men in business suits about to be annihilated in a shoot-out, Searle observed: 'That is one of the problems with art that attempts to make statements … It gets assimilated.' Continuing to describe the potential for political art, Searle finished: 'I want an art more powerful – not just loud, not just blunt. Most of art's audience already know what they think about the state of America and the war on terror. The job of artists, novelists, film-makers, musicians and playwrights demands that they go further than stating the obvious. [This exhibition] is an expression, more than anything, of impotence.'[50]

In a similar vein, critic Eleanor Heartney's final word on the Istanbul Biennale read: 'Many of the works came across as didactic and hectoring, with the show at times resembling a series of social science projects.'[51] Her sentiments are similar to those found in Maria Vetrocq's dismissal of Vanessa Beecroft's 2007 video *Still Death! Darfur Still Deaf* – a video of a performance staged in Venice just before its biennale, in which '30 or so dark-skinned women, wearing sheer underwear and crowded on a low platform' covered in white canvas, are circled by Beecroft, who occasionally tosses a bucket of red paint (blood) over them. Vetrocq wrote: '*VB61 Still Death! Darfur Still Deaf?* makes for a case study in what can go wrong when an artist whose works invite political interpretation ventures to make a work of political art.'[52]

Vetrocq's separation between art that requires political interpretation and political art is an interesting one. Into this division falls the rhetoric of the artworld, which dismisses anything that comes close to the parochialism and clichéd sentiments of the term political art. Indeed, in many ways, a belief that political art cannot function in a political manner is pervasive in academic and critical writing around the issues raised by the alter-globalization and the later antiwar movements. One might read such critiques as echoing John Jordan's exasperation with the artworld, though filtered through an academic apparatus. In a 1997 catalogue entry for InSite, Susan Buck-Morss sums this up nicely when she wrote of post-1991 political art: 'Such art is a moral statement. If successful, it leaves the viewers with a bad conscience. This is the source, but also the limit of its political effect. In the words of one critic of this piece, it is art of a particularly devastating sort, simultaneously expressing art's stunning power and its inescapable weakness, its eloquence and its impotence.'[53] The 'artworld' is encapsulated, and hence, anything within it is politically ineffective. As Adrian Searle concluded, tongue firmly in cheek: 'Who cares about the art or the concepts? They're just the MacGuffin. Tell us about the parties, the openings, the drugs and the dresses. Artists are creative, and creative is sexy and good.'[54]

Depoliticization and (as Buck-Morss puts it) *anaestheticization* seems complete.[55] Art cannot be political because it is a part of the artworld. Which leads to this question: Can art be political when it is *apart from* the artworld? While the answer to that question might be yes, it would seem that dismissal is immanent to the production of contemporary political art. The antiwar art described above cannot say enough, it cannot be effective because it cannot account for the context in which it is displayed. As such, it becomes a visual artefact that says nothing. Similarly, the work

of Ryan McGinley reflects the empty core of the artworld as his photos visually echo the anarchic liberation of protest without ever engaging in the anarchist politics. This process is made clear in a description of Mc-Ginley's work through the spectacularly vacant term *anarchist formalism:* 'the authentic moment, the sense of motion, the anarchy of form within the composition.'[56]

Anarchist formalism (or a formal anarchism?) notwithstanding, writing that criticizes any obvious attempt to bring protest into the artworld can also be contextualized via its position within a history of art history. In any writing on political art there are two persistent ideas at odds. On the one hand, there is the mainstay of connoisseurship: mainstream artists have never responded to current events, art should represent universal aesthetic and transcendent values of beauty, and any political avant-garde has always been positioned outside the artworld. On the other hand, such conservative notions of universal aesthetics are undermined by an equally trenchant myth of the artist as inherently rebellious, politicized, and radical.[57] Both these ideas, however, have been vociferously criticized by those left-wing academics, artists, and scholars who have found both the connoisseur model and the idea of artistic genius to be exemplary of the kinds of master narratives that have maintained the formidable hierarchies underlying the teaching and dissemination of a linear model of Western art history. Any argument that questions the ability of political art to function in the artworld can be seen as the extension of these debates.

However, what is also of interest is the way that the same critics who dismiss the political art described above are also intent on finding exceptions to any rule that all protest art is futile. Take, for example, Buck-Morss's description of artist Fred Wilson's work: 'The political effectiveness of such actions is admittedly temporary, and always in danger of being co-opted into a system that thrives on the new, the untried, the transgressive. But we are dealing here with political effects that make no claim to permanence. They cannot be reified and secured within the artwork itself.'[58] Buck-Morss concludes that, in its very ephemerality, Wilson's work is indeed successful. In the case of Adrien Searle, one might point to his write-up on Darren Almond's film *Bearing*, which traces the plight of a sulphur harvester in Java. Searle writes that '*Bearing* is fascinating, shocking, uncomfortable. But what is our discomfort compared to the plight of the workers?' Yet unlike in the above-quoted review, in which he dismissed political art as instantly assimilated, here Searle notes the following: 'Filmed without comment, *Bearing* escapes voyeurism. It

bears witness and is at its most painful in the periods when the camera waits with the man as he rests, labouring over his breath, the crippling weight, the inhuman conditions.'[59]

There is a noted difference here between the visual work dismissed by Buck-Morss, Searle, and Vitrocq above, and the ephemeral, embodied, and affective work described here. When Jordan described the coming together of art and life in protest, he also focused on a distinction between material object and the embodied effect of participation. And so too, as Carey Young exhaustingly repeats the phrase 'I am a Revolutionary' over and over, what is lost is the meaning of language, not necessarily the meaning or effect of action.

I would like to conclude with this effort on the part of critics to find a residual resistance in the artworld, and to point to what I see as the influence of the alter-globalization movement, if not on the political art being produced for mainstream exhibitions and galleries, then on the critics, scholars, and writers trying to fashion a new discourse to describe the current confluence of concerns that make up a globalized culture. In their search for language can be found a new radicality.

Returning to activist John Jordan, and to the alter-globalization movement itself, I contend that what was radical about the protest movement was its embodying of politics, its refusal to separate bodies from actions. As Brian Holmes put it: 'We know we should all "go out in the streets," but when we get there, there's no there there. We have to create arguments so strong that they can merge with feelings, in order to reshape reality.'[60] In the images and films of actual protest (as opposed to the more removed work of McGinley, Young, and Wallinger), there is often a separation between what is characterized as the freedom of protesters and the imposition of biopolitics through the use of tear gas and violence. Putting one's body 'on the line,' so to speak, is often characterized as a moment of profound alterity and of separation from one's daily life.[61] Thus it can be surmised that the embodied experience of the protest is fundamentally important to understanding that moment of being 'outside' – or perhaps more accurately 'without' – the regimented and stratified society of late capitalism.[62] In analysis, however, the embodied politics of the actual protest are almost invariably overlooked, folded into the politics of sight – which, of course, fits comfortably within the logic of the artworld, and eventually with dismissal. This is precisely the problem that is described in the reviews by Searle and Heartney of political art that simply does not 'work.' By contrast, what *Bearing* does, states Searle, is to 'sustain sensation rather than highlight representation

or communicate meaning.'[63] Almond's work is *effective* because it is *af-fective*, and it draws the critic's attention to himself in the moment – a much-muted imitation of the experience of protest.

It is not that I want to highlight the comparison of the experience of art and of protest, which might read, in any case, as somewhat affected (more so than affective). However, it leads to a question of Searle and Buck-Morss's language, and their inability to fully account for what it is about Wilson or *Bearing*'s art that makes it political. It is precisely this uncertainty and hesitation that mark these statements as worthy of un-packing. The inability to describe is important, for, as Buck-Morss noted in a 2006 article, 'attempts to describe the present transformation are bound to be inadequate because the terms of description are themselves undergoing a transformation.'[64] In her paper, Buck-Morss calls for a radical creativity of thinking, a willingness to 'move beyond cultural ap-preciation of the other, to trans-cultural research and theory that opens up new spaces for imagination and action.'[65] In the fault lines created by what she terms the slow and decisive end of Western hegemony and of capitalism as formulated by the West, there is the potential to create 'theories ... that resonate as meaningful with global social and political movements who can make out the lines, the forms within these theories of their own practical aspirations.'[66] So too, suggests theorist Irit Rogoff, the act of criticism needs to be unbounded: 'instead of "criticism" being an act of judgment addressed to a clear cut object of criticism, we now recognize not just our own imbrication in the object of the cultural mo-ment but also the performative nature of any action or stance we might be taking in relation to it.'[67] Freed from the bonds of 'criticism,' 'critical-ity' can accept the agency of art practice and the idea that it is not the artwork that is in and of itself somehow political; rather, 'artistic practice is being acknowledged as the production of knowledge ... existing in the realm of potentiality and possibility rather than that of exclusively material production.'[68] For Rogoff, and also for Jordan, political art is not necessarily related to the work itself, but to the relations developed through participation, through moving beyond *seeing* an artwork to un-derstanding oneself within it and in relation to its context. There is, in this analysis, no solid sense of history to anchor things, no art-historical discourse to fall back on, no legitimating structures to draw on.

The fumbling for words and for meaning, the embrace of the ephem-eral, the momentary, and the in-between draws much from Deleuzian thought but can also be seen as indirectly yet inexorably related to the street protests of the late 1990s and early twenty-first century (in which

both Buck-Morss and Rogoff have a distinct interest). Politics were acted out in the streets before theorists such as Buck-Morss, Rogoff, and others folded them into a scholarly project that signalled an end to the 'criticism' with which the critical project of the 1990s had been associated. Whereas the imposition of 'Master Theoreticians' imparting knowledge implies a regression into modernist–Marxist scholarship, both Rogoff and Buck-Morss are immensely careful to couch their writing in an openness of dialogue (and polylogue); both papers are presented as unfinished thought pieces, are freely available for download, and are published outside the sphere of academic journals and within the reticulated culture of online networks.[69] For both these theorists, the political lies firmly outside of the didactic and firmly within the performative, the participatory, the engaged, and the affective.

To bring this paper full circle, what I see in McGinley is a similar grappling with a situation that has moved beyond the bounds of traditional art-historical discourse. While some writers have attempted to reinsert him into comfortable narratives of artistic genealogy, the repetition of the term anarchy in descriptions of his work should not go unmarked. What McGinley's work does is capture the pure affect of the moment, and as such it is peculiarly open to empathic response. His photography has been analysed as almost timeless, as lost somewhere in a netherspace between the American Dream and the declining Empire of post-9/11. It is rarely ascribed any political significance outside of its documenting of subculture, and it is rarely, if ever, placed in the context of the work of his more politicized colleagues. As McGinley took to the road with his cameras in 2007 asking companions to come on cross-country road trips, to frolic naked in the leftover spaces of America, and to experience the cultivated freedom of the highway, the tentacles of oil and gas and consumption connecting McGinley's trips to the geopolitics of a changing world were folded into and under an enduring concept of Kerouackian freedom. McGinley's work, with its images of young white privilege masquerading as bohemia, might be seen to effectively represent late capitalism, in its celebration of instant gratification and the pleasure-filled testing of the boundaries of this system. This is precisely what makes it so compelling, yet inevitably so purposeless. These are two sides of the same situation, with McGinley's work clearly contained within a rhetoric of neoliberal creativity, marked by alternative lifestyle, niche markets, hipsterism, gentrification, and pseudo-bohemianism, contrasted with the theory of Rogoff and Buck-Morss, who attempt to break through the

stifling control of the neoliberalized language of aesthetics. The proximity, however, should not be underestimated.

NOTES

1 Philip Gefter, 'A Young Man with an Eye and Friends Up a Tree,' *New York Times,* 6 May 2007, http://www.nytimes.com/2007/05/06/arts/design/06geft.html?_r=1&oref=slogin, accessed 15 October 2008.

2 I use the term *artworld* here in the same manner as does Susan Buck-Morss, collapsing the two words 'art' and 'world,' into one, arguing that the artworld represents a flexible strategy of accumulation and commodification circulating around the world through biennial exhibitions, art markets, and curatorial strategies that imitate corporate mergers and acquisitions policies. See Buck-Morss, *Thinking Past Terror: Islamism and Critical Theory on the Left* (London and New York: Verso, 2003), 84–5.

3 Dash Snow died of a drug overdose in 2009 at the age of twenty-seven.

4 Ariel Levy, 'Chasing Dash Snow,' *New York Art Magazine,* 7 January 2007, http://nymag.com/arts/art/profiles/26288, accessed 15 October 2008.

5 Levy, 'Chasing Dash Snow.'

6 For example, Martha Schwendener writes that 'in many ways, the figures in McGinley's photographs are recreating the age-old art pastoral: Titian's bacchanals; Manet's *Le dejeuner sur l'herbe,* everyone's bathers (from Boucher to Cezanne to Picasso).' In 'Ryan McGinley: An Accessable Eden,' http://gdmorning.com/log/?p=277. http://www.tinyvices.com/Ryan_McGinley_An_Accessible_Eden.html, accessed 15 October 2008.

7 See, for example, reviewer Adda Birnir's ill-concealed disappointment at finding out that McGinley's works were staged in 'Ryan McGinley at Team,' *ArtCat,* 23 April 2008, http://zine.artcal.net/reviews, accessed 15 October 2008.

8 Gefter, 'A Young Man.'

9 Brian Droitcour, 'Suddenly, Last Summer,' *Artforum,* 10 April 2008, http://www.artforum.com/diary/id=19862, accessed 15 October 2008.

10 Levy, 'Chasing Dash Snow.'

11 For one example among many, see coverage in *Time Magazine,* 13 December 1999.

12 Reporters at the anti–Free Trade Area of the Americas protests in Quebec City in April 2001 referred to protesters as, among other things, 'parasites,' 'SUV activists,' '$100,000 a year union officials,' 'ideologically irritating par-

ty animals,' 'the political equivalent of soccer hooligans,' 'stoned rioters,' 'yuppies looking for a 60s fix,' and, more generally, kids 'mumbling on their tongue studs' and 'looking for a place to party.' See Chris Vander Doelen, 'Summit: Blah Says It All,' *Windsor Star*, 25 April 2001; Canadian Press, 'Protesters Just Want to Have Fun,' *Sarnia Observer*, 16 April 2001; Canadian Press, 'Crackdown Hurts Canada's Reputation, Protesters Say,' *Halifax Daily News*, 17 April 2001.

13 For a summary of just some of these creative groups, see the post from Brian Holmes on the empyre listserv titled 'an "ethico-aesthetic paradigm" – in France and Argentina,' 2 May 2008, https://mail.cofa.unsw.edu.au/pipermail/empyre/2008-May/000638.html, accessed 15 October 2008.

14 John Jordan, 'The Art of Necessity: The Subversive Imagination of Anti-Road Protest and Reclaim the Streets,' in *DIY Culture: Party and Protest in Nineties Britain*, ed. George McKay (London and New York: Verso, 1998), 129.

15 Ibid., 129.

16 Ibid., 130.

17 Ibid., 130.

18 Ibid., 130.

19 Ibid., 130.

20 Ibid., 131.

21 For a more in-depth analysis of the 'culture wars,' see Jasper James, *The Art of Moral Protest: Culture, Biography, and Creativity in Social Movements* (Chicago: University of Chicago Press, 1997); or Anthony Julius, *Transgressions: The Offences of Art* (London: Thames and Hudson, 2002).

22 There are several excellent collections describing the carnivalesque outpourings of the alter-globalization movement, among them David Graeber and Stevphen Shukaitis, eds., *Constituent Imagination: Militant Investigations, Collective Theorization* (London: AK Press, 2007); Andy Opel and Donnalyn Pompper, eds., *Representing Resistance: Media, Civil Disobedience, and the Global Justice Movement* (London and Westport: Praeger, 2003); and Benjamin Shepard and Ronald Hayduk, eds., *From ACT UP to the WTO: Urban Protest and Community Building in the Era of Globalization* (London and New York: Verso, 2002).

23 Yogesh Chawla and Sachin Pandya, 'Naomi Klein's Passionate Discourse,' *AlterNet*, 9 March 2004, http://www.alternet.org/story/18067, accessed 15 October 2008.

24 Ibid.

25 Kathryn Rosenfeld, 'This Is Not a Political Essay,' *In These Times*, 15 September 2003, http://www.inthesetimes.com/article/105, accessed 15 October 2008.

26 For more on the yBas and late-1990s Britain, see Jonathan Harris, ed, *Art, Money, Parties: New Institutions in the Political Economy of Contemporary Art* (London and Liverpool: Liverpool University Press and Tate Liverpool, 2004).

27 Hakim Bey, *The Temporary Autonomous Zone: Ontological Anarchy, Poetic Terrorism* (New York: Autonomedia Anticopyright, 1985, 1991); Michael Hardt and Antonio Negri, *Empire* (Cambridge, MA: Harvard University Press, 2000).

28 David Graeber, 'The New Anarchists,' *New Left Review* 13 (2002): 61–73.

29 Gavin Butt, 'Introduction: The Paradoxes of Criticism,' in *After Criticism: New Responses to Art and Performance*, ed. Gavin Butt (Oxford: Blackwell, 2005), 3–9.

30 Brian Holmes, 'The Flexible Personality: For a New Cultural Critique,' in *International Seminar of Class Composition in Cognitive Capitalism* (France: The Sorbonne, 2002), http://www.16beavergroup.org/pdf/fp.pdf, accessed 15 October 2008.

31 Rosenfeld, 'This Is Not a Political Essay.'

32 For one example among many, see Art Pine, 'Collapse Fading Shouts – Anti-Globalization Movement,' *Los Angeles Business Journal*, 7 May 2001, n.p.

33 See, for example, Jeremy Rifkin, *The Age of Access: How the Shift from Ownership to Access Is Transforming Capitalism* (London: Penguin, 2000); and George Yúdice, *The Expediency of Culture: Uses of Culture in the Global Era* (Durham: Duke University Press, 2003).

34 Gilles Deleuze and Félix Guattari, *A Thousand Plateaus: Capitalism and Schizophrenia* (London: Athlone, 1987).

35 Peter Osborne, 'Imaginary Radicalisms: Notes on the Libertarianism of Contemporary Art,' in *ISMS: Recuperating Political Radicality in Contemporary Art, Constructing the Political in Contemporary Art*, ed. Marta Kuzma and Peter Osborne (Oslo: Office for Contemporary Art Norway, 2006), 14.

36 See Kirsty Robertson, 'Capitalist Cocktails and Moscow Mules: The Art World and Alter-Globalization Protest,' *Globalizations (Special Issue: Disciplining Dissent)* 8, no. 4 (2011): 473–86

37 David Ebony, 'War, Terrorism, and SARS Fail to Sink Spring Auctions,' *Art in America* 91, no. 7 (2003): 17–18; David Ebony, 'Fall Auction Totals Soar to Nearly $2 Billion,' *Art in America* 96, no. 1 (2008): 37.

38 The extent of this ambiguity might be found in Justin Fox's article on anarchism for *Time Magazine*, which uses Peter Kropotkin's anarchist theory of a 'gift economy' to suggest that 'one of the most interesting questions in business has become how much work people will do for free.' See 'Getting Rich Off Those Who Work for Free,' *Time Magazine*, 26 February 2007, 51.

39 Kirsten Forkert, 'Transgression, Branding and National Identity,' *Fuse* 29, no. 1 (2006): 22.

40 Raimudas Malasauskas and Carey Young, 'Revolution: It's a Lovely Word' (Budapest: Trafo Gallery, 2005), http://www.careyyoung.com/essays/malasauskas.html, accessed 15 October 2008.

41 Ibid.

42 Ibid.

43 Ibid.

44 Ibid.

45 The one major exception to this might be the 2007 Venice Biennale, curated by American Robert Storr, who declared 'early on ... that he would depart from recent precedent by refusing to freight the art works with an all-inclusive sociological or political message.' As noted by Marcia E. Vetrocq, 'The Venice Biennale, all'americana,' *Art in America* 95, no. 8 (2007): 139.

46 Eleanor Heartney, 'Museums II: Make It New,' *Art in America* 96, no. 4 (2008): 82.

47 Faye Hirsch, 'In Memoriam,' *Art in America* 96, no. 4 (2008): 132–3.

48 Eleanor Heartney, 'Optimism of the Bosphorus,' *Art in America* 96, no. 1 (2008): 51.

49 Marc Wallinger, *State Britain*, Tate Britain Exhibition Material, 15 January–27 August 2007.

50 Adrian Searle, 'Schlock and Awe,' *The Guardian*, 5 October 2006.

51 Heartney, 'Optimism of the Bosphorus,' 52.

52 Marcia E. Vetrocq, 'The Italian Job,' *Art in America* 96, no. 2 (2008): 75.

53 Susan Buck-Morss, 'What Is Political Art,' in *inSITE 97: Private Time in Public Space*, ed. Sally Yard (San Diego and Tijuana: inSITE, 1997), 14–27.

54 Adrian Searle, 'Critical Condition,' *The Guardian*, 18 March 2008.

55 Buck-Morss, 'What Is Political Art.'

56 Gefter, 'A Young Man.'

57 At the opposite end of this spectrum one might find the Stuckist Party and Stuckist Art Group, who have been getting a lot of press in Britain lately with their calls for a return to 'traditional' art (notably landscape painting) and for an end to 'the current hype and marketing values of Brit Art,' combined with a radically left-wing political program that would decriminalize drugs and prostitution, renationalize railways and health care, and ban advertising aimed at children. See the Stuckist Party, 'Manifesto,' (2001), http://www.stuckism.com, accessed 15 October 2008.

58 Buck-Morss, 'What Is Political Art.'

59 Adrian Searle, 'Rebels Without a Cause,' *The Guardian*, 12 September 2006.

60 Brian Holmes, 'Articulating the Cracks in the Worlds of Power, 16 Beaver Group Talking with Brian Holmes,' *Continental Drift, a Seminar with Brian Holmes*, http://www.16beavergroup.org/drift/readings2006ny.htm, accessed 15 October 2008, 6.

61 See, for example, John Drury and Steve Reicher, 'Explaining Enduring Empowerment: A Comparative Study of Collective Action and Psychological Outcomes,' *European Journal of Social Psychology* 35, no. 1 (2005): 35–58.

62 I'm borrowing the notion of 'without' from Irit Rogoff, 'What Is a Theorist?' (2006), http://www.kein.org/node/62, accessed 15 October 2008.

63 Jill Bennett, *Empathic Vision: Affect, Trauma, and Contemporary Art* (Stanford: Stanford University Press, 2005), 21.

64 Susan Buck-Morss, 'Theorizing Today: The Post-Soviet Condition,' *Susan Buck-Morss: Free Thoughts* (2006), http://falcon.arts.cornell.edu/sbm5/thoughts.html, accessed 15 October 2008.

65 Ibid., 8.

66 Ibid., 9.

67 Rogoff, 'What Is a Theorist?'

68 Ibid.

69 David Graeber's thoughtful argument about anarchism, consensus, and 'the vanguard' led me to this point in 'The Twilight of Vanguardism,' in *Realizing the Impossible: Art against Authority*, ed. Josh MacPhee and Erik Reuland (Oakland: AK Press, 2007), 250–1.

10 Transnationalizing the Rhythm / Remastering the National Dance: The Politics of Black Performance in Contemporary Cinema of the Americas

DEONNE N. MINTO

But don't forget who's taking you home
And in whose arms you're gonna be
So, darlin', save the last dance for me.

<div align="right">Ben E. King & The Drifters, 'Save the Last Dance for Me'</div>

Nations are usually defined in terms of the unitary markers of demarcated borders, a shared ethnicity, a common language, and customs that identify the people. Among these customs, dance remains one of the features of national identity that mirrors national culture, or the way in which the nation represents itself to the rest of the world. Specific rhythms, beats, and movements distinguish national dances from one another. The performance of a national dance reflects a desire to master these unique rhythms, beats, and movements; and the mastery of the dance indicates that the performer feels a sense of belonging to the nation. But what happens when the national dance evolves beyond what is understood and accepted as the national culture? How might the national culture be redefined as the national dance changes? What are the implications of this evolution for the nation, its people, and their sense of belonging to the nation?

Dance is a powerful medium for the release of emotion and for communicating what words often cannot fully express. In individual spaces, dance may be viewed as a temporary, cathartic retreat from the pressures of modern life. In national spaces around the globe, dance involves literal steps but also expresses what may be termed 'national steps,' or the historical, social, and legal discourses that dictate the people's past, present, and future movements in the nation. In national spaces the dancer

especially 'becomes inscribed in nationalist histories and is refigured to conform to those histories, yet ambivalence about the dancers and their practices is often evident because the practices themselves often resist being fully incorporated into nationalist discourses. Indeed, the very aspects that make dances appealing and colorful as representations of the past may be precisely the things that do not easily fit into the self-representation of the nation.'[1]

The blurring of national boundaries as a result of globalization has led to the incorporation into national cultures of elements that do not necessarily reflect the national steps. This has influenced the evolution of national dances that, in incorporating rhythms, beats, and movements from outside of the nation, resist nationalist ideologies in an effort to find a third way out of the binary of individual catharsis and cultural re-membering. This new third movement of dance represents a reinterpre-tation of national steps that have been influenced by transnationalism, which is characterized by the movement of subjects, ideas, and practices through or across the boundaries of nations. These subjects, ideas, and practices represent those things that are not fully incorporated into the nation, remain marginal to the nation, and may move or be moved be-tween multiple national spaces. Dance, in particular, as a medium that involves the expression of ideas and practices through subjects in mo-tion, reflects well how transnationalism may transform the ways in which national steps may be interpreted in the Americas.

Apart from actually viewing and / or participating in national dances, many people look to film as the most immediate medium for translat-ing the dance and its potential meanings. The incorporation of dance into film is not a new phenomenon in the Americas. Almost as soon as film became a medium for visualizing societal relations, filmmakers be-gan including various forms of dance in their depictions of national cul-tures. Indeed, 'dance for the camera is not only about dance.'[2] In many ways it functions as a means of representing the rhythmic movements of national subjects as they seek to master and remaster the national dance. Dance for the camera also has activist repercussions. Contempo-rary filmmakers, applying to cinema a type of Brechtian theatre poetics[3] that opens up the space of performance to include and challenge the audience, invite viewers to respond to the orality and kinetic motion of the dance in order to transform the national steps in the larger society. Moreover, with regard to cinematography, the use of filmic representa-tions of dance reflects the aims of Artaudian film theory, which envisions a cinema of purposeful stimulation that 'acts directly on the grey matter

of the brain ... [in order to] go way beyond the theatre which we will rel-
egate to a shelf of memories.'[4] In short, viewers of these films are meant
to leave the theatre with the shared intention of actively influencing the
national steps in some way, after having been influenced cerebrally by
the images of dance on film. While there has been an increasing amount
of scholarship related to dance on film, such examinations have been
limited to singular, national contexts, and only recently have these stud-
ies begun to highlight black dance movements. There remains a need
for comparative analyses of dance on film, particularly in terms of black
performance.

This chapter offers a comparative study of the intersections of dance
performance and cultural, racial, class, and gender representations in
contemporary cinema from various areas of the Americas. Contempo-
rary filmmakers working in Jamaica, Brazil, and Canada, for example,
have been using the medium of cinema as a visual polemic that encour-
ages viewers to engage, interrogate, revise, and expand the discursive
and rhythmic national steps that supposedly represent belonging and
citizenship. Analyses of such films as Don Letts and Rick Elgood's *Dance-
hall Queen* (1997), Carlos Diegues's *Orfeu* (1999), and Clement Virgo's
Love Come Down (2000) reveal the ways in which dance in several contem-
porary national contexts reflects the transnationalization of those na-
tions and a concomitant awareness of how race, class, and gender may be
reimagined in terms of transnationalism. This reimagining is significant
because it expands the discourses of nation and of belonging so that rec-
ognition may be given to elements of the nation that have been margin-
alized but express themselves through movements that are influenced by
forces and cultures beyond the nation.

The National Steps

Before engaging the films noted above, it is important to identify the
national steps signified by the dance performances in each film. Letts
and Elgood, Diegues, and Virgo focus on the interplay between racial-
ized bodies and nationalist ideologies in Jamaica, Brazil, and Canada,
respectively. The interrogation of the politics of performance in these
countries at the same historical moment is significant: the almost simul-
taneous evolution of legal and social discourses and of dance in these
nations has particularly reflected the effects of globalization and trans-
nationalism within the geopolitical space of the Americas since the 1960s
and 1970s. The filmic depictions of Jamaican dancehall, Brazilian sam-

ba, and black dance in Canada highlight the challenges that continue to be expressed towards national metanarratives of race, class, and gender – metanarratives that have yet to fully address the sense of (un)belonging felt by marginalized national subjects.

Originating during slavery as a creolization of European and African folk dances, dancehall evolved over time in Jamaica as a form of musical and dance expression that represented black colonial subjects who, without access to power, claimed power through the space of dance. Dark bodies usually made up the dancehall, but lighter-skinned elites also gained admittance into this space, bringing with them the politics of race and class that characterized the social hegemony of pre- and post-independence Jamaica. After the declared independence from Britain in 1962, Jamaican dancehall became 'a place that rallied opposition to the status quo [of rigid racial and class hierarchies] and challenged the myth of independence,' especially given the internal and external influences of black nationalism, characterized by a strong sense of pride in black culture and a strident patriarchy.[5] The new status of nationhood created a need to unite the different cultures within the population and to elevate the darker bodies, particularly those in the inner cities. These darker bodies, continuously relegated to the bottom of the socio-economic ladder, spoke back to the status quo, often through violent and seemingly vulgar means. Dancehall became one of those means; and, 'because dancehall is a primary idiom through which the black lower class has constructed counterideologies, counteridentities, and counterpractices, it has had a transformative, counterhegemonic potential.'[6] Dancehall, particularly in the late twentieth century, borrows from earlier forms of creolized Jamaican music and dance but also diverges from them by incorporating music and technology from outside the nation and the violent and vulgar expressions of border clashes and disrespect *within* the nation.[7] This dance atmosphere is characterized by its 'deejays, sound systems, stage shows, club scene and energetic dances.'[8] The carnival atmosphere of the dancehall, with its emphasis on costume and accessories, allows Jamaica's downtrodden, marginalized, and disenfranchised to 'transcend their confining identities and become popularized as the kings, queens and superstars of the dancehall.'[9]

Samba, the Brazilian national dance, like dancehall, symbolizes the power of creolization and the carnivalesque. Also like dancehall, its origins may be traced back to early encounters among the Portuguese, Amerindians, and enslaved Africans. After gaining independence from Portugal in 1825 and establishing itself as a republic in 1889, Brazil made

the creation of a national culture, separate from that of Europe and reflective of its own racial make-up, a top priority. Thus the rise of the samba as the national dance runs parallel with colonial encouragement of racial mixture (in order to 'lighten up' the population) and the modern adaptation of a cultural theory of 'racial democracy,' in which all races supposedly contribute equally to the construction of the nation.[10] Once it spread to the bigger cities, such as Rio de Janeiro, samba developed into a popular urban expression that enabled those who resided in inner-city areas, or *favelas*, to achieve recognition from the nation. But samba did more than reflect a transcultural combination of 'mestiço pride and elements of urban popular culture';[11] it also provided a means to retrace the steps of African and indigenous peoples in the erased or submerged histories of the nation. This became even more pronounced during the 1960s, when international black nationalism began to influence black artists in Brazil.[12] Samba then became more than a dance of 'exaggerated elation' over a racial democracy that supposedly had triumphed over racial conflict.[13] It became and continues to be

> the dance of the body articulate a complex dialogue in which various parts of the body talk at the same time, and in seemingly different languages. The feet keep up a rapid patter, while the hips beat out a heavy staccato and the shoulders roll a slow drawl. It is all funky with message. To articulate means, of course, to flex at the joints, and samba may seem fluid and jointless, and at the same time entirely disjointed. The message is simultaneously narrative and lyrical. That is to say, it spins itself out over time, increasing in meaning as it recounts its origins; and yet it compresses its significance in a momentary image. Samba narrates a story of racial contact, conflict, and resistance, not just mimetically across a span of musical time but also synchronically, in the depth of a single measure.[14]

In samba, the 'strong beat is suspended, the weak accentuated. This suspension leaves the body with a hunger that can only be satisfied by filling the silence with motion.'[15] Samba achieves its most commercial and international display during Carnival, during which the weak assume the roles of royalty through the use of costume. With the performance of the samba at Carnival, the poverty and violence of the *favelas* are downplayed, the disparate classes unite, and citizens of the nation perform its unique culture of racial democracy through motion. As with dancehall, Carnival kings and queens are crowned in relation to their mastery of costume and movement.

Finally, unlike dancehall and samba, black dance in Canada is relatively new, specifically in terms of state recognition. While black subjects (native-born, runaway slaves, and their descendants) in Canada danced to the beats of ragtime in the 1890s, jazz and blues from the 1910s onward, and, later, rhythm and blues, the Canadian nation-state, lacking a specific national dance of its own, did not officially recognize black dance. Its emergence as a popular cultural expression can be traced back to the 1970s with Prime Minister Pierre Trudeau's policy of multiculturalism, through which newly landed immigrants, appearing in larger numbers in the 1960s and 1970s, would be recognized and included in the nation. Under this policy, the cultures of recent immigrants, including African and Caribbean immigrants, would be incorporated into a new national model that celebrated individual ethnic identities and cultural differences. As this policy was promoted, multicultural dance became defined as 'any dance tradition other than Western European-based classical genres,' such as the gigue / jig and ballet.[16] This policy worked not so much in practice as in theory, for mainstream dance companies (ballet and modern) continued to receive the majority of federal funding and attention. A breakthrough in matching policy with praxis did not occur until the 1990s, when a government committee offered recommendations for how to make multicultural dance in Canada more reflective of the landscape through greater recognition and visibility. While the enactment of these recommendations 'helped to alter the concept of Canadian mainstream dance,' the division of dance into categories resulted in the marginalization of ethnic dance forms in Canada and 'hindered them from symbolically becoming part of the mainstream.'[17] Though ethnic dance companies have developed contentedly outside the mainstream, the achievement of equal recognition from the mainstream has remained elusive. The status of black dance in Canada, as popular but not equally recognized, reflects the status of black subjects in Canada. Black Canadians live in the 'in-between' of cultural and national affiliation, for the 'impossibility of imagining blackness as Canadian is continually evident even as nation-state policies like multiculturalism seek to signal otherwise.'[18] In spite of continuing marginalization, black dance in Canada, particularly Afro-Caribbean dance, expresses a need to create from the 'edge' of the in-between space of identity. It also reflects a need to recognize the 'collision of cultures and the inseparable union of music and dance' that are at the heart of the black struggle to survive in the in-between spaces in Canada, particularly in urban centres such as Montreal and Toronto.[19] As with dancehall and samba, mastery of

the Canadian multicultural dance requires the ability to negotiate various cultural beats and to disguise through performance the erasure and fragmentation that occurs with marginalization.

These three forms of dance correspond to major geographical areas of the Americas: the Caribbean, South America, and North America. While there are certainly other national dance traditions that have emerged from these areas, the performances of these representative dances especially reflect the ways in which marginalized individuals across the region use dance to deconstruct nationalist discourses; to transgress and transform the boundaries of race, class, and gender; and to redefine belonging as a result. Though dancehall, samba, and black dance in Canada are distinctive and unique to their respective nations, they do share commonalities. All three forms highlight the movement of ethnic (mainly black) bodies as they interpret national rhythms. They all deploy elements of the carnivalesque in terms of costuming and disguising individual histories within the framework of a national dance. Finally, the reinterpretation of these particular traditions, more than others in the Americas, reveals a transnational sensibility that expands the space of the dance beyond the limited framework of nationalist discourses.

Art Imitates Life: The Backdrop of the Dance

The films *Dancehall Queen, Orfeu,* and *Love Come Down* share similar plot lines that lead up to powerfully emotive dance scenes that resolve or offer potential solutions to the problems of the nations represented. In each film the main characters occupy a marginal or liminal space. They are part of the nation but not part of the elite. The main characters in each film are influenced by forces and situations that have the potential to overpower and even destroy them. Modern cultures of drugs and violence abound, fuelled by underground economies that tap into international markets. This reflects the ways in which globalization produces self-inflicted injuries on the extremities of the national body. The characters risk making missteps, or being off beat, in order to confront these pressures and heal their wounds and the wounds of others. As the protagonists find the right rhythm, they master the national dance. But mastery does not just involve mimicry of the literal and ideological steps of the nation. As these subjects infuse the dance with their histories and transnational sensibilities, they redefine and reconfigure the dance, which in turn redefines and reconfigures the nation. Ultimately, the challenge to all is to master the nation's literal and ideological steps

in order to transcend them so that the characters may live beyond rather than merely exist at the margins of the nation.

A Caribbean Cinderella story. This is how one may describe Don Letts and Rick Elgood's *Dancehall Queen*. But that characterization is too simplistic. With no viable Prince Charming available to save her, Marcia, a street vendor, must creatively construct an alternative existence to the one she knows in the inner-city 'yard' of Kingston, Jamaica. Forced to prostitute one of her daughters to one of the 'dons' of the area and to view the psychological deterioration of her brother as a result of witnessing the murder of his best friend, Marcia must confront and manipulate the violence of a hyper-patriarchal and appearance-driven society in which the spectres of madness and death always loom. Marcia, representing the poor, dark-skinned, ghettoized masses of Jamaican society, chooses to manipulate the space of the dancehall in an attempt to better her life. This manipulation signifies the transgression of racial, class, and gender boundaries that usually frame Jamaica's national culture.

Carlos Diegues's *Orfeu* also represents heroic dance movement around spaces of violence, patriarchy, and death. A contemporary adaptation of Vinicius De Moraes's play *Orfeu da Conceição*, which was also the basis for Marcel Camus's now legendary (though problematic) film *Black Orpheus*,[20] *Orfeu* reimagines the Greek myth of Orpheus and Eurydice in terms of the contemporary struggles of those living in the *favelas* of Rio de Janeiro. Like his Greek counterpart, Orfeu is an enchanted musician and philanderer who possesses the ability to seduce the world around him with his music and dance. As a result, he becomes king of the Carnival, as he leads his samba school of Carioca Hill. As Orfeu prepares for Carnival and woos Eurídice (an indigenous character missing in the earlier production), the violence of police raids against the street gang, led by Orfeu's white childhood friend Luchino, imperils the community. Orfeu, the black king of Carnival, leaves the safety of the samba space to confront Luchino about the terror on the hill and later to avenge the death of Eurídice. Orfeu's final dance invites all Brazilians and the international community watching Carnival to reconsider their relationship to the nation of Brazil and to use his legacy of dance to change the ways in which performers and spectators of different classes, races, and genders relate to one another. Indeed, Orfeu's final dance forces an engagement of multiple people across multiple borders by blurring the boundaries of performer/spectator, insider/outsider, margin/centre, so that all present may dance more freely.

As with the other films, inhabiting a border space where one can

dance freely is also represented in Clement Virgo's *Love Come Down*. Signifying on the multicultural space that is Canada, *Love Come Down* is set in Toronto, one of Canada's most multicultural cities. The nation's complex and often vexed relationship with blackness is metaphorically represented in terms of the bonds between two brothers – one white, one black – born of different fathers but of the same mother. Neville Carter is figured as the marginalized black Other; his brother, Matt, is the conflicted white subject, warring against the Other but feeling a sense of paternal responsibility for his darker brother. Reflecting both Caribbean and Canadian roots, Neville is consistently represented as an absence or a troubled presence within his brother's space of intimacy. Both brothers seek the bliss that may come with release from intersecting narratives of pain, engendered by the murder of Neville's abusive father. Neville, in particular, looks to drugs as a means of escape from the reality of his past. Overcoming this misstep is crucial to Neville's final performance of a dance that expresses a love that encompasses more than origins, ethnicity, or national affiliation.

With these scenarios as backdrops, these films present both the challenges inherent in seeking to master the national steps and the potential for movement beyond the margins and borders of the nation through improvisation and the creation of new steps. This improvisation, as the films posit, is best enacted in terms of transnationalism, which allows for flexible movement along borders and across cultural spaces and for mutual empowerment as a result of such interactions. Therein lies the exigency for placing the dance within a transnational frame.

Transnational Improvisation: Movement, Break, and Point of Connection

The scenarios highlighted above imitate actual, lived realities, in that they reflect the very real material concerns of black subjects living in the modern space of the Americas, influenced by an international system of globalization that rips people apart as easily as it appears to bring them together. Dance, in these films, becomes the vehicle that transports the main characters out of spaces of violence and marginalization and into arenas of empowerment. While the use of dance in this manner is not new to film, what sets these films apart from others like them is the alteration and transnationalization of the performance as integral to a reframing of national culture. The filmmakers purposely create tension during these scenes as the camera frames the space of the dance, cross-cuts

between the dance and scenes of destruction, and ultimately closes in on the liberatory poetics of the body as it moves to transnational sounds and rhythms. One may read the influence of three common dance features that repeat in all of the works: movement, or a shift in original position; a break, a movement that is not standard but that accents specific parts of the dance; and a point of connection, or a visible or invisible stationary point that connects partners with varying degrees of connection. All of these characteristics call into question the national steps; prove that the steps can be mastered; and provoke questions of how to re=master, or transform, the steps in order to more accurately reflect national culture.

As noted above, the national dance of Jamaica, dancehall, is characterized by 'vulgar' movements, disguise, and power plays. Marcia's manipulation of the dancehall through 'erotic disguise' troubles many nationalist ideologies.[21] As international reggae superstar Beenie Man introduces the 'mystery lady,' rumours circulate through the crowd about her identity as a street vendor. The lighter-skinned women, in particular, favouring the current light-skinned dancehall queen, ridicule Marcia's appearance to others. Marcia dances to prove that she has an authentic right to perform in the dancehall, particularly since, underneath the make-up and costuming, she represents the dark-skinned majority of the participants.[22]

With a quick shift in her position from recognizable street vendor to dancehall competitor, Marcia performs non-standard movements that contradict her roots in the countryside and the standard, self-promoting moves of the dancehall performers. With this break, she draws attention to the stationary point of the stage, winds up her waist and behind as she turns in a full circle, stretches her arms out to the crowd, and then draws her arms close to her body again. Marcia thus signals to the crowd to join her in her bodily expression, as she uses the stage as her point of connection. As Marcia inhabits the dancehall space, the two dons, who seek to win Marcia-as-object, confront each other, thanks to Marcia's manipulation. One emerges as the victor but is rejected, as the mystery lady enjoys her new title as the dancehall queen.

An earlier statement by Marcia's daughter, that her dance 'is fuh all ah we,' is echoed by Beenie Man, who dedicates the final song to 'all ghetto people who have big dreams.' As the transnational rhythms of techno-pop layered upon reggae resound in the dancehall, while Beenie Man and Lady Saw 'big up' the dancehall queen in song, Marcia leaves the dancehall in her common clothes. Her victory is a victory for the (mainly dark-skinned) downtrodden of the nation, for lower-class women with

no outlets for their creative energy, and for the larger diaspora resisting patriarchal constructions of nation that limit movement across borders.[23]

Orfeu's music and dance also speak across multiple borders. Similar to Marcia's movements, Orfeu extends his arms in broad, sweeping motions, as if to welcome and draw the world closer around him into the space of the dance. His movements also include jumps and prances, which indicate both vertical and lateral movement of the people of the *favela* within the space of the samba. Orfeu's carnival song, a combination of samba and rap, is a break in the standard delivery of carnival music and signals a transnational sensibility that links Brazil with the rest of world through a contemporary music form that has been consumed more readily than most other musical genres by people around the globe.[24] As Orfeu leads the Carioca Samba School at Carnival, he unifies the *favela* of Carioca Hill and links it to the national and international community through the medium of television. Throughout his performance, the points of connection between Orfeu and his audience remain his free-flowing cape and the television screen, which represents the 'power of electronic media ... [to enact] a mythical continuity in local soundscapes,' as the screen frames him permanently and always in motion in the space of the dance.[25]

Orfeu's triumphant dance takes place in the face of violent opposition from Luchino, whose imperial status threatens to disrupt the steps of the dance. Anxiety attends the scene of Carnival, for the viewer anticipates a move by Luchino's henchmen to somehow maim or even murder Orfeu and thus kill the dance. With the cross-cutting of scenes, the viewer discovers that both Eurídice and Orfeu will be victims of Luchino's drug-induced madness. While Orfeu dances, Eurídice inhabits the costume of Carnival but does not enter the space of the dance. Instead, she waits to be reclaimed by Orfeu. Eurídice's static position at the margins of the *favela* represents the indigenous position of waiting to be recognized as an equal part of a national dance that has been interpreted as singularly African in origin. Her death, at the hands of Luchino, represents the loss of indigenous history at the hands of imperial conquest and the continuing erasure of indigenous identity from the national landscape. Thus, when Orfeu descends beneath the *favela*, without state intervention, to reclaim Eurídice's body, his movement signals a necessary attempt at retrieval of the indigenous roots of Brazil from the margins and a desire to place those roots once again at the centre of the nation.

The appearance of Eurídice's dead body in the arms of Orfeu prompts a jealous lover to kill him. But this is not the end of Orfeu and Eurídice:

the film infers that the memory of an African and indigenous past in Brazil will live on in the myth of the two lovers. Thus, while the final scene around the dead bodies is chaotic and fractured, it is also unifying, bringing together diverse representatives of the multiple races and cultures of modern Brazil. Before the camera closes in on Orfeu leading Eurídice in a final triumphant dance of the samba in a mythic space outside the nation, all of the races and classes of Brazil gather together in an alternative space of Carnival, where these cultures exhibit the potential, though not yet realized, of dancing a samba that exceeds the national steps. Such a samba does not yet exist in Brazil's present national context. However, as the closing scene of the film suggests, there remains the possibility of a samba that calls for and exhibits recognition and love of multiple races and classes, if the dancers are willing to move beyond the national space of the dance into a more representational, transnational one.

Recognition and love are the themes that echo in the dance scenes involving Neville Carter. In a scene from childhood, Neville dances a jig freely in front of his mother and is unconscious of the disjointed rhythms around him that threaten to disrupt his sense of the beat. Neville's unstable domestic space explodes in rage as his brother murders Neville's father in order to bring to an end the abuse of their mother. The cross-cuts that provide flashbacks to their childhood turmoil provide references for Neville's adult state of disorientation and drug addiction. Amidst the cross-cuts, one hears Neville's refrain over the film's soundtrack: 'Why can't we just dance?' But Neville cannot just dance. The denial of his pain and the use of drugs to suppress that pain hinder his ability to express himself through dance. Though he has mastered the dance of drug etiquette, he cannot master his own dance while under the influence of drugs. As a result, his dance remains off beat in the techno club scenes that reflect his desire to reach new heights through performance. Instructed by a nun at a rehabilitation centre to 'be still' in order to find the right beat that will allow him to feel as high as he once felt as a child, Neville must stop dancing altogether in order to learn how to dance anew.

Once he confronts the violent ruptures of the past that disturbed his literal and metaphorical dance with the world around him, Neville's refrain echoes on screen again. This refrain signals a movement in his consciousness towards embracing his multiple roots, his violent past, and his marginal position in Canadian society. Neville's ultimate performance at an open-mic club reflects this new consciousness, as he breaks with the traditional comedic routine and introduces his life story into the national

discourse from a stage that functions as his point of connection with the nation. The beats and rhythms of African drums in the background, as Neville once again dances the jig, signal the syncretic expression of black dance and identity in Canada. This also suggests, by way of a camera shot of a captivated, mixed audience, that the nation must begin to rethink its relationship to blackness, which, though marginalized, is rooted both in the nation and in the diasporic movements of African peoples around the globe. The transnationalization of the dance and of the club space demands recognition of the various cultures both within and outside the nation. Moreover, Neville's re-mastery of the national dance extends the space of performance to areas beyond the national boundaries that remain unrecognized in nationalist discourses. Ultimately, the reception of this performance points to a new way of interpreting and engaging creative expressions that emanate from edges, borders, and boundaries.

Neville Carter's improvisational performance opens up a discursive space in which viewers may begin to interrogate what it means to live life on a transnational boundary, at the margin of the nation, and to love themselves from that position. 'Love runs deep,' declares Neville. This is the message at the heart of Neville's refrain and final dance. Love – love of self, love of the anxieties and terrors of history, love of the Other, love of the otherness of multiple Others, love of cultural entanglements – attends and supports life at the boundary and charges that marginal space with an energy not provided by the nation alone. As with Marcia and Orfeu, Neville's penultimate movement reveals to us that true love of the self allows for a freedom of expression that is not based solely on recognition from the nation. Love does indeed run deep; but, as these films express, that love need not originate in and flow from the nation to the Other. Instead, it may move outward from the Other's consciousness into a space of alterity and into other national borders already occupied by Others who have been marginalized by the nation as well. Such a revolutionary move enacts the type of 'redemptive love' that bell hooks argues for, one that may suture the wounds inflicted by nations upon the marginalized Others of the Americas:

> We begin our journey with love, and love will always bring us back to where we started. Making the choice to love can heal our wounded spirits and our body politic. It is the deepest revolution, the turning away from the world as we know it, toward the world we must make if we are to be one with the planet – one healing heart giving and sustaining life. Love is our hope and our salvation.[26]

To turn away from the nation and instead to embrace ourselves in the transnational spaces of the boundary, which we create, is the choice we must make in order to instantiate such a revolution. Only then can we redress marginalization and erasure. Only then can we repair the fissures that come with brokenness. Only then can we know real love. Only then can we truly dance.

Remastery: 'Save the Last Dance for Me'

In 1960, Ben E. King & The Drifters released their international hit, 'Save the Last Dance for Me.' It is fitting that this song, about dance and the movement of bodies, received global airplay at a time when the stereo-typical image of blackness across the globe was just beginning to change, due to television exposure. It is also fitting that the group's name was The Drifters, signifying the random and often unmapped movement of black people, black dance, and black music across multiple border spaces. In many ways, the lyrics of this song express the meaning of contemporary black subjects to the national spaces captured on film and in everyday life. Black performance, after its breaks and its drifts across the ideologi-cal boundaries of nation, race, culture, class, and gender, embraces the heartaches and hopes of various national subjects who identify with both its melancholy and its elation. Through various points of connection, black performance often takes us 'home,' for it expresses what is frac-tured at the centre of the nation. Given the worldwide consumption of black popular culture, it would be naive to deny the importance of black subjects to the marginal movements that focus attention on what is in need of repair at 'home' in the nation. Through their transnational re= mastery, or subtle transformations of national steps, ideologies, and dis-courses, black subjects are communicating to the nation that they dictate the next movement of the national dance. The last dance, in effect, must include and recognize black participation, because it is often the black performance of the last dance that determines the next movement.

The films discussed in this chapter do more than present a re-mastery of national dances and a directive to recognize marginalized blackness as integral to the movement of the body politic. They also enact a re-mastery of the traditional gaze upon the black body. In *Dancehall Queen, Orfeu,* and *Love Come Down*, black performance plays a pivotal role in challenging and reconfiguring national spaces and discourses of race, culture, gender, and class in multiple sites of the Americas. These films reveal that contemporary filmmakers in the Americas seek to make a

clean break with the objectification of the black body and are instead moving towards the celebration of its resistance to and survival against national discourses and nation-state practices that seek to keep it in its marginal place and/or use it to subsume the presence of others in similar places.

Contemporary filmmakers are transforming films into activist projects as they use the camera to shift the world's gaze to those marginal or boundary spaces where the creative, political work of transnational activism is taking place. This transnational sensibility, born out of and expressed from the margins of the nation, infuses border identities with a kinetic energy that compels subjects across the Americas and beyond to keep dancing. These cinematic activists are specifically calling on marginalized subjects to save the last dance for the camera, so that it can record and preserve the movements that will inspire future activist movements across the globe.

NOTES

1 Susan Reed, 'The Politics and Poetics of Dance,' *Annual Review of Anthropology* 27 (1998): 511.
2 Hilary Preston, 'Choreographing the Frame: A Critical Investigation into How Dance for the Camera Extends the Conceptual and Artistic Boundaries of Dance,' *Research in Dance Education* 7, no. 1 (2006): 85.
3 Bertolt Brecht, *Brecht on Theatre: The Development of an Aesthetic*, trans. John Willett (New York: Hill and Wang, 1964).
4 Antonin Artaud, *Collected Works: Volume Three*, ed. Paule Thevenin, trans. Alistair Hamilton (London: Calder and Boyars, 1972), 65.
5 Norman C. Stolzoff, *Wake the Town and Tell the People: Dancehall Culture in Jamaica* (Durham: Duke University Press, 2000), 65.
6 Ibid., 227.
7 Carolyn Cooper, *Sound Clash: Jamaican Dancehall Culture at Large* (New York: Palgrave, 2004), 35; Donna P. Hope, *Inna di Dancehall: Popular Culture and the Politics of Identity in Jamaica* (Kingston: University of the West Indies Press, 2006), 26.
8 Hope, *Inna di Dancehall*, 27.
9 Ibid., 129.
10 Gilberto Freyre, *The Masters and the Slaves: A Study in the Development of Brazilian Civilization*, trans. Samuel Putnam (New York: Alfred A. Knopf, 1946). Followers of Freyre popularized the term 'racial democracy' as a means of

classifying the unique national culture that Freyre claimed had emerged out of Brazilian plantation societies.

11 Hermano Vianna, *The Mystery of Samba: Popular Music and National Identity in Brazil* (Chapel Hill: University of North Carolina Press, 1999), 113–14.

12 Christopher Dunn, 'Tropicália, Counterculture, and the Diasporic Imagination in Brazil,' in *Brazilian Popular Music and Globalization*, ed. Charles A. Perrone and Christopher Dunn (Gainesville: University Press of Florida, 2001), 72–95. Dunn traces well the emergence and impact of the late-1960s Tropicália Movement, particularly how it influenced the rise of black pride and a diasporic consciousness in Brazil.

13 Barbara Browning, *Samba: Resistance in Motion* (Bloomington: Indiana University Press, 1995), 15.

14 Ibid., 1–2.

15 Ibid., 9–10.

16 Nina DeShane, '"Multiethnic" Dance in Ontario: The Struggle over Hegemony,' in *Canadian Music: Issues of Hegemony and Identity*, ed. Beverley Diamond and Robert Witmer (Toronto: Canadian Scholars Press, 1994), 86.

17 Katherine Cornell, 'Dance Defined: An Examination of Canadian Cultural Policy on Multicultural Dance,' in *Canadian Dance: Visions and Stories*, ed. Selma Landen Odom and Mary Jane Warner (Toronto: Dance Collection Dance Press/es, 2004), 420.

18 Rinaldo Walcott, *Black Like Who? Writing Black Canada* (Toronto: Insomniac, 2003), 48.

19 Paula Citron, 'Black Dance in Toronto: A New Voice in the Global Village,' *Dance Magazine* 2 (Feb 2001): 69.

20 Robert Stam, *Tropical Multiculturalism: A Comparative History of Race in Brazilian Cinema and Culture* (Durham: Duke University Press, 1997), 166–78; Charles A. Perrone, 'Myth, Melopia, and Mimesis: *Black Orpheus*, *Orfeu*, and Internationalization in Brazilian Popular Music,' in *Brazilian Popular Music and Globalization*, ed. Charles A. Perrone and Christopher Dunn (Gainesville: University Press of Florida, 2001), 46–59. Stam and Perrone point out the historical importance of the translation of De Moraes's play into the film *Black Orpheus*. Both emphasize how the film offers the world a view of Brazilian Carnival and samba and, even more important, of black Brazilian culture. Their major criticisms revolve around the film's limiting Africanization and exoticization of the nation and its romanticized depiction of life in the *favelas*. Perrone astutely argues that Diegues's film more realistically portrays blackness in Brazil and the uniquely modern culture of the *favelas*.

21 Cooper, *Sound Clash*, 125–44. Cooper especially calls attention to the ways in which Marcia uses the space of the dancehall to redefine the traditional

roles of woman as mother and as object of the emasculated man's domination.

22 Hope, *Inna di Dancehall*, 55–77. Hope outlines the characteristics of many female characters that exist in dancehall culture, stressing that dancehall allows for access to upward mobility for darker-skinned women in ways that the national space outside the dancehall simply will not allow.

23 Jenny Sharpe, 'Cartographies of Globalization, Technologies of Gendered Subjectivities: The Dub Poetry of Jean "Binta" Breeze,' in *Minor Transnationalism*, ed. Françoise Lionnet and Shuh-mei Shi (Durham: Duke University Press, 2005), 261–82. Sharpe's analysis of the globalized networks of women's dub poetry through radio technology may be applied here, for she stresses the importance of radio technology in expanding the movements of Jamaican women. Marcia's forced migration from country to city in search of greater access to economic power eventually leads her to the space of the dancehall, where the presence of deejays, who unite hard-core reggae with techno-pop, facilitates her dance, which extends the agency of this Jamaican woman from a localized, rural space to a globalized, urban space.

24 Charles A. Perrone and Christopher Dunn, '"Chiclete com Banana": Internationalization in Brazilian Popular Music,' in *Brazilian Popular Music and Globalization*, ed. by Charles A. Perrone and Christopher Dunn (Gainesville: University Press of Florida, 2001), 25–30; Frederick Moehn, '"Good Blood in the Veins of This Brazilian Rio," or a Cannibalist Transnationalism,' *Brazilian Popular Music and Globalization*, ed. Charles A. Perrone and Christopher Dunn (Gainesville: University Press of Florida, 2001), 268. Perrone and Dunn – and even more so Moehn – address this issue of the transnationalization of samba and the influences of diasporic consciousness on Brazilian national culture.

25 Perrone, 'Myth, Melopia, and Mimesis,' 65.

26 bell hooks, *Salvation: Black People and Love* (New York: Perennial, 2001), 224–5.

11 Author as Metabrand in the Postcolonial UK: Booking Daljit Nagra

SARAH BROUILLETTE

Eye-catching as they are, the candy colours of the first cover of Daljit Nagra's wildly anticipated *Look We Have Coming to Dover!* are subdued compared to the packaging the poems received when they were printed for a second time (Figs. 11.1 and 11.2). Here we encounter an array of items normally found in a dollar store or corner shop, where eclectic collections amass in a haphazard fashion. Included for display are a soccer ball, a stack of plastic chairs, an ironing board, fake flowers, a package of 'Wonda'-brand cleaning pads, and some water jugs. Their arrangement does not conform to our expectations about how a shopkeeper would shelve things for customers' convenience. Instead, each piece, from the training potties stacked at the bottom to the mops and brooms placed at the sides, adds to a visual composition that frames the crucial information of the name of the author and his book. Behind them, doing the work of a canvas, is what appears to be the kind of room divider often placed between office cubicles. The words of the title, sandwiched between Nagra's name and the distinctive Faber & Faber logo, seem to be spray-painted on it in bold scarlet. Thus rather than offering us a naturalized depiction of consumable items – designed perhaps to reflect the book's interest in the real lives of the poet's shopkeeper parents – the cover points to its own use of these everyday things as a means of grabbing the attention of a different kind of customer: the potential reader milling over the latest poetry. The screen's use as a canvas fronts the deliberate placement of everything around it. The work itself, as a result, through the vehicles of title, publisher's logo, and author's name, becomes at once another part of the hodgepodge collection and a showcase item that is framed and highlighted by the commodities that bracket it. The effect is remarkable. We encounter a package for a book

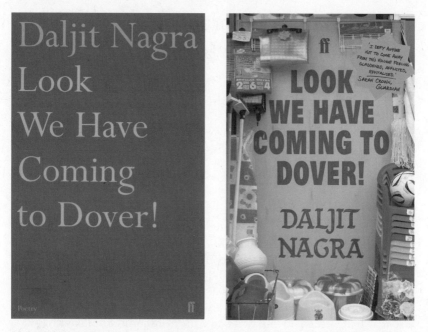

11.1 and 11.2 Book cover art for Daljit Nagra, *Look We Have Coming to Dover!*
Courtesy Faber & Faber.

that revels in self-consciousness about its importance to the book's marketing. It simultaneously packages the product and draws attention to itself as a mediated, deliberately constructed package for what is, at least in part, yet another commodity now available to potential customers: brand Daljit Nagra. We are asked to imagine the poet's work as a kind of quintessential second-generation South Asian commodity, whether it overshadows, displaces, or merely supplements the sort of fungibles that are factory-produced in Taiwan and then sold by the poet's stereotypically shopkeeping immigrant parents.[1]

First collections by contemporary poets, even those published by Faber & Faber, are rarely reprinted. Achieving the sales figures that warrant a second run is just one of the ways that Nagra's emerging career has been exceptional. From the moment it was released, *Look We Have Coming to Dover!* was uniformly heralded as important work by a bold new writer. Critics agreed that he was rejuvenating English literature by mashing it up with voices drawn from his Punjabi family and from the suburban

milieu to which they continue to belong. In light of the author's instant acclaim, what the packaging of the collection's second printing does is highlight his – and his co-producing publishers' and marketers' – humorous appraisal of such instant celebrification. 'Look We Have Coming to Dover!' shouts the exclamatory voice of a Punjabi speaker, as the book itself declares 'Look I Have Coming to Market!' Already a minor star, the author is represented to us here as a playful, fantastical, colourful character ready to enliven and diversify English verse, and also as a cultural creator knowingly jockeying for position within a market glutted by more voices than can secure room in our reading lives and occupying niche positions cleared for them on bookstore shelves.

The final touch to the cover is the nature of the endorsement blurb offered by *The Guardian*'s Sarah Crown, in which she challenges us all 'not to come away from this volume feeling gladdened, afflicted, revitalised.' That her words are contained within the shape of a sheriff's badge is surely a sly acknowledgment that the paper is not called *The Guardian* for nothing. The gatekeepers of elite culture have policed the scene and have offered Nagra their badge of approval. This is not surprising, since before they appeared in the book some of the pieces were printed in the same paper's arts pages, including Nagra's first widely circulated poem, which was to become the collection's title. That initial piece demands in its first breath that an audience 'Look' at the 'We' arriving at England's shores – the shores docked by immigrants 'Stowed in the sea to invade,'[2] but also the borders crossed by the coming of a second-generation Punjabi writer to the region of English verse. When it won the Forward Prize for best single poem in 2004 it created a thirst for Nagra's work that he waited three years to slake.

In the meantime, as Nagra worked on his collection, commentators began to discuss and debate the conscription of notions of 'diversity' and 'community' into the operations of cultural capitalism. The word 'diversity' is now a common one in British cultural policy, and its recurrence has proven particularly predictable in the framing documents that attend efforts to help expand underdeveloped cultural sectors. A notable example of such efforts is the decibel program, whose first incarnation was as a 2003–4 Arts Council England initiative designed to 'address long-standing issues of under-representation' within the British arts scene. £5 million in Treasury funds were allocated for the purposes of supporting African, Asian, and Caribbean artists and arts managers, as well as arts programs involving people of African, Asian, or Caribbean origin now living in Britain. Decibel worked directly with companies and orga-

nizations that shared its goals; it also channelled monies into regional arts councils that were already acting to increase awareness of diversity in the arts sector. Initiatives developed during 2003–4 included a high-profile performing arts showcase and a fellowship program for promising curators. Though they were not unalloyed successes, on the basis of these foundational activities decibel's funding was extended until 2008.[3]

The program has had a number of effects specific to the literary field. Most notably, it has joined with the British Book Awards and Penguin to present an annual decibel Penguin Prize. In its first appearance in 2005 the prize could be awarded only to writers of Asian, African, or Caribbean background. The first winner was Hari Kunzru, and those shortlisted had their work included in an anthology, *New Voices from a Diverse Culture*, published by Penguin. However, a recent policy change, made under pressure from the Commission for Racial Equality, means that one's minority ethnicity is no longer a criterion for inclusion. Instead, in 2006 any 'personal stories of immigrants to the UK' could compete to win and to have their works included in *Personal Tales of Immigration to the UK*, the non-fiction follow-up to the earlier story anthology. Writers have expressed mixed feelings about these developments. Controversial novelist and columnist Nirpal Singh Dhaliwal has called the prize 'a special pat on the head for Britain's ethnic minorities' and has deemed it 'wholly patronizing.'[4] Meanwhile, 2006 winner Diana Evans's more ambivalent response was that though it 'helps to get ethnic minority writers in the limelight,' it is the product of an unfortunate necessity.[5] For Evans, in an ideal world – a world that decibel wants to create – potential readers would not need their attention specially drawn to 'BME' (black and minority ethnic) writers, because enough would already exist and they would encounter no difficulties in selling their works to a sizeable reading audience.

Evans's remarks suggest that rewarding BME artists is only part of the prize's purpose. The high-profile awards are also a marketing strategy designed to help the book industry attract more BME employees and to secure more diverse audiences and greater revenues. These two motivations are related: an increasingly diverse workforce is thought to be indispensable if publishers want to continue to access niche markets through street-level knowledge of the consumer preferences of specific communities.[6] These efforts in the world of books are in line with the logic of the decibel program more generally. As it seeks to increase the diversity of labour within the creative workforce, it works in tandem to foster the kinds of culture and forms of marketing that will prove most appealing

to minority populations, and thus most useful for interpolating them into roles as better, fitter, more active consumers of culture.

Indeed, what the decibel program indicates is that 'the corporate embrace of multiculturalism and diversity,' which Miranda Joseph sees emerging in the United States in the 1980s as 'a strategy for the production of subjects for capitalism,' is an important factor in recent British cultural and civic development.[7] Such development is increasingly crucial for securing the power of the creative economy, which encompasses what was once more commonly called the culture industries. This economy has growing importance as a means of generating post-industrial capital and helping build a powerful yet devolved regional identity around which transnational business arrangements can cohere. Joseph argues that in locating production of and reference to 'community' securely within the marketplace, the language of diversity 'deploys existing differences and elaborates new ones as occasions for the voluntary and enthusiastic participation of subjects as niched or individuated producers and consumers.'[8] Decibel makes this process plain, as arts funding and corporate branding conspire to isolate clear affiliation with specific underrepresented communities as the thing that licenses writers' and artists' access to and distinction within existing or emerging markets. These communities are targeted by producers (authors, agents, editors, marketers, distributors, managers, and executives), who stand to benefit from urging people toward modes of cultural consumption that they may have previously neglected because they found them unappealing, alienating, irrelevant or inaccessible.

One thing that is not yet clear is how an initiative like decibel, which is representative of larger patterns in post-industrial creative industries development, affects both the work of literary production and the meaning of texts. It is in order to think about answers to this question that I discuss schoolteacher *cum* celebrity poet Daljit Nagra's way of managing the connection between access to the market and belonging to a community that constitutes an underdeveloped consumer niche. In part I argue that this author's labour, made up of all of the aspects of his performance of himself as a writer – including his poems, but also their packaging, as well as his self-presentation in interviews and profiles – is designed to reveal the 'antagonisms of class' that tend to be obfuscated by the incorporation of diverse communities into lifestyle niches.[9] A useful beginning framework for understanding Nagra's case is Michael Denning's recently articulated 'labor theory of culture,' proffered as a challenge to the two definitions of cultural practice that have been dominant through-

out much of the past century. One of these definitions reads culture as 'civility,' while the other interprets it as 'solidarity,' so that it is either (after Matthew Arnold) a collection of 'the best that is known and thought in the world' or (after E.B. Tylor) 'the complex of values, customs, beliefs and practices which constitute the way of life of a specific group.'[10] According to Denning, what unites these seemingly divergent views is their mutual tendency to construe the cultural sphere as precisely that which is outside of capital. Both deploy the term 'culture' as a means 'to name those places where the commodity does not yet rule,' whether they are occupied by 'the arts, leisure, and unproductive luxury consumption of revenues by the accumulators' or by 'the ways of life of so-called primitive peoples.'[11] Denning contends instead that culture is first and foremost 'the product and result' of labour.[12] Culture always involves work because it is constituted by labour, and it is also 'a name for that habitus that forms, subjects, disciplines, entertains, and qualifies labor power.'[13] He maintains that recognizing as much is a means of avoiding the division between manual and mental labour, or between labour as conception and labour as execution. This division, which is falsely and even tragically propagated within capitalism, is mirrored in these same broad conceptions of culture – as the best expression of individual geniuses, or as the non-reflexive mores of a community – that Denning wishes definitively to displace.

The tragedy of the false distinction between the head and the hand is always present in Nagra's work. His poems suggest that as the language of collectivity and community is deliberately subsumed into the workings of post-industrial capital, the writer reluctantly experiences his own labour (the labour of producing culture) as a process of converting 'collective symbolic capital' (anthropological cultural horde, or 'culture as solidarity') into individual, self-distinguishing self-expression (Arnoldian 'best' culture, or 'culture as civility'). The output of the producer's labour circulates successfully within the cultural market – or, after David Harvey, captures and rents space within it – precisely because it establishes itself as having a monopoly on a particular, unique, irreducible form of expression borrowed from community affiliation.[14] At the same time, these conditions foster the writer's expressions of embarrassment about the affiliations he draws upon in order to circulate unique and brand-worthy cultural property. In this way, Nagra's *Look We Have Coming to Dover!*, at once a carefully packaged product and a collection of poems that is self-conscious about its marketed production, can be interpreted as meta-branding that labours against the fact that the author's access to value

within the market depends on his ability to inhabit a literary space that had not yet been occupied by any English child of Punjabi immigrants.

But exactly what function does this metabranding perform? One crux of Denning's theory is that there is a crucial and indeed politically propitious distinction between labour itself and the process that valorizes the products of labour, or between 'the material content of purposive human activity and the specific form labor takes under capitalism.'[15] In the case of writers this might be reformulated as the common tension between the work of writing and the often traumatic experience of seeing one's writing turned into a freely circulating item. Yet such a divide seems at best precariously maintained, not least because authors often find material fit for transformation into literary property in the very experience of working as writers, experience that often includes their fate at the hands of the processes of circulation and valorization. Indeed, Nagra's voice in his very first collection already involves an acknowledgment of the way his work's appearance is co-produced by specific acts of market valuation. Hence there is no resistance to his own labour power in the breach between the work and its valorization. Instead, the cultural producer's labour is already directed toward, first, the work necessary to achieve success, and second, the work of critiquing that process of evaluation, which always informs whether and how work circulates in the market. In Nagra's case, these two moves begin to collapse into each other, since much of his work already imagines how it will be validated within the market as a product of the poet's labour – in this case, first and foremost through its connection to a community underrepresented in English verse. The poet activates that connection in his writing but also indicates his ironic distance and even alienation from it. Nevertheless, the poet's act of predicting and lamenting the constraints operative within the process of valuation itself – which might be read in Denning's terms as the poet's resistance to his own labour value, or as his attempt to stake a claim to the open ground between labour and labour value – simultaneously remains an additional *source* of distinct value for his product. Indeed, the work of predicting and lamenting is what he adds to it in order to ensure that it is more than simply an item whose value derives from its attachment to an underdeveloped but desirable community of potential consumers.

As I mentioned above, Nagra has become a favorite subject for journalists who cover the literary beat. Responding to Rachel Cooke's wondering whether he is worried about becoming 'the media's latest Asian,' Nagra states: 'Well, I've set up myself for that. The book is obsessed with

Asian-ness. But there hasn't been a lot of successful poetry about the Indian working classes so, to be honest, I'm happy to carry on writing it. If people label me, that's their concern. I don't even know who I am myself.'[16] Here Nagra is acknowledging that his verse is saleable and interesting because it does something that is as rare in poetry as it is common in novels and screenplays: it locates itself in the experience of South Asian immigration. Nagra's Punjabi-inflected language, which he calls 'Punglish,' is deployed in various guises and tones throughout his collection, and serves as a constant index to the milieu from which the verse emerges. When using it he comically mimics the non-standard 'deviations' that are common to new or otherwise non-standard speakers – so, 'have coming to' for 'have arrived in' or 'have come in to.' Just as the book's cover image refuses to appear unstaged, however, the writing within it makes no pretence to realism when evoking its characters' idiomatic turns of phrase. The relatively elite, college-educated voice of the England-born poet is never far from us. Thus the title poem's first words also hint at what carries over into its remaining lines: a running engagement with Matthew Arnold, whose legibility as a literary reference is by no means restricted to London's literati. That 'Dover Beach' is standard British curriculum is something Nagra knows well, since he works as a schoolteacher. 'I'm working in a school, I'm teaching English, I'm living English and breathing English all the time,' he tells Patrick Barkham. 'Some part of me wants to be Indian as well. I really enjoy writing about Indian people ... I find that far more liberating. All that stuff you grew up with – the intensity of India – has to find its outlet somewhere. Poetry feels like a natural form.' He goes on to state clearly that his aim is not attentive or accurate devotion to the telling ethnographic detail, but rather an absorption of Punjabi idioms into 'an artificial English voice' – one that he delights in reading aloud because he can adopt 'an Indian voice' to 'black it up, minstrelise it.'[17]

Yet even while engaged in such minstrelsy, he rarely stops insisting on his significant discomfort about using his college-level English literary education to (mis)represent those closest to him – namely his family. He describes them as people who were never 'bookish.' He was ashamed of their foreignness during his youth, and they did not understand why he wanted to be a poet until he became famous for it. He describes himself as someone who always tried to be an exception to the rules of English racism, to 'fit in' with the white kids, to share their ways of talking, dressing, and being in the world. He wanted to be 'the OK one,' the boy who wasn't too foreign and thus escaped being bullied by the 'National

Front kids.'[18] Profiles of Nagra tend to focus on this tendency he has to confess to his most shameful behaviour, whether to the journalist or in his poetry.[19] We learn that he would not allow his schoolfriends into his house and would 'bin letters about Parents' Evenings' to ensure that his mother's 'illiterate body' remained 'hidden' to his peers.[20] Yet despite all this, he clearly belongs to these parents for purposes of Arts Council England diversity programming and for commercial marketing that highlights some appeal of (if not to) niche communities. Far from refusing to write about being a child in the Punjabi community – a refusal that would have meant his irrelevance to the market – he makes chaotic, parodic, and sometimes tragic invocations of its members' voices the heart of his verse. He does so while stressing repeatedly that his performance celebrates and lionizes himself and his expressive individual voice by 'booking' their sometimes painful experiences – that is, by making a book out of them, by undertaking their staging or even, most extremely, by filling a charge sheet that imprisons them in his work of representation.

The poem 'Booking Khan Singh Kumar' is where this process is clearest. Nagra's first published poems were written under this pseudonym. The name combines Muslim, Sikh, and Hindu elements, perhaps marking Nagra's prediction and indictment that his carefully crafted verse will be reduced to what Dave Gunning deems 'effluvia from an undifferentiated British Asian whole.'[21] Within the poem it labels a performer who objects to his own clichéd role, asking 'Must I wear only masks that don't sit for a Brit' and wondering whether he should admit he has 'discorded his kind as they couldn't know it.' They 'couldn't know it,' we presume, because there is not much chance that they will encounter the results of his depictions of them in performance or print. The poem is a long list of questions directed many ways simultaneously: at the speaker, the poet, and us. The querying lines 'Did you make me for the gap in the market / Did I make me for the gap in the market' acknowledge the performer's participation in his own commodification, while 'Can I cream off awards from your melting-pot phase' suggests that he understands his success as, in part, a manifestation of a temporary stage in multicultural 'melting-pot' policy making. Meanwhile the line 'Do you medal yourselves when you meddle with my type' intimates that the speaker's very existence as a voice may be a way for someone else to 'medal' herself, while such 'meddling' with his 'type' – his kind, but also his words on the page, which convert the experiences of 'his kind' into typeface (once metal) – is a path to self-satisfaction, and also a response to the push to develop the

market for BME writers, which here is connected to a socially conscious, left-leaning urge to feel good about trumpeting diverse communities' rightful access to and representation within cultural texts. Here Nagra is prodding the Arts Council's decibel program and its highly publicized commitment to support artists who can be said to belong to specific minority milieux. He is pointing out that the publicity accorded his own work is part of a larger cycle of promotion that draws attention to writers like him in order to highlight a general diversity in the field – a diversity that is substantiated by his success with regular readers and their accredited counterparts.

A more subtle but equally telling instance is 'Darling & Me!,' a poem that has appeared in a number of guises. It is the first piece in the collection, and it was read aloud for one of Oxfam's *Life Lines* fundraising CDs in a performance recorded for a promotional video now available via YouTube.[22] Nagra was one of more than sixty poets who read their works after being selected by Oxfam's own poet-in-residence, Todd Swift. Swift says of the project:'Poetry has been hotly debated within the media recently, facing concerns that it is losing its mass appeal. But Oxfam believes poetry is alive – and can help save lives. In a bid to demonstrate how diverse and exciting poetry can be, and to show their support for Oxfam, the UK's leading poets have teamed up to create a CD of their most enthralling work to date.'[23] In this conception, poetry saves lives not because it persuades important people to do or not do certain things, but because its 'diverse and exciting' writers willingly lend their names and their personalizing voices to CDs that are sold to raise money for Oxfam's charitable works. I would add that being able to boast the creation of a product that features respected contemporary poets lends Oxfam the cultural cachet that it needs to thrive as a charity that is also a major brand and, as such, a site of consumer affiliation. After all, Oxfam now markets its own series of products, which are sold along with other environmentally friendly, fairly traded merchandise to the socially conscious consumers who frequent its growing number of retail locations online, across Britain, and abroad. *Life Lines* is one of those responsible products, and I urge my readers to download and listen to Nagra's performance of 'Darling & Me!' before proceeding to my analysis.

Here we encounter the monologue of a man recently married to the 'Darling' of the title, whom he affectionately deems his 'dimply-misses.' As the poem opens he speaks of calling her to announce that he is about to return home. The barman's 'bell done dinging' and he imagines how he will soon be with his new wife again, dancing once more to the

soundtrack for *Pakeezah*. A Bollywood classic from the 1970s, *Pakeezah*'s much-noted decadent grandeur stands in notable contrast to the simple kitchen that the newlyweds 'rumba' into to eat the roti that the speaker's wife so diligently prepares for him. Still the film's story of a courtesan trapped in a set of patriarchal power struggles bears a distinct relation to the situation of the poem's silent, kitchen-bound wife, whose husband, at first sweet and attentive, turns threatening with surprising – indeed jaunty! – rapidity.

Looking forward to his meal, the speaker soon begins to muse about his pub mate Jimmy John, who has his dinners delivered to him by a girlfriend who is envisioned as an incarnation of Hilda Ogden, *Coronation Street*'s luckless, beloved, perennially curler-headed charwoman. To our speaker, what she brings poor Jimmy is clearly bland fare: a 'plate of / chicken pie and dry white / potato!' The exclamation here performs two notable functions (in addition, that is, to conveying some lightness of tone): it indicates the speaker's mockery of the flavourless English cuisine, and, standing in for the 'es' that would be at the end of the correct plural for 'potato,' it draws the reader's attention to his immigrant's English in a way that adds comic irony to his sense of superiority. Soon after, in voicing the girlfriend's command that Jimmy eat his '*chuffy dinnaaah!*' – the word 'chuffy' making her akin to the speaker, as her own demotic phrases reveal their shared class positioning – we encounter a double ventriloquism: the poet voices a speaker who is imagining the voice of this working-class Englishwoman delivering her boyfriend's dinner to the pub.

The shame of having one's private life infiltrate the public space of the bar in this way, as Jimmy's girlfriend emits anger about being made into his servant, is of considerable concern to the speaker. He declares that he would never think to have his wife deliver his meal to him 'in publicity' – a play on the origins of the word 'publicity' in the pub, a place where gossip has long been broadcast and transmitted. But if he did do so, and she advertised the fact by making an angry pronouncement about it, she would earn herself a 'solo punch in di smack.' The use of 'publicity' instead of 'public' and the description of the scene as one that involves an untoward 'advertisement' are, again, partly Nagra's way of appealing to the comic potential in the difficulties of the non-native speaker, but they are also once again more than that. When coupled with the threat of violence, the poem's market-based vocabulary reminds the reader that tales of immigrant South Asian men mistreating their wives have been highly visible in Britain, in part because their circulation

tends to be attended by scandals that erupt when the represented community objects to its characterization.

In his Oxfam performance, Nagra voices the speaker's unusual locutions to their full effect, ensuring that his upbeat tone makes a clear contrast with the sobering implications of what he is actually saying, since, as I have indicated, what begins as gallantry ends as brutality. The poem's final stanzas are tainted by the threat of violence. As we envision the couple dancing, the speaker likens their routine to an ice dance performance by famed English Olympians Torvill and Dean. The new wife falls and is swung up dramatically, her body thoroughly subject to her husband's lead. Indeed, the dance is less a coupling than an exertion of his force over this 'pirouettey' but silent being whose cooking makes such a welcome contrast to the bland English meat and potatoes. These two have been married a 'whirlwind' month and there is no mistaking why she is there: she will labour to produce the 'disco of drumstick in pot' that, with its chef, awaits the return of this man who works 'factory-hard,' tends to refer to himself in third person, and ends his monologue with that most telling of pronouns: 'me.'

The speaker's unsavoury ideas about his wife's rightful position and potential receipt of a 'punch in di smack' are the kinds of things that generated controversy when Monica Ali published *Brick Lane*, a novel featuring several unsavoury male characters. Ali is in many ways an ideal foil for Nagra, since a focus of opposition to her novel was the fact that she was only half Bangladeshi and belonged neither to the working-class milieu nor to the particular community that was her book's focus. The fact that it was necessary that she do research about the treatment of female garment workers – a process she discussed quite openly – became for some critics irrevocable evidence of her outsider status. Yet as a work of fiction *Brick Lane* evinces remarkably little self-conscious interest in Ali's approach to representing the kinds of traumas she unearthed through research. Nor does it pay much attention to the politics of representation that might have been expected to erupt, given the difference between the author's own social location and that of her characters.[24] In contrast, in 'Darling & Me!,' the speaker's mixed-up references to 'publicity' and 'advertising' are there precisely to remind us all that he is himself a fiction and that his characterization here, especially his working-class social location, his immigrant's English, and his by turns sentimental, patronizing, and threatening attitude towards his wife, are what allow the emergence into community-based branding of the poet who created him.

Hence the packaging of Nagra's book – from deriving its title from a poem that won a prestigious prize, to its featuring a cover image and endorsement that slyly acknowledge such strategizing – is very much continued by the poetry within it. Each aspect of the work contributes to the poet's construction of an overarching metabrand that registers his effort to negotiate a livable position within a cultural system that merges the ostensibly civic language of diversity with a private-sector desire to increase capital through the capture of niche markets. These markets are appealed to and constituted as unique communities – and often uniquely disempowered ones – and it is by no means clear that the presence of a writer like Nagra actually encourages community members to be more invested in these target forms of cultural consumption. Still, as arts and culture organizations and policy makers collaborate with private capital to incorporate more diverse communities into the mainstream cultural field, those who most observably author new works are making texts responsive to these conditions of production. Here, specifically, the writer reckons with the notion that his access to the cultural market is premised on the degree to which his texts can be said to have emerged from a distinct – and distinctly disenfranchised – community.

If, then, the job of those who belong to communities of consumers is to lend the author the base material that provides his reason for existing in the market, it may be that becoming a producer entails becoming capable of articulating an alienated relationship both to one's market and to one's community, two things that are mutually constituted in post-industrial capitalism in a way that makes them less analogous and more a dialectically interconnected pair (so that the term 'community' holds the place of whatever remains non-market, for instance). Perhaps, too, for those engaged in the elite cultural practice of literary production – and especially for those who experience alienated distance from the milieux they reference for content – the market circulation of texts on the basis of some attachment to those milieux serves as a constant reminder of what is often an uncomfortable process, one that entails establishing distinct market value on the grounds of one's connection to a particular community. This is hardly a new source of authorial anxiety and concern. To cite just one earlier example, a figure as celebrated as Derek Walcott has long been equally likely to reference the suffering of the people of St Lucia and to bemoan the celebrity he builds through engagement with their plight. It seems to me, however, that for Nagra the quandary presented by the transmogrification of collective experience into personal capital produces a new and more integral or even obsessive

set of textual effects. The very focus of the poetry is the writer indicating his alienation from the 'type' he is aligned with, as he presents himself as one who ventriloquizes their voices because it serves in the construction of his particular brand identity.

In this way what distinguishes Nagra's verse is not just that he engages and enlivens English literary heritage by incorporating select Punjabi vocabulary, demotic speech patterns often presented through dramatic monologues, and references to real and imaginary products, brands, and popular culture. While all of that might be enough to guarantee him some relevance, part of why Nagra has achieved such success is his remarkable willingness to build into his oeuvre so much framing of his own valorization as an outcome of the community-based branding that has been crucial to capital's continued expansion. His work is interesting precisely *because* it continuously evinces suspicion about how belonging to an identifiably minoritized group becomes a means of constituting the distinction necessary to the assured growth of cultural capitalism.

Of course, Nagra does not function alone in this system. As heated conversations about Arts Council England and special dispensations for BME figures have erupted and circulated, the methods and means of market expansion have become contentiously familiar for much of Nagra's core British audience. Supporting and reading Nagra is one way that audiences can then emphasize their own knowingness about their participation in the solidification of the relationship between cultural diversity and consumer capitalism. As David Harvey has argued, 'capital has ways to appropriate and extract surpluses from local differences, local cultural variations and aesthetic meanings of no matter what origin,' and one of the most attractive 'variations' for capitalist repurposing is anything that seems anti-market and anti-commercial.[25] Indeed, to approximate too closely any pure commercialization is to risk losing the 'monopolistic edge' of 'non-replicable cultural claims' that Harvey deems the heart of the functioning of cultural capitalism.[26] Nagra's work – and acclaim for Nagra's work – can be read as an expression of this very tension: it offers resistance to its own reduction to a market function, but in a way that is readily available for renewed commodification, becoming a form of saleable distinction offering poet and reader the chance to avoid buying into the routine repetitive structures scorned by critics of industrial standardization of culture. Nagra thus achieves something additional, and thereby wins even more distinction within the literary field, through his anti-capitalist or non-market critique of the selfsame pursuit of market distinction. This added distinction remains indistinguishable

from continued branding, despite its articulation in a way that displays its author worrying about the fact that it is indistinguishable from continued branding.

Still, to return to Denning's labour theory of culture, there is good reason to highlight, if not to celebrate, the simple fact of Nagra's attempt to lament his own recruitment for specific pairings of state mandate and corporate initiative. In the tradition of Karl Polanyi, Denning's argument implies that labour capacity inherently resists commodification because it remains on some level inseparable from the working bodies that make it operative.[27] It implies that the people who work to make commodities that others might own cannot themselves have their essential labour power turned into a commodity, because it resides in their bodies and in the work those bodies are capable of performing. Those who operate the presses that produce copies of *Look We Have Coming to Dover!*, for instance, go home at the end of the day not owned by the printing company that employs them, pays them, and differentiates so markedly between their labour and that of the poet who writes the words that fill the book. These press workers are joined by forestry employees, by those who run the machines that make the paper and the ink, by those who captain the many vehicles that transport books around the world, by those who count and manage and organize transport and circulation, by those who work in the bookshops, and by the countless others engaged in making, distributing, and selling multiples of a text whose contents they may or may not be familiar with. In marked contrast, Nagra himself provides a source text that remains singularly his and that derives its market value and claim to copyright protection from its integral connection to an author's indivisible subjectivity. Part of what is distinct about literary production as a form of labour may be precisely this: rather than disguising the labour that goes into the production of the thing for sale, the commodity fetishism that obtains within the literary field obfuscates the realities of the making of the product by channelling our attention towards the author as the singular creator whose work is in a crucial sense irreducible – that is, non-reproducibly original. Nagra's work is made available for purchase, derives value, and achieves success due to the ostensible singularity of the expression it contains, an expression attached not only to Nagra's body, to the eyes, brain, and hands most obviously engaged in the act of writing, but to his being as a person, to his emotional and intellectual life as a child of Punjabi-English immigrants. What is commodified is in this crucial sense Nagra's very labouring self, since to buy his work is to purchase access (however illusory) to the be-

ing whose identity is so often used to sell the product. Again, the labour of literary authors is perhaps *sui generis* in this respect. They work with others to co-produce ownable literary products, and their labour power – the power to produce ownable commodities – derives mainly from the value attached to their names and to the ideologies of authorship that make literary expression interesting to audiences. In this sense there is no separation between the thing for sale and the working body behind it; the being whose body it is is a crucial enough feature of the product's valuation to prevent any such disentanglement.

This does not mean that, given the conditions of late capitalist cultural production, the distinction between literary labour and the valorization of literary labour simply evaporates, ceasing to matter entirely. Instead the transformation of the writer's labour into products (products that meaningfully *embody* or simply *are* the writer's labour) becomes a problem that is continually restaged within the work itself. To recognize the sources and signs of this process is to go a long way towards understanding the function of self-conscious gestures within this kind of literary expression – that is, their articulation doesn't solve but merely highlights or even exacerbates the problem: every attempt to distinguish oneself from commodity functions is also a way of distinguishing oneself within a market full of other texts that may not contain this particular kind of added value. Is self-consciousness, then, a necessary correlate to the transformation of a writer's labour into a commodity that is authorized, made, and circulated by a growing army of disparate workers and consumed by an increasingly diverse set of globally dispersed readerships? Is it a means for authors to intimate their solidarity with all the other people who work to ensure that texts reach our hands, but whose labour too often seems to have nothing to do with the meaning of literature? What is clear is that establishing grounded responses to these questions will require acknowledging the simple fact that writers are also workers, in some ways mundanely and in some ways uniquely so. Ceaselessly self-monitoring, self-regulating, and invested in the work that is a 'labour of love,' British writers operate now within a transnational literary field that is enmeshed with acts of 'nation branding' that sell Britain in a series of interconnected ways: as a rapidly globalizing region; as a set of integrated but pleasingly different communities bent on standardizing 'respect' for 'diversity'; and as a staging ground for flourishing creative industries that will realize the promise of a rich cultural heritage and thereby usher the United Kingdom into the next phase of post-industrial development.

NOTES

1 My thanks to Travis DeCook for this point. Thanks also to Dave Gunning for conversations that informed this piece.

2 Daljit Nagra, 'Look We Have Coming to Dover!,' *Look We Have Coming to Dover!* (London: Faber and Faber, 2007), 32.

3 Problems with the program are outlined in Arts Council England, 'Decibel Evaluation: Key Findings,' April 2005, http://www.artscouncil.org.uk/publication_archive/decibel-evaluation-key-findings, accessed 10 November 2011.

4 Nick Tanner, 'Literary Prize Bows to Pressure over Racial Discrimination,' *The Guardian*, 18 January 2007.

5 Ibid.

6 Danuta Kean, ed., 'In Full Colour: Cultural Diversity in Book Publishing Today,' *The Bookseller*, 12 March 2004, supplement.

7 Miranda Joseph, *Against the Romance of Community* (Minneapolis: University of Minnesota Press, 2002), 22.

8 Ibid., 22.

9 Ibid., 29.

10 Terry Eagleton, *The Idea of Culture* (Oxford: Blackwell, 2000), 34.

11 Michael Denning, *Culture in the Age of Three Worlds* (London: Verso, 2004), 79.

12 Ibid., 92.

13 Ibid., 96.

14 David Harvey, *Spaces of Capital* (Edinburgh: Edinburgh University Press, 2001), 394-411.

15 Denning, *Culture in the Age of Three Worlds*, 94.

16 Rachel Cooke, 'Hilda Ogden Is My Muse,' *The Observer*, 4 February 2007, Books section.

17 Patrick Barkham, 'The Bard of Dollis Hill,' *The Guardian*, 18 January 2007, Arts section.

18 Ibid.

19 For further instances, see AE, 'A Gourd Time,' 10 February 2007, http://books.guardian.co.uk/review/story/0,,2009444,00.html, accessed 10 November 2011; and Sean O'Brien, 'Poet of a Streetwise School of Eloquence,' review of *Look We Have Coming to Dover!* by Daljit Nagra, *The Independent*, 12 October 2007, Books section.

20 Nagra, 'In a White Town,' 18.

21 Dave Gunning, 'Daljit Nagra, Faber Poet: Burdens of Representation and Anxieties of Influence,' *Journal of Commonwealth Literature* 43 (2008): 100.

22 YouTube, 'Daljit Nagra Poetry Reading for Oxfam,' http://youtube.com/watch?v=QzlabElZx2c, accessed 10 November 2011.

23 Oxfam, Shop, http://www.oxfam.org.uk/shops/content/poetry.html, accessed 10 November 2011.

24 Monica Ali, *Brick Lane* (London: Doubleday, 2003).

25 Harvey, *Spaces of Capital*, 409.

26 Ibid., 397, 399.

27 Denning, *Culture in the Age of Three Worlds*, 94.

Afterword: Sentiment or Action

RINALDO WALCOTT

But there is no way such a demand will ever be honored unless the habit of transnational connection has already been established, rooted in routine duties and pleasures as well as in once-in-a-lifetime renunciations, made part of ordinary culture.

Bruce Robbins, *Feeling Global: Internationalism in Distress*[1]

Nothing can bring back the hygienic shields of colonial boundaries. The age of globalization is the age of universal contagion.

Michael Hardt and Antonio Negri, *Empire*[2]

This book set out to work in the grooves of at least three large bodies of literature – transnational, activist, and artistic – and three complicated and difficult concepts – transnationalism, activism, and art – that are not settled concepts. Even more significantly, this book has sought to make those literatures and concepts speak to one another and inform one another in ways that illuminate each, that deepen our understanding of each, and that enrich our appreciation of a moment in human history during which the transnational has become 'something' we can no longer ignore. The pressure of something called the global bears down on this book in ways too many to enumerate. It appears that the transnational and the global are intimately connected to each other; but in the critical dictates of contemporary scholarship, transnationalism need not always align with a notion of the global or globalism. It is in fact at the crucial juncture of transnationalism as a kind of critical gaze, one that is both outwards and inwards, and globalism as an essentially outward gaze, that this book has attempted to grapple critically with art and activism.

In the global context, transnationalism as a form of intellectual activism has become a powerful stake in contemporary conversations about what we might become as a planetary species. Let me be clear, then: it is my critical stance that, conceptually, transnationalism offers a more dynamic conceptual palette, one that requires that we think about globalism, postcoloniality, diaspora, and a range of other concepts simultaneously. Principally, for me, transnationalism as a concept requires us to think about the ethical and to consider the practice of freedom in regard to the positioning of peoples within and beyond the contexts of the nation-state; it thereby offers a certain kind of specificity.

In what follows, I push back against theoretical and critical attempts to demarcate the transnational and postcolonial as always different; instead, I read them together as self-constituting critical and practical lived realities evident in art and politics, both of which require forms of action or forms of activism to animate their most crucial components for social, cultural, and political change. While the critical regime of academic institutionality requires the uncoupling of various modes of thought so that institutional networks of power might routinize them into departments, programs, fields, and methods, such forms of routinization – which are also an important element of academic labour – do not also have to contradict the still necessary work of reading together the terms under which we might come together to act, to produce a world different from the one we currently inhabit, but a world we know we need. It is my intention, then, to inquire into the current nature of our unfreedoms in the context of how transnational, postcolonial activism and art might move us along to a world that we cannot yet name, or even sometimes imagine, but that we desperately require.

In this response, I want to centre upon the role that the university plays in the production of critical discourses that can often mirror those of other governing institutions. Since the university is an institution that helps govern and discipline the social and the cultural in ways that collude with other governing institutions, it is important that when activism, art, and critical discourse from the university meet that those discourses be accountable to something. The corporate university requires us to discipline our selves in ways that do not ask for cross-resonant conversations, dialogues, and debates. It is my view that a transnationalism that takes seriously the art and activism of black subalterns refuses such disciplinary measures because such measures do not produce modes of freedom for the dispossessed.

What is the quality and nature of our unfreedoms today, right now, in

the present? In March 2007 many of us celebrated the two hundred years since the end of the British Atlantic slave trade, as well as the fifty years since Ghana's independence as the first modern African nation-state. It is within the frames of black diasporic peoples and African postcolonial disappointment and pleasure that the quality and nature of unfreedom remains a crucial mode of analysis for me. To turn the analytical lens away from languages of domination towards languages of freedom and unfreedom is, for me, an attempt to reanimate what might be at stake in this moment of heightened information technologies and global flows of people, planned and unplanned; unprecedented corporate greed that is called profit, and the collapse of that scheme; the unabating spectacle of the commodity as a new life form; and the pervasiveness of neoliberal ideologies, alongside the reassertion and display of new and old colo-nialisms that are symbiotically and incessantly reorganizing all of human social life. It seems to me that our task as scholars, artists, activists, and cultural workers more broadly is to think this moment in a fashion that requires more action and less sentiment.

I hear in discourses of the Left, or among progressives, a nostalgia for what once was that rings of a sentimental re-enactment of a historical past that is now passé. Even when the historical is dressed up in fluent theoretical languages, genealogies, and genres, a certain kind of lament is evident – one that seems to bemoan a time when a unified Left, mainly made up of white men, plotted the political activities and theorized and led the movements that would produce a new social and political con-sensus for populations and peoples for whom they held the right to care. This cynical and deliberate caricature of Left and progressive politics that I have just laid out takes its highest form in the intellectual and scholarly Left's critique of identity politics. The scholarly Left's too quick and glib dismissal of the idea of identity as a mode through which strug-gle and theory could sustain movements in the face of newer and vastly increasing forms of unfreedom was one that did not seriously grapple with the history of the 'how and why of identity' in the first instance. In what follows, then, I want to set up a provocation in which the language of identity and, more specifically, what I call the ethno-political, might make a reappearance in Left and progressive intellectual circles as at least one of the grounds and terms, among others, from which an analy-sis and thus an activism related to our unfreedoms might proceed – at least in the academy.

In his essay 'Another University, Now: A Practical Proposal for a New Foundation of the University,' the philosopher of history William Haver

argues – in the aftermath and in concert with Bill Readings's announce-
ment of the university's ruins – that

> no longer is it possible simply to assume that the university is sustained by
> and has its relation to reason; nor is it any longer possible to assume that the
> work of the university is to bring our victims to the realization of a mature
> cultural and national identity. And this because the university has come to
> not merely resemble, but to be in fact, a transnational corporation conse-
> crated to sustaining and reproducing the metamorphoses of an inescapable
> postindustrial capitalism.[3]

This is not merely an indictment of the function of the university in late
capitalist culture; rather, Haver is posing an altogether much more dif-
ficult problematic and thus project. Another university now is Haver's
call, and I follow it.

Haver's essay is a sympathetic reading of the ways in which institutions
like universities 'devour their most cogent critics with such appetite and
apparent lack of indigestion' as to make very little of the critique that
we bring to them.[4] But lest we believe that Haver's critique offers no ap-
parent ray of hope, or, put differently, other possibilities, let me quote
him again: 'the most pressing demand for those of us who work toward a
future that would be something other than a continuation of the present
is to make the political appear.'[5] Haver's injunction guides my analysis
of what I believe to be at stake when the discourses of the university,
activism, and art collide and take residence in the everyday details and,
importantly, in the materialities of our lived realities. We are in fact faced
with the difficult and ethical task of how to make the political appear in
such a manner that it is not devoured and marketed as merely yet an-
other moment of the corporate university.

In an elegant and stunning essay titled 'Imperatives to Re-Imagine the
Planet,' Gayatri Spivak writes, 'it is in the context of the global face of the
European nation and the international divide, that I hear the impera-
tive to reimagine the planet.'[6] Spivak is not trying to trump globaliza-
tion discourses by moving to the planetary, but rather to cast the net of
responsibility and ethicality in a new and different register. Spivak thus
states: 'I speak of the imperative to reimagine the subject as planetary' in
a modification of her title.[7] This imperative has important consequences
for localities that are attempting to make sense of how to do more than
manage multicultures and multiculturalism. In short, the imperative is
an ethical injunction.

At the conference that gave the impetus to this book, Timothy Brennan laid out a narrative of the 'economics of cultural theory' in which laziness, monopoly, and the rigours of labour had receded to a kind of wordplay in which the literariness of scholarship pre-empted its political liveliness in the actual world.[8] His narration of the Derridanization of the academy seemed to overplay and calcify the impact of French post-structuralism on and in the academy, refusing an engagement with other sites and traditions, namely the newly emergent: queer-of-colour critique and theory, black and ethnic studies, strains of postcolonial thought not recognizable on the terms he outlined, diaspora studies, black and Caribbean philosophies, and so on, which wrestled Hegel to the ground in many different ways as they formed at the same time as post-structuralism's arrival in the academy. These other studies are conceived both within post-structuralism, within its orbit and/or against it as well. These other studies and intellectual traditions cannibalize post-structuralism and indeed are cannibalized by it.

In the political economy of the North Atlantic academy, who circulates and who is cited plays a fundamental role in the crasser economies of representation, compensation, teaching loads, research grants, part-time and non-tenured labour, and forms of career advancement that might impact the conditions of all of us labouring in the corporate university. In this regard, the politics of canon formation and deformation is not merely one of returning to an origin as such; it seems to me that it is also one of placing on the table the ways in which a certain kind of political philosophy has hijacked and demarcated in good old colonial fashion what constitutes the good hard work of conceptual labour – and much of it is scholarship that does not have to sully itself with identity talk.

Thus if we take seriously a Left Hegelianism, I wonder out loud about the work and labour of C.L.R. James, Frantz Fanon, Sylvia Wynter, Edouard Glissant, and Kamau Brathwaite,[9] among others who have had to think coloniality and its production of the indigenous and the black as primary sites of and for Enlightenment thought, modernity, and the late modern, not to mention capital. This particular turn brings with it the scandalous unthought of 'vicious modernism' that has now morphed into a 'vicious postmodernism' spectacularized in the dead flowing bodies as the evidence of U.S. neoliberal policies, otherwise known as Katrina victims; the devastations of HIV/AIDS and other diseases; civil and political bodies in Africa and the black diaspora; the routinized and largely overlooked violences now plaguing the subalterns of the Middle

East and here at home in North America; the ongoing attempts at Indian (I use this word deliberately) genocide in North America; and the deep policing and recolonization of the archipelagos of poverty, otherwise called the Caribbean; to but name a few of the maladies of our time that call for urgent and cogent politics, action, and ethics.

Thus, what has become particularly pertinent for me over the last while is that where one stands in regard to, and understands, the origins of the material and philosophical and discursive impact of modernity and the modern is where one takes a radically different approach to the question of what is at stake in the deracinated social, economic, and cultural conditions of neoliberal late capitalist organization of human life. The critical stance is where one locates the origins of modernity. I stand with C.L.R. James, Eric Williams, and Sylvia Wynter, among others, who locate transatlantic slavery as central to the origins of the Industrial Revolution and the ideas and discourse of freedom and self-determination that flowed from the contexts of unfreedom in the colonies. In this regard, Susan Buck-Morss, writing in *Critical Inquiry*, attempts to reanimate the debate concerning modernity and its discourse of freedom through a discussion of Hegel and Haiti. Buck-Morss courageously argues that Western political philosophy failed to grapple with the implications of slave labour's spread in the colonies at the exact same time that the Enlightenment discourse of freedom, as 'the highest and universal political value,' was being produced by Enlightenment thinkers.[10] She further asks how we in our times can still produce this same blind spot, if it was indeed a blind spot and not an intentional act in our scholarship in the first instance. She stops short of calling this scholastic neglect the fraud that it is. And she cautions us not to merely place the counter-evidence of what Paul Gilroy once brilliantly called 'the counter-cultures of modernity' as simply belonging to someone else's story.[11] Buck-Morss wants us to mix it up, so to speak. What she systematically documents and demonstrates is the centrality of unfreedom to Europe's global ambitions and aspirations as those desires are now realized, especially in Euro-American terms. The impact of Buck-Morss's argument is that the afterlife of European colonization projects of the Americas has silenced the evidence that in fact Indian genocide and near genocide, as well as African enslavement, are its backbone, both materially and intellectually.

Sibylle Fischer and Michel-Rolph Trouillot have both respectively and differently extended Buck-Morss in placing the Haitian Revolution of 1804 (1791) – or more accurately its culmination – as central to both the practice and the idea of the emergence of the central tenets of European

political philosophy – a philosophy that had to ignore, write against, and collude with practices of unfreedom as the source of its very making or constitution. Thus the epistemological violence inherent in European political philosophy is not new; rather, it takes its imprimatur from a history of intellectual practice that has always sometimes looked the other way, as Buck-Morss so excellently points out. The question for us now is: Why are we surprised that looking elsewhere continues to happen today?

The slave ship as a technology of the modern; the Indian reserve as yet another technology of biopower and biopolitics: while no longer a part of the discourse of many in the academy, both nonetheless remain crucial sites for making sense of the nature and quality of our unfreedoms today. If, as Henry Giroux has expressed, theories of bare life do not go far enough in diagnosing the conditions of disposability and waste, then we must read those theories in conjunction with the discontinuous histories of earlier and more primitive practices of disposability and waste.[12] The slave ship did not just pack bodies in, it overpacked its African cargoes of humans made into non-humans; records show that the slavers sometimes tripled their cargoes in the recognition that the conditions of the crossing would produce much 'waste.' The politics of disposability was built into the ideology and the actual practice of slavery and colonization. Similarly, the politics and ideology of human waste and disposability were central to the genocide and near genocide of Indians, and to the production, the execution, and now the afterlife of their reserves, where deadly effects continue today. That these moments might represent the continuity and discontinuity of discourses and logics of human waste and disposability is not to make them exceptional, but it *is* to point to the fundamental concern at hand – a concern that seeks to make evident that technologies of biopower and biopolitics have a history to them that is located in the move from primitive accumulation, to industrialization, to postmodern late-capital information economies. These practices and logics give us narratives of nation-states and settler colonies that still trade in histories of peopleless lands, savagery, and infrahumanity that embed the logics of bare life, waste, and disposability in a history longer than that of the first half of the twentieth century, culminating in the Nazi death camps.

Thus it is not surprising that the excesses of neoliberal conditions are spectacularized on and in the bodies of the black, Indian, and coloured peoples; the white poor; the queers – categories of the human who, in the second half of the twentieth century and now well into the twenty-first century, are the descendants of the first era of biopower and bio-

politics and are possessed of bodies that have had to make themselves human on the incomplete terms of capitalist modernity's twisted logics. The politics and practices of remaking the human – a central dynamic of post–Second World War politics and ideas – often still find themselves webbed to the categories of the partial and incomplete terms of European man–human conceptions of the globe. Such partiality means that often not resignified, both philosophically and materially, are important elements of political control and the global flows of wealth for peoples who have had to struggle to become recognizable as humans in a post-1492 world. These things bear repeating only because the second half of the twentieth century seems to have been continually resistant to the insights and the counter-narratives of the others of modernity and its unfolding impact, despite the constant mushrooming of new modes of inquiry into the conditions of those of whom we must continually ask these questions: Can the subaltern speak? And if so, what do we hear? These questions are transdisciplinary questions, ones that push against the social sciences, the humanities, and the sciences as gene pools and DNA become textualities in a seamless flow of information alongside the easily recognizable artefacts – or should we say products? – of the corporate university as one node in late capitalism, that those of us lodged in the gaps between the social sciences and the humanities already know and love and hate with equal amounts of *jouissance*. Thus if the last great social movements (civil rights, feminism, gay and lesbian liberation) of the second half of the twentieth century were identity-based and ushered in a discourse and practice of multiculturalism that requires a constant critique so that those identities do not calcify into entities with rigid and unmoving boundaries, those same movements have been central to the new conditions of human life in ways that require us to think their solidarities again. And again.

It is in this light that I want to propose a return to identity, without its 'behaviour-orienting practices,' as a site for the expression of a Left and progressive politics that is willing to recognize that bodies are at stake in ways that make them identities and ethnicities. Thus I am suggesting that the ethno-political is important because we must confront the ways in which the new colonialism and imperialism has continued to make identity a locus of control, containment, and regulation. The recent past of a knee-jerk identity politics critique has now reached its logical end. Past critiques of identity politics very easily dismissed appeals to identity in a claim to mobilize a politics that might be more than one of self-recognition, which is an important gesture. Those critiques sought to produce

a context in which we might care for those with whom we do not share anything in common. These critiques of identity politics that so many of us fell victim to so quickly, however, did not take seriously the fact that identity claims mean something more than recognition and affirmation. Rather, they point to the deeper processes of how commonality and difference work to produce subjects and material realities. Instead, we became stalled debating identity as opposed to analysing and assessing why the claim mattered in the first instance.

Identity claims quickly gave way to a moment of post-identity politics for Left intellectuals, who left only one category still usable: that of class. Class became an empty category filed up with all the coloured folks who had earlier claimed identities based on race and ethnicity and a range of other markers invented in colonial and modern eras. Yet if class politics is a signifier of contemporary racial politics and the claims of dispossession, previous identity claims have much to teach us about how class works in neoliberal times. This is, then, a curious moment, for clearly identity politics critiques did not do the work to sustain the interventionist acts of various groups who have deployed identity as another mode of pointing to dispossession. What I call the ethno-political is an appeal, not to essentialize identity – and in this case ethnicity – but rather to highlight the ways in which identity and, particularly, ethnicity matters in our colonial present. Thus as Diana Fuss stated back in the heady days of the essentialist/constructionist argument: 'To insist that essentialism is always and everywhere reactionary is, for the constructionists, to buy into essentialism in the very act of making the charge; *it is to act as if essentialism has an essence.*'[13] Thus I am not making a case for ethno-politicality as the only ground of a renewed collective politics, but I *am* arguing for the language of ethnicity as a central element for how we approach a collective politics of the possible, and thus a postcolonial to come.

When Stephen Clarkson and his abolitionist comrades were able to impact the British Atlantic slave trade, they did so fully located in their white, male difference from those they sought to help on the plantations in the colonies. While the movement was not an altruistic one, it nonetheless has something to teach us in contemporary times about the nature of political organizing. Importantly, as Adam Hochschild points out,[14] all of the various ways in which contemporary campaigns for numerous social justice projects are still organized are founded on the very inventions of political action used by the abolitionists (investigative reporting, consumer boycotts, activist cells and chapters, posters, detailed targeted lettering, lobbying of politicians, and so on). Similarly, I would

suggest that abolitionist organizing has much to teach us in our time of proliferating and speedy information technologies about how solidarities can be achieved through the ways in which those of us engaging with them make use of them to push beyond the limits of the imagined communities we engage – in order to engage those we can't yet imagine. This, then, is a solidarity without advanced guarantees, as Stuart Hall would suggest.

The history of Ghana's independence is one of those stories where various solidarities have come to grief and disappointment since the hopeful event of Kwame Nhrumah's 'Wings of Change' speech – especially for many diasporic blacks who made the return voyage and also for poor Ghanaians. As I listen to that speech in the present, I hear the language of hope and the possibility of change, the desire for a United States of Africa, and the articulation of a material and symbolic home for the children of those made into slaves, as well as a dream of African socialism. I am also confronted by the lack of clearly articulated public sphere alternatives to the ways in which late capital and its juridical neoliberal policies, practices, and procedures have reorganized social life and continue to do so. It seems to me that much scholarship and cultural work that seeks to be activist, to activate something, has been trained to accept and wallow in the ongoing fluid networks of late capital as if it can be and is the only behaviour-orienting system for organizing all of human life.

Finally, many years ago the late C.L.R. James argued that black women writers in the United States – but one might now say globally – represented a force of the ethical–political to reckon with. James's claim was not one grounded in the exceptionality of black women writers; rather, it was an insight that concerned itself with seeing from another perspective the imperative to see and hear – to listen, even – differently in an attempt to apprehend the conditions under which human life was ordered and being reordered. James's insight was one that recognized that solidarity and change are premised on hearing those most disenfranchised and acting in concert with them on both practical political and ethical–political terms, contexts, and conditions. James's articulation of and insights about the works of black women writers that exhibited various solidarities across race, gender, and class still hold much promise today, I would argue. But in this moment we must turn our political attentions and desires to hearing those of the racialized poor, the ethnicized security threat, the sexualized transdeviant, and this we must do decidedly within and against the nation-state since the nation-state remains a foundational category for the organizing and policing of various forms of human life. Hence we need to articulate our activisms and arts transnationally.

What Dionne Brand calls in her long poem *Inventory* 'the science-fiction tales of democracy'[15] – in that same book she takes inventory of the upheavals, to put it mildly, of the beginning of the twenty-first century – must be the principal site of our collective struggle. I would argue, then, that as cultural workers of various sorts the task before us is, for the first time in history, to strive for a democracy that is no longer practised and premised on the terms of partiality. To end on a *Derridanization*, we must work for a democracy yet to come.

NOTES

1 Bruce Robbins, *Feeling Global: Internationalism in Distress* (New York: New York University Press, 1999), 23.
2 Michael Hardt and Antonio Negri, *Empire* (Cambridge: Harvard University Press, 2000), 136. Italics in original.
3 William Haver, 'Another University, Now,' in *Equity and How to Get It*, ed. K. Armatage (Toronto: Inanna, 1999), 25.
4 Ibid., 26.
5 Ibid., 27.
6 Gayatri Spivak, 'Imperatives to Re-imagine the Planet,' in *Alphabet City 7: Social Insecurity*, ed. Cornelius Heesters and Len Guenther (Toronto: Anansi, 2000), 268.
7 Spivak, 'Imperatives to Re-imagine the Planet,' 269.
8 Timothy Brennan, Keynote Address, Transnationalism, Activism, Art Conference, University of Toronto, March 2007.
9 Sylvia Wynter, 'On Disenchanting Discourse: "Minority" Literary Criticism and Beyond,' in *The Nature and Context of Minority Discourse*, ed. A. JanMohamed and D. Lloyd (New York: Oxford University Press, 1990), 432–69.
10 Susan Buck-Morss, 'Hegel and Haiti,' *Critical Inquiry* 26, no. 4 (2000): 821–65.
11 Paul Gilroy, *The Black Atlantic: Modernity and Double Consciousness* (Cambridge, MA: Harvard University Press, 1993), 5.
12 Henry Giroux, *Stormy Weather: Katrina and the Politics of Disposability* (Boulder: Paradigm, 2006).
13 Diana Fuss, *Essentially Speaking: Feminism, Nature, and Difference* (New York: Routledge, 1989), 21. Emphasis in original.
14 Adam Hochschild, *Bury the Chains: Prophets and Rebels in the Fight to Free an Empire's Slaves* (Boston: Houghton Mifflin, 2005).
15 Dionne Brand, *Inventory* (Toronto: McClelland and Stewart, 2006), 8.

Contributors

Prasad Bidaye is a professor in the English Department at Humber College. He is completing his PhD at the University of Toronto in the Department of English and in collaboration with the Centre for South Asian Studies. Prasad has written extensively about electronic music for publications such as *Exclaim!* and has produced programs for community radio and the CBC. He is also a deejay and performs live electronic music.

Sarah Brouillette is an associate professor in the Department of English at Carleton University, where she teaches contemporary British, Irish, and postcolonial literatures, and topics in print culture and media studies.

Jeff Derksen is a founding member of Vancouver's writer-run centre, the Kootenay School of Writing. He was an editor of *Writing* magazine. His work has been anthologized in *East of Main and Verse: Postmodern Poetry and Language Writing.* As an editor, Derksen organized 'Disgust and Overdetermination: A Poetics Issue' for *Open Letter* as well as 'Poetry and the Long Neoliberal Moment' for *West Coast Line.* Derksen's poetry and critical writings on art, urbanism, and text have been published in Europe and North America. He currently works in the English Department at Simon Fraser University. He collaborates on visual art and research projects (focusing on urban issues) with the research collective Urban Subjects. His *Down Time* won the 1991 Dorothy Livesay Poetry Award at the BC Book Prizes.

Kit Dobson is an assistant professor at Mount Royal University, where

he teaches and researches Canadian literatures, film, and globalization. His first book, *Transnational Canadas: Anglo-Canadian Literature and Globalization*, was published in 2009 by Wilfrid Laurier University Press. He has recent and forthcoming articles in a number of journals and books, including *Canadian Literature, Studies in Canadian Literature, Canadian Review of American Studies*, and *Open Letter*.

Chantal Fiola is Métis Anishinaabe-Kwe (Saulteaux, Cree, French) with roots in the Red River region of Manitoba. She holds a PhD in Indigenous Studies from Trent University and wrote a dissertation entitled, "Rekindling the Sacred Fire: Métis Ancestry, Anishinaabe Spirituality and Identity." She also holds degrees from the Universities of Toronto and Manitoba. Chantal is currently working as a sessional instructor for the University of Manitoba and as an independent consultant specializing in Aboriginal-centered projects.

Graham Huggan teaches in the School of English at the University of Leeds, where he is also founding co-director of the cross-disciplinary Institute for Colonial and Postcolonial Studies. He is the author of *The Postcolonial Exotic* (Routledge, 2001) and *Australian Literature* (Oxford University Press, 2007). His current work includes books on postcolonial literature, animals and the environment, contemporary travel writing, and celebrity conservationism in the television age.

Sam Knowles completed his PhD in the School of English at the University of Leeds in 2011. His thesis, *Between Travel Writing and Transnational Literature: Michael Ondaatje, Vikram Seth, and Amitav Ghosh*, explored the multiple intersections of travel writing and transnational fiction in the work of three particular authors. He is currently working on articles in several areas, from the politics of travel writing to graphic novel representations of migration.

Lee Maracle, of Salish and Cree ancestry, is a member of the Stó:lo Nation. She is one of the founders of the En'owkin International School of Writing in Penticton, BC, the first Aboriginal writing school developed and run by and for Aboriginal people. Widely published and internationally read, she is an award-winning writer and teacher as well as a gifted orator. Her works of fiction include *Ravensong* and *Daughters are Forever*. Her works of non-fiction include *Bobbie Lee: Indian Rebel, I Am Woman: A Native Perspective on Sociology and Feminism*, and *Oratory: Coming*

to Theory. She has also published a book of poetry titled *Bent Box*, as well as several collaborations, anthology contributions, and critical essays. Recently, she contributed an article titled 'First Wives Club, Salish Style' to Drew Haydon Taylor's *Me Sexy: An Exploration of Native Sex and Sexuality.*

Áine McGlynn completed her PhD in English from the University of Toronto in 2010. Her thesis, *White Male Anxiety and the Queer in Recent Anglophone Literature*, productively combines her diverse interests in transnationalism, queer theory, and cultural studies. Over the course of her graduate career she has contributed essays on film, hip hop, and contemporary American, British and African fictions. With the support of the Centre for Diaspora and Transnational Studies at the University of Toronto, McGlynn created the Transnational Reading Group in 2005.

Kelly Minerva is a doctoral candidate in the English Department in collaboration with the Centre for South Asian Studies at the University of Toronto. In her dissertation, *Creating Identity in the City Spaces of Bombay/ Mumbai*, she explores fictional representations of Bombay (by Vikram Chandra, Rohinton Mistry, and Salman Rushdie) in order to examine the ways in which the identities of individuals and of urban spaces are created and manipulated through texts.

Deonne Minto is an independent scholar who earned her PhD from the University of Maryland–College Park. Her research interests include literature of the Afro-Americas, gender and diaspora, and transnational cultural studies. In addition to presenting papers at a multitude of international conferences, she has published articles and book reviews in various journals. She is currently revising a manuscript that examines twentieth-century black women's literature of the Americas in a comparative context.

Nick Morwood gained his PhD from the University of Toronto in 2011, where he wrote a dissertation on power in twentieth- and twenty-first-century fiction and theory. His work turns particularly around that of Italian philosopher Giorgio Agamben, but also ranges across fiction dealing with the postmodern, the postcolonial, and the transnational. Authors of interest to Morwood's project include Salman Rushdie, Margaret Atwood, Don DeLillo, and William Gibson. In addition, he researches trends and innovations in digital media and networks as markers of the impact of new technology on contemporary culture and life. He is cur-

rently preparing work on the representations of terrorism, violence, and empire in the political philosophies of Hobbes and Benjamin and in popular video games.

Kirsty Robertson is an assistant professor of Contemporary Art and Museum Studies at the University of Western Ontario. Her research focuses on activism, visual culture, and changing economies. She has published widely on the topic and is currently finishing her book *Tear Gas Epiphanies: New Economies of Protest, Vision, and Culture in Canada.* More recently, she has turned her attention to the study of wearable technologies, immersive environments, and the potential overlap(s) between textiles and technologies. She considers these issues within the framework of globalization, activism, and burgeoning 'creative economies.' Her co-edited volume, *Imagining Resistance: Visual Culture, and Activism in Canada,* was released in 2011.

Imre Szeman is Canada Research Chair in Cultural Studies and Professor of English and Film Studies at the University of Alberta. Recent books include *After Globalization* (2011, with Eric Cazdyn), *Contemporary Literary and Cultural Theory* (2012, co-ed), and the third edition of *Popular Culture: A User's Guide* (2012, with Susie O'Brien).

Rinaldo Walcott is an associate professor at the Ontario Institute for Studies in Education. He is currently at work on a manuscript titled *Black Diaspora Faggotry: Frames Readings Limits.* Questions of diaspora, modernity, and queer and gender studies are the focus of his research and teaching.

Melissa Autumn White is an assistant professor of Gender and Women's Studies at the University of British Columbia, Okanagan campus. A transdisciplinary queer and feminist queer scholar, her research involves viruses, affect, embodiment, subjectivity, knowledge, territoriality, sovereignty and power. Her writing has been published in *WSQ: Women's Studies Quarterly* and *Topia: Canadian Journal of Cultural Studies,* and is forthcoming in *Interventions: International Journal of Postcolonial Studies,* and *Feminist (Im)Mobilities in Fortress North America: Rights, Citizenships and Identities in Transnational Perspective* (Ashgate, Gender in a Global/Local World Series).